NEW YORK CITY
MARATHON

Skyhorse Publishing books may be purchased in bulk at special discounts for sales promotion, corporate gifts, fund-raising, or educational purposes. Special editions can also be created to specifications. For details, contact the Special Sales Department, Skyhorse Publishing, 307 West 36th Street, 11th Floor, New York, NY 10018 or info@skyhorsepublishing.com.

Skyhorse® and Skyhorse Publishing® are registered trademarks of Skyhorse Publishing, Inc.®, a Delaware corporation.

Visit our website at www.skyhorsepublishing.com.

10 9 8 7 6 5 4 3 2 1

Library of Congress Cataloging-in-Publication Data is available on file.

Cover design by Thomas Cabus
Cover photo credit: Ed Lederman/NYRR

ISBN: 978-1-5107-5868-1

Printed in China

NEW YORK CITY
MARATHON
50 YEARS RUNNING

EDITED BY RICHARD O'BRIEN
INTRODUCTION BY GEORGE A. HIRSCH

Skyhorse Publishing

NEW YORK ROAD RUNNERS

CONTENTS

Introduction By George A. Hirsch vii

Photo by Scott McDermott/NYRR

Photo by Drew Levin/NYRR

INTRODUCTION

BY GEORGE A. HIRSCH

This year marks a special occasion for all of us at New York Road Runners—the 50th running of the New York City Marathon (1970–2021). While Boston is older, New York became the first truly urban marathon, bringing the 26.2-mile footrace to the citizens of our great city. That path has been followed by London, Berlin, Beijing, Tokyo, and so many other spectacular marathons in splendid cities around the world.

I did not run the first New York City Marathon, held in Central Park on September 13, 1970. You might wonder why, considering that I had already run three marathons and my good friends Fred Lebow and Vince Chiappetta were the race directors of the new event. The running community was small and close-knit, so I knew many of the 127 starters, all men except for Nina Kuscsik. (Only 55 finished.) Back then the Boston Marathon was the only distance race that really mattered, and as a busy magazine publisher I focused on that race as my main event. Let's face it, Lebow and Chiappetta's marathon clearly had a slight inferiority complex, charging runners a one-dollar entry fee while big-time Boston was commanding double that!

In fact, I ran none of the five Central Park marathons, but on those race mornings I would run in the opposite direction of the runners, cheering on my friends. By today's standards it seemed quite disorganized, with bicycles and pedestrians weaving in and out among the racers.

During those years in the early 1970s something was happening. Our offbeat sport started getting mainstream attention, and with Frank Shorter's victory in the 1972 Olympic marathon, America had a new sports hero. Shorter became the face of the running boom.

So when in 1976 George Spitz, a civil servant and a runner himself—and a true New York character—proposed a five-borough marathon, the time seemed almost right. *Almost.* Despite Spitz's persistence and repeated phone calls, even Lebow felt it was too big a lift. "A race like that could cost $15,000 and where are we going to get that kind of money?" Lebow asked. But Spitz just kept calling a number of us, and

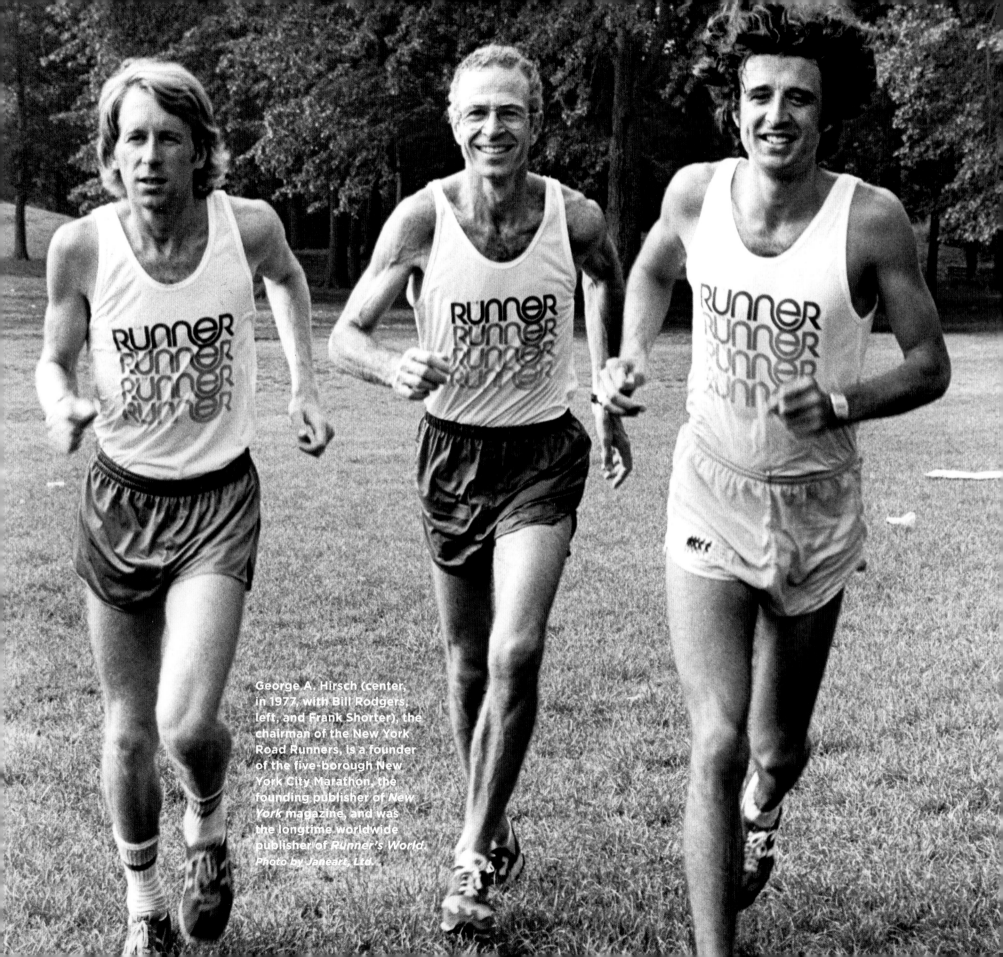

George A. Hirsch (center, in 1977, with Bill Rodgers, left, and Frank Shorter), the chairman of the New York Road Runners, is a founder of the five-borough New York City Marathon, the founding publisher of *New York* magazine, and was the longtime worldwide publisher of *Runner's World.* Photo by Janeart, Ltd.

finally Manhattan borough president Percy Sutton agreed that the idea just might work. Sutton, got two of New York's most influential and public-spirited businessmen, Lew and Jack Rudin, to put up $25,000 for the event. That was the turning point, and when Lebow, Sutton, and I went to visit Mayor Abe Beame to ask for his support for the idea, we pitched it as an added attraction to go along with the tall ships celebration of the nation's bicentennial. At the meeting we never spoke of a Year 2 or of any kind of recurring event. We simply presented the idea as a way to lift a nearly bankrupt and crime-ridden city's spirit during America's 200th birthday party. The mayor agreed and after that Lebow was all in.

The Romanian-born Holocaust survivor who had been doing "knockoffs" in the garment center had now found his life's calling. Lebow relished the task of organizing the race. He asked Ted Corbitt, the legendary running pioneer and first president of the New York Road Runners Club, to lay out the course. Soft-spoken and humble, Corbitt was an iconic figure in running, a former Olympic marathoner who was respected for the exactitude of his course measurements. Like every Big Apple promoter, Lebow needed star power to gain the media's attention. That meant Frank Shorter and Bill Rodgers, Shorter's fellow Olympian and holder of the American marathon record. Shorter accepted Lebow's invite, in part, he quipped, "to

see if the police could close down New York City's streets for a footrace." Shorter flew in from Colorado to attend the race's only press conference, held near the marathon's finish line outside Tavern on the Green in Central Park. Lebow figured that with Shorter he could attract the media without using any of his funds to rent a room and provide coffee and bagels. He had plenty of expenses, not the least among them the two $3,000 "under-the-table" payments that I'd arranged with Shorter and Rodgers, since amateur rules at the time strictly prohibited paying athletes appearance fees or prize money.

In the months leading up to the race, more and more people were getting interested in joining the dedicated runners who made up this niche sport. Lebow was delighted when I told him that my friend Jacques d'Amboise, America's best-known male ballet dancer, had started training for the race without telling George Balanchine, New York City Ballet's director and choreographer, who would *not* have been pleased. Now Lebow had two celebrities, since Newark mayor Kenneth Gibson had announced that he would run, as well. D'Amboise and I would meet most mornings for runs around the Central Park reservoir. When the company traveled to Paris, D'Amboise sent me a postcard: "Ran ten miles in the Bois de Boulogne after our performance tonight." He added, "It was beautiful."

In 1972 Nina Kuscsik, here alongside Vince Chiappetta in Central Park, won the first of her two New York titles. *Photo by Duomo/PCN Photography*

I had told d'Amboise that even though he was fit, he needed at least one long run of twenty miles in preparation for the marathon.

I received my last prerace phone call from d'Amboise on Friday afternoon, less than forty-eight hours before the start of the marathon. His voice quivered with excitement. "George, that long run you suggested was just amazing," he said. *Oh no*, I thought. "When did you do it?" I asked. "Oh, I just walked in the door," he replied. I didn't have the heart to tell him that he wasn't supposed to do a long run this close to the marathon.

That evening Shorter arrived at my house, and we watched the third Jimmy Carter-Gerald Ford presidential debate. I couldn't understand why Shorter, bundled up in a heavy parka, was shivering. But then I had never met anyone before with only 2 percent body fat!

The next day Shorter and I ran six miles on Staten Island before driving over the marathon course. For him it was an easy shakeout run; for me it was pretty much all out. I feared that I had left my race out on the Staten Island boardwalk.

Marathon morning, October 24, we were up early to head to the start area. My journal describes the scene at the Verrazano Bridge: "It was like a thrilling Felliniesque spectacle. The day was cloudy and cool, ideal for running. As 2,000 of us waited for the start, helicopters hovered overhead. With all the noise, I never heard the starter's gun, but began running when everyone else did."

At the 21-mile point, a spectator with a transistor radio called out that Bill Rodgers had won the race. The course that first year made

a brief entry into the Bronx on the Willis Avenue Bridge, with a U-turn around a telephone pole. When Rodgers made the turn, he had a sizable lead over Shorter, and, as they passed each other going in opposite directions, Shorter said, "Great race, Bill." At that moment the torch was passed from the man who had dominated the sport in the first half of the '70s to the one would do so for the rest of the decade. Rodgers would go on to win the next three New York City marathons, as well as marathons and road races all over the world.

When I reached the finish line next to the Tavern on the Green, Shorter was waiting for me. We headed out to Central Park West to find a taxi. "Got any money?" I asked him.

"No."

"Neither do I."

So we started hitchhiking and were soon picked up by two guys from Philadelphia who had driven up to watch the marathon. When the driver looked in the rearview mirror, he recognized Shorter with his wool cap pulled down over his ears. "Oh my god, Frank Shorter!" When we said we were going to 32nd Street, he responded, "How about Miami?"

Rodgers fared even worse. After being awarded the Samuel Rudin Trophy, he jogged to the Upper West Side, where he had parked his car. It had been towed away. So with Lebow's help and $90, he was able to recover it from a police impound.

That evening, about 100 people crowded into my house to celebrate the event. And there was much to celebrate. The city had embraced the race, and the 1,549 finishers exceeded the number who had run in Boston earlier that year, making New York the largest marathon in the world. Everyone agreed that Lebow had done a magnificent job. Rodgers and Shorter

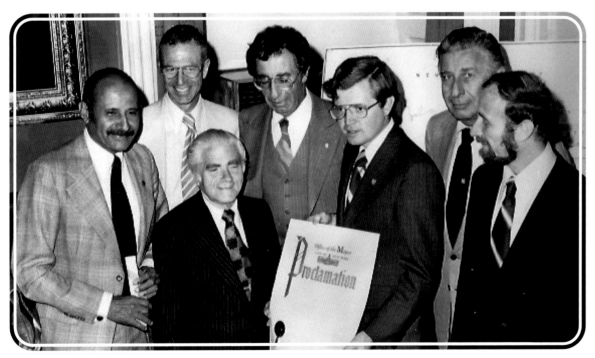

Reason to smile: A proclamation honoring the inaugural five-borough marathon was presented in 1976 by (from left) Percy Sutton, George Hirsch, Mayor Abe Beame, Lew Rudin, Charlie McCabe, Jack Rudin, and Fred Lebow. *Courtesy of George A. Hirsch*

were amazed at the enthusiasm of the crowds. Spitz for the first time was practically speechless. And d'Amboise, who finished in just over four hours, said that the taskmaster Balanchine had called to congratulate him.

After that no one, absolutely no one, even questioned whether the city-wide marathon should be run again. We all knew that we had an instant hit on our hands—one that would become an annual institution and the best day in the life of New York City.

The following pages are a chronicle and a celebration of the first fifty years of the New York City Marathon—captured in reprinted stories that ran in newspapers and magazines at the time and in photographs that convey all the drama and energy and life of the race (even as fashions changed and the cityscape blossomed). Over the past half century, more than 1.2 million runners have finished this marvelous event. I am proud to be among them.

—*George A. Hirsch*

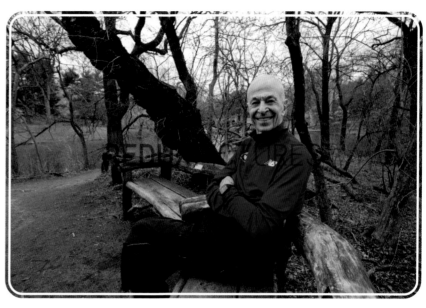

George Hirsch in 2009. *Photo by James Estrin/*New York Times *via Redux*

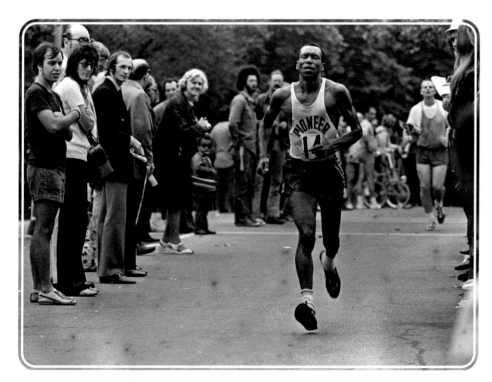

Ted Corbitt, here finishing the 1971 Marathon, truly was a pioneer in his sport. *Photo by Duomo/PCN Photography*

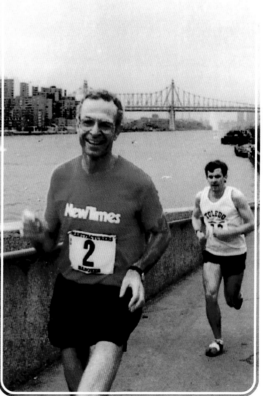

The author rose to the occasion in 1976. *Courtesy of George A. Hirsch*

NEW YORK CITY MARATHON ★ 1976 ★ IBM
FINISH
THE BIG APPLE YMCA WEST SIDE RRC NewTimes FINNAIR AAU USA MANUFACTURERS HANOVER PARKS NewTimes

In its first decade, the Marathon was an up-close experience for runners and spectators alike, as Bill Rodgers found out in his victorious 1976 run. *Photo by AP Photo*

1970s

September 13, 1970, was a typical bustling Sunday in New York City, cool in the morning but climbing to a warm-for-the-season 80 degrees in the afternoon. In the final month of the baseball season, the Yankees were out of town, succumbing 3–1 to the Indians in Cleveland, while the Mets also took a loss, 5–4, to the Cardinals at home. For that game, more than 43,000 fans were in attendance at Shea Stadium in the borough of Queens. Meanwhile, seven miles to the west in Central Park, a far smaller, presumably far skinnier crowd had assembled at 11:00 that morning for a very different sporting event. The first New York City Marathon drew a field of 126 runners, only 55 of whom finished the multiloop course set entirely within the park. A small story about the race appeared, without a photo, on page 54 of the next day's *New York Times*.

Following that inauspicious beginning, the race, under the direction of New York Road Runners, would explode over the decade into a major international athletic event and a cultural touchstone. To "run New York" became not only a career must for elite marathoners, but also a shining goal for running boomers across the globe.

Those first ten years featured a number of indelible, only-in-New York moments—from a "disabled" fireman's victory in that inaugural running to a women's sit-in in 1972 to the majestic chutzpah of a race through the streets of all five boroughs to celebrate the Bicentennial. The 1970s also introduced three of the sport's most iconic figures: visionary race director/dictator Fred Lebow (the title *impresario* might be even more fitting), whose indefatigable energy and eccentric marketing genius transformed the sport he loved; four-time champion Bill Rodgers, whose gee-whiz demeanor belied his athletic ferocity and made the marathon seem accessible to the masses; and Grete Waitz, the Norwegian school teacher whose power and grace in victory after victory would crown her New York's running queen. Countless compelling figures have followed in the footsteps of those three—and more than a million runners have followed in the footsteps of those first 126—and the races of the ensuing decades have seen world records and electrifying competition as well as indelible moments of triumph, tragedy, and inspiring humanity. But the '70s, just like the first miles of any marathon, set the stage for an amazing road ahead.

FIREMAN IS FIRST TO FINISH IN MARATHON

BY AL HARVIN

Gary Muhrcke, a 30-year-old fireman running for the Millrose Athletic Association, finished nearly a half-mile ahead of his nearest competitor as he won the first New York City Marathon in 2 hours 31 minutes 38.2 seconds in Central Park yesterday.

Finishing second over the 26-mile, 385-yard course laid out on the roadway of the park, which is closed to auto traffic but open to cyclists on Sunday, was Toni Fleming, a student at Paterson State College in New Jersey. His time was 2:35:34.

Of 126 runners who started in front of the Tavern on the Green at 11 A.M., 55 finished. The first 10 received wrist watches, the next 35 clocks and everybody who competed got commemorative trophies.

In addition Muhrcke, from Freeport L. I., who finished 10th in the Boston Marathon three years ago, received a big trophy with a Miss Liberty atop holding a torch.

The lone woman in the race—unofficially—was Mrs. Nina Kuscsik. She went home, empty-handed, having dropped out after the third circuit, covering 14.2 miles in 1:39. Her husband, Richard, did not finish either.

"I wanted to finish very badly," said Mrs. Kuscsik, who completed in the Boston Marathon in 3:11 unofficially earlier this year. "But I had a virus earlier this week and just couldn't. I can't accept any awards and, by dropping out, I avoided any problems with the A.A.U. [Amateur Athletic Union]."

Moses Mayfield of Philadelphia, running unattached, led on every lap, but started to feel dizzy on the last. He fell behind and finished eighth in 2:49:50.

"This is a nice, easy course," said Mayfield, who finished 23rd in the Boston Marathon. "I don't know why I got dizzy. I'm in very good shape. I'm going to a doctor to check it out."

"I knew Moses was going to fade," said Muhrcke. "He always starts fast. I passed him around 90th Street with about three miles to go."

THE FIRST WINNER LOOKS BACK

A Q&A WITH GARY MUHRCKE
RUNNERSWORLD.COM, OCT. 28, 2009
REPORTED BY PETER GAMBACCINI

Gary Muhrcke, who now lives in Huntington, on Long Island, was a firefighter at the time of his victory in the inaugural New York City Marathon and was generally sleepless after a night of battling blazes when he made his claim on marathoning history, achieving a distinction he acknowledges means more now than it did 39 years ago ("I'm not so sure sleeping the night before is so important," suggests Muhrcke. "The week before is important"). Muhrcke was perhaps the most talented competitor in the small corps of New York area distance runners in the 1960s, when most of the city's road races

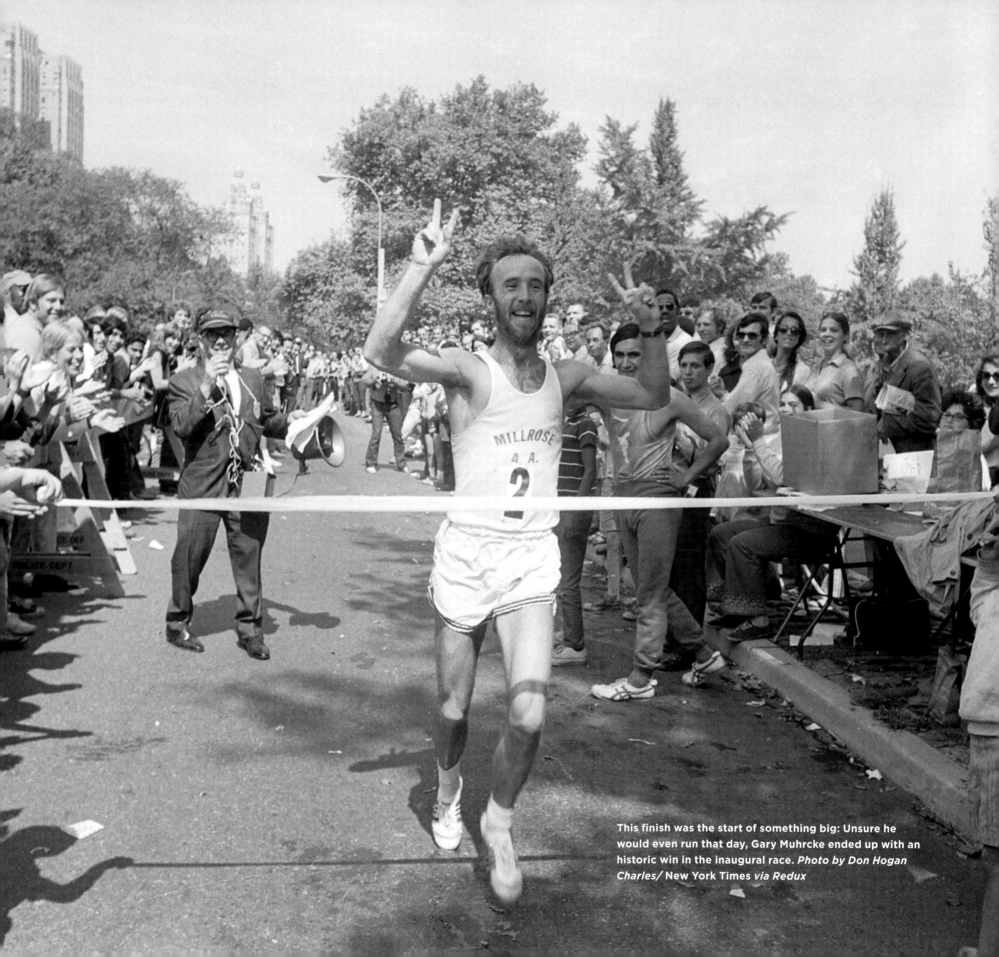

This finish was the start of something big: Unsure he would even run that day, Gary Muhrcke ended up with an historic win in the inaugural race. *Photo by Don Hogan Charles/* New York Times *via Redux*

took place in the Bronx, near Yankee Stadium. Muhrcke was a two-time winner of the Yonkers Marathon, which in that era was second in this country only to Boston in prestige. He is also a winner of the Empire State Building Run-Up. At a luncheon before the 2009 New York City Marathon Muhrcke took a moment to reflect on his victory 39 years before.

Runner's World *Gary, you'd run Yonkers (a famously hilly and difficult course). What was more difficult, Yonkers or four times around the northern (Harlem) hills of Central Park?*
Gary Muhrcke I don't know, I'll tell you truth. All the last nine miles of Yonkers was very tough. I think four laps around Central Park, with Cat Hill and the Harlem hills on the west side, I don't know if there's marathon that could be any tougher than that.

RW *How did you feel the fourth time around on the northern hills?*
GM Well, I had it easier than anybody else, because anybody else was finishing behind me.

RW *Can you take us back to the day going into the race?*
GM I had worked the night before (at the fire station in Far Rockaway), and we were busy. And I had called my wife at about 8:30 in the morning and said, "You know, I don't really want to go [to Central Park], I think I'm going to come home and take it easy. I don't want to run a marathon on September 13 [with] 85 degrees possible." I heard a disappointment in her voice, because we had three little children. I said, "All right, we'll go, let's go, pick me up, we'll go."

And we entered at the race, and I had number 2 on me. And of course, Joe Kleinerman (the NYRR registrar) kept the first

10 numbers for people he knew were going to run reasonably well (Ted Corbitt got number 1). So, you know, one dollar and we were there. We were on the line and I had not run competitively for a while, and I knew Pat Bastick was running reasonably well. I basically wanted to stay with him; I felt that he would run respectably. So I stayed with him and we did the lower loop [about two miles] and then we did two [six-mile] loops. And I guess we were in about 10th place with two loops to go, and all of the sudden he says, "I quit."

So I was out there by myself and I had to get into it mentally, and I had to adjust my stride and my pace and was actually able to pick up the pace. With one lap to go, I was in third place and I caught Tom Fleming going up the East Side. And I caught Moses Mayfield at the north end of the park, before we went up the Harlem hill. He was going so slow at the time compared to what I was running, and there were bicycle riders with him and they said, "No, that guy's not in the race, don't worry about him." That was the difference in our pace at the time. Moses Mayfield was from Baltimore and he always ran very, very hard in the beginning of the race. He faded to eighth place, 'cause he was pushing a piano up that hill.

RW *When you came across the finish line, did you think it was a big deal?*
GM No. It was just another race. Thank God we were finishing.

RW *Did you run the next year in New York, in 1971?*
GM No. I don't know why. I know I ran the first five-borough. I got hurt in '72, and it took me a couple of years before I got back into running again. I know I ran in '76. I've run a few since then. I think I've run 12 New Yorks [most recently in 1999].

RW Was your victory (in 1970) important to your colleagues at the firehouse?

GM No. It was just another race. I was a strange person who ran, to them, I think. Today it's more important than it was 40 years ago, Without a doubt.

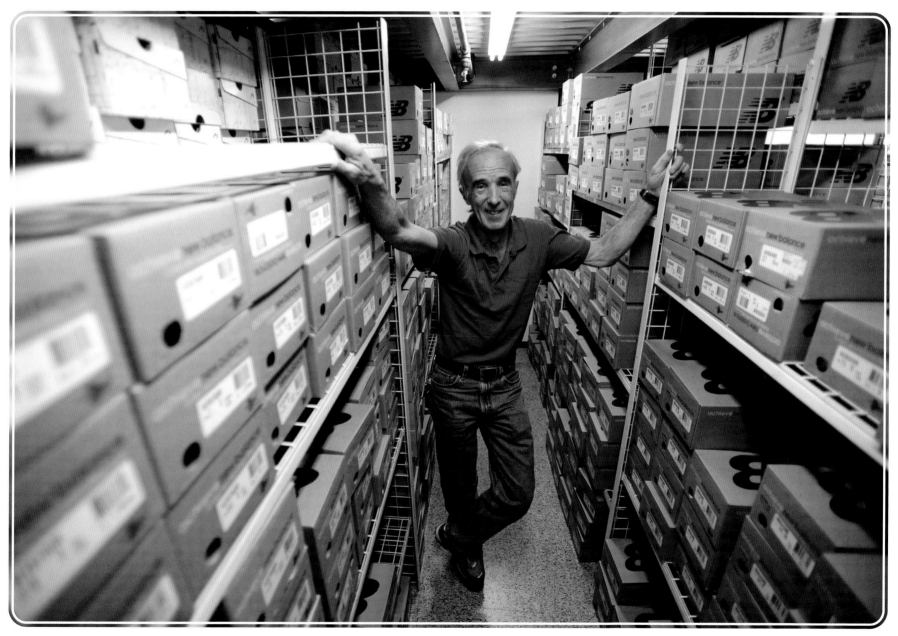

Muhrcke, here nearly four decades after his victory, has remained a fixture on the New York City running scene.
Photo by Jennifer S. Altman/Contour by Getty Images

NEW YORK TIMES, OCT. 2, 1972

IN NEW YORK'S MARATHON, THEY ALSO RUN WHO ONLY SIT AND WAIT

BY GERALD ESKENAZI

The six women entrants in the annual New York City marathon walked to the starting line at Central Park yesterday, heard the starter's gun go off, and immediately sat down in the lotus position.

They sat for 10 minutes in protest against the Amateur Athletic Union, which had called for a separate-but-equal race for women. The A.A.U. does not sanction races in which men compete against women. But as soon as the 272 men were ready to go, the women stood and then began running with the men on the 26-mile, 385-yard course.

Earlier, the "women's" race competitors had lined up, five of them holding home-made cardboard signs ("The AAU Is Midevil"; "The AAU Is Archiac"). The starter's gun went off, and a woman in the crowd shouted "Right ON!" and a man screamed "Chauvinist Pig!" Then the women sat.

Fred Lebow, the bearded meet director, said the women would be timed on the basis of when the gun sounded for them. "Theoretically, they're not running with the men," said Mr. Lebow, who as a contestant dropped out later, complaining of heartburn.

Pat Barrett, a 17-year-old freshman at Monmouth (N.J.) College, was not holding a sign as she waited for the "men's" race to start.

"I didn't know what to do," she admitted. "I was just there to run. And anyway, I thought the A.A.U. might do something to me if they saw a picture of me carrying a sign."

It was clear and crisp at 11 a.m. when the women sat down near the Tavern on the Green, on Central Park West and 67th Street. They were surrounded by about 500 fans. As the men prepared to start, one shouted, "Men and women together." But no one in the crowd picked up the chant.

The competitors included Justice Arnold Guy Fraiman of the State Supreme Court, who is a former City Investigations Commissioner.

"Is Erich Segal here?" a teenaged girl asked a meet official about the writer and marathon runner expected at the race.

"Who needs Segal?" the official replied. "We've got Fraiman."

The 46-year-old judge finished 92nd, well behind Mrs. Nina Kuscsik, the Huntington, L. I., mother of three, who was 63rd.

"It's a damn shame," said Justice Fraiman. "Nina is a first-rate competitor. I think they should have ignored the A.A.U. Any court would declare the ban unconstitutional."

At 11:10 the 278 runners took off on a grind that took them on the Park Drive south to 61st Street, east to the Fifth Avenue side of the park, then north to 110th Street, west up an Incline known as "Heartbreak Hill," and back to the starting line. The marathoners ran the route four times.

After a few miles the women were back of the pack. Along the way all the runners were passed by hansom cabs carrying small families or by the hundreds of bike riders who also used the road. There is no automobile traffic on the park roads on Sundays.

Mrs. Kuscsik, the first woman to officially finish a Boston Marathon, took 3 hours 8 minutes 41 seconds yesterday. Officially, however, her time will be 3:18:41.

The winner was Sheldon Karlin, a senior studying urban affairs at the University of Maryland. Karlin also has had run-ins with the Establishment. He refuses to run for his school.

"They wanted to cut my hair and change my lifestyle," he said, 2 hours, 27 minutes 52.8 seconds after he started. "How? Well, they said no beer—and that I should dress neatly."

His clocking was about 15 minutes slower than Frank Shorter's time in capturing the Olympic marathon in Munich last month. However, since the courses vary—the one in Munich was less hilly, for example—few track people believe marathon times should be compared.

Ed Bowes, the track coach at Bishop Loughlin Memorial High School in Brooklyn, had been second when he collapsed after 23 miles.

"You know what he told me?" said Dr. Emery Szanto. "He's been on a crash diet. Eating two meals a day. No wonder."

"Sometimes I wonder why we do it," said Robert Reinertsen, a former Federal Bureau of Investigation agent now security chief at Yonkers Raceway. "Every race I have I say will be the last one. But when you're running out there, every marathon runner thinks he's the best in the world. We're all nutty individualists."

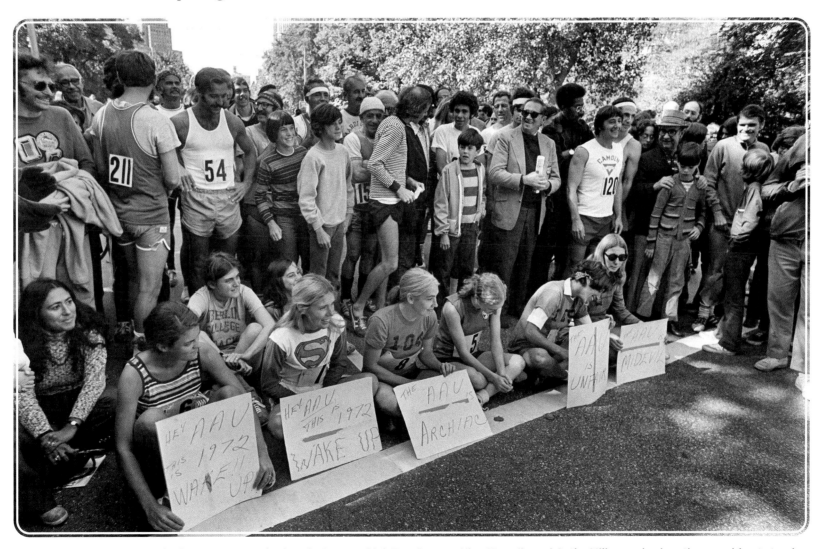

From left, with signs, Lynn Blackstone, Jane Muhrcke, Liz Franceschini, Patt Barrett, Nina Kuscsik, and Cathy Miller made clear they would not stand for discrimination against women runners. *Photo by Patrick A. Burns*/New York Times *via Redux*

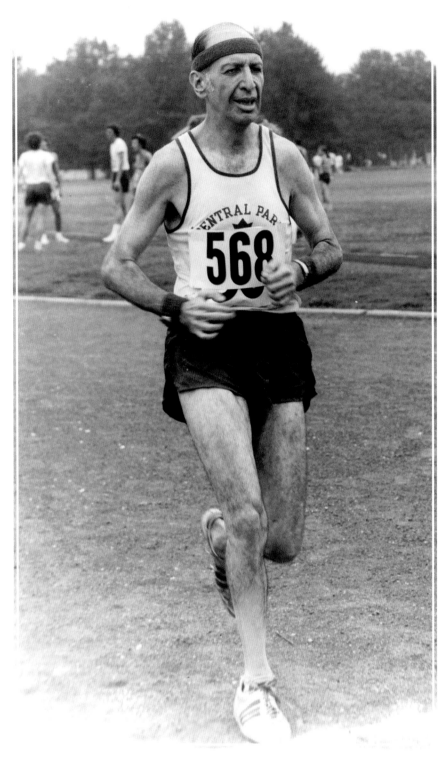

NEW YORK TIMES, OCT. 18, 2014

ONE MAN'S VISION: FOOTRACE IN FIVE BOROUGHS

BY GEORGE A. HIRSCH

By even the dauntingly high standards of New York, the man who "invented" the New York City Marathon, George Spitz, is a bona fide character. Two weeks after this year's marathon, he will celebrate his 92nd birthday by doing what he does most days: writing the history of New York City for an independent book project.

Mr. Spitz still has 100 years to go before he arrives at the date of the first five-borough marathon in 1976, but he figures he has a good pace going. When he does get to 1976, he will probably give himself little credit, and many will continue to believe that Fred Lebow, Percy Sutton or someone else dreamed up the citywide race.

But, no, it was Mr. Spitz, an unlikely source. As Jim Dwyer once wrote in *The Daily News*, the New York City Marathon is a bit magical because it "has a special place in the history of Crazy Ideas That Worked. That's because the author of this, the great George Spitz, has a long and nearly perfect history of lost causes."

On Oct. 30, New York Road Runners will induct Mr. Spitz into its Hall of Fame. The other inductees are German Silva of Mexico,

George Spitz: the New York character whose "crazy idea" truly had legs.
Photo by Robert Naeher/Campus Photos

a two-time New York champion; Kathrine Switzer, a women's running pioneer; and Allan Steinfeld, a former Road Runners president.

The others are better known than Mr. Spitz. But his contribution to the sport of running makes him deserving of the honor.

Mr. Spitz was born in New York City, served in the Army during World War II and graduated from Columbia. He has held several midlevel positions in and out of government, and admits to being fired more times than he can remember. He has had his successes, too. In 1941, he spent weeks walking the picket line of the giant retailer Gimbels in a strike that helped bring the five-day workweek to New York department stores. He has been protesting about one thing or another ever since.

For more than half a century, Mr. Spitz has repeatedly run for public office to make passionate statements on issues that generally tilt to the far left. At times, however, he has taken positions to the far right.

Mr. Spitz knew he could never win his iconoclastic and underfinanced campaigns. That wasn't the point. He eschewed campaign brochures, saying, "They just cause litter." But he never missed an opportunity to take a stand.

He last ran for mayor in 2001. After a Democratic primary debate, *Newsday*'s Jimmy Breslin wrote: "Suddenly out of these dusty men seated at a table and ready to bore a vibrant city, here comes George Spitz, old, bald, fighting to get words out of his mouth, sometimes looking completely cuckoo. He is a fabulous citizen of the city."

Mr. Spitz has a halting, awkward speaking style and a lack of social graces, but his sincerity, persistence and childlike optimism have won over occasional allies. A pacifist and vegan who gets by on one uncooked meal a day, he calls people at any time of day or night when he has a new project to promote. He rarely remembers to identify himself or to begin the conversation with a brief pleasantry.

So how did he dream up this great marathon? It seems he had too much time on his hands. Fired from yet another job in 1975, Mr. Spitz began running seriously in Central Park. He soon was so fit that he ran a respectable 3 hours 20 minutes in the Boston Marathon. Afterward, he began asking friends, "If Boston can have a marathon on the city roads, why not New York?"

No one was interested, not even Lebow, the New York Road Runners impresario.

"There's no way the city will close down for a running race," Mr. Lebow told him.

Nothing gets Mr. Spitz going like a resounding "no." Soon I was on the list of people who received after-midnight calls from him. I said I liked the idea but couldn't imagine it happening. The first person to warm to Mr. Spitz's marathon scheme was Sutton, then the

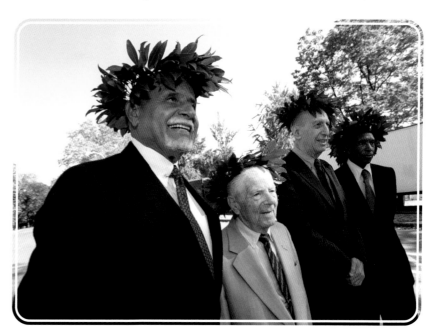

In 1996, Marathon founders (from left) Percy Sutton, Mayor Abe Beame, Spitz, and Ted Corbitt gathered again in Central Park. *Photo by Susan Watts*/NY Daily News *Archive via Getty Images*

Manhattan borough president and a supporter of the marathon in Central Park, which had begun in 1970.

Mr. Sutton called a meeting attended by Mr. Spitz, Mr. Lebow and the Olympic marathoner Ted Corbitt at the home of two marathon founders, Lynn and David Blackstone. Mr. Lebow, still skeptical, said an event through all the boroughs could easily cost $15,000.

"Where in the world are we going to get that kind of money?" he asked.

The next day, Mr. Sutton secured a commitment of $25,000 from Jack and Lew Rudin, heads of an influential and civic-minded real estate firm. That did it. Mr. Lebow, the consummate promoter, embraced the idea and raised another $25,000 from three more sponsors: Manufacturers Hanover Trust, Finnair, and my magazine, *New Times*.

Mayor Abraham D. Beame agreed that the race could be part of the nation's Bicentennial celebration, along with the tall ships visiting New York. He hoped the marathon would help lift the spirits of a crime-ridden city on the verge of bankruptcy. In our discussions with him, there was never any mention that the race might become an annual event.

Finally on a damp, chilly Oct. 24, 2,002 men and 88 women set off from Fort Wadsworth on the Staten Island side of the Verrazano-Narrows Bridge. Ahead, they faced the unknown. Many predicted utter chaos, or worse.

"I just wanted to see how the police would clear the streets," said Frank Shorter, the 1972 Olympic marathon champion.

Mr. Spitz was among the runners that day, and just as curious as the rest.

"When we came off the bridge and entered Bay Ridge, there were crowds of cheering people," he said, referring to a neighborhood in Brooklyn. "I was shocked, absolutely shocked."

This time, it seemed, one of his off-the-wall ideas had actually worked.

After New York's rousing marathon success, the urban marathon spread to London and eventually the rest of the world.

Pekka Paivarinta was out front at the start, but the Finn would be just fifth at the finish. *Photo by Janeart Ltd.*

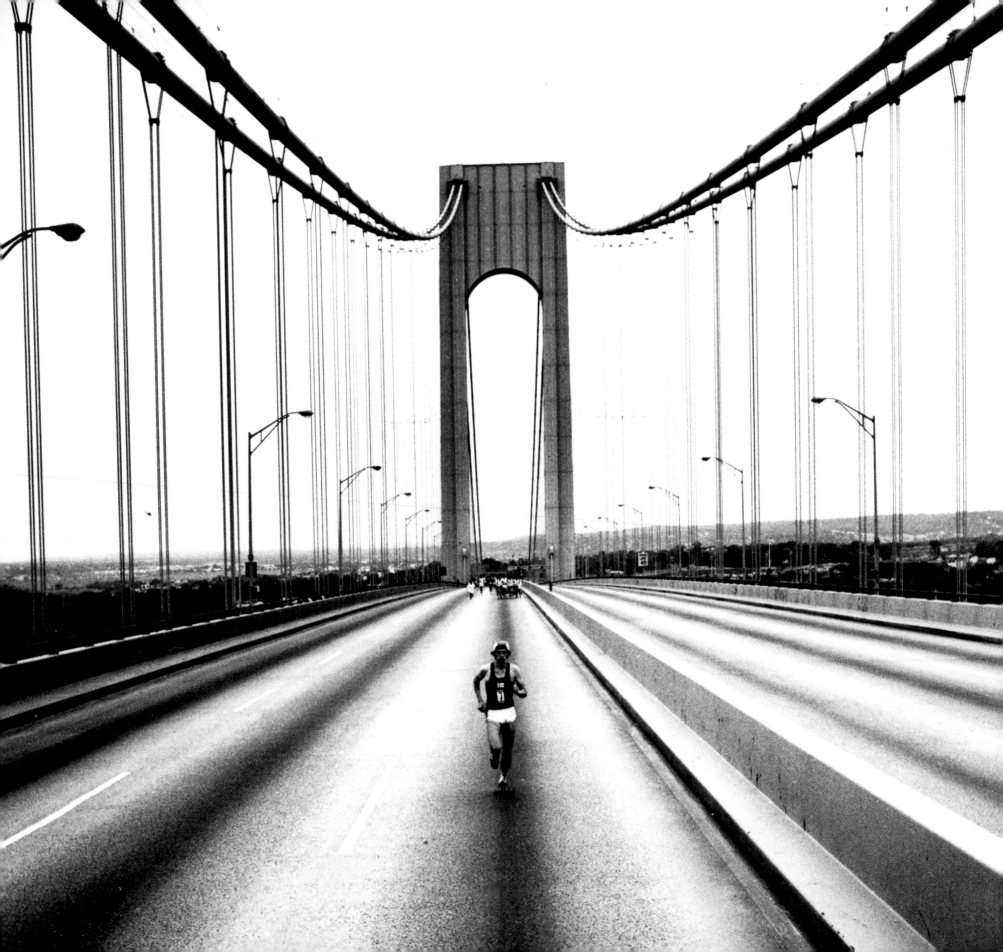

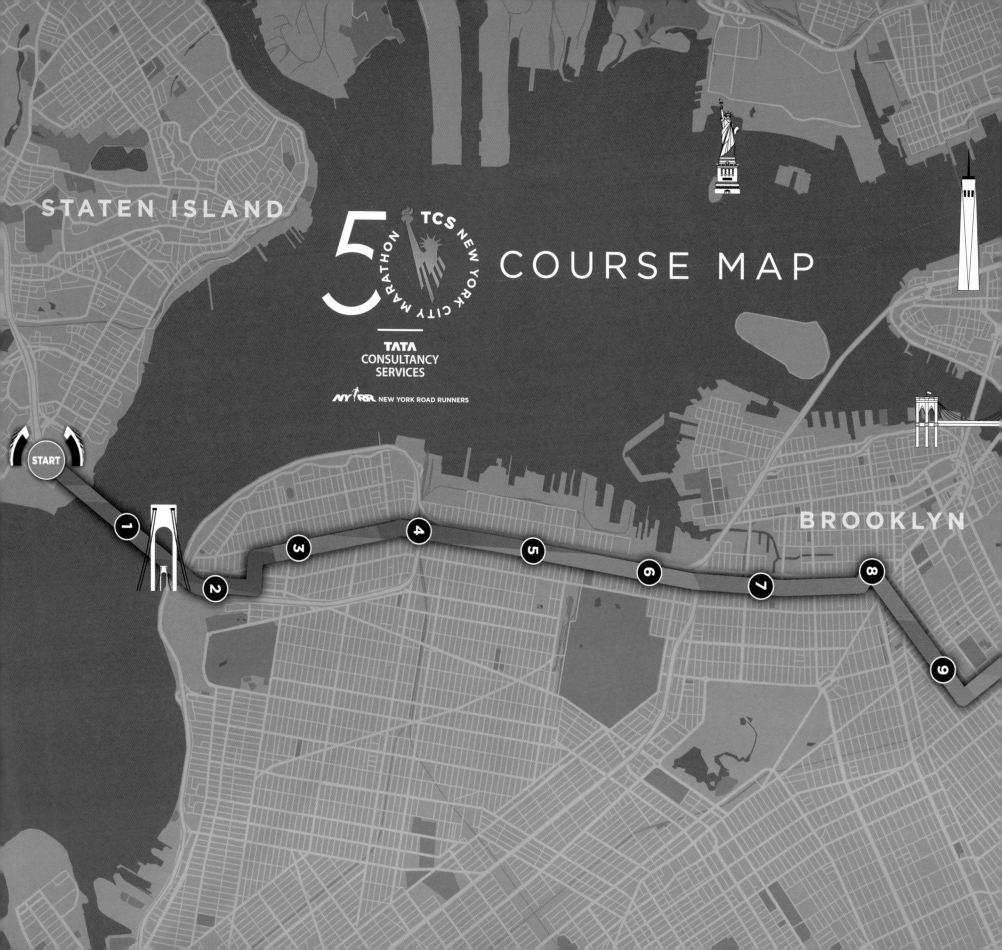

STATEN ISLAND

COURSE MAP

TCS NEW YORK CITY MARATHON

5

TATA
CONSULTANCY
SERVICES

NYRR NEW YORK ROAD RUNNERS

START

BROOKLYN

1 2 3 4 5 6 7 8 9

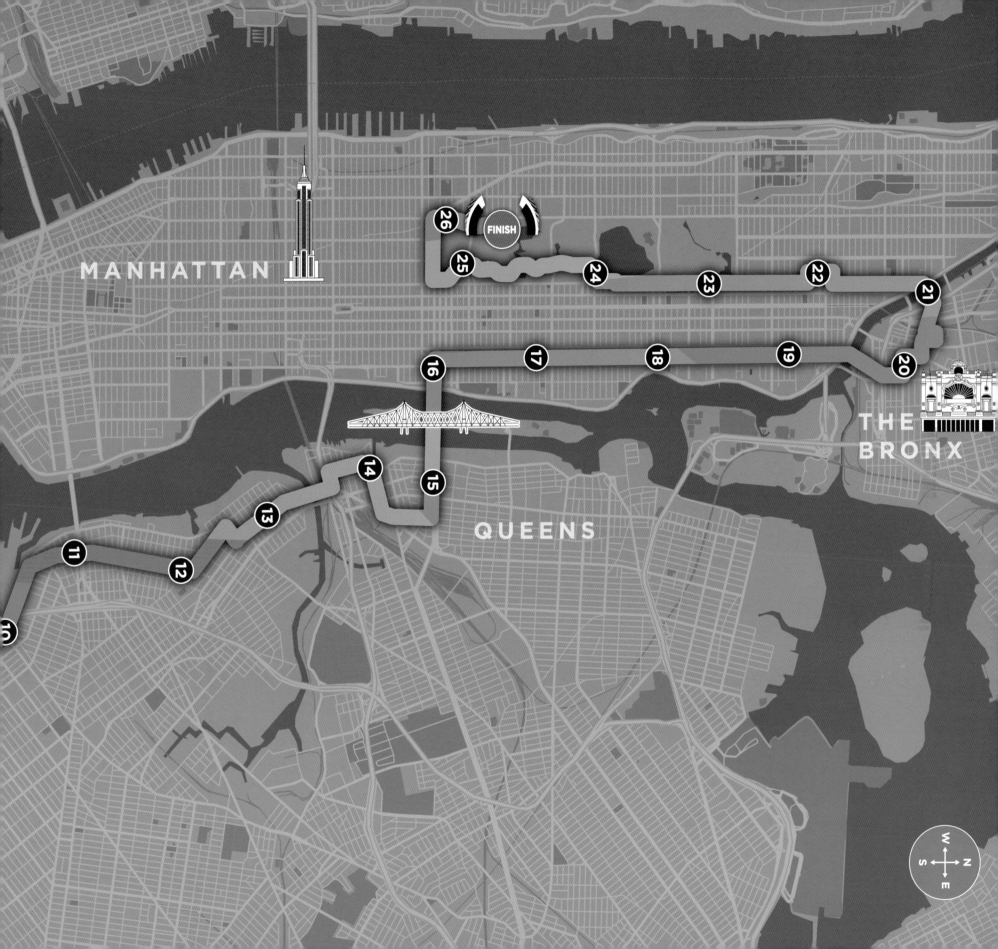

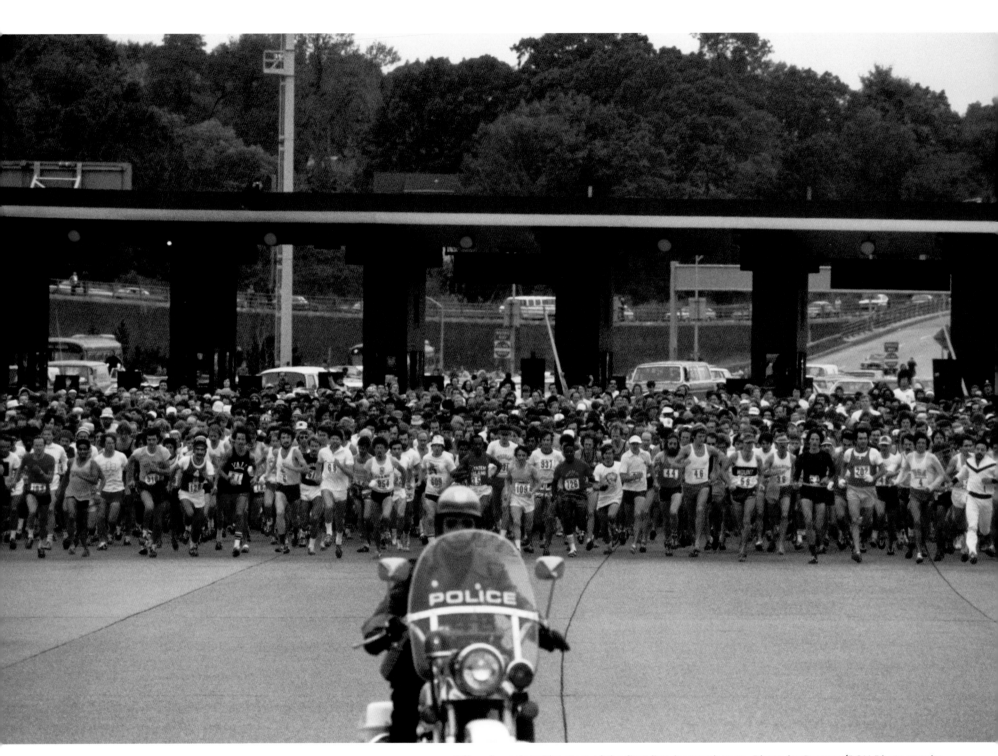

Off and running: The start of the first five-borough race. *Photo by Duomo/PCN Photography*

BOSTONIAN WINS MARATHON

BY GEORGE JAMES

The runners were cheered by boys with footballs under their arms in Queens, by motorists honking horns on the Queensboro Bridge and by people on the East River Drive and Harlem's streets.

What a wondrous machine is the human body! There were 2,100 such machines performing—with varying degrees of efficiency—yesterday in the New York Bicentennial Marathon, some broke down, some huffed and puffed bravely and one, Boston marathon champ Bill Rodgers, made all the other human racing machines see only his back as he sped to victory.

Rodgers, who won the Boston Marathon last year in the fastest time ever clocked by an American, completed the 26-mile, 385-yard trek in two hours 10 minutes and 9.6 seconds. It was, according to one official, the eighth fastest marathon in the world.

"I am very happy with my time," exclaimed Rodgers. "I just had a very good run today."

The marathon, which touched each of the city's five boroughs, began 10 minutes later than the scheduled 10:30 a.m. starting time from the Staten Island toll booths of the Verrazano Bridge and ended—depending on the quality of the running machine—at the Tavern-on-the-Green in Central Park.

Second was Frank Shorter, 29, considered the top United States long-distance runner, with a gold medal in the 1972 Olympics and a

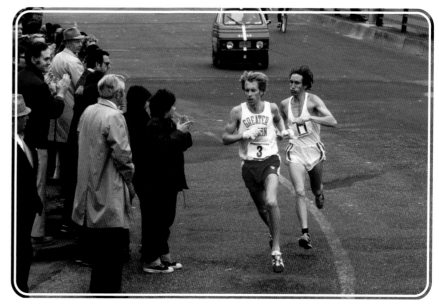

Street fight: Bill Rodgers led England's Chris Stewart midway through. *Photo by Duomo/PCN Photography*

silver medal in the 1976 games in Montreal. He clocked a time of 2:13:12. Chris Stewart, 30, of England finished third with 2:13:21.

Many runners continued to struggle to the finish, late into the evening. The last runner to cross the line before the officials stopped counting five hours after the race began, was Richard Adams, 31. His time of 4:41:14 put him in 1,450th place. Officials, however, expected at least 1,600 to finish the marathon—the first five-borough event in the city history.

The fastest of the 100 women who competed in the event sponsored by the Road Runners Club of New York was Miki German, 41, of California, who finished in 2:39:11:4. She was the winner of the women's title in the Boston Marathon in 1974. Second place

went to Doris Brown Heritage of Seattle with a time of 2::53:02. Third was Laurie Pedrinan, with a time of 3:15:50.

The runners were cheered by boys with footballs under their arms in Queens, by motorists honking horns on the Queensboro Bridge and by people on the East River Drive and Harlem's streets. The biggest applause always went to Richard Traum, a 35-year-old behavioral scientist from Manhattan who lost his right leg in a freak auto accident 10 years ago. He wore an artificial leg and finished 869th yesterday.

Traum was allowed to start at 7 a.m. three and a half hours before anyone else began. He finished at 2:20 p.m. He was accompanied by his wife, Elizabeth, in a car behind him and a young friend on a bike beside him.

"I was amazed to see a man running with wooden leg in the race," said one spectator. "I couldn't believe a person with a handicap could work up the nerve and strength to compete. It said something to all of us. It says our troubles aren't so great. If he has enough stamina to do that we have enough stamina to do what we have to do."

Runner after runner pushed on. One was Newark's mayor, Kenneth Gibson. Another was 10-year-old Bradford Kelly, the race's youngest contestant.

Forty-one-year-old Miki Gorman (39) came up big, winning in the second-fastest women's time ever.
Photo by Duomo/PCN Photography

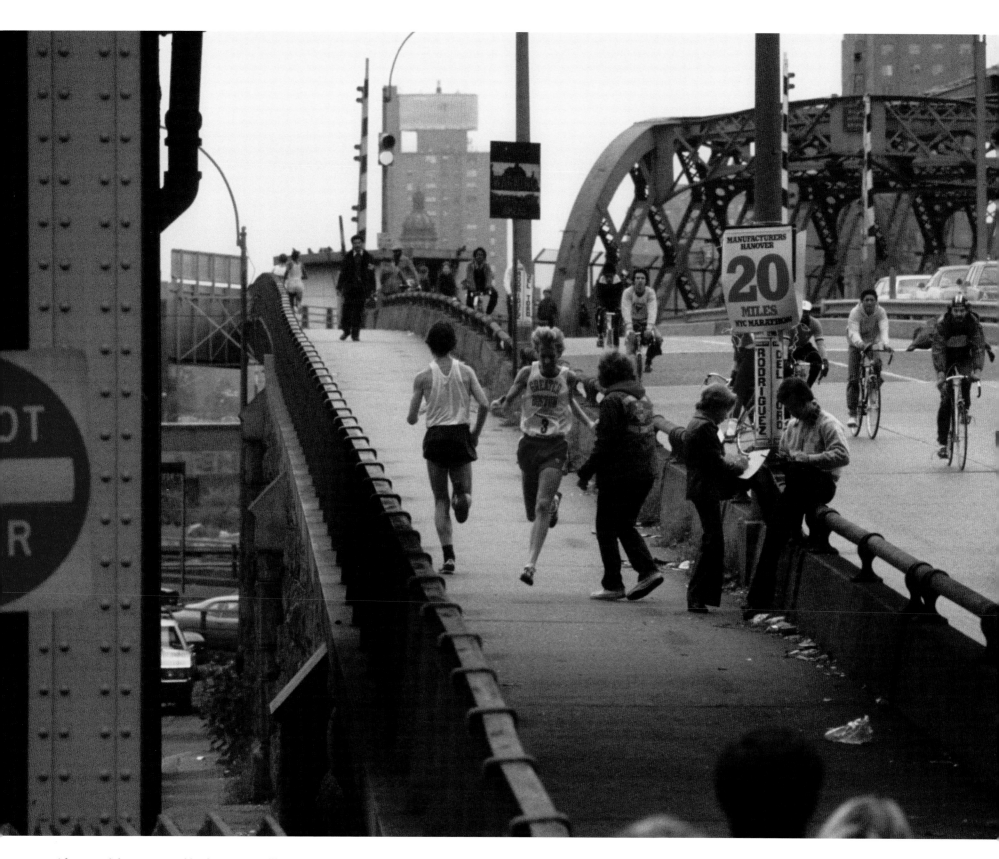

After a quick turnaround in the Bronx, Bill Rodgers was headed home. *Photo by Duomo/PCN Photography*

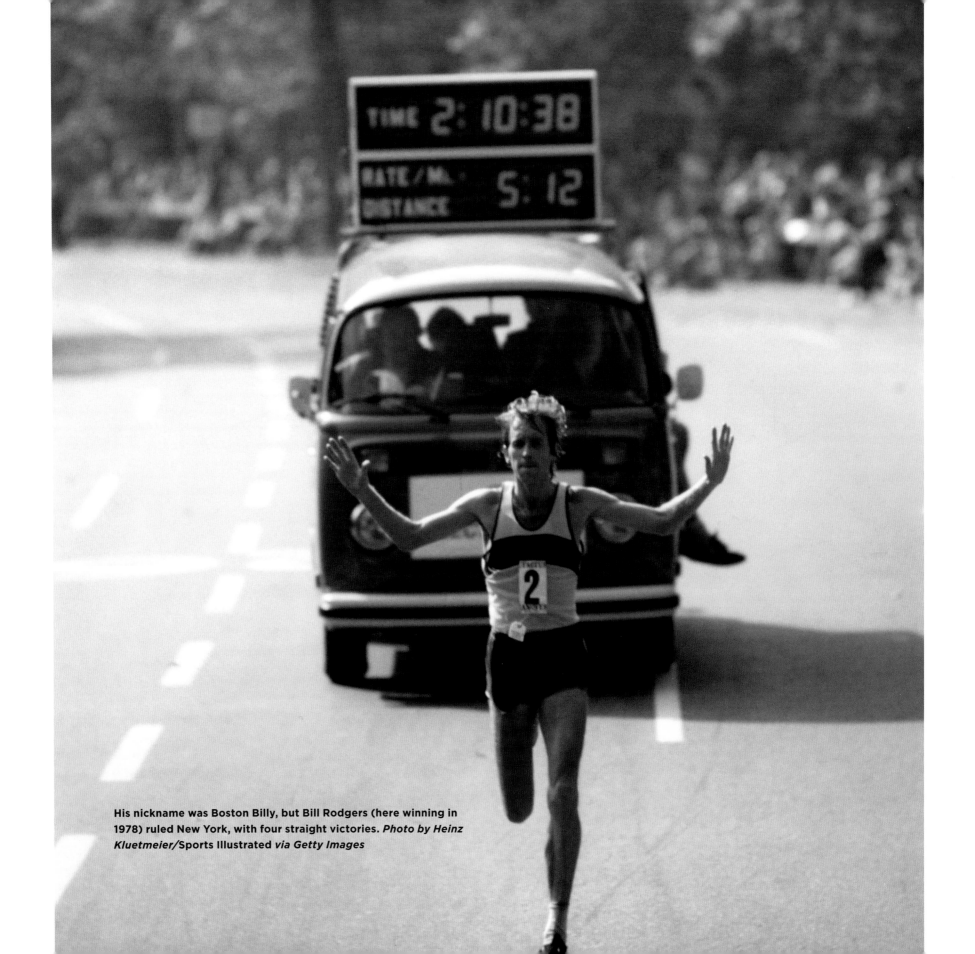

TIME 2:10:38

RATE/MI. 5:12
DISTANCE

His nickname was Boston Billy, but Bill Rodgers (here winning in 1978) ruled New York, with four straight victories. *Photo by Heinz Kluetmeier/*Sports Illustrated *via Getty Images*

SEE BILL RUN

BY GEORGE A. HIRSCH

The leading marathoner of his generation, Bill Rodgers won four straight times in New York, helping to establish the race as a major international event and—with his accessibility and relentless goodwill—bringing new fans and participants to the sport. The following portrait captures Rodgers at the height of his career, preparing for another showdown on the streets of New York with his longtime rival, 1972 Olympic champion Frank Shorter.

Frank Shorter and Bill Rodgers are a study in contrasts. One is a 29-year-old man; the other a 29-year-old boy. One all business; the other half whimsy. One cautious, the other naive, even vulnerable. Shorter hates the rain; Rodgers doesn't care. Rodgers hates the heat; Shorter doesn't care. About all that they have in common is the fact that they are both superb long-distance runners, and the odd coincidence that both are second sons with a brother one year older.

To highlight the differences, it's almost enough to say that Bill Rodgers started running to catch up with butterflies. At least, that is the way his father remembers it, and Rodgers's father is a man of precision—the chairman of the mechanical technology department at Hartford State Technical College. Five glass cases of pinned butterflies now hang on his son's wall—mute confirmation of his father's testimony. Bill Rodgers's older brother, Charlie, recalls that he and Bill decided to go out for the high school cross-country team more or less as a lark. "We did not really know what we were getting into," says Charlie. "We spent that summer running around a park down near Hawk's Nest, a beach area

near Old Lyme, Connecticut. Most of the guys on the team weren't interested in running more than a mile or two—four at the most. More than that was almost frowned upon. Bill would simply take off down side roads. One afternoon we all stopped at my girlfriend's house for Cokes. Except Bill. He just kept on running. When he ran 12 miles once, everyone whispered about his strange dedication, but it was still all fun and games for Bill in high school. He would come running down the street and jump over a four-year-old instead of running around the terrified child."

It seems no one took Rodgers's running very seriously. His mother, a nurse's aide at Newington Children's Hospital, remembers a time early in his running career when her son's coach accompanied him home after a meet." I asked Mr. O'Rourke how Bill was doing. He said in effect, 'I wouldn't get too excited about his prospects.'"

Rodgers wasn't. If it had not been for his Wesleyan University roommate, Ambrose Burfoot, Rodgers might still have nothing but butterflies to show for his gift. But Burfoot (a senior when Rodgers was a sophomore) was as good as his name—he could run prodigious distances. "He was a tremendous influence on me," says Rodgers now. "I'd just get behind him and follow him everywhere." Everywhere but into the Boston Marathon. That year Burfoot won the Boston Marathon while his roommate sat it out. "I was still smoking a little and never thought I'd run a marathon," says Rodgers. During his senior year, preoccupied with his schoolwork and getting conscientious objector status, and having no one to shove a burr under his foot, Rodgers stopped running completely. After college, he got a job with the post office delivering mail. "My life," he says, "was upside down. I thought I might be going to New Zealand on a barge any day if I got called by the draft. I would never go to Vietnam." His c.o. status finally came

through, even though his high school coach and friend refused to write a letter on his behalf. "Very unusual, bizarre," he says now, using the strongest language in his vocabulary.

Rodgers got a job at the Peter Bent Brigham Hospital in Boston and spent his evenings hanging around bars with friends. "Life wasn't that interesting to me. I needed to work hard at something." After serving out his time as a c.o., Bill began graduate work in special education. He started running again shortly before he watched Frank Shorter win the Olympic Marathon on TV. Soon after, he received further inspiration: his Triumph 650 motorcycle was stolen and he began running everywhere. He improved steadily and in 1975 won the Boston Marathon in record time. He "died" in the 1976 Olympics after leading through the first half of the race. "A lot of people wrote me off after that," he recalls without bitterness.

Now, no one writes off Bill Rodgers. There was one other small "death" when Rodgers dropped out of the Boston Marathon this year from the heat, but ever since his second-place finish behind Shorter at the Peachtee 10K in Atlanta, Rodgers has had a hot foot. In early August, he set American records at 15 and 20 kilometers, on the way to a new record in the esoteric one-hour run. On August 26, he scored a stunning victory over Frank Shorter in the colorful Falmouth race; Rodgers demolished the old Shorter record by running the 7.1-mile course at a clip of four minutes and 33 seconds a mile. The *Boston Globe* paid tribute with the frontpage headline, "Red Sox Lose, Rodgers Wins."

Today, as he sets off on his usual 10-mile run through his hometown of Melrose, Massachusetts, a neighbor who is up on his roof calls out, "Good race Sunday, Bill." Rodgers waves back and runs on, his longish blond hair flopping in rhythm with his floating stride.

The course ends back at Number 6 Rockland Street. Rodgers enters his house and flops onto a sofa. The house has the requisite photographs and posters of various road races, but seems

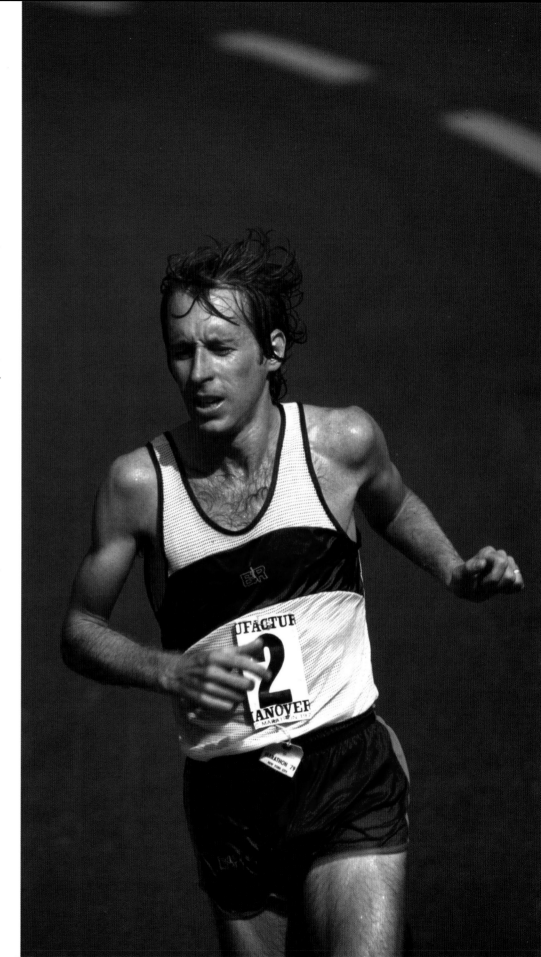

curiously devoid of trophies. There is only one on display—a handsome iron sculpture of two runners on a white stone base with a plaque indicating that it was first prize for the Campari Marathon in Amsterdam in May, 1977. "Why that one?" a fellow runner asks. "It's my favorite, I saw it before the race, and while I was running I kept saying the sculptor's name over and over . . . Kees Verkade … Kees Verkade … Kees Verkade . . . " But where are all the other trophies? Rodgers, who until very recently was teaching children with special problems, explains that he gave most of them away in school to the kids as prizes in behavior modification programs. "I'd bring them in and would give points … you know. They had to work five days for a really huge one."

Rodgers turns on the news and spreads a mat on the floor in front of the TV so that he can do some stretching exercises. Lifting his legs up and over the back of his head, he keeps talking. "I never ever read a newspaper," he says sheepishly. "Maybe we should get a subscription or something." His wife, Ellen, clearly accustomed to such guileless confessions, rolls her eyes heavenward as the phone rings.

With his new fame, Rodgers now answers the ring of the telephone as often as a punch-drunk prize fighter answers the bell. Landing on his feet, he takes the call. It is a young man who runs an army surplus store in Worcester who wants Rodgers for a running clinic. Rodgers gets out his calendar, always at the ready, and earnestly searches for an open date, as if the fellow is doing him a favor. Before he can get into another exercise, the phone rings again. Can he come to Virginia a day before the October marathon for radio interviews, someone wants to know. Out comes the calendar. Well, yes, that's possible …

In short, Bill Rodgers is incorrigibly and incorruptibly nice. Amby Burfoot, who still keeps up with his old roommate and protégé, put it best: "Rodgers hasn't changed at all since his college days," he says. "He's still like a little puppy wagging his tail, hoping to please and waiting to play."

As they prepare to sit down to the teriyaki dinner Ellen has prepared, the telephone rings again. This time it is Tommy Leonard with an invitation to the Cape for Labor Day weekend. Tommy is the bartender at the Eliot Lounge, the driving force behind the Falmouth Race, and a guru to hundreds of New England runners. "A boat?" says Rodgers. "Good grief, I'd sure like to come, but I'll have to talk with Ellen."

Over the lukewarm remains of his dinner, Rodgers reminisces about the Falmouth road race. This year, an odd assortment of prizes were spread out on the table for the top 10 finishers to choose from. Rodgers took a bottle of wine, which right now is sitting half empty before him on the kitchen table. The year before, Tommy Leonard had put up a color television for first place because he knew Rodgers needed one, but Frank Shorter won it instead. "Tommy Leonard says Frank and I are the Secretariat and Man o' War of road running," Rodgers says shyly, taking another sip of first-prize rose.

"What about your rivalry with Frank?"

"It's very friendly. I like to see Frank excel; of course, I'd like to be a step ahead of him. I feel that I can beat him, say, two times out of 10, maybe even three or four times. He's better at peaking for a big race and he's been at it a longer time. I think his approach is more systematic, although we do pretty much the same training."

"When you see him at the starting line of a race, are you intimidated?"

"No. When I'm in top shape, like in New York last year, and the weather is cool, I can run with anyone in the world."

Rodgers has just resigned from teaching in order to concentrate on his running. He talks of opening a sports store in Boston, and possible arrangements with several companies about employment that will involve his running. Pepsi-Cola is launching a program called "Run, America, Run," and the company would like to sign Rodgers up. But nothing is resolved and Rodgers is concerned. Though aware that there are numerous opportunities opening up to him, he must be careful not to violate AAU restrictions. "I don't ever

Photo by Carlos Rene Perez/AP Photo

want to be like Tarzan Brown," he says with conviction. "He was an Indian from Rhode Island who won the Boston Marathon twice. A great athlete, he always lived in poverty and was killed a few years ago, run over by a car outside a bar. I won't sell my soul, but I will take care of myself. I will run around, over or under anyone who stands in my way."

"Not through them?"

"Oh, no. I don't like confrontations."

Friends have offered to put up money and be partners in the store, but Rodgers says no. "I really want to do it on my own." A few months earlier, it might have seemed that Bill was too trusting, too naïve and too easy to exploit to organize a business, but now Bill Rodgers' Running Center seems closer to

reality. "Tomorrow we'll check out store locations at Cleveland Circle when I go for my track workout at Boston College." Then, a minute later, he says, "I sure wish I had Frank's business skills."

After dinner, Bill turns on WBOS, probably the only radio station with a regular show on running anywhere in the country. The entire hour is devoted to the Falmouth race. Of course, Rodgers, taking fresh phone calls, misses most of the show. He patiently answers questions from a local reporter, goes over his upcoming schedule of races, and makes plans for the next day's interval workout. It is hard to imagine anyone who enjoys what he is doing as much as Bill. "I still consider myself a part-time runner," he says.

"But you do work awfully hard at it."

"I like to work hard. I have the potential for it. Mao Tse Tung said life is a struggle and I believe it is — part of the time. I don't view running in such dark, dreary terms, but sometimes it has to be that way."

It is after 11:00 when Rodgers heads out for the first run of the day. A young man in

a windbreaker carrying a motorcycle helmet walks by, recognizes Rodgers and says, "On to Moscow." "I hope so," Bill returns.

"How important is Moscow," his companion queries.

"I have a lot of goals in running and it's one of them, but I'm not a Lasse Viren type." Rodgers is referring to the double gold medal winner in the past two Olympics who seems to peak at the precise moment every four years. "I would like to go to the Olympics again if it were not hot and humid. If it were cool, I could really get psyched. It would be outstanding to win an Olympic medal."

"Why do you say *a* medal and not the gold medal?"

"The East Germans regard them as moon rocks and it's true. There's a lot of luck involved."

Bill leaves his running clothes to dry in a tiny sunporch full of plants, at least a dozen pairs of running shoes and assorted shorts and T-shirts. Lunch, his first meal of the day, is a tuna fish salad with a large dollop of mayonnaise, and an RC Cola. Later he drives his 1973 white Volkswagen over to Boston College to scout for store sites, and take a run. Bill parks and does the two-mile loop to loosen up. As he enters the Boston College

"I LIKE TO WORK HARD. I HAVE THE POTENTIAL FOR IT. MAO TSE TUNG SAID LIFE IS A STRUGGLE AND I BELIEVE IT IS— PART OF THE TIME. I DON'T VIEW RUNNING IN SUCH DARK, DREARY TERMS, BUT SOMETIMES IT HAS TO BE THAT WAY."

—BILL RODGERS

stadium, several of his Greater Boston Track Club teammates greet him. "You sure got your revenge on Frank," one of them gloats. "Oh, no," Rodgers protests. "We each have our ups and downs." Bill has planned a "light speed workout" to train for a 10-mile race coming up in Michigan on Saturday. He is joined by several runners as he alternates half miles and quarter miles on the wet Tartan track. Between each, he jogs a quarter mile. After a while only Bill and Jack Fultz are still at it. Jack is the same height as Bill, 5-foot-8½, and has the same fair complexion. Jack's friend Marge is timing the intervals. Now the two of them are rolling along through the evening summer drizzle. "What a pretty sight," Vinnie Fleming says admiringly as the winners of the 1975 and 1976 Boston Marathons move down the homestretch. Then Fultz, who is still recovering from pleurisy, pulls up. Rodgers is on his own now. "Watch how his tempo picks up with nothing to hold him back," says Fultz. The times do become faster as Rodgers flows effortlessly. "Two-eleven for the half," Marge calls out. "I'm feeling pretty zippy," Rodgers comments as he goes into his final jog.

It is dark as the runners return to the fieldhouse for showers, a sauna, the Jacuzzi hot bath and lots more shoptalk. "Are you guided by your fatigue levels?" Fultz asks. "Oh, yes, I go by the way I feel. You've got to avoid injuries," Bill says, thinking about the one thing that could ruin it all. Once, when asked if he was concerned about turning 30 this year, he replied, "Oh, no, I only worry about being injured."

Everybody heads for the Newbury Steakhouse on Massachusetts Avenue across from the Eliot Lounge. Bill orders a well-done bacon burger and a 7-Up. Jack Fultz whispers, "Bill's a walking contradiction to the rules of nutrition." Long after the others have whipped through full steak dinners with lots of beer, Rodgers is still picking over his meal.

Finally he finishes, and the group moves across the street to the Eliot Lounge, where there's a large crowd and a live band with a brassy female singer. Tommy Leonard, in short pants and running shoes, comes over. Bleary-eyed from the days and nights at Falmouth, he has brought Rodgers the local newspaper, which is full of photographs

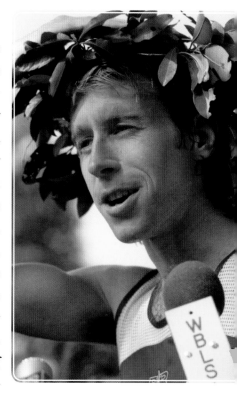

Photo by Bettmann via Getty Images

and coverage of the event. As Rodgers looks over the paper, Leonard starts talking about him with fatherly admiration. "They want to name a candy bar after Reggie Jackson. They should name a bubble gum after Billy. He's someone for the kids to emulate. You should have seen him after the race on Sunday. He was signing autographs. Not just his name, but a *message* for each kid. Two weeks ago, when he set the American record in the one-hour run, it was beautiful. He was moving like a ballet dancer. Completely effortless. The sun was setting on the Boston University track—it reflected off his flowing blond hair. Each time they gave him his lap time, he smiled a little. There were no more than 100 people there. Kids were throwing frisbees on the infield, so I went over and told them what was happening. With a real crowd, he could have lowered the world record."

Bill has to go to Michigan today, so he is out on the roads much earlier than usual. Looking out on the crowded rush-hour traffic, he reflects, "Sometimes I wish every one of those cars was a runner. Running really helps people in so many important ways." For the drive to the airport, he slips on tortoise-shell eyeglasses that add a few years and give him a more serious appearance. "Ever since the lenses fell out of my spectacles in a cross-country race, I've worn contacts when I'm running." Like Frank Shorter, Rodgers fears he is pushing the fine edge, where a runner can quickly go from being sharp to sluggish. He has a lot on his mind and, for the first time, does not seem so carefree. When his fellow runner asks, "How do you feel?" Rodgers lowers his voice and prophesies, "impending doom." Then, just as quickly, the mood passes, and Bill Rodgers laughs the laugh of a teenage boy chasing butterflies.

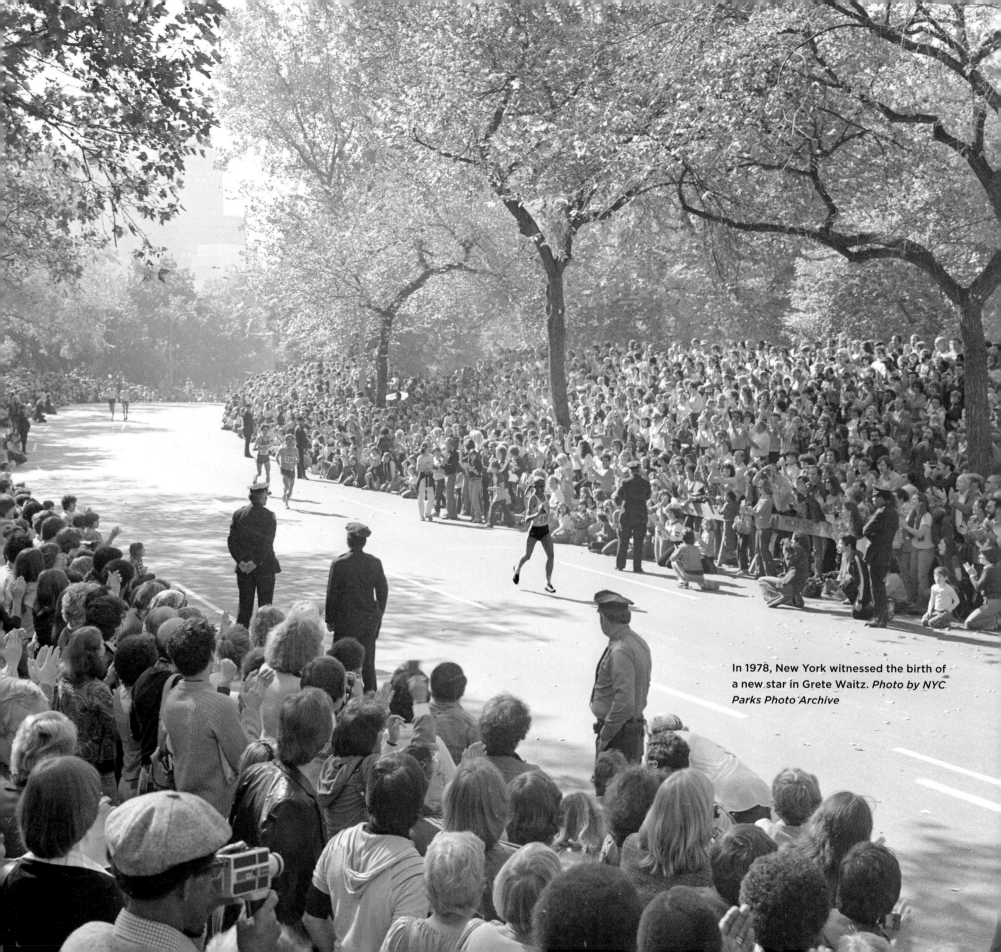

In 1978, New York witnessed the birth of a new star in Grete Waitz. *Photo by NYC Parks Photo Archive*

IT'S WAITZ—IN HER FIRST MARATHON!

BY CHERYL BENTSEN

"Who are you? What's your name?"

It is a moment after 1 p.m., and the hordes of people trying to out-lean one another near the finish alternate glances between the digital timing clock hanging above the Marathon's banner and the final yards below it. Then she appears, a woman with blonde, red-ribboned pigtails striding easily through a shower of leaves scattered by the whirring helicopter blades above.

The cheers can be heard above the helicopter roar, and the PA announcer calls the stretch run for the railbirds. "Eleven-seventy-three is leading—we don't know who she is. . . ." Her name and number, it seems, are not listed in the race program, but her final time is there in large yellow numerals for all to applaud: 2:32:30—more than two minutes faster than the woman's world record.

The excitement is almost excruciating. TV cameramen and photographers rush forward. "Who are you? What's your name?" they scream impatiently, stumbling into each other as they push to the medical station, past dozens of male runners who are wrapped in shiny silver thermos-blankets and look like dazed warriors from a sequel to *Star Wars*. Maybe it is a Scandinavian reserve, but the woman apparently is unfazed by the commotion. Finally, she acknowledges her pursuers. She is, she explains, Grete Waitz, a 25-year-old junior high school teacher of language and physical education from Oslo, Norway.

More questions from all directions, and Grete replies with impeccable English.

"How was the race?"

"Fantastic! But very hard—much harder than I expected."

"Why wasn't your name in the program?"

"I entered late. I was invited by Finnair."

"What was your strategy?"

"No strategy. This was my first marathon."

Heads shake. Eyebrows raise. Disbelief. First marathons are supposed to be learning experiences even for exceptional runners. They are studies in frustration, they elicit I-told-you-sos from seasoned colleagues and are the raw material for reminiscences that color with age.

Her first marathon, for sure, but certainly not Grete's first victory. It will take hours for the media and the spectators to make sense of Waitz's remarkable performance, but slowly the pieces of the puzzle fall into place. Waitz is not untried, she was simply unknown in this country. For the past few years, she has been a heroine in Europe. She competed for Norway in the 1972 and 1976 Olympics in the middle distances, and in 1978 ran the fastest mile for women—4:26.9. In the European championships in Prague, just a few months earlier, she had placed fifth and third in the 1,500 meters and 3,000 meters, respectively. Last spring she won the world cross-country championship in Scotland, and in 1977 she was nothing less than the leading female middle-distance runner in the world.

Even so, he audacious performance must be explained, and now. Not since a relative unknown named Bill Rodgers set the American record in 1975 have the media and the insiders been so taken by surprise. Grete patiently—almost apologetically—tells how she happened to take the world's record without even being listed in the program.

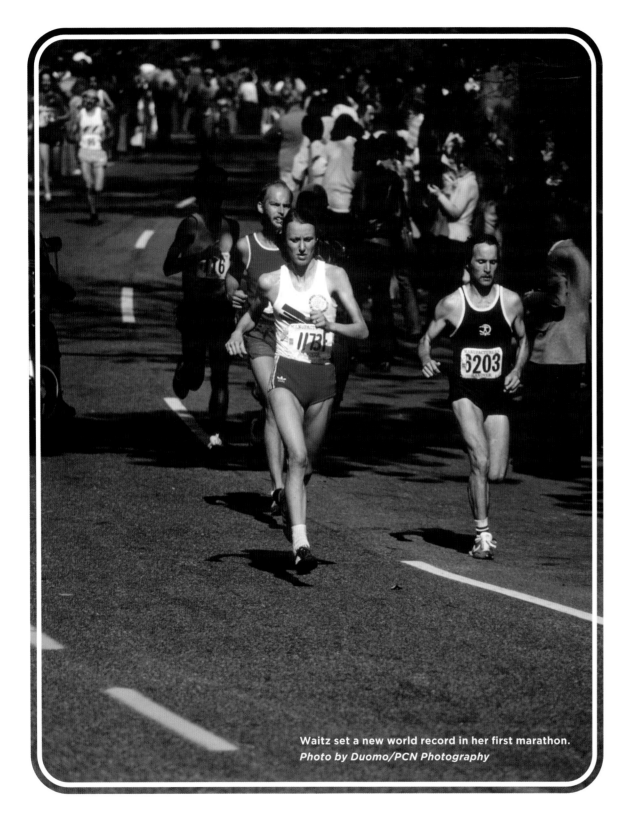

Waitz set a new world record in her first marathon.
Photo by Duomo/PCN Photography

"I ran 18 miles in training once," she says. "My longest competition is 20 kilometers, and I really didn't train for this race. But I liked it—running with that many people.

"Not many women run in Norway, except in track. There's very little road racing, some cross-country. I'm a track runner. I was too slow in the 800, so I wanted to run the 1,500, 3,000, the marathon."

That Grete Waitz tried the marathon made life difficult along First Avenue for Martha Cooksey, no match for the Norwegian when she turns to short bursts of speed. As Cooksey, 24, sits on a cot in the fabricated infirmary nursing a blood blister, she reviews the turning points.

"I was running up First Avenue in a group of men, hanging together. A man who was running alongside me said there was no woman behind me. I didn't hear anything, and all of a sudden she surged past. Ten yards ahead. I knew who she was because I saw her this morning in the coffee shop.

"I thought, 'Oh, she's going to leave me now.' Then this guy encouraged me and said, 'She's just surging, don't let her get away.' Then I remembered this passing drill I've worked on that's used when somebody gets by you. You pass them back and try to break them. I surged three yards ahead of her. Then she went out again, vacated the area and just took off."

There were seven miles to go, and even

without Waitz, it was a tough road for Cooksey. "I don't know what got me to the finish line," she says as tears well up in her eyes. "Columbus Circle seemed miles away. I didn't know how I was going to make the turn toward the finish. About a tenth of a mile in, I went down, fell. I had no strength at all. Some guy on the side tried to help me. I said, 'No, you can't help me, you can't …' Then some runner helped me up. I started to run again and I heard the crowd and I don't know what happened, how I kept running or staggering. I lunged at the finish line, but I didn't cross it. So I crawled."

Cooksey's second-place time was 2:41:48. Since the woman's race counted as the National Amateur Athletic Union championship—and Cooksey was the first American to finish—she has a U.S. marathon title to add to her victories in the Avon International and Pikes Peak Marathons. Christa Vahlensieck of West Germany, whose world record of 2:34:48 was shattered by Waitz, was thought not to have reached her limit in liught of her consistent near-record marathon performances in Europe. But for the 29-year-old co-favorite, the string snapped at 18 miles. Christa left the race with severe pain in her legs and feet and comforted Jacqueline Hansen, another 29-year-old woman who once held the world record. Hansen was doubled over with hamstring cramps and a bruised foot.

Two other contenders would call a premature end to their toils. Young Celia Peterson, the Cornell University student, left the field after 15 miles. "I just blew up," she said. "I was totally exhausted at ten. At 13 I was walking, feeling dizzy. There was no reason to continue. This had never happened before."

It has happened to Julie Brown, the American marathon record holder whose recurrent injuries have played havoc with her racing goals. "Around 19 or 20 miles my knee started to hurt," she says, stretched out with an icepack on her right knee. "I was trying to ignore the pain at 20, around 22 ½ I couldn't even walk. My knee locked."

Susan Peterson and her husband, Peter, of California reach the finish wearing matching blue-and-white striped uniforms. Her time was 2:44:43. "Third? Me?" she exclaims, "It was super—quite an experience." In the past 29 months, Sue says, she has run 28 marathons, winning 13 of them.

The remaining leading women come in, most following each other by 30 seconds to a minute or so. Doreen Ennis, Eleonora Mendonca, Margaret Lockley … Linda Schreiber, a 33-year-old mother of five, including quadruplets, in 11th place … Cindy Dalrymple right after her … 39-year-old Nina Kuscsik, in 18th place, the first woman to run in a New York City Marathon back in 1970.

A few women runners are probably still out on the course as Grete Waitz and her husband, Jack, dress in their hotel room for what will be a leisurely dinner with Norwegian friends. "What is the *Today* show?" Grete asks. "They're going to pick me up in the morning, but it's so early. What kind of show is that?"

NOT SINCE A RELATIVE UNKNOWN NAMED BILL RODGERS SET THE AMERICAN RECORD IN 1975 HAVE THE MEDIA AND THE INSIDERS BEEN SO TAKEN BY SURPRISE. GRETE PATIENTLY—ALMOST APOLOGETICALLY—TELLS HOW SHE HAPPENED TO TAKE THE WORLD'S RECORD WITHOUT EVEN BEING LISTED IN THE PROGRAM.

FRED'S SHOW

For a race with thousands of runners, the New York City Marathon throughout its first decades could sometimes feel like a one-man show. From sponsor meetings to press conferences, from aid station stocking to blue line painting, from starting cannon to finish line banner, the race's indefatigable majordomo, Fred Lebow, was seemingly everywhere, the face, the voice and the driving force of the marathon.

Lebow, as other stories in this book make clear, was a complex man, quirky and passionate and capable of deep loyalty. A larger-than-life figure with a colorful backstory, he became one of those classic New York characters recognized and hailed on the street, even by folks who would never consider running farther than it took to catch a cab. But in some ways the real essence of Fred Lebow was most clearly revealed in his day-to-day, running-shoes-on-the-ground engagement with New York Road Runners and with the Marathon, his Marathon. The following two stories from the 1978 edition of the race capture that essence, Fred in full.

More than a quarter century after
Fred Lebow's passing, his spirit, and
distinctive figure, still stand watch over
all of New York's runners in the heart of
Central Park. *Photo by John T. Suhar/NYRR*

BLUE LINE IN THE NIGHT

BY CONNIE BRUCK

"I've mellowed this year, yet I have a feeling the marathon worked better when I was more the dictator."

Lebow has foregone the 24-hour day. It's 1:30 a.m. He hasn't slept in close to 48 hours and doesn't plan to this night, either. "I feel *good*," he asserts, standing on the ramp of the Queensboro Bridge at 59th St. He is handing out Marathon '78 T-shirts—he gives them out, like totems, wherever he goes these days—to the city

Photo by George Tiedemann/Sports Illustrated *via Getty Images*

crew who will paint the blue line. Last night, they surveyed the dual start, being used for the first time (women and first-time marathoners at one line, seasoned men on the other), and painted from the merge ("You should see the merge, *perfect*," rhapsodizes Fred, "no overlap!"), to the tip of the Queensboro Bridge.

The truck sends out its first few jets of "Marathon Blue" (renamed this year by the paint company). Fred writes a commemorative "New York City Marathon '78" in the wet paint, hops into the lead van with the spinning red light, and the vehicles slowly begin to make their way up First Avenue. Fred remarks that he not only hasn't slept since Tuesday, he's barely eaten. Wednesday was Yom Kippur; he broke his fast with a poppy-seed cake at the Citicorp Building, and he's hardly stopped to eat since then. At 81st Street, the paint runs out and a new drum has to be put in, so Fred goes to chat with the crew. Who are this year's favorites? "Bill Rodgers and Garry Bjorklund are both hungry for victory," says Fred, "and I predict a battle right down to the finish line." Among the women, he's watching Julie Brown. Meanwhile, a young man wearing jeans and a suede vest rushes up, gesturing angrily toward Fred. "That's *Lebow!*" he exclaims to no one in particular.

Fred turns his back. "I was rejected," the angry young man continues, "because Highland, the guy I gave my application and money to, was on the outs with Lebow, so he just kept my money and threw the application out. It's all political, you know, all this bull about no entries after midnight, and they've been letting in friends of sponsors right and left."

He stares hard, bringing his face up close. "Do you know what it's like to train and train and then be told you can't run? But I'm gonna be in that race, just watch. Len Duey broke his foot, but he's kept his number, and I'm gonna use it. You just tell Fred Lebow for me that as Yogi Berra once said, 'The game's not *over* till it's over.'"

Back in the van, Fred says he has no idea what the guy's talking about. Besides, he's got real worries—his day did not go well. It started with a five-borough police meeting; 800 cops will be assigned to

Photo by Duomo/PCN Photography

the marathon, the same number as last year. Despite the fact that no other race or parade is so demanding of the NYPD—the 75-mile bicycle race is on limited-access roads, Macy's Thanksgiving Day parade is comparatively localized—Fred feels he's won them over in the last three years. This morning, though, he didn't get what he wanted. "There were things I should've fought over, like barricades on both sides of First Avenue. Their plan for the Madison Avenue Bridge. It would have meant a battle, but I could have won. Never go to a meeting tired," he adds ruefully.

From there he went to Fort Wadsworth for a final scouting and then on to a series of meetings at the Huntington Hartford headquarters on radio communications, medical teams and water stations. "I am very worried about the water stations," Fred murmurs. "You know, I've been severely criticized in the past for being such a dictator, so this year, I thought maybe it was time to start delegating.

"I stayed away from the water stations, for example, and now I don't like the way they look. I've mellowed this year, yet I have a feeling the marathon worked better when I was more the dictator."

According to Peter Roth, this is a recurrent concern of Fred's. "The club is Fred's baby," Roth would say later, "and the only one who wields any real influence there is

Fred. Whenever he does give responsibility away, he's almost sure to take it back. Often he doesn't give enough information to get the job done properly; then he can say that he *knew* it wouldn't work. I don't think it's deliberate, but a subconscious way of always being in control.

"That's why he likes the chaos," Roth added. "It keeps everyone jumping and also unknowing; if everything's chaotic, then only Fred knows what's really going on."

"Look at the street here," Fred says, as we

"TO HAVE DIRECTED IT SO WELL THAT I COULD AFFORD TO RUN IN IT, TOO. TO BE ABLE TO RUN IN THE NEW YORK CITY MARATHON—THAT'S MY ULTIMATE DREAM."

—FRED LEBOW

move up First past 106th. The street is a graphic before-and-after image: One side is paved smooth, unmarred, the other is covered with cobblestones from the turn of the century. "In '76, runners complained about those cobblestones," Fred explains, "so I told Tony Gullotta, chief engineer in the Manhattan borough president's office, and for Marathon '77 he paved that side of the street from 106th to 120th."

Fred ran the entire course recently, noting

the location and measurement of *every* pothole, and sent the complete list to the Commissioner of Highways, asking that they be repaired. "At the bottom, jokingly, I wrote, 'Why don't you just re-surface the entire roadway from Staten Island?'"

Some joke. Lebow flashes a rare smile. The city performs for him now, and in most cases he gets what he wants. Except for the wheelchair athletes. Two days after Evelyn Goodman's terse visit, Lebow was subpoenaed to appear at a judicial hearing and charged with unlawful discrimination against wheelchair athletes in a class-action complaint. "I had been stalling because I wanted to go to court and fight it there, but Commissioner Davis said no. I said to the Commissioner, 'Are you afraid we would win if we left it to the court?' He said, 'I don't care if you win or lose in court, I am *ordering* you to accept them.' He told me flat-out that if I didn't, there would be no marathon. Well, the marathon is bigger than me and the commissioner and the mayor and the wheelchair athletes put together. So I accepted them, okay? But their times will not be merged in the computers, their names will not appear in the results."

Though he talks a lot about the hazards wheelchairs present, the real wellspring of Lebow's vehemence seems to be a purist notion of the footrace, the sense that it gets adulterated by wheels. But if the marathon is

testimony not simply to the human ability to move one leg after the other, but to what engenders that movement—determination, will, disciplined preparation, a kind of massive overcoming—then surely the wheelchair athletes belong on that courses as much as the runners. "Not really," Fred counters. "It does not require as much training or effort to do the course in a wheelchair; I don't believe it. It is only for emotional reasons that you think they should be there. Besides, I am thinking of the marathon's future. By 1980 we could have 100 wheelchair entrants."

Looming ahead in the dark is the Willis Avenue Bridge. Fred hasn't yet decided whether the runners should veer right to Willis or left toward 135th Street. Last year, the question didn't arise; they used only the left-hand walkway and just followed it around to 135th. But with twice as many runners, he has demanded part of the roadway as well—but *which* part? He stops the procession and jumps out to run the bridge. The grating is another worry; it caused a bad spill in the 75-mile bike race, and he wants to cushion it with some rubber matting but hasn't even located the right product yet. Now he directs Sam Vitale, his companion for the blue-line ride each year, to bear right for Willis. Seconds pass. "Stop!" Fred yells. "I'm not going to gamble by crossing traffic. We stick to last year's route with 135th." But the blue line already points to Willis. Vitale says he'll get Fred some black paint to cover it up.

At the Madison Avenue Bridge, Fred again tells Vitale to stop, and then disappears into the dark. "Last year," Vitale remarks, "I remember drawing that blue line—see, you can still make it out—right up to the walkway. He was afraid before that the police wouldn't let him use the roadway on the bridges."

Fred, however, cannot make up his mind. He knows the police are opposed to stopping the Bronx-bound traffic on the left side, but if he takes the right side, the measurement may change too much from last year's course. He tells Vitale to stop the paint before the bridge, then start it again on 135th Street, in Manhattan. Lebow sits silent, distraught. He should have measured before; now he'll either have to come back and paint or risk a lapse in the line. Both bridges—his nemeses—are nagging at him. He might want to change back to Willis Avenue. He desperately wants the course to be perfect. "This is the year," he says finally, "when the marathon could establish itself. This is the important year. Until now, there have always been changes: the number of runners has doubled, I've altered the course.

"To have directed it so well that I could afford to run in it, too," adds Fred. "To be able to run in the New York City Marathon—that's my ultimate dream."

The end is in sight. We have traveled ten miles, painting Manhattan and the Bronx with 28 gallons of Marathon Blue. "Finished!" yells Fred, exultant. It is 4:34 a.m., the ritual complete. He goes around pumping the hand of each man in the crew, and when he gets to Vitale, he smiles broadly. "Sal," he says eagerly, "I'll see you in '79."

COPING WITH THE AFTERMATH

BY CONNIE BRUCK

The final remains of Marathon '78 are being cleared from Central Park, the awards have just been presented, the race has been declared an unmitigated triumph, the best ever, by runners, spectators, public officials and sponsors—and the man of the hour, Fred Lebow, sits in the Red Baron on Columbus Avenue, craving anonymity, downing a Heineken to try to cut the taste of the ashes. His race is gone. He is not only barren, bereft of his obsession, but aching with disappointment. This year, he's even foregone his traditional post-mortem meeting with his aides. "I *know* what went wrong," he says despondently. "I don't have to hold a meeting to find out." Ultimately, Lebow holds his own counsel; there is nothing really shared about this event; from start to finish—no matter how passionately involved his assistants become. How much they mirror his own mania—he feels himself alone with this race. And the accolades that come tonight, as people stop him at every corner, are like salt to a wound; he winces slightly with each one. Doesn't *anybody* have any concept of how perfect this marathon might have been?

"People just look at the big picture," he objects, "although it's true that for its size this marathon ran more smoothly than any I've seen—and I've seen them all over the world." For the record, he dutifully counts his blessings. There *was* enough water. He'd been petrified of a casualty from the heat, but there was only one serious

Photo by David Pickoff/AP Photo

HE GIVES HIS LIFE TO THE MARATHON. WHAT DOES IT GIVE HIM? MORE TO THE POINT, PERHAPS: WHAT WOULD FILL THE VOID IF IT WERE GONE?

hospitalization, and the man is now recovering. The bridges had stayed put. The course at the Bronx bridges—his greatest gamble—remained intact; had it not, Grete Waitz's world record would have been lost. And the police, he adds warmly, were fantastic.—he was delighted that, at the awards ceremony, Chief Schawaroch got the biggest ovation of all.

"But it's the little things, the little things," Fred laments, "that really make a race—and my personal disorganization was inexcusable." Since he assumed from the start that his was the exclusive power to make it right, every wrong now comes to rest at his door, and he feels he failed the marathon most at the finish. Last year, he had 200 policemen there; today they were all over on First Avenue. Had he had the cops, and had he put snow-fencing on both sides of the line, the finish might have been saved. As it was, the line was actually bent out of shape from the press of the crowds, and the scene, where the chutes right-angled—with spectators milling about in them, runners lying down, volunteers, in no particular formation, handing out blankets, medals and Perrier, the wheelchair athletes holding a press conference right in the middle—seemed to him a travesty. "The chutes were too wide,"

he berates himself. "They invited people in. I wanted to make them like last year's, but Tony Gullotta saiud we should make them bigger to accommodate twice as many runners—and I *listened*."

A young man approaches the bar, peers at Fred and says eagerly, "You're the director of the marathon, right?" "No," Fred answers shortly, staring into his beer. Others who work for the marathon may covet recognition, but Fred says he hates it. "It's not for recognition that I do the marathon," he says almost primly. "And you know how I feel tonight? Why are all these people congratulating me? I didn't even run." He closes his eyes, looking bone-weary and sad. "When I finish running a marathon, I am tired but also exhilarated. Tonight I am only tired. Today was my kind of weather, too—I love to run when it's hot. Maybe part of my depression is that I want so much to be a really good runner—not world-class, just good—and I'm not."

Perhaps it's time to take stock. He wonders aloud if it's worth it. He gives his life to the marathon. What does it give him? More to the point, perhaps: What would fill the void if it were gone? "Once," says Fred, imagining alternate routes, "there was a woman I was involved

with as I am with the marathon—but that was long before running." He pauses, considering. "Look, I know the event is successful, it's here to stay, the public thinks it's terrific. And I feel tonight a little like the happily married man who goes down to the corner for a pack of cigarettes—and never comes back. Maybe I should just walk away from the marathon, disappear, do something different."

He does not sound convincing. Besides, this is his classic post-marathon depression. He's always lured back by the longing to reach that consummate moment when the real corresponds to the imagined, when the event achieves its form (would he ever grant that it had?)—and when he can run. "Last night, I was working at the finish line at about 4 a.m., and it was so lovely," he says dreamily. "It looked like a graveyard almost, eerie, because the blankets came in these big boxes, and I had stacked them neatly in rows with even spaces between them—they looked like caskets. I had the blankets there, the medals in another place, the Perrier in its place—the order was so *perfect*. Then, I guess because when I was a child I always loved parades with lots of flags flying, I went and put the flags of all the different countries on the bleachers. It was so beautiful, so clean, the computers were humming, everything was in order, and then five Italian runners, all in uniform, came running around the bend—" His eyes have softened, he's half-smiling, rapt with the thought of how it was, might be next year, at the finish line.

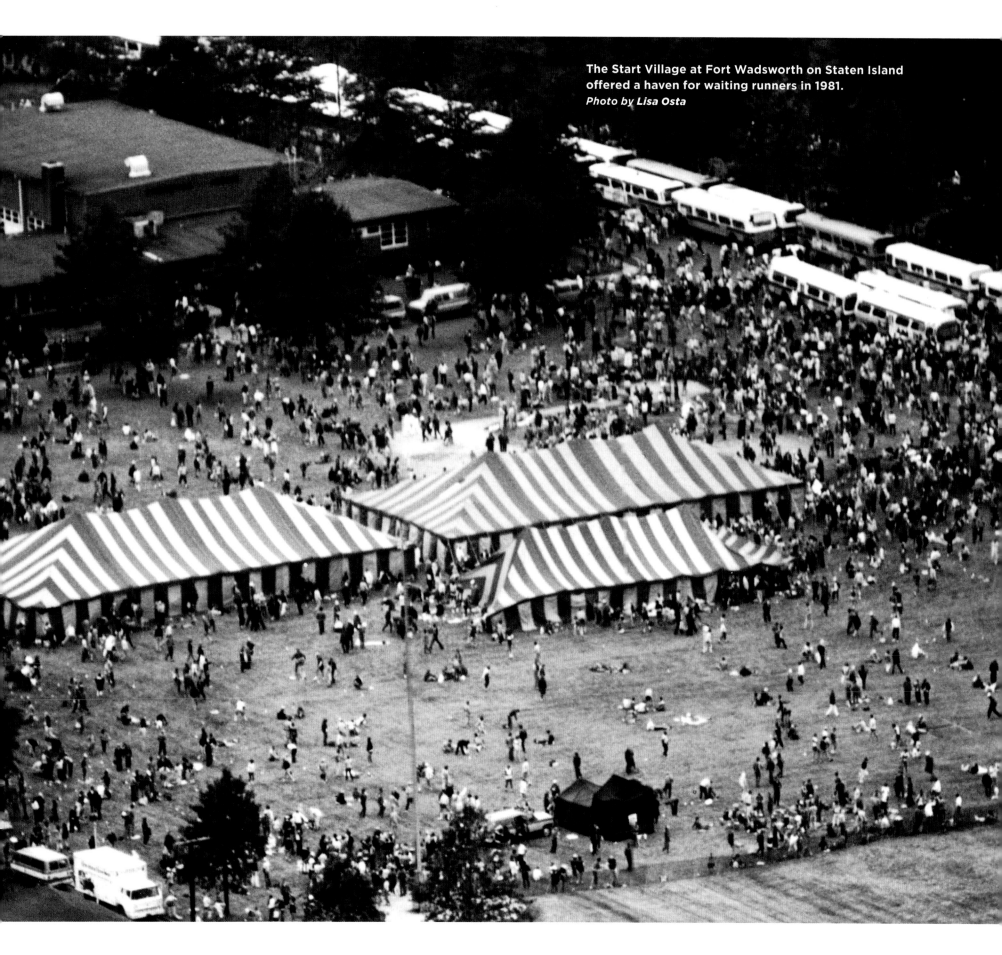

The Start Village at Fort Wadsworth on Staten Island offered a haven for waiting runners in 1981.
Photo by Lisa Osta

THROUGH THE YEARS:
SPECTATORS

"They also serve, who only stand and wait" is Milton's famous line, evoked so many moments since in times of conflict to praise the efforts of those on the Home Front. Modify it just a bit—They also serve, who only stand and wait, and wave and cheer and film and text and hold signs and play bongos and bagpipes and hand out water and oranges and slap high fives and shout, "You can do it!" and "Go, Mommy!" and "Lookin' good!"—and it applies just as well to the multitudes who turn out on Marathon Sunday, lining the route from the foot of the Verrazzano to the finish line in Central Park.

It wasn't always like that, of course. Look at photos of the first few editions of the marathon, run around Central Park in the early 1970s, and you'll see precious few folks paying any attention at all to the "joggers" passing by. But, hey, New Yorkers love a good show, and once the race busted out of the park and took to the streets, folks turned out to watch. That first year, in 1976, winner Bill Rodgers could barely elbow his way to the tape, so dense was the crowd at the finish. It would only grow from there, to more than a million in 2019.

And—fittingly mirroring the race itself—the crowd in New York is more gloriously diverse than any other in sports, with spectators of every age, ethnicity, gender, religion, and economic stratum represented as the runners make their way through the numerous distinct and historic neighborhoods along the route.

Finally, just as the spectators, with their signs and cheers, buoy the runners and lift them on toward the finish, those same spectators are inspired by the men and women flowing past.

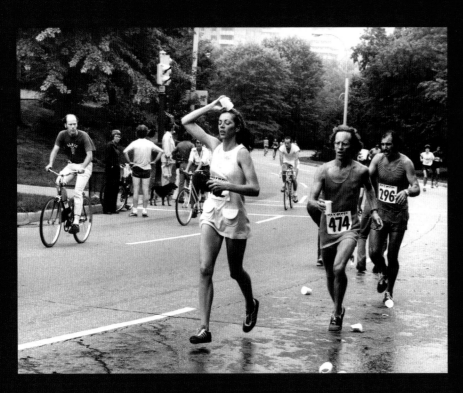

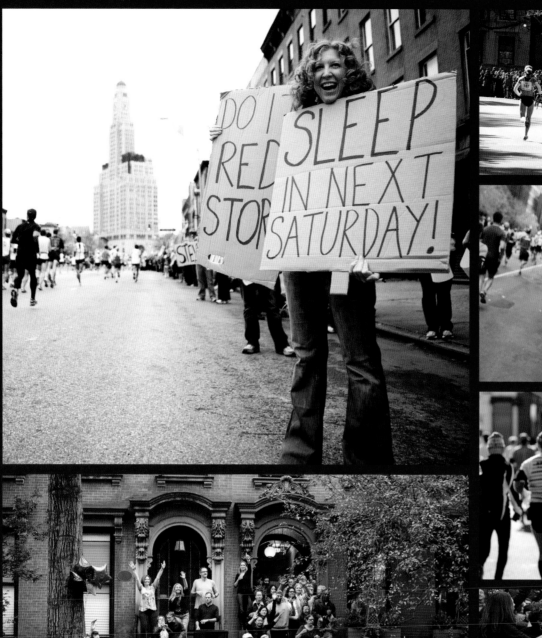

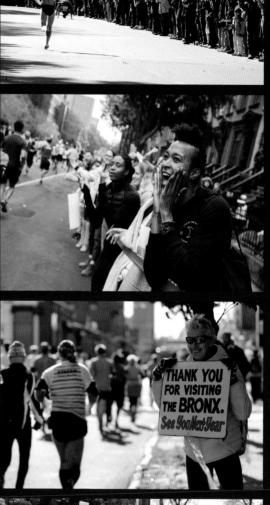

Photo credits, clockwise from top left: Ramin Talaie/Corbis via Getty Images; E.H. Wallop/NYRR; Lou Bopp/NYRR; Mark S. Berna/NYRR Ben Ko/NYRR; Lou Bopp/NYRR

THROUGH THE YEARS:
VOLUNTEERS

About four-to-one. That's the ratio of runners to volunteers for the New York City Marathon these days. Where once a rag-tag collection of helping hands could keep the early race fields hydrated and on course, it now takes a supremely organized and lavishly equipped army of nearly 12,000 volunteers under the auspices of New York Road Runners throughout race week to see that the world's largest single-day sporting event goes off without a hitch.

For the runners, those smiling faces and outstretched arms holding water cups or pointing the way can make all the difference between a torturous slog and a successful and fulfilling run to the finish.

Volunteers come from all over, from colleges and senior communities, running clubs, and youth groups. Each year, some 1,500 licensed medical professionals offer their services, providing care for runners along the course and at the finish. One of the largest contingents of volunteers comes from abroad, through the U.S. State Department's J-1 exchange, with more than 1,000 U.S. visitors—students, interns, au pairs, and research scholars—manning water stops and aid stations. Theirs is a fitting addition to a gloriously diverse event featuring runners from more than 130 countries. "We can make lives better … and you always get something back," said one J-1 exchange participant, Selina Kliesener of Germany, of the volunteering experience.

Including the gratitude of more than 50,000 runners.

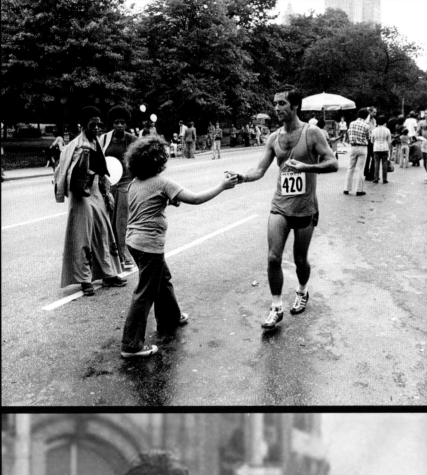

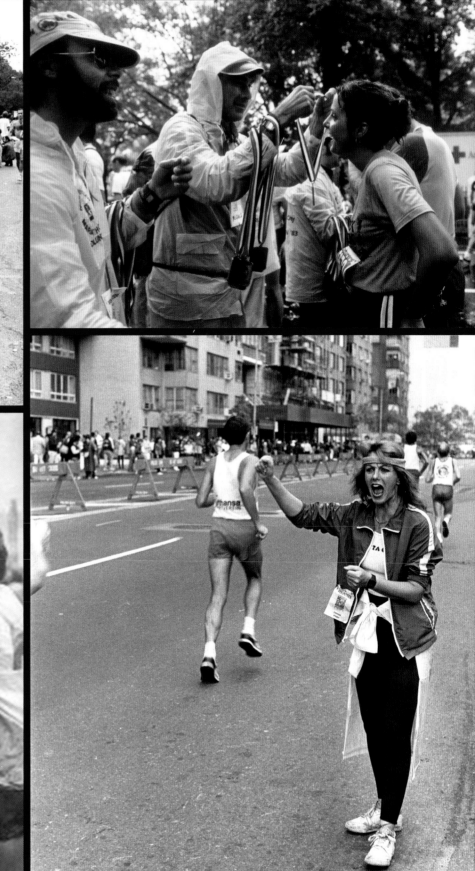

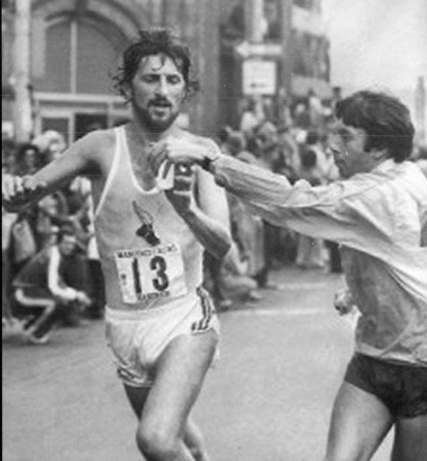

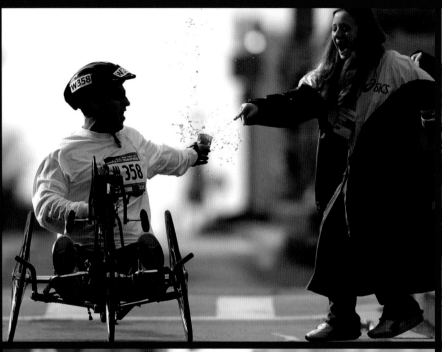
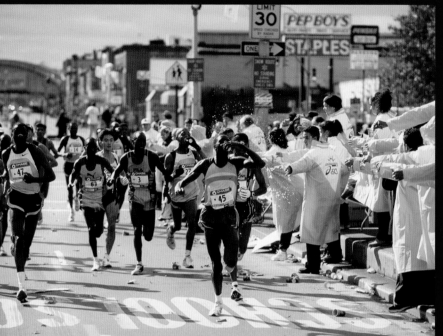

Photo credits, clockwise from top left: Suzy Allman; Photo Run/NYRR; Drew Levin/NYRR; David Gardiner Garcia/NYRR

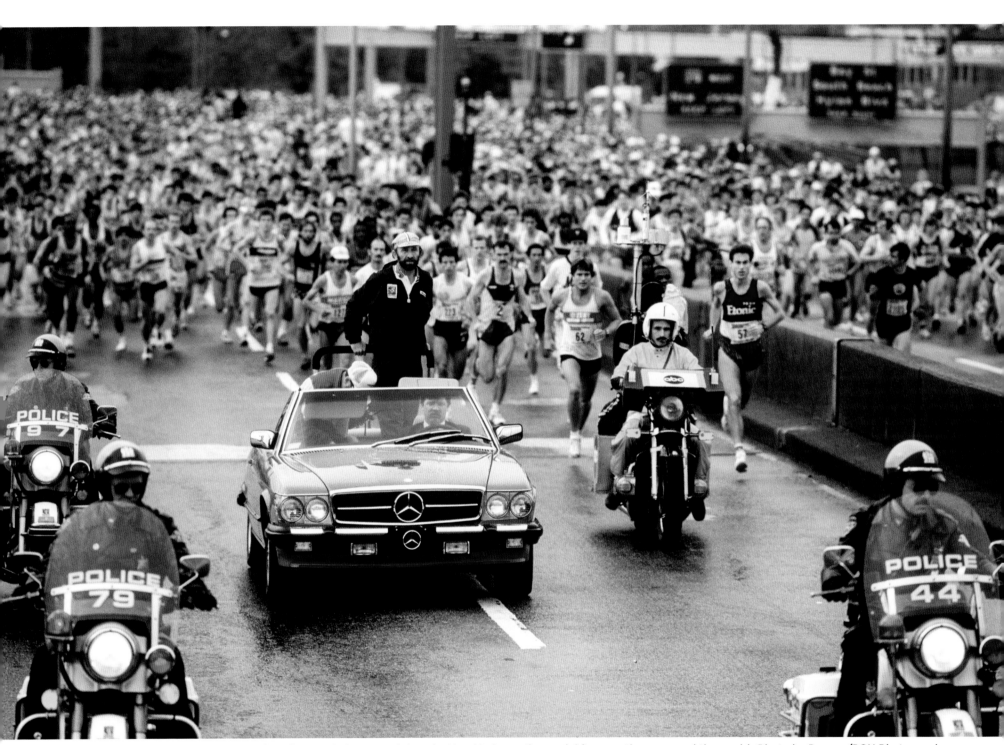

Leading the way: In its second decade, New York was the model for marathons around the world. *Photo by Duomo/PCN Photography*

1980s

It was the decade, famously, of big hair, big shoulders, and—Greed is good?—big ambition. It was also the decade that saw the end of the Cold War, the fall of the Berlin Wall, and the inspiring spectacles of Live Aid and "We Are the World." Just coming into its teens, the New York City Marathon got firmly into the spirit of the era.

In the decade's first year, American track star Alberto Salazar chose New York for his marathon debut and, showing no awe at the distance, ran to victory in a new course record. The following year Salazar would return and set a world-best time for the marathon. His performance would be matched on the women's side by a striking new face, as Allison Roe of New Zealand sliced 13 seconds from Grete Waitz's mark from the year before. A remeasurement of the course that found it to be 150 meters short of the requisite 26 miles, 385 yards, would call both records into dispute, but the die was already cast: At the front of the pack, the marathon was no longer just a test of endurance, it was a *race*—and there was no greater setting in the world for that competition than the streets of New York.

Salazar would win for a third time in 1982, prevailing in a big-shouldered duel that came down to the final quarter mile, but after that New York went global. In '83, New Zealand's Rod Dixon, a former miler stretching his legs, became the first non-American man to take the title. A quarter century would pass before the next U.S. man broke the tape in New York. Dixon's victory was followed by three years of Italian rule—call it *la dolce vitesse*—and then, in 1987, Ibrahim Hussein of Kenya became the first African champion. He would be followed by a Brit and a Tanzanian. (On the women's side, by contrast, Waitz—call her Greedy Grete?—kept things neatly Norwegian with seven wins in the '80s.)

Behind the leaders, the field reflected the international trend. Of the record 24,659 finishers in 1989 (up from 12,512 in '80), 10,151 came from foreign countries. We are the world, indeed.

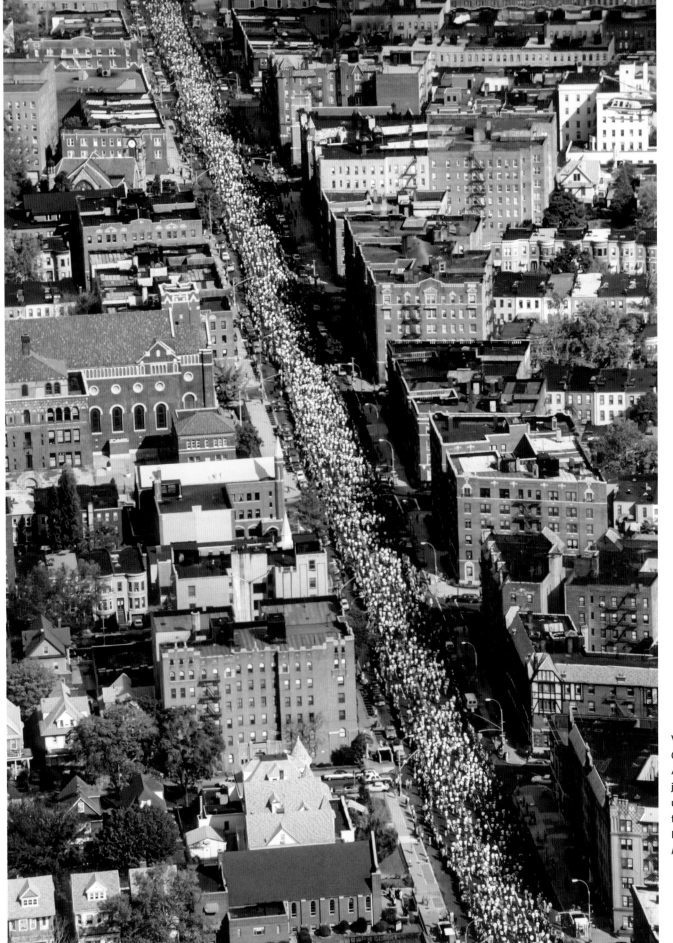

While Bill Rodgers (opposite, 3) and rookie Alberto Salazar (gold jersey) were dueling up front, the rest of the field streamed through Brooklyn. *Photo by David Madison/Getty Images*

THERE ARE ONLY 26 MILES TO GO

BY KENNY MOORE

Bill Rodgers is 32 years old and has won the Boston and New York marathons four times apiece. Alberto Salazar is 22 years old, and before last Sunday and the 11th running of the New York race he had never entered a marathon, though he was the second-fastest American at 10,000 meters this year, at 27:49.3. Both are from Massachusetts, and both are exceedingly confident men, which led to a most spirited prerace exchange for usually mild marathoners.

"I feel capable of a 2:10," Salazar had said, a pointed remark because Rodgers's New York record, set in 1976, was 2:10:09, "and I'd like to—I intend to—beat Billy Rodgers at his own game."

"There are 20 miles out there after Alberto is used to stopping. He's going to learn something in them," Rodgers said after hearing of Salazar's remarks. "And I'm firm on one point: no rookie is going to beat me."

It is more normal to hear marathoners sounding like Norway's Grete Waitz, who, though she had set world records in the last two New York marathons, rejected any attempt at clairvoyance. "You can't predict a record," she said before the start. "I'm running for the victory. It's hard enough to predict that."

In New York it was hard for the top contenders just to get through the welter of press and corporate receptions that comes so easily to the media capital when it has a movement on the rise thrust at it. Thus there was a sublime relief in the hearts of many of the 14,000 runners as they took off at the toll plaza of the Verrazano-Narrows Bridge and climbed the first mile to the span's summit with the chill (45°) wind, which gusted to 35 mph, at their backs, a crystalline view of the Manhattan skyline to their left, rainbows beneath them from fire boats spraying water in celebration of their passage, and all the film crews and meet promoters left blissfully behind with the "world's longest urinal" at the marshaling area. Two hundred feet must not have been quite long enough. Several men stepped to the railing in midspan and created the world's highest—228 feet.

Fank Nenshun of the People's Republic of China led for the first three miles, while Rodgers and Salazar stayed in a huge pack. "My plan was just to keep close," said Salazar. "I hoped to have something left for the last six miles." The pace was fast, but easy. "The wind just threw you along," said Rodgers, "but it scared me a

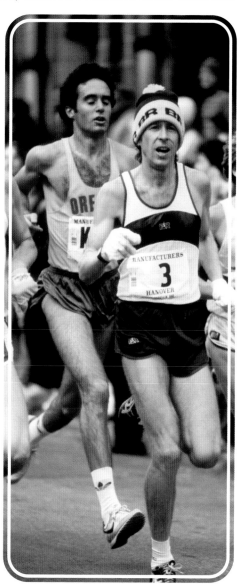

Photo by Duomo/PCN Photography

little. I was afraid we'd get lulled into battle too early."

That appeared to be a possibility as Filbert Bayi, the former mile world record holder, led two fellow Tanzanians quickly up to Nenshun as they ran past overcoated spectators in Brooklyn. Salazar alertly kept close, having tossed aside the T shirt he had worn over his University of Oregon singlet at the start. Salazar has one track season of eligibility left at Oregon, but none for fall cross-country, "so I thought this would be a perfect time to try the marathon."

Despite doing no training run longer than 20 miles, Salazar had to be taken seriously, for he sets himself no task lightly. "He will win," said his father, Jose, who brought the Salazar family to Wayland, Mass, from Havana in 1960, when Alberto was two. "He has always called the outcome, and he has always done it."

Waitz had led all women from the gun, the wind blowing her pigtails around into her eyes. Patti Catalano, who holds all American records from five miles to the marathon, drew up beside her. "I thought, I'm not here to be intimidated by her," said Catalano, "so I went by. But at five miles I heard my time of 27:03—awfully fast. I was afraid of blowing up at the end." Catalano eased, and Waitz went on, never to be headed again. She hit halfway at 1:12:30, world-record pace, looking serene. "I wasn't calmer, I was cooler," she said later. "The last two years have been hot."

"AND I'M FIRM ON ONE POINT: NO ROOKIE IS GOING TO BEAT ME."
—BILL RODGERS

After seven miles the lead pack was down to perhaps 30 men, 10 of whom led at one time or another. Rodgers was easily identifiable by his fluffy lemon-and-green stocking cap. He was relieved that there seemed plenty of elbow room because with the wind behind, there was no need for runners to draft along on someone else's back.

Behind, that great field stretched back for miles, filling the street to the horizon. It was an arresting vision, this moving city of 14,000 running souls, and it couldn't help but provoke a stream of thoughts. First, one simply marveled at the raw figures, the 20,000 entrants turned away to wait for another year; the 1,142 lawyers and 546 doctors running; the 2,000 foreign entries representing 43 countries; the 2,500 volunteers who readied 450,000 drinking cups and who had used 130 gallons of blue paint to put down the line that drew the throng through the five boroughs.

A New York Telephone Company computer revealed that there were 168 company presidents competing, but only 166 construction workers; that 300 intersections were closed; that its own printout of the results would be 70 yards long. It showed that as the mass of the field has grown, the percentage of finishers hasn't suffered, going from 71%

of 1976's 2,090 starters to 91% of last year's 11,405 (90% of this year's starters would hang in to the end). It reminded us that in 1970 but one woman ran, Nina Kuscsik, though she didn't finish. This year there were 2,465, of whom only 10 asked for extra-large T shirts.

The conductor of this vast symphony, as ever, was Fred Lebow of the New York Road Runners Club, who had easily disposed of all the usual problems in the weeks leading up to the race, and some not so usual. When Jordache jeans offered to put up $250,000 in prize money, with $100,000 for the winner, Lebow sought approval from The Athletics Congress, which told him that if the athletes' amateur standing was to be preserved, the money would have to be awarded to (read funneled through) their clubs. The freshly formed Association of Road Racing Athletes then protested that arrangement as perpetuating the hypocrisy of under-the-table payments and said its members, including Rodgers, would boycott if such a plan were put into practice. So Lebow decided there would be no prize money. "We just didn't have enough time to create a plan that all the sides could live with," he said, firmly implying that next year would be different.

A far more elemental crisis blew out of the Atlantic on the day before the race. A storm dropped 1.54 inches of rain on New York City, and winds up to 50 mph blew down a tent in the starting area. Lebow fretted about

the three-quarter mile carpet that crews were about to lay across the open grating of the Queensboro Bridge at the 15-mile point. "We don't know what's worse, running in high winds on soaked carpet or on slick grating," he said. Finally he judged the carpet was such an unknown variable that it might be dangerous and vetoed it.

But the sight of the 14,000 as they passed through a dismal industrial district in Queens toward what turned out to be a perfectly dry bridge inspired more than interest in the logistics of their welfare. Watchers were struck again with the satisfyingly democratic observation that in a marathon the weak and faint and lame get right out on the same road with the species' finest runners, and in New York they do it with the vocal help of about two million curbside assistants. "We're all devout marathoners here," said Parks Commissioner Gordon Davis, "even those of us who don't run a step." Since most viewers only got to see the runners once, they howled as if it were the homestretch, even if 20 miles remained. "This would be a hell of a spectator sport," said Jim Dunaway of Tenafly, N.J., as he labored toward his goal of completing the race in four hours, "if somebody invented a truck that would carry 60,000 people."

Yet for all their sharing of the asphalt, the runners soon divided themselves. Up front, nearest Rodgers and Salazar and Waitz and Catalano, were athletes born to run long distances. Behind came those persuaded in more complicated fashions. Few humans need run more than six miles at a time for the optimum health benefit, but marathoning in this country has little to do with health. Rather it has become a very literal rite of passage. Through this test the determined thousands seem to stride their way to what some know as therapy and others as chemical release (running has been shown to increase pain-blocking hormones in the brain), and still others as an enduring sense of worth that comes from keeping a promise to oneself and mastering this brute, daunting distance.

Powerful forces can be set loose in these people, and no one knows that better than New York officials. "One woman told me, 'My life is nothing, the marathon is all I'm living for,'" said Gloria Averbuch of the Road Runners Club. "Another said finishing was 'more gratifying than the births of my three children.'" Lebow has had threats of suicide if he will not accept an entry, and last year received a note from a woman who said she had a brain tumor and only a few months to live. Lebow let her in. Her name was Rosie Ruiz.

Waitz had smiled at the carnival attending

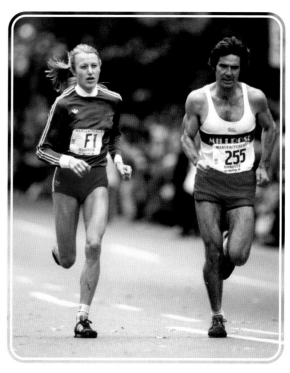

It was Grete again, as Waitz ran to her third straight victory. *Photo by Walter Iooss Jr./ Sports Illustrated via Getty Images*

the race. "In New York you can go out in the street and watch the people and be wonderfully entertained," she said. All through Manhattan she returned the favor. "It only looked easy," she said later. "I was suffering. I felt a cramp coming in my left thigh with six miles to go. I just said, 'Now forget about the time, just be first woman.'" Even so, she barely slowed. "It has to do with your will, and how much pain you put in your running," she said, seeming the stern schoolteacher she is. "At 23 miles I saw the time of 2:08 and I knew I had a chance to break the record."

Salazar had known his chances to win were very good as the leaders leaned through two lefts off the Queensboro Bridge and headed up First Avenue in Manhattan. Steve Floto

"IT HAS TO DO WITH YOUR WILL, AND HOW MUCH PAIN YOU PUT IN YOUR RUNNING."

—GRETE WAITZ

of Boulder, Colo., had led strongly by 40 yards at the halfway point, in a rapid 1:04:42. Salazar and Jeff Wells of Dallas had led the pack of close contenders, now down to 20.

Then at 14 miles, Dick Beardsley of Excelsior, Minn., stumbled on a Queens pothole and went down, tripping Rodgers. Beardsley was up quickly, but Rodgers stayed on the road long enough to lose 80 yards. He finally rose with skinned knees and resumed, but off the bridge was still back in 10th. Across the grating, watching the wind-scoured water hundreds of feet below, the pack drastically rearranged itself. With 10 miles to go, the three front-runners were John Graham, 24, of Birmingham, England, running his third marathon; Rodolfo Gomez, 30, of Mexico, who had led the Moscow Olympic marathon until the final five miles and had finished second to Waldemar Cierpinski; and Salazar. The crowds were thick outside the East Side singles bars, and Salazar felt a rush. "I was tempted to take off right then," he said. "I had to hold myself back." He carefully placed himself behind the other two and settled down to wait, his dark eyes hooded.

At 20 miles, Salazar and Gomez realized that they had met before, and shook hands, exchanging a word or two in Spanish. Salazar began to feel the need for a faster pace. "The only guy in the field I knew I'd have a hard time beating if it came down to the last half or quarter mile was Rodolfo," he said. So Salazar ran the 21st mile up some stiff hills in

4:57. Graham dropped off, and suddenly this was a very Latin affair.

Gomez stayed on Salazar's back, thinking that the headwind they faced as they turned south for the run into Central Park was hurting him a lot more than it had helped when it was pushing. He is a bounding runner, slighter than the six-foot, 144-pound Salazar, and his expression occasionally seemed frantic at the effort it took to stay near.

Salazar runs like no one so much as Bake McBride, with a kind of hunched posture and low knee lift, but the middle of one's footstep is where the most power lies, and against the wind Salazar moved easily away: by 10 yards at the 21½-mile refreshment station, by 40 yards at 22 miles, by 100 yards as he entered Central Park with three miles to go. "I knew I would win then," he said later. "It was a different feeling from a hard race on the track. There you hurt most of the way. Here it was really bad only the last two miles. I was surprised. I thought I'd have to kill myself to do 2:10." He ran through swirling dry leaves to finish in 2:09:41, clipping 29 seconds from Rodgers's course record and becoming the only other American ever to go

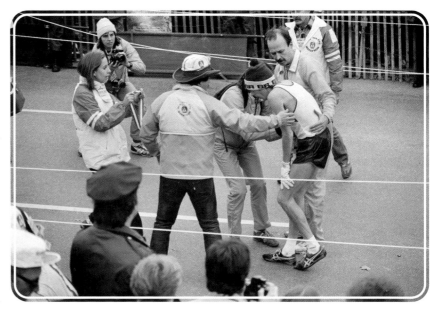
Photo by Marilynn K. Yee/New York Times *via Redux*

under 2:10. In addition it was also the fastest first marathon ever run.

Rodgers himself hadn't lost hope after his fall. He worked himself into seventh with nine miles to go, and fifth with six. "I felt good to 20 or 21 miles, but I struggled then, had to grind. People would shout, 'He's got two minutes on you,' and I would think, 'If he's got that, he'll break my American record.' It was agonizing."

Gomez held second in 2:10:14, Graham took third in 2:11:47, Wells was fourth in 2:12:00, and Rodgers finished fifth in 2:13:21. The first thing he did when it was over was ask Salazar's time. Learning it, he reeled back. "It's shocking when a guy runs 2:09:41 in his first try," he said. "I've run more than 30, and I've only run one faster than that. And it took me three years to learn how to

run the thing...." It seemed he walked away more battered by the significance of Salazar's run than by his own fatigue.

Jack Waitz, Grete's husband, waited at the 25-mile mark, where he knew she would need him. He called to her that she was on record pace, to keep on enduring. "I thought, 'Oh, you should know how tired I am,'" Grete said later. "If it feels like that, I know one of these a year is enough."

She crossed the line in 2:25:42, a minute and 51 seconds better than her record, in 74th place overall, then was embraced by the long and none too tender arms of the police, who hustled her to the interview area. "I have not had a moment to think, to feel anything but crushed by people," she said, growing faint.

Catalano had run the first 16 miles accompanied by her husband and coach, Joe. He then took a shortcut to the 24-mile mark. With Waitz out of sight, Catalano's goal was to become the second woman ever to break 2:30. "With two miles to go I looked at my watch," said Joe. "I saw that in order for her to make it, she had to keep a 6:30 pace. I yelled, 'Six-thirty! Six-thirty!' and she got pumped."

"I'm no sprinter," said Patti, "but when I got near the end and saw the clock reading 2:29:20, hoo, I ran as hard as I ever could." She reached the finish line with a face that showed all the toil of the previous hours, and all the reward, as she was timed in 2:29:34, lowering her American record by 1:23.

The winners were gathered in the sudden

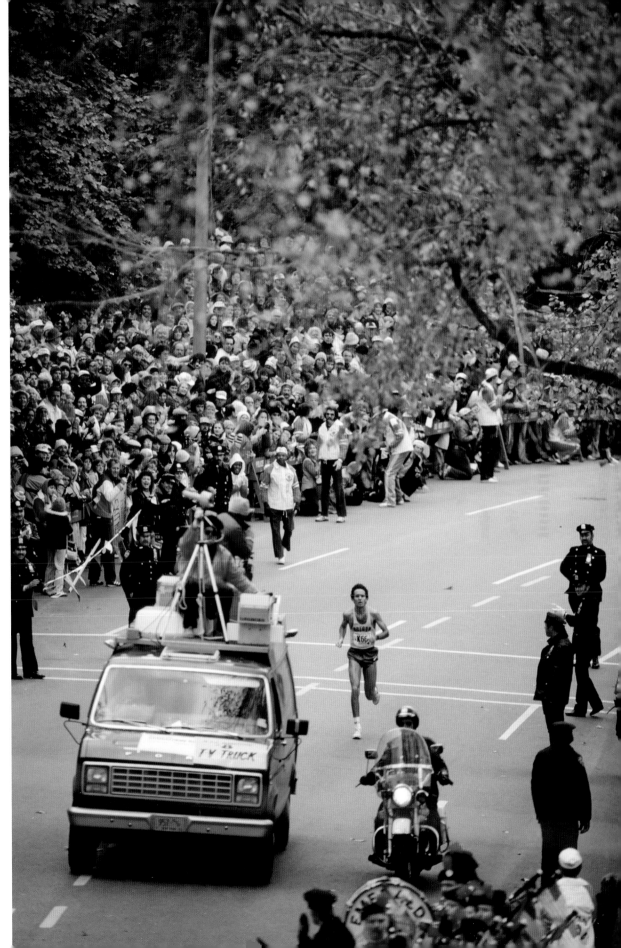

The four-time champ ended up a spent fifth (opposite page), while the rookie (right) won in record time.
Photo by David Madison/Getty Images

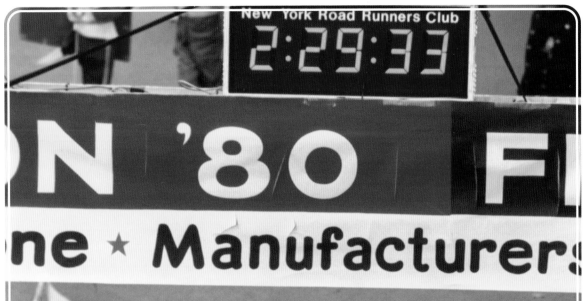

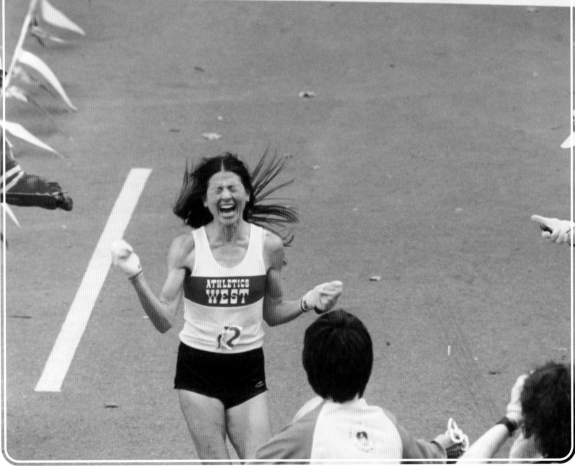

warmth and gentility of the Tavern on the Green and began to reflect. Waitz and Salazar chatted, finding themselves kindred spirits, both saying they would not run again in a marathon for a year, both asserting the importance in long races of training and racing on the track; both equally calm, equally sure. Here they were, the woman who has cut the world women's record by 8:30 in the last two years and brought it to a point 37 minutes faster than it was in 1970, and the man who clearly has the best chance to break the men's record of Australia's Derek Clayton (2:08:34), which has stood since 1969. And they seemed alike, too, in both carefully rationing a deep reservoir of discipline that only they can judge.

Salazar might have spoken for both of them when he said, "I don't want to add to the myth of the marathon. It's just a distance, not a shrine. I didn't think you had to run it a lot to run it well. But everybody told me you did. 'It's different, Alberto,' they would say, 'those last miles.' It wasn't that much different from the pain I've known before. I don't think I proved anything to myself, but I imagine I did to a lot of others."

Though she couldn't catch Grete, Patti Lyons-Catalano delivered a gallant run to grab the American record. *Photo by Tom Madine*

Opposite: NYC Marathon, 1982, Family Reunion.
Photo by Photo Run/NYRR

FAMILY
REUNION

2 WORLD RECORDS SET AS 13,360 FINISH MARATHON

BY NEIL AMDUR

The 12th New York City Marathon became the biggest and best yesterday, from world records by Alberto Salazar and Allison Roe to a record field of 14,496 starters, 13,360 finishers and perhaps as many as 2.5 million spectators.

Fulfilling his prerace prediction, the 23-year-old Salazar won the five-borough race for the second consecutive year. His time of 2 hours 8 minutes 13 seconds shattered Derek Clayton's 12-year-old standard by 21 seconds.

Mrs. Roe, 25, from New Zealand, then lowered the women's record for the 26.2-mile distance to 2:25:28, after Grete Waitz of Norway, the three-time defending champion and previous record holder at 2:25:41, was forced out with painful shin splints at 15 miles. Ingrid Kristiansen of Norway was second among the women in 2:30:08.

With almost perfect race conditions—cloudy, cool, 55 degrees— New Yorkers waved signs, played music, handed out oranges and water, cheered and lined familiar outposts along Fourth Avenue in Brooklyn, First Avenue in Manhattan and Central Park. Some spectators ran onto the course and into the paths of the leading runners at several stages, but Mrs. Roe, competing here for the first time after a victorious performance in the Boston Marathon last spring, said, "The crowds were fantastic, it was an exciting journey."

"I did notice the roads were fairly uneven," said the former secretary from Auckland, who finished 113th overall. "We build them that way," Mayor Koch quipped at the postrace news conference, where he was seated next to Mrs. Roe, who had received treatment for tendinitis in her right ankle only two days before the race . . .

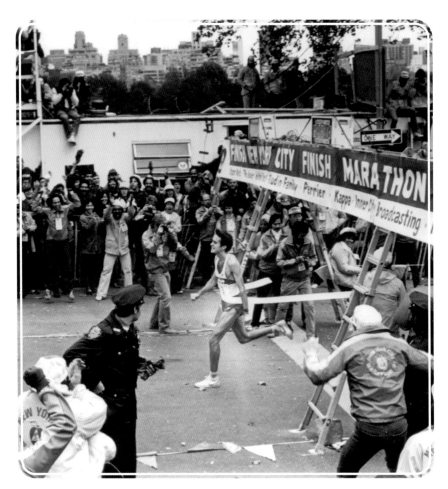

Photo by David Getlen

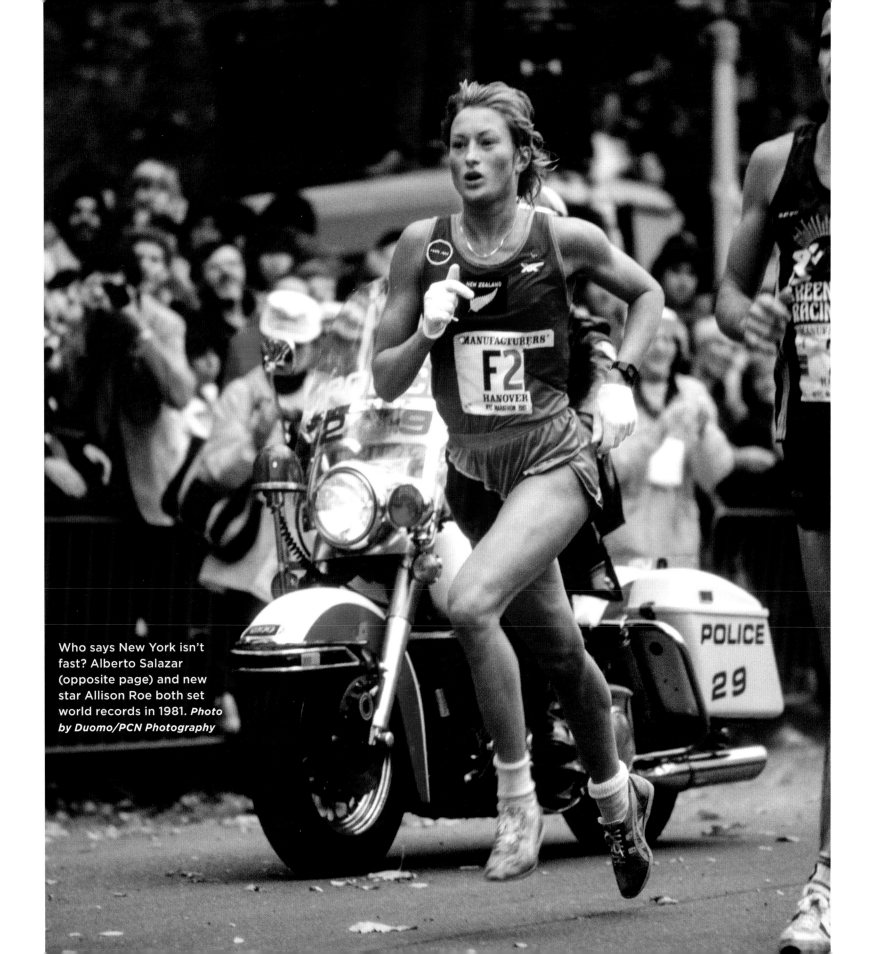

Who says New York isn't fast? Alberto Salazar (opposite page) and new star Allison Roe both set world records in 1981. *Photo by Duomo/PCN Photography*

FROM MAKING IT IN NEW YORK

BY ERIC OLSEN

It became a two-man race with five miles to go, the closest finish ever in the New York City Marathon. They entered Central Park together at 22.9 miles, and the toughest part of the race began. Salazar was determined not to let Gomez stay with him to the last quarter; he had every confidence in the Mexican's ability to outrun him with a straightaway to go. It became necessary to break him well before then.

Salazar began to throw in a series of surges, and each time he did so, Gomez would pull back up and even gain a step or two. But Salazar noticed that it was taking Gomez longer to come back after each surge, and with about 600 yards to go, just as the two made the final turn at Columbus Circle to the finish, Salazar threw in one final move. The two were enveloped in a cloud of dust thrown up by the leading vehicles just as Salazar made his break, and Salazar seemed to maintain

*Photo by Jerry Cooke/*Sports Illustrated *via Getty Images*

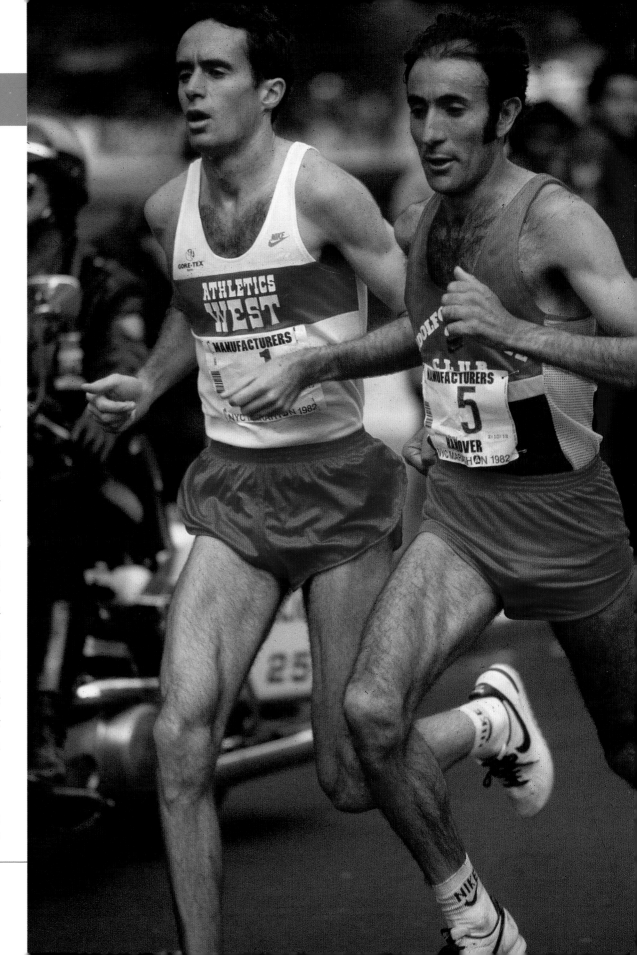

his poise a little better than Gomez. Coming out of the haze, Gomez had dropped back about 10 yards.

The last mile was clocked at 4:35. After 26 miles, it was coming down to a sprint, as though Salazar had set it up to show that if need be, he had speed like the rest of them. Salazar held his lead and finished in 2:09:29, four seconds ahead of Gomez.

In the days before the race, there was much talk about speed, who had it and who didn't, and speed was unquestionably the most important factor in the race, though the winning time was slower than last year's. The speed posesed by Gomez weighed heavily on Salazar's mind. As he sped through the last few yards of the course, he kept looking back over his shoulder. He didn't want to be surprised by Gomez; even with a lead of 10 yards, he was concerned about Gomez's speed, and in a way he was looking back over his shoulder not only at Gomez, but at all the men who'll challenge him in the future, men not only possessed of great endurance, but men of speed.

This time it was close: After slugging it out with Rodolfo Gomez (5, opposite page), Alberto Salazar earned win No. 3 by just four seconds.
*Photo by Lane Stewart/*Sports Illustrated
via Getty Images

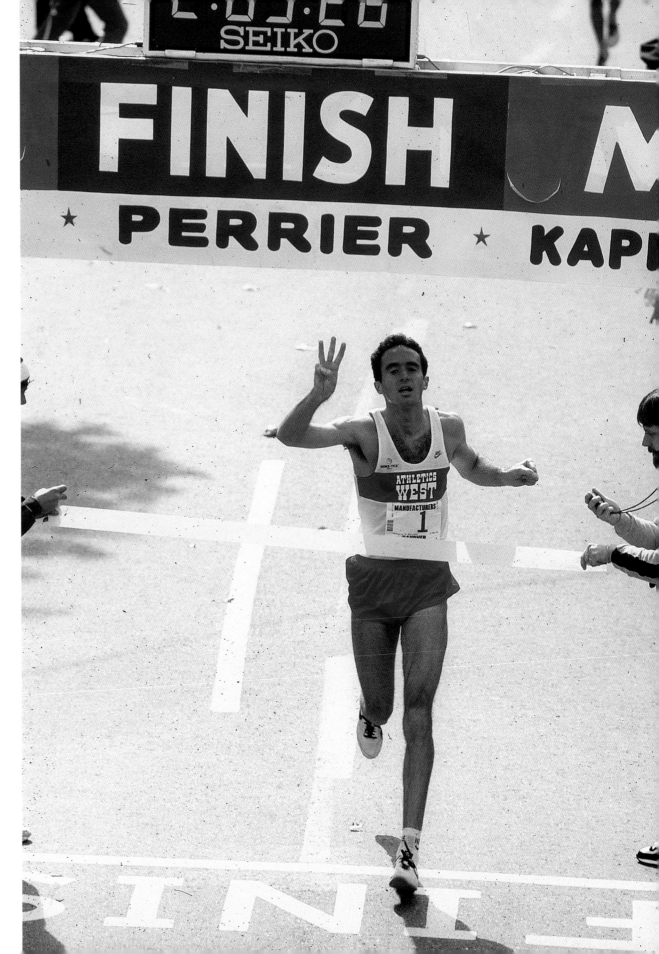

THERE WAS NO NIXING DIXON

BY CRAIG NEFF

After 16 cold, drizzly miles of Sunday's New York City Marathon, Geoff Smith looped down off the Queensboro Bridge onto First Avenue and was greeted with a roar. He had all but shed one of the largest fields in marathon history—more than 15,000 starters—with a devastating 2:06:25 pace that, if he could sustain it, would give him, in his first marathon, a world record by nearly two minutes. And so, as he entered Manhattan, he was consumed by the crowd noise. Despite the rain, people had come out en masse and decorated the area with a dazzling autumn foliage of slickers and umbrellas. "It all felt so good," Smith said later, wistfully. "I just seemed able to float away."

But Smith hadn't shed everyone: Tanzania's Gidamis Shahanga, whom he'd overtaken on the bridge less than a mile before, lurked several yards behind. Shahanga, 26 and a senior at Texas-El Paso, is the NCAA 5,000- and 10,000-meter track champion; on Sunday he'd scorched through Brooklyn and Queens, pulling Smith, 29, along at what seemed a suicidal pace. Now, as Smith floated north toward the Bronx, Shahanga shadowed him.

New Zealand's Rod Dixon came off the bridge third, in desperate pursuit of the pair 120 yards ahead of him. Dixon, the prerace favorite, was already nursing a right hamstring he'd strained on slick pavement at five miles. Here, in an effort to gain on the leaders,

he put on a surge—and almost lost control, stretching the muscle to the brink of tearing. "I hit another slippery patch," he said later. "My right leg shot out from under me." Dixon caught himself and then accelerated some more. He had come to the race off months of hard training in the forest near Reading, Pa., where he currently lives, hoping to shatter Alberto Salazar's two-year-old world best of 2:08:13. He had also brought to New York a streak of 19 consecutive road-race victories at distances ranging from five to 10 miles. That was his obsession: winning. A 1972 Olympic bronze medalist at 1,500 meters, a onetime 3:53 miler, a hardworking and hard-partying and hard-as-nails competitor, the 33-year-old Dixon saw New York as the capstone of his wide-ranging running career. But only if he won.

With Dixon and Shahanga chasing hotly after Smith, and with Grete Waitz of Norway running masterfully toward her fifth New York women's title—she would finish in 2:27:00, nearly five minutes ahead of runner-up Laura Fogli of Italy—the 1983 marathon was at last dispatching some considerable prerace worries: that its field was too weak; that fan and media support might consequently wane; that a new challenger, the rapidly growing America's Marathon/Chicago, which offered $135,000 in legal prize money and was held only one week before, might be taking over as the major race of the fall. "I welcome the so-called competition from Chicago," New York Marathon Director Fred Lebow had said. "Chicago is throwing all kinds of money around to buy top runners, but they cannot buy the vitality of New York. New York is magic."

But because of Olympic training and offers from Chicago, most big-name marathoners had performed a vanishing act on Lebow. Salazar, the three-time defending champion, canceled out because

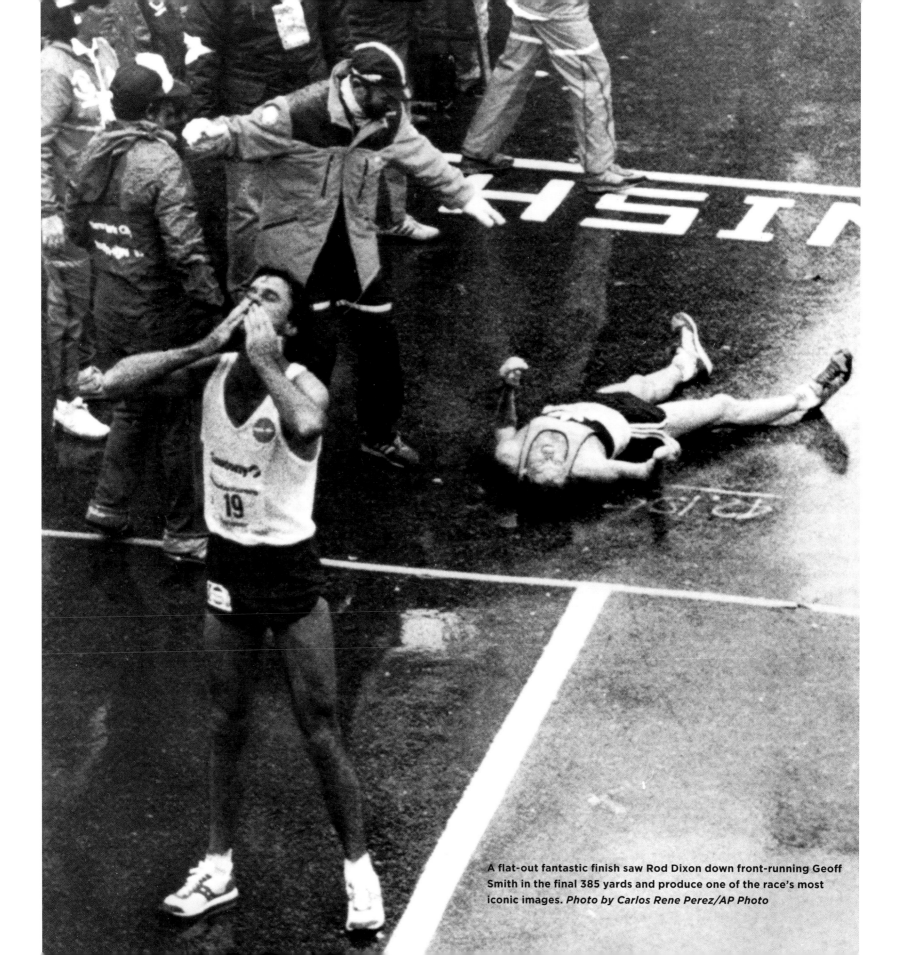

A flat-out fantastic finish saw Rod Dixon down front-running Geoff Smith in the final 385 yards and produce one of the race's most iconic images. *Photo by Carlos Rene Perez/AP Photo*

"CHICAGO IS THROWING ALL KINDS OF MONEY AROUND TO BUY TOP RUNNERS, BUT THEY CANNOT BUY THE VITALITY OF NEW YORK. NEW YORK IS MAGIC."
—FRED LEBOW

the race didn't fit into his training schedule. Four-time New York winner Bill Rodgers chose to run in Chicago, as did 1983 Boston champ Greg Meyer and a score of other good runners. Neither world champion Rob de Castella of Australia nor women's world record holder Joan Benoit had any interest in New York. Says a Lebow acquaintance, "Fred was panicking."

What made Chicago more attractive to some of the runners was not just its purse but also its numerous under-the-table appearance payments; New York is said to hand out $200,000 in sub rosa prize money but very few appearance fees. "We spread our money around," said Chicago Marathon Coordinator Bob Bright, adding, "I think Fred's program is showing a little wear." Bright also said, "They're getting a reputation for going roughshod on athletes there, and it's starting to hurt them."

But the only hurts showing on Sunday were Dixon's right hamstring—he kept reaching down to grab it every few minutes—and both of Smith's hamstrings, which began to spasm in the Bronx, at 20 miles. "They started cramping up so bad I didn't know if I could finish," said Smith, who had put away Shahanga at about the 17-mile mark. Smith, a native of Liverpool, England, is a senior at Providence College and a relative latecomer to running. If nothing else, he's gritty—and now he had to be.

Dixon was closing fast, moving into second place at 18 miles and shaving Smith's lead steadily as the two crossed back into Manhattan. Smith's pace was slowing. At 20 miles he led by 500 yards; by 23 miles, the gap had been narrowed to 75. Through Central Park and around its border Dixon stalked his prey—"Better the hunter than the hunted," he would say—until with half a mile to go he was only 30 yards from the lead. Dixon had cannily run tangents on the turns along the windy park road, thereby saving yardage. Smith hadn't. "My mind wasn't there," Smith would say later.

At precisely 26 miles, Dixon caught his rival and surged past. "He didn't respond, and that gave me a charge," said Dixon. Smith was wobbling, his legs causing him what he later called "complete agony." He would stumble across the line in 2:09:08 and collapse.

Dixon hit the finish at 2:08:59, a two-minute, 22-second improvement over his only previous marathon, in Auckland in 1982. Exuberant, he fell to his knees, blew a two-handed kiss to the Lord, bowed his head onto the New York pavement, stood up and then jumped as high as he could—arms thrust upward in triumph. He planted another kiss on Waitz when she crossed the line.

Smith, having run the fastest first marathon ever, 33 seconds better than Salazar's 1980 New York performance, sat motionless in the pressroom, his hamstrings so sore he could not touch them. "This was the hardest thing I'll ever do in my life," he said softly.

Dixon explained what the race had taught him about marathoning. "That it's bloody hard," he said with a laugh, leaving one lesson unspoken: A marathon can also be bloody satisfying.

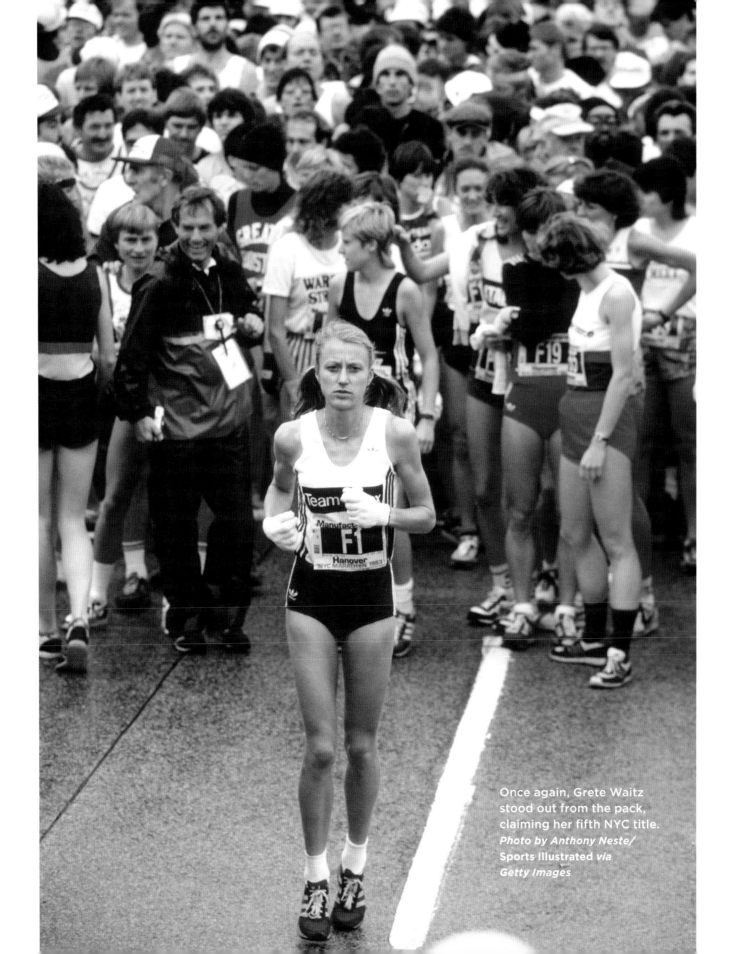

Once again, Grete Waitz stood out from the pack, claiming her fifth NYC title.
Photo by Anthony Neste/
Sports Illustrated via
Getty Images

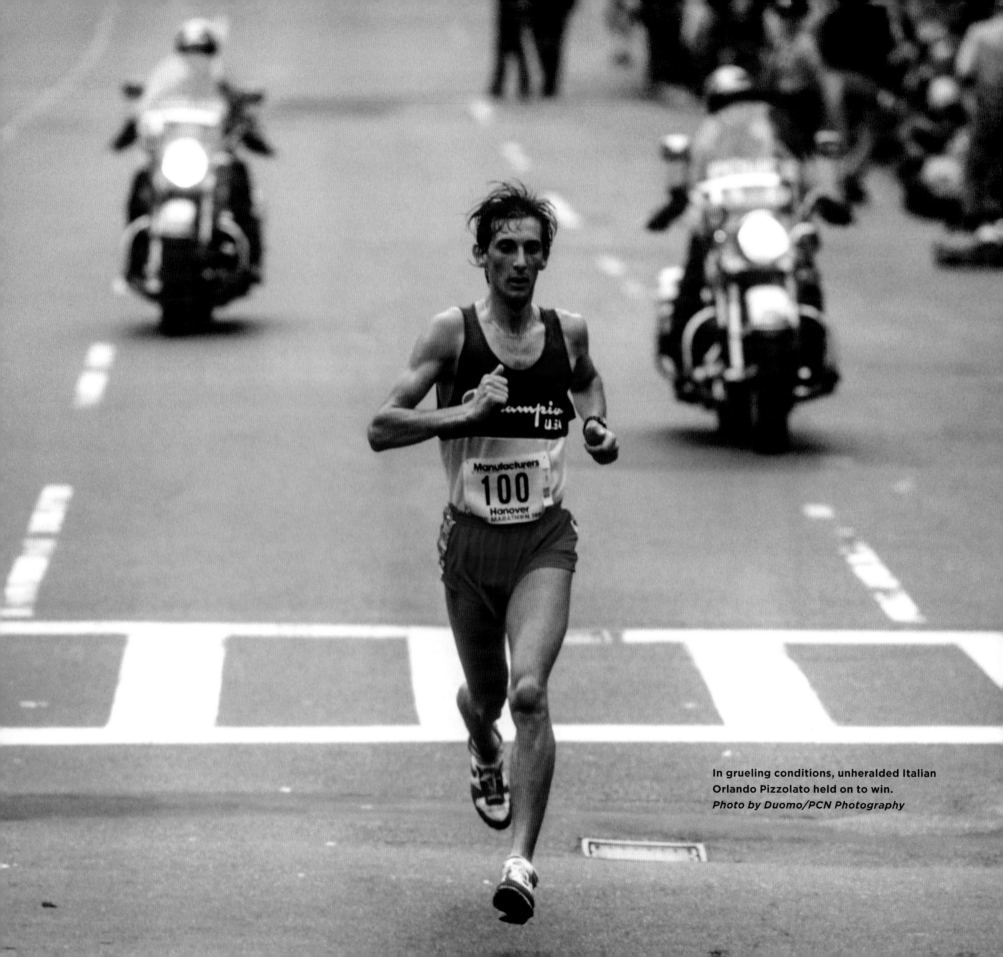

In grueling conditions, unheralded Italian
Orlando Pizzolato held on to win.
Photo by Duomo/PCN Photography

PIZZOLATO WINS NYC MARATHON

BY CHRISTINE BRENNAN

The hottest and most unrelenting of New York City's 15 marathons brought 26-year-old Orlando Pizzolato, a student from Milan, to a complete stop eight times within five miles of the finish line this afternoon.

He would turn around to see who was following him along the dotted blue line that led to Central Park. When he saw no one, he did the only thing he could do as 74-degree temperatures and 96-percent humidity tried to return him to the other runners. He turned back and kept on going.

The ninth time he stopped, he was finished. That was when he hit his knees to kiss the pavement after he completed his 26.2-mile ordeal in two hours, 14 minutes, 53 seconds—43 seconds and about 200 yards ahead of his only challenger, Briton David Murphy, now of Louisville (2:15:36).

"I don't believe I won the New York City Marathon," Pizzolato said later. "The time was not very good, but the people's applause gave me a lot of strength to go on."

Someone asked what his most important victory was before this one.

"There wasn't," he said.

Defending women's champion Grete Waitz of Norway won the women's championship for the sixth time in 2:29:30, the 57th best time overall. But she drank too much water, became ill and later called it her "worst" marathon.

There also was a fatality for the first time in the history of the race. Jacques Bussereau, 48, of Périgueux, France, who was part of a group of about 500 French runners who annually run the marathon, collapsed 15 miles into the race (just before the Queensboro Bridge) and was rushed to Elmhurst Hospital, where he died at 2:10 p.m.

He was in cardiac arrest when he was picked up by an Emergency Medical Services unit, an EMS spokeswoman said. He died in the emergency room. Bussereau, who had run four marathons, suffered a heart attack four years ago.

By 10 p.m., 1,180 runners were reported receiving treatment; 81 required hospitalization. Last year, only nine runners were taken to hospitals.

Pizzolato, who has run, but never won, 11 other marathons, was a huge surprise in this race. His competitors said they didn't know who he was when he breezed past them between the 12th and 13th miles in the working class Greenpoint neighborhood of Brooklyn to take a lead he never relinquished. Murphy and the others, including favorite and defending champion Rod Dixon, who withdrew with leg cramps after 21 miles, figured he would finally come back to them.

> **"THE PEOPLE'S APPLAUSE GAVE ME A LOT OF STRENGTH TO GO ON."**
> **—ORLANDO PIZZOLATO**

Pizzolato's lead, once 70 seconds with eight miles remaining, withered to 10 seconds with two miles to go. Murphy, who forced himself to look at the ground, not at Pizzolato's back, imagined himself alongside Pizzolato's shoulder.

"This will be a great finish," he said he told himself. "This is going to be a real dramatic finish again."

Last year, Dixon passed leader Geoff Smith in the last mile to win by nine seconds. In that race, Pizzolato was 27th in 2:15:28. He had hoped to finish 20th this time.

But this fall, it stayed hot in Milan, where Pizzolato lives with his parents. He was in good shape. And, for a change, most of the world's best marathon runners decided to skip New York, either to rest after the Olympics or to run in Chicago last weekend.

Pizzolato did not make the Italian Olympic team and is not considered even one of the top five marathon runners in the country. "He is too nervous before races," said Laura Fogli of Italy, the third-place finisher among the women. "When he has lost before, many times, it was because he was nervous."

If Pizzolato is known for anything in Italy, it is for running road races. Basically, though, he is not known for anything in Italy.

Now that he has the $25,000 first-place check and a new Mercedes-Benz worth $22,000, that may change.

Pizzolato was back in the pack for the first 10 miles, trailing the early leaders, who included fourth-place finisher Pat Petersen of Ronkonkoma, N.Y.

"I began to run fast at 10 miles, but I didn't think I had a chance to win until 15–20 miles," Pizzolato said. He passed Jose Gomez, another early leader, and Petersen as they neared the 13th mile, and then headed into Queens, where the Mondale-Ferraro posters got especially thick and the hazy Manhattan skyline came into view.

But just past the 21-mile mark, nearly 40 seconds ahead of Murphy, Pizzolato stopped running. He looked behind him, hung his head, and poured water over himself.

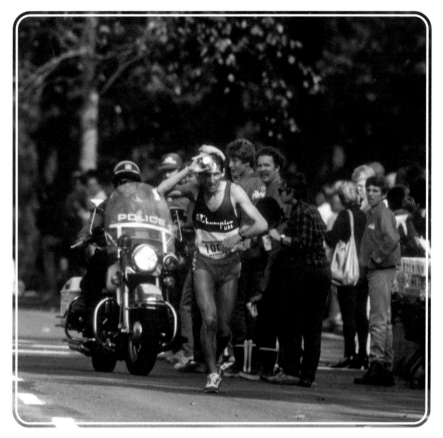

For Pizzolato, and for the entire field, it was a race to survive.
Photo by Duomo/PCN Photography

"It was a psychological problem," he said with the help of an interpreter. "I was lucky nobody was coming from behind. It means that the people behind were not doing better than me."

Murphy, who moved into second place after 19 miles, was determined not to follow Pizzolato's pace. He finished 44th in the London Marathon earlier this year because he burned out staying with the leaders. "I was hoping to have enough left in the last six miles to catch him," Murphy said. "He was hurting at the end. We were all hurting. But I didn't catch him."

If ever there were a deceiving finish, this was it. Murphy looked much fresher than Pizzolato, and ran much faster (16 seconds faster in the 22nd mile alone) until the final mile and a half.

"If you look back and that guy sees you look back, you're in trouble," Murphy said. "He was in trouble. If I could have gotten up to his shoulder, it would have been very competitive."

As it was, their legacy is that they finished first and second in the slowest New York City Marathon in the nine years it has been run on the five-borough course.

Third place went to Herbert Steffny of Freiburg, West Germany, in 2:16:22. "I've got to show you something I put on," he told a news conference, standing up to model shorts made out of an American flag. "I got one million people to cry 'U-S-A' to me. Sorry, it was a trick."

In the women's race, Waitz led from the beginning, easily defeating Véronique Marot of England (2:33:58) and Fogli (2:37:25).

But, she said, "I was seriously thinking about dropping out around 10 miles. I had diarrhea. I drink a lot not to be dehydrated . . . I've had it other times, always when it's warm and I drink a lot of water."

Meanwhile, Gabriele Andersen-Schiess became the folk heroine of the race. In the Olympics, she staggered to a dramatic 37th-place finish in the women's marathon with a time of 2:48:42.

Today, she finished with no trouble in 11th place in 2:42:24, as specatators recognized her and shouted out her name.

"It was a hard race," she said, "because in the back of my mind was lingering my experience at the Olympics. After hearing the forecast, I was a little disappointed that I would have to fight similar conditions to those at Los Angeles.

"So I went out very, very carefully, and in those last few miles, I told myself to keep remembering the Olympics. I'm pleased I finished in a lot better state than I did at the Olympics."

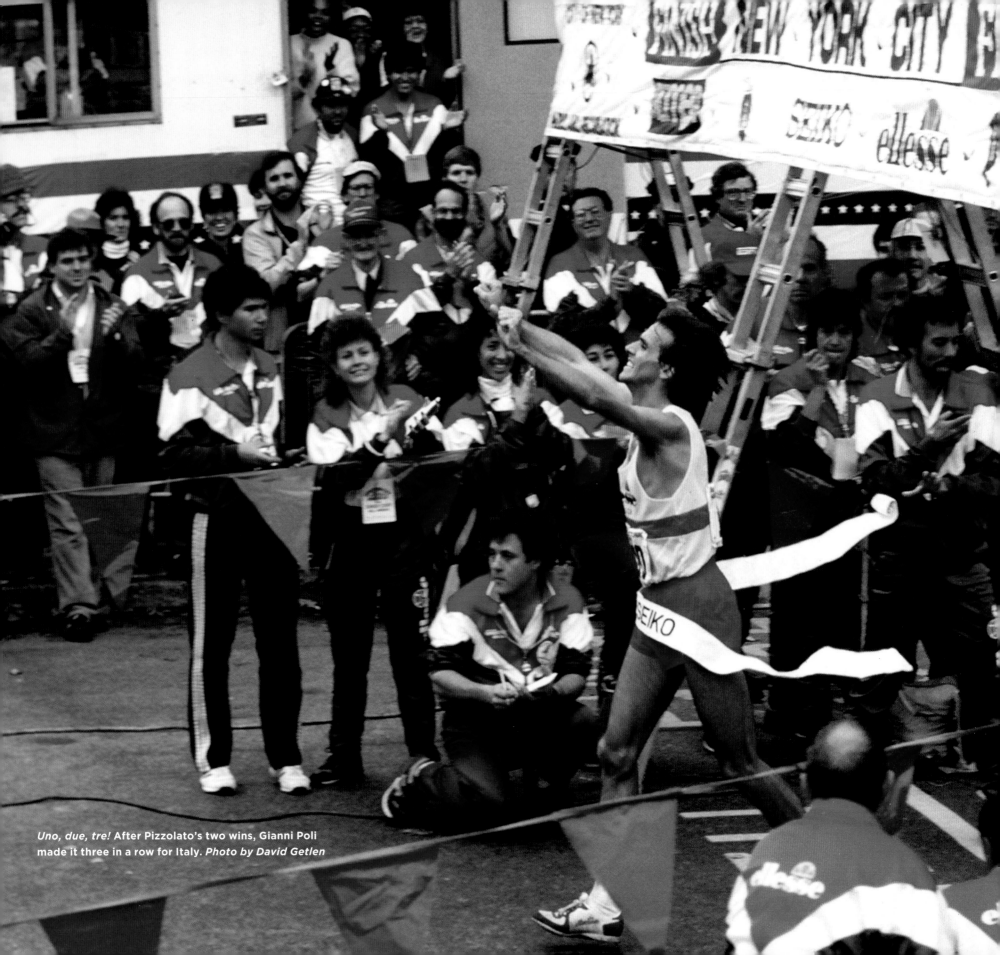

Uno, due, tre! After Pizzolato's two wins, Gianni Poli made it three in a row for Italy. *Photo by David Getlen*

CHEERS FROM ACROSS THE ATLANTIC

BY PETER ALFANO

Last year, he was a spectator at the finish line, watching his countryman Orlando Pizzolato raise his arms in triumph after winning the New York City Marathon a second time. A week earlier, Gianni Poli had set an Italian best, completing the Chicago Marathon in two hours nine minutes 57 seconds. He finished fourth, however, and the celebration was a private affair.

Still, Poli was feeling exhilarated until he returned to Italy, where his national record was overshadowed in the fuss being made over Pizzolato, his friend but also his rival. It was then, he decided, that if an Italian runner had to succeed in New York City to win the hearts of his countrymen, he would return here to take his place at the starting line on the Verrazano-Narrows Bridge.

"I went home and the magazines were not writing about my time, but only that Pizzolato was the winner in New York," Poli said yesterday. "I knew if I ran in New York, I have a possibility to win. And to win New York is very important in Italy."

Poli will be leaving for Italy either today or tomorrow, he said, and this time, no one will overlook him. In Lumezzane, the small northern Italian industrial town where he lives and is a partner in a ceramics store featuring kitchen and bathroom supplies, the party has already begun. "The store is closed today," Poli said. "The community is celebrating." The cheering in Lumezzane could be heard in New York City on Sunday afternoon when Poli telephoned his mother. His four brothers and sister, friends and neighbors were at his home. "Every time I run, they meet there," he said. "I could hear everyone was happy. There was much noise." He attended yesterday's post-marathon news conference dressed like a young businessman instead of a world-class marathon man. He wore a gray tweed sport jacket and gray slacks. In front of an audience, he is more comfortable speaking through a translator. Alone, however, Poli speaks English well enough to carry on a conversation.

He may have been a newcomer to the spectators watching on the sidewalks of New York, but this was Poli's 17th marathon. He ran his first in 1979, which is when he and Pizzolato began their rivalry. They have competed in nine marathons and Poli said he has finished ahead of Pizzolato in five. This was only his second marathon victory, though.

He credits Pizzolato for starting the latest running boom in Italy. "When Orlando won in New York in 1984, it's difficult to explain, but I didn't believe it," Poli said. "He is a good athlete but I did not think it was possible."

Pizzolato's winning times in New York City were 2:14:53 and 2:11:34, slow in comparison to Carlos Lopes's world best, 2:07:12, but competitive given two unseasonably warm, humid days and the difficult course. Poli liked traveling in the fast lane, so he bypassed New York City last year, to run Chicago's mostly flat course.

When he entered the New York City Marathon this year, he believed he had a chance to win. But then injuries slowed his training and he ran poorly at the European championships in late August. When he learned that Rob de Castella, the third-fastest marathoner

ever, was going to run here, Poli lowered his sights, willing to settle for finishing ahead of the other Italians.

So he was just as surprised as anyone when he and de Castella made the marathon a two-man race as they ran up First Avenue. At about the 20-mile mark, Poli noticed that de Castella was laboring and he put on a burst of speed to pull away. But despite the placid look and graceful, even strides, Poli said he too was beginning to weaken. The rabbit who likes to run fast became cautious.

"I did not want to risk losing for a good time," he said. "My legs were weak at the finish line. I am not in good condition—only about 80 percent—or I could have gone much faster. It was more important to win the race." His time was 2:11:06, respectable on a day when conditions alternated from mild and humid to windy and cool along the route. His victory, as well as the overall showing of the Italians—four finished among the top 10; Pizzolato was fourth—once again raised questions whether they are blood-doping, the practice of removing and re-injecting one's own blood to raise the hemoglobin level, thus enhancing performances. Hemoglobin carries oxygen to the heart.

Poli was annoyed by the charges, which he denied. "We work and train hard, that is why we have good results," he said. "I don't understand why we are asked this question. We do not use these methods."

None of the Italians has dramatically improved his time as yet or approached the world best.

The talk also did not spoil Poli's victory party on Sunday night. The Italian runners and officials went to a midtown Italian restaurant for a dinner that would have made running difficult yesterday. And Poli also met someone who also knows a thing or two about running.

"Senator Ted Kennedy was at the restaurant," Poli said. "We posed for a photo. It was very nice."

Courtesy of *La Gazzetta*

"I KNEW IF I RAN IN NEW YORK, I HAVE A POSSIBILITY TO WIN. AND TO WIN NEW YORK IS VERY IMPORTANT IN ITALY."

—GIANNI POLI

Photo by Gayle Jann

THE STARS WERE SIMPLY DAZZLING

BY FRANZ LIDZ

In the last few New York City Marathons, elite runners have headed for the finish like characters assembling for the finale in *42nd Street*. We all knew the plot, and the principals looked vaguely familiar, though we couldn't quite recall their names.

But Sunday's production in the Big Apple featured bankable stars, a cast of 23,463 and a rival producer who doubled in the role of

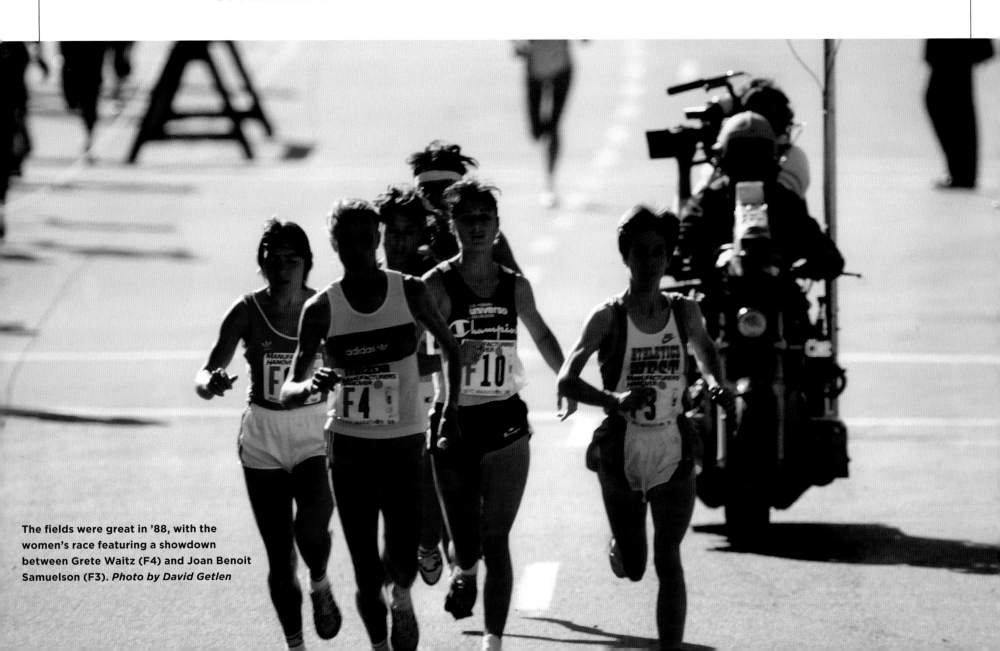

The fields were great in '88, with the women's race featuring a showdown between Grete Waitz (F4) and Joan Benoit Samuelson (F3). *Photo by David Getlen*

out-of-town critic. The stars with the most marquee value, Steve Jones, a Welshman who three years ago ran the best time ever on U.S. soil, and Joan Benoit Samuelson, the American who won the 1984 Olympic gold medal, had never run New York before. Jones was triumphant in his debut, winning the men's title in a virtuoso 2:08:20, just seven seconds shy of Alberto Salazar's '81 course record. But Samuelson was upstaged by Norway's remarkable Grete Waitz, who won her ninth New York marathon—a record number of victories by a runner in the same marathon—and hinted it may have been her final curtain call in New York.

"No one doubted this was the strongest field in our 19-year history" said New York marathon director Fred Lebow. That was because New York reportedly had lured the top runners with whopping guarantees.

Most of the appearance money came from sponsor John Hancock Financial Services, which also revived the Boston Marathon in 1986 with an infusion of cash. Hancock had contracts with Jones, Samuelson and Mark Nenow, the U.S. record holder at 10,000 meters, whose eighth-place finish on Sunday was the best by an American man.

Estimates of Hancock's prerace payout went as high as $500,000, the figure bandied about by Bob Bright, promoter of the Chicago Marathon, which had been run the previous week. The disgruntled Bright claims Hancock is out to bludgeon the Windy City's race, which offers more prize money and a faster course but lower appearance fees than the New York marathon does. "Hancock has paid out all that appearance money solely to keep those runners out of Chicago," Bright insisted on Saturday. "It uses Mafia-style tactics. It makes runners offers they can't refuse."

Bright said he offered Samuelson an $80,000 appearance fee, with incentives that could have earned her up to $350,000. But he says Hancock doubled the guarantee for her to run in New York.

Hancock's sports marketing consultant, Jack Mahoney, called Bright's figures "outlandish." And Lebow predictably downplayed the bidding war. "It's a healthy competition," he says. "Gimbels was good for Macy's."

But Gimbels went out of business.

"So did the Chicago Marathon," said Lebow.

That race folded in 1986 after its main sponsor, Beatrice, dropped out. It was back in business two weeks ago with a new benefactor, Heileman's Old Style Beer, and a less stellar field. Alejandro Cruz of Mexico won the men's title in a startling 2:08:57 and Lisa Weidenbach of the U.S. won the women's in 2:29:17.

Jones, 33, got his first marathon victory, in Chicago in 1984, in a then world-best 2:08:05. His reputation is that of an impetuous, impatient frontrunner, notorious for his

The men's field was bunched from the start.
Photo by David Getlen

suicidal pace. His second win in Chicago, in 1985, is regarded as one of the guttiest runs ever. It was also one of the most reckless. Whizzing by his paid early-race pacesetter after the first mile, Jones passed the halfway point in 1:01:42, well ahead of the record pace. He missed setting another world standard by one second.

Then his career hit the wall. He seemed to run out of luck—or common sense. He was on record pace again in the first half of the 1986 European Championships marathon in Stuttgart, West Germany, only to sputter home 20th in 2:22:12. When he didn't qualify for this year's British Olympic team, Jones decided to make some drastic changes. He quit the Royal Air Force, in which he had served for 14 years as a mechanic, training on his lunch breaks.

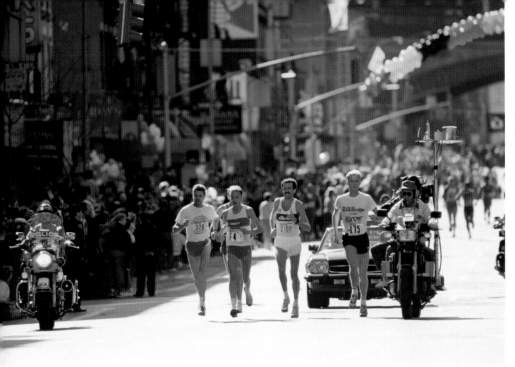

By First Avenue, Grete was first.
Photo by David Madison/Getty Images

He went to New York after several weeks of altitude training in Boulder, Colo. "I consciously planned to run a cautious first half," he said. "I figured I'd test my strength in the second half. It's a measure of my restraint. I suppose."

The plan worked. At 14 miles he broke clear of a lead pack that included Gidamis Shahanga of Tanzania, who has a marathon best of 2:09:39, and Wodajo Bulti of Ethiopia, whose 2:08:44 in Rotterdam last spring was a record for a first marathon. "The two Africans surged ahead, then eased back, and I just kept going," Jones said afterward.

"He was just gone then," said John Treacy of Ireland, who would finish third in 2:13:18. Jones's closest pursuer, Salvatore Bettiol of Italy, seemed to be a borough behind. In fact, Jones finished 3:21 ahead of Bettiol.

But if the men's competition lacked drama, that was O.K., because the real showdown was supposed to come between Samuelson and Waitz. The two women had competed in the same marathon only once before—at the Los Angeles Olympics, when Samuelson got the gold and Waitz the silver.

Samuelson, 31, hadn't lost a marathon in seven years. But then she hadn't raced in one since 1985, having undergone foot surgery in late '85, given birth to a daughter, Abigail, in '87 and had back and hip ailments in '88.

Waitz, 35, also had been hurting. She suffered a stress fracture in her right foot last summer, which caused her to miss last year's New York race. In June she qualified for the Norwegian Olympic team by winning the Stockholm Marathon on an ailing right knee. Just six weeks before the marathon in Seoul, she had arthroscopic surgery to repair the injury. She phoned an old friend for some advice.

"Hello, Joan, this is Grete calling from Oslo."

"Hey, how are you doing?"

"Pretty well. I had surgery on my knee two days ago."

"No kidding!"

Samuelson had won the 1984 U.S. Olympic trials less than three weeks after a similar operation. Waitz followed Samuelson's training routine, but unfortunately didn't obtain the same results. She failed to finish the Olympic marathon, which was won by Rosa Mota of Portugal.

But Waitz came to New York ready to go. For the first 13 miles, she ran with Samuelson and Laura Fogli of Italy. Then, as the three crossed the Pulaski Bridge into Queens, Waitz gradually pulled away. A mile later Samuelson made a pit stop between two parked cars to relieve stomach distress.

When Samuelson returned to the course, she had lost some 30 seconds to Waitz and Fogli, the eventual second-place finisher. Samuelson seemed within striking distance of Fogli at Mile 21 when she collided with a

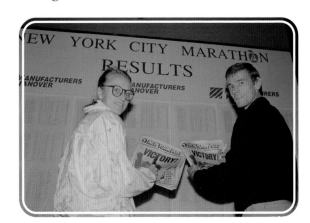

Photo by Richard Drew/AP Photo

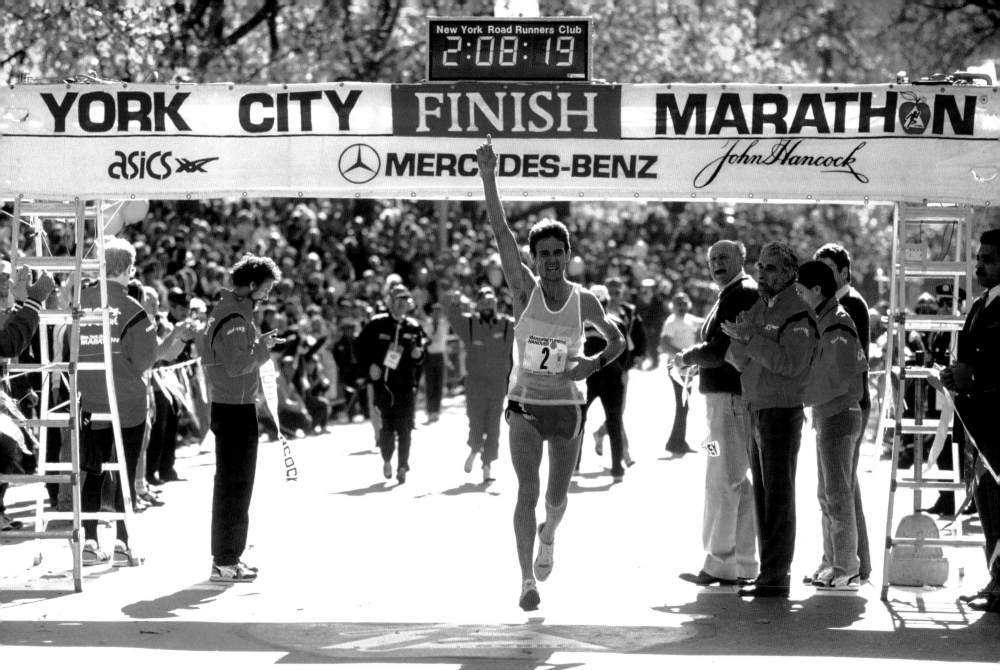

New York Road Runners Club
2:08:19

YORK CITY FINISH MARATHON

ASICS ✖ Ⓜ MERCEDES-BENZ John Hancock

After his record-setting victory, Steve Jones joined Waitz (opposite) to savor the headlines. *Photo by Duomo/PCN Photography*

child trying to give water to another runner and crashed to the pavement. "I was stunned more than anything," she said after finishing third. "I never would have caught Grete anyway."

Waitz cruised for the final 10 miles, covering the course in 2:28:07 for her 13th win in 18 marathons. She hedged, though, when asked about plans to return for a 10th crown. "I don't know if I will," she said. "Last year

Fred [Lebow] told me if I won 10, he was going to retire. I don't want to make him quit."

"Make me, Grete," pleaded Lebow, who was standing nearby. "Make me."

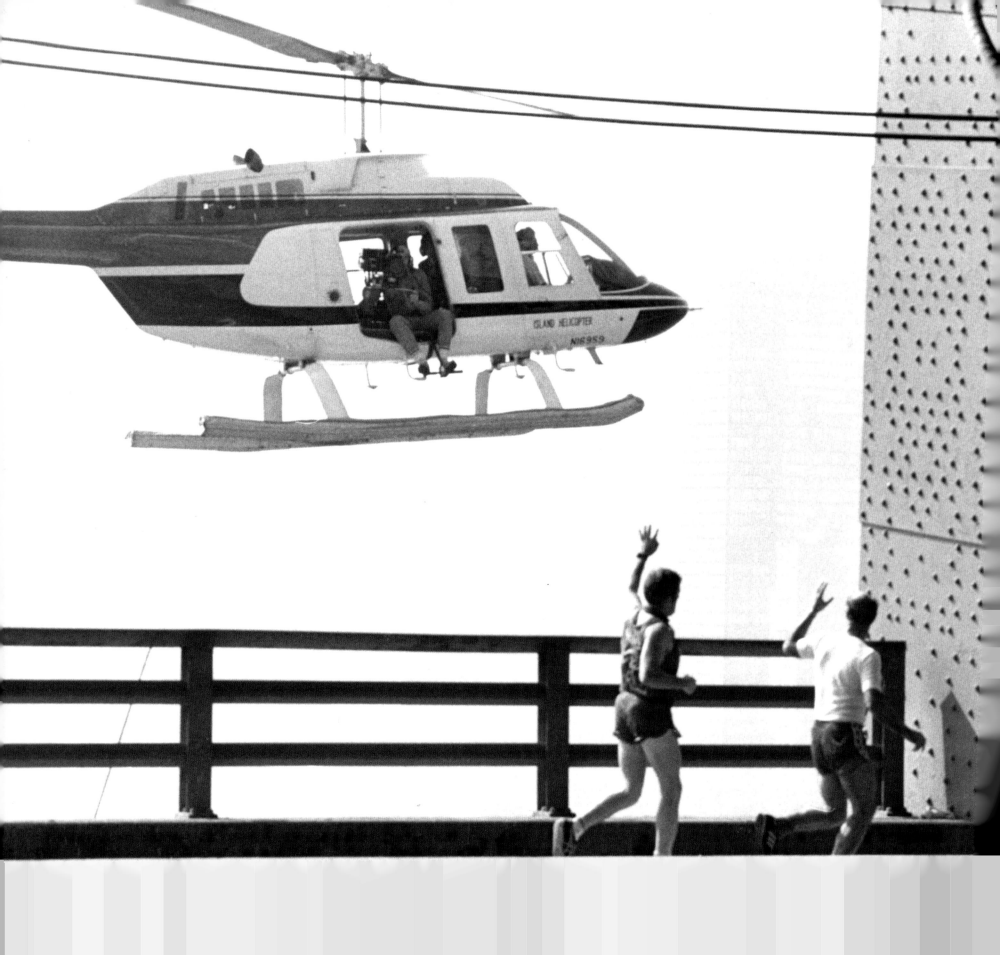

THROUGH THE YEARS:

MEDIA

In most cases, covering a sporting event is a fairly straightforward process. Sportswriters settle into the press box, photographers stake out their spots on the sidelines, the TV cameras are positioned for all the best angles. The action unfolds on a well-marked field or court. Two teams, or maybe just two athletes, face off in structured, carefully officiated action. Tidy. Controlled. Simple.

Covering a 26-mile footrace for tens of thousands of people through the rutted streets and concrete canyons of one of the world's biggest and busiest cities is anything but.

Since the days when a handful of reporters and photographers waited bemusedly at the finish line, coverage of the marathon has grown exponentially in size and scope and technological achievement. The myriad logistical challenges presented by the race—everything from the distance and terrain to weather and crowds and the unpredictability of the competition itself—have led over the years to a number of innovations in coverage, including helicopter-mounted cameras, digital tracking of the competitors, TV commentators riding alongside the runners in motorcycle sidecars, and live-streaming on social media. (Some experiments, like Rod Dixon's Jetsons-like "helmet-cam" in 1985, didn't prove quite so successful.) Likewise, the exploding popularity of the New York City Marathon has seen coverage expand around the world. Today, more than 400 accredited journalists from some 20 countries take up their spots in the high-tech New York Road Runners Media Center at the TCS New York City Marathon Pavilion for four days filled with press conferences and media events leading up to the race.

And, of course—and also unlike their counterparts covering so many other sports—the media members on hand for New York aren't just focusing on the event's winners and the other headliners. They're also looking for the thousands of stirring, inspiring, and unforgettable stories and images to be found among all the other runners in the race.

Photo by Kathryn Dudek

GEORGE HIRSCH JOURNALISM AWARD

Inaugurated in 2010, the George Hirsch Journalism Award (named in honor of NYRR Chairman George Hirsch, former publisher of *Runner's World* magazine) recognizes excellence in the reporting, writing, and broadcasting of the sport of marathon running and long-distance running.

YEAR	WINNER
2010	Dick Patrick
2011	Amby Burfoot
2012	Kenny Moore
2013	Frank Litsky
2014	Neil Amdur
2015	Marc Bloom
2016	Jere Longman
2017	Tim Layden
2018	Don Kardong
2019	Lindsay Crouse ▽

Photo by Jon Simon/NYRR

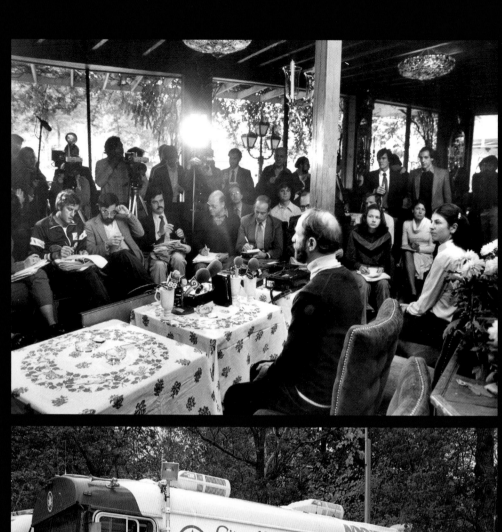

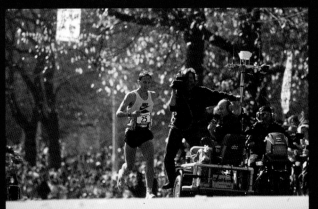
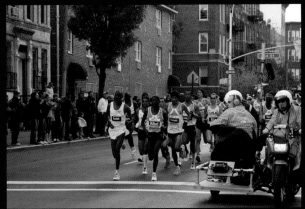
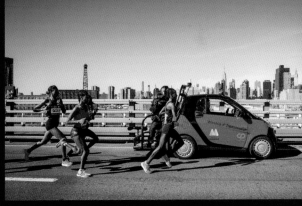
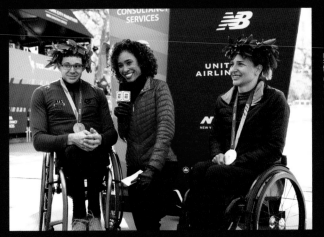

THROUGH THE YEARS:
ACHILLES

In 1965, at age 24, Dick Traum was crushed between two cars and had to have his right leg amputated. From that tragedy was born one of the most inspiring stories in the history of marathoning. A wrestler in college, Traum was determined to stay involved in athletics. In 1976, at New York City, he became the first runner to complete a marathon with a prosthetic leg. Seeking to share that empowering experience with other people with disabilities, in 1983 Traum founded the Achilles Track Club in New York City.

In the years since, the club, now called Achilles International, has expanded to more than 150 chapters across the US and around the world, each of which provides support, training, and technical expertise to runners at all levels, with all kinds of disabilities, including amputation, visual impairment, paraplegia, arthritis, multiple sclerosis, and many others. Achilles International's volunteer guides help athletes to participate in workouts and races using prostheses, crutches, wheelchairs, and handcycles. The organization has also created dedicated programs for wounded military personnel and veterans and for children with disabilities and has even expanded to the triathlon.

But Achilles International remains forever linked to the New York City Marathon and each year brings the largest contingent of athletes with disabilities to the starting line on Staten Island.

For Traum, who was inducted into the New York Road Runners Hall of Fame in 2016 and who last year published the bestselling book *The Courage to Go Forward: The Power of Micro Communities* with David Cordani, the inspiring run continues.

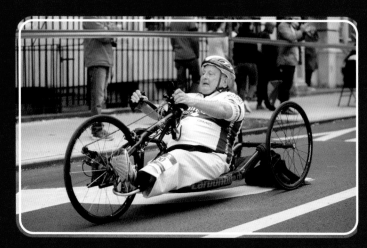

Photo by Da Ping Luo/NYRR

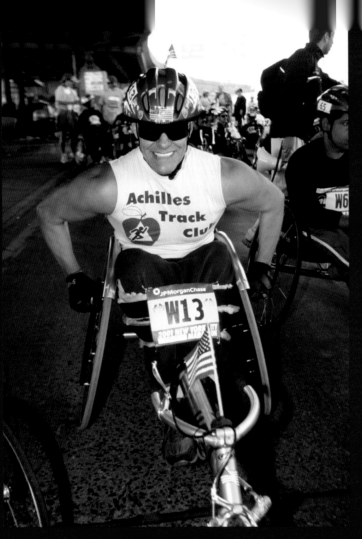
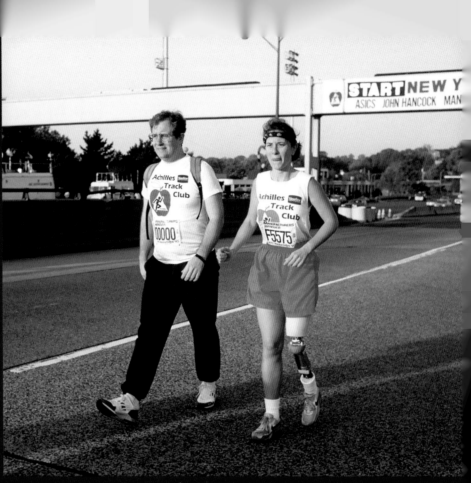
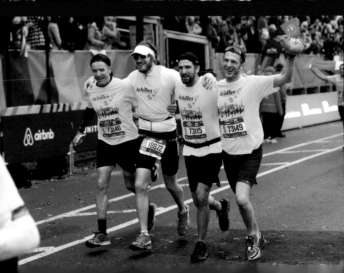
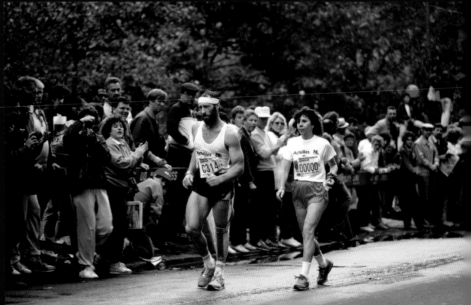

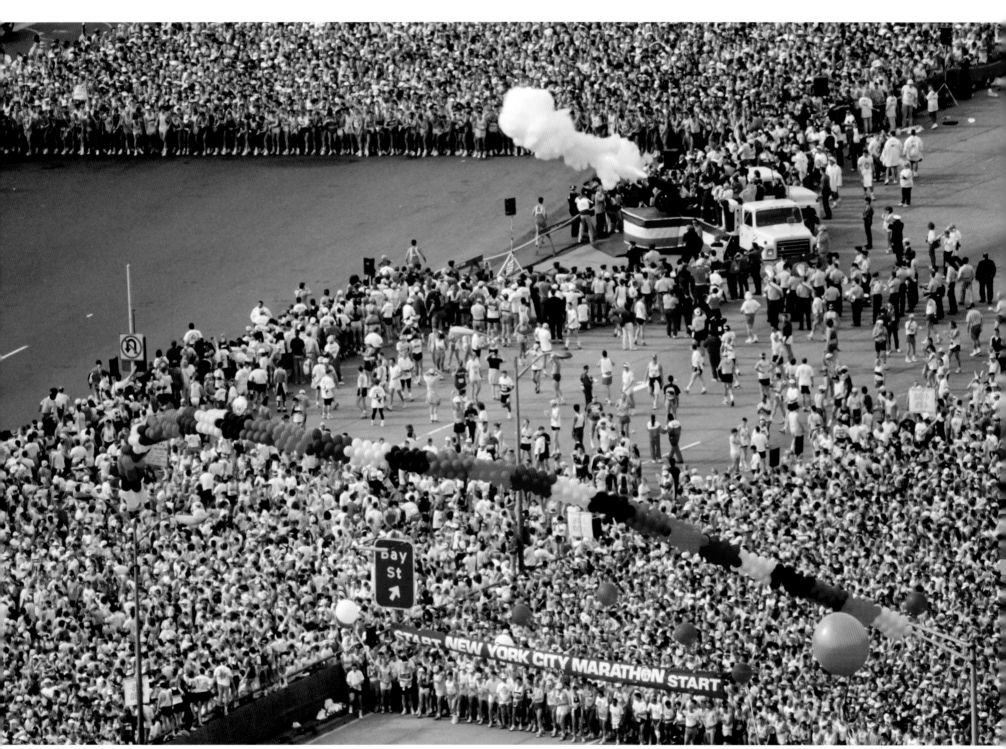

Boom time: In 1990, the Marathon surpassed 25,000 starters for the first time. It would only keep growing. *Photo by David Madison/Getty Images*

1990s

Fred Lebow ran the five-borough New York City Marathon—*his* marathon, it must be said—just once. But what a run it was. On a chilly morning on the first day of November 1992, Lebow, 60 years old and in remission from brain cancer, joined his old friend Grete Waitz and 28,654 other soulmates (a record field yet again) and set out on a tour of the city he loved.

Fred's journey that day remains one of the emotional highpoints of the race's first half century. It was also emblematic of the stature that the event had obtained by that point, striding toward a new millennium. Lebow finished in five hours, 32 minutes and 34 seconds, tears in his bright-blue prophet's eyes. He and Grete had been cheered every step of the way by throngs of New Yorkers who recognized and clearly appreciated just how much this thing he had done so much to give them—this great annual celebration of city and spirit—meant.

And not just to New York. Finishing three hours, 23 minutes and five seconds ahead of Fred and Grete that day, Willie Mtolo of South Africa won the men's race. His victory, which had been made possible by the recent lifting of athletic sanctions against South Africa, resonated around the world.

Indeed, the international flavor of the race begun in the previous decade continued apace in the 1990s. In addition to Mtolo's historic win, Kenyan men collected four victories. Mexican men gathered another four (two by German Silva, whose final-mile detour in '94 is a highlight reel staple), and dark horse (or lion?) Giacomo Lione added to the Italian tradition in '96. On the women's side, redoubtable pioneer Tegla Laroupe of Kenya became the first female African winner of a major marathon with her victory in 1994 and then defended her crown the following year. The other eight winners came from eight different nations—and three continents.

After his emotionally charged race in 1992, Fred Lebow passed away just weeks before the 1994 marathon, the event's 25th running, which featured (yes, a record) 31,129 starters. One can only hope that the Romanian-born garment salesman turned running impresario, who famously and meticulously logged every mile he ran, realized just how far he—and his sport—had come.

And Fred had left both in good hands. His longtime second-in-command, Allan Steinfeld, took over as New York Road Runners head and marathon race director, bringing unmatched technical expertise that helped to keep the New York City Marathon at the head of the pack.

A MARRIAGE MADE IN A HEAVEN CALLED THE NEW YORK CITY MARATHON

BY GEORGE VECSEY

Fred and Grete. In the movie, they would have been played by Tracy and Hepburn, he of craggy cussedness, she of willowy strength.

Even Hollywood would have known not to monkey with the main characters, not to turn this into a romance, because it is not. They are two of the great people of the bizarre calling known as the marathon. They started as the Scandinavian neophyte and the New York promoter, and they became friends, good friends.

Now, for the first time, they will run together, side by side, a sentimental journey in the New York City Marathon next Sunday. Grete Waitz, one of the most popular athletes ever to set foot in the city, deserves her jaunt through New York because she won this race an astonishing total of nine times. Fred Lebow has completed 68 marathons, half of them on foreign soil, but on Sunday he will run New York for the first time since he expanded the race, his race, to a five-borough, 25,000-runner extravaganza.

Lebow will deserve as many cheers as his companion for the way he has fought back from brain cancer that struck him two years ago. Out of sheer willpower, he got up from his hospital bed and began plodding his way forward, step by step. In his own race, Lebow has worked himself back into good enough shape to dare to run the marathon. A few months ago, Jack Waitz, Grete's husband, casually asked Lebow if he would like company on his trek through the city.

Photo by Martin Lederhandler/AP Photo

Very little touches this force of nature named Fred Lebow, but the offer from the Waitzes set him back on his emotional heels. Yes, he said, he would love to run with Grete.

The two old friends met in New York a few weeks ago, to discuss the race they would run together. Before Lebow arrived, Waitz sat in a hotel chair, blond and healthy and 39, and talked about her friend in her nearly perfect English, clucking the way Hepburn would cluck over one of Tracy's idiosyncratic ventures.

"I know he's done his mileage," Waitz said. "I hope be's not been doing too much. He told me he ran a half marathon and a five-mile workout afterward. I told him, 'You're crazy.'"

Lebow, 60 years old, came over and they kissed European-style, on both cheeks. His beard has grown back dark since the chemotherapy and he wears a running cap on his head, as always. He was wearing a running outfit, but then again, he always wears a running outfit. Somebody told Lebow that Waitz was worried he was working too hard.

"I'm being cautious," he said in his thick Romanian accent. "I'll do a 19 or a 20. I'll do a 15 and that's it."

"No more long runs?" she entreated. "I'm concerned for you."

Their dialogue, edited slightly, is better than anything a writer could say about them and their sport and their friendship.

"She's run 2:25," Lebow said. "How can she run 5:00?"

"Time goes so fast," Waitz said. "I ran a half marathon with an intellectually disabled girl, who wrote to me and asked me to run with her. We did it in two hours and it went so fast. I'm sure people will give you support. The pace will allow us to look around."

"I'll wear earplugs," Lebow said. "You know I have to concentrate. I can't wave to everybody. I'll just do this." (He held up his two thumbs.)

"I'll tell Norwegian jokes," Waitz promised. "I hope it doesn't tire you out."

"When you're tired, the noise gives you a headache," Lebow said.

"I found the same thing," Waitz said. "I remember hitting First Avenue in 1979, how noisy it was. I mean, it's great, but you feel it."

"I never realized how much of an effort it is," Lebow said. "I haven't done one in five years."

"It's a commitment," Waitz said. "I'm sure you will feel great. You'll find it's worth it."

They recalled how they met in 1978, when she was a championship long-distance runner who had never tried the marathon. She had just gotten off the plane from Norway and was whisked to a news conference in this zany city.

"I didn't understand," Waitz said. "This was my first time in the U.S. I just wanted to go to bed, but I went to the reception. They started to ask me about my long runs and I said, my longest was 12 miles. These were writers,

but also Fred, and they all looked at me. Fred must have felt, 'What are you doing here?'"

"I decided she'd be a great rabbit," Lebow recalled, meaning somebody who sets a fast pace for more experienced runners.

"I was afraid of speaking good English," Waitz said. "We stayed at the Mayflower across the street from the park. I remember there were two buses for the special runners going out to the fort. Now there is a whole chain of them.

"I didn't know what side of the bridge I should start at. I remember pulling at Fred's pants and saying, 'Please . . .'"

Waitz recalled discovering, midway through the race, that the marathon was more than a trifle uncomfortable.

"I could have killed my husband," she said. "He talked me into it. I had a high number, and people were saying, 'Who is that blond girl?' I was so tired and angry. I just wanted to go home to Norway. You get a tired feeling running other races, but it only lasts a few minutes. Here, I had pains in my side. I was coughing. I was just hurting. I said, 'I'm going to tell Jack how terrible this is.'"

Grete's final victory, in 1988. *Photo by Duomo/PCN Photography*

It was so terrible that the rabbit was far ahead of any woman in the race, and she was passing men of considerable skill and ego.

"A lot of guys dropped out," Lebow said, smiling. "I know one guy, she passed him on the 24th mile, and he just walked off the course. He couldn't stand for a woman to pass him. That was not uncommon."

When she reached the Tavern on the Green that day, Waitz took off her running shoes and threw them at her husband and said she would never run another marathon. Then somebody told her she had set a world best for women of 2:32:30.

The next day she was still in pain, she said, but not so bad she could not hit Lebow for a few expenses. "I felt since I won it, they should pay my taxi to the airport," Waitz recalled. "I was a little embarrassed, but I asked him, and he gave me $20. And the trophy."

In later years, Lebow would be able to give her prize money, and the men in New York would consider it a signal honor to see the lean, tall frame of Grete Waitz passing them.

"Now it's accepted," Waitz said. "Men realize it's nothing to be ashamed of. Now they know that some women can run faster than men."

On Sunday, speed will not be the criterion. Waitz subtly suggested that Lebow does not have to push himself, that anything under five hours would be good.

"When I ran with that intellectually disabled girl, we stopped for water and walked for half a minute," Waitz said. "Some people run as long as they can but then they walk for three miles. I'd say it's better to walk for half a minute. If you put in these little walk breaks, you don't get tired."

Besides, she said, the first half of the course is easier than the second half.

"In my wildest dream, I would like to finish half the race before the winner crosses the finish line," Lebow said, referring to the normal winning time, around 2:10.

Waitz said softly: "It's better to be conservative. I always say, 'Take the first 18 miles as transportation. Without wasting too much energy.' Then you can run. If we can get to First Avenue. . . ."

Lebow listened to this advice and he said: "I have all kinds of coaches. People say I should take a packet of pills. I've got bottles in my drawer. I take five pills a day, one for medicine, one for iron. I've got cancer patients writing to me, telling me how to run." His 68 marathons have been his way of seeing the world, but his body is different now. He

"THIS YEAR I FELL IN LOVE WITH MY SPORT. MY RUNNING IS MY CHILD."

—FRED LEBOW

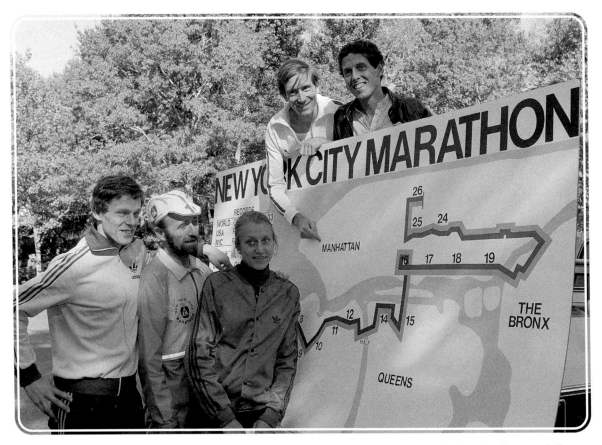

By 1980, when Grete joined Fred for this prerace promotional photo—along with Olympic silver medalist Gerard Nijboer (far left) and contenders Chris Stewart and Kevin McCarey—she surely already knew her way around the five-borough course. *Photo by Dave Pickoff/AP Photo*

wondered if he would feel hungry, and he recalled running Boston back in 1971:

"I got so hungry and they didn't have anything on the course for us. Nothing. I got to Commonwealth Avenue and I saw a little boy with a chocolate bar, and as I ran past, I grabbed the chocolate bar, and I could hear the boy telling his father, 'Daddy, that man stole my candy.' But I finished the race."

Waitz said he should eat "bananas or a power bar."

"You should have some energy. Bananas are the best because they have potassium and are easy to digest. I eat like a horse before the race. I have a bagel and bananas. I wouldn't cross the Verrazano Bridge if I didn't have a good breakfast. I eat around six, so there's time to get your digestive system going."

Lebow seemed to be paying attention to Waitz, who won 14 of her 16 marathons, losing only the 1984 Summer Games and the 1990 New York. Waitz now spends the winter in Gainesville, Fla., and runs a fitness campaign in Norway to get the average

citizens in shape for the 1994 Winter Games in Lillehammer.

"Now I have no races to run, now I have no time to beat, it means more to me," Waitz said. "If you take it away from me, I love it more."

"This year I fell in love with my sport," said Lebow, a lifelong bachelor. "My running is my child."

Lebow was asked to describe Grete Waitz. He talked as if she were not sitting by his side.

"I always said that if a computer could put together an ideal runner, it would create Grete," he said. "I always say she's the Queen of the Road, but she doesn't behave like a monarch. She's a very nice person. She had a great deal to do with the acceptance of women."

Waitz was asked to talk about Fred Lebow. His face was impassive as she spoke: "In my opinion, he has led every city into having a major marathon. New York set an example. There is not a marathon he has not been to. He's the man behind all the other ones. I have come to know him as Fred, only Fred. Our relationship started as business, but now he is my friend."

In the spring of 1989, when Waitz heard that he was in the hospital, she called him. "I got the number," she said. "I followed his development. I saw him that summer."

"I had no hair. I ballooned up to 160 pounds," Lebow said.

"I saw him at the 1990 marathon," she said. "I ran it for him. For Fred. I was shocked to

see him. You looked so sick and tired. I felt sorry for him. I worried for him. I heard he had only six months to live. I didn't think we would be running a marathon two years later. If somebody had told me, I wouldn't have believed it."

"I ran in the hospital," he said. "I figured it was 67 times around the roof to make one mile. I would go 67 laps."

"You are crazy," Waitz said, matter-of-factly. "In the winter, sometimes I run outside in Oslo. There is one sidewalk that is clear for 300 meters. I go back and forth on the sidewalk. My husband says I am crazy. You are crazier."

He smiled appreciatively. She headed off to Florida and he headed off to run the city streets. They agreed to meet next Sunday, for a run together through the city.

Every step of the way: Fittingly, Grete saw Fred through his only NYC Marathon run, in 1992. *Photo by Photo Run/NYRR*

In his first international race, Willie Mtolo won for all of South Africa. *Photo by Mike Powell/Allsport via Getty Images*

EMBATTLED ARE FREE—AT LAST

BY TIM LAYDEN

The news was shuttled across an ocean, a continent and hundreds of miles of rolling South African hills, traversing generations of athletic repression along the way. A telephone rang at the Hillcrest Hotel, in the mountain resort of the same name, and was answered by Julie de Vries, who then called the only store in the tiny Zulu village of Kilimon. A messenger was sent to run four miles to the white mud hut where the family lives, even today. Willie Mtolo has won the New York City Marathon, the man would say, and the announcement would light the evening with a glow from the outside.

A 28-year-old man whose talent once seemed doomed to obscurity by the primitive politics of his country, a man who was prepared to retire at the age of 24, Mtolo ran yesterday with arresting poise and courage to win perhaps the greatest footrace in the world. It was a forceful and telling uphill surge 23 miles deep into the marathon that sent Mtolo to the front, a move six years in the making. Six years since Mtolo first ran fast, six years in isolation, full of fear and doubt.

"We have been waiting so long to compete," said Mtolo, a black man who has lived his life in an apartheid society. "I'm very happy; the people of South Africa, they will be very happy." He guards his politics as if they were fine crystal, especially since the May 31 ruling that freed South African athletes to compete internationally. And he grinned as if silly yesterday afternoon, suddenly free and famous all at once.

"This means so much to him," said his fiancée, Fikile Mhlungu. So very much."

Mtolo's time was two hours, nine minutes, 29 seconds, winning for him a $20,000 prize and a Mercedes worth $36,000, plus a time bonus of $30,000. He finished 84 seconds in front of Andres Espinosa, the Mexican he dismissed.

Espinosa held off kicking South Korean Kim Wan-Ki by one stride.

As much as it seems Mtolo has won, for him it is even more. "It won't change Willie's life, it will change his family's," said Mtolo's manager, Ray de Vries. It was de Vries who met Mtolo four years ago while Mtolo was training for an ultramarathon and offered him a room in his hotel, at the center of a segregated city.

De Vries negotiated for Mtolo an appearance fee of $7,000 for a race in South Africa last summer and with that and his winnings he bought a tractor for his family to use for farming. Now he can buy more, and attempt to expand the multiracial fun run he hosts each August. He was offered two international shoe contracts in the hours after yesterday's race, and de Vries already has entered him in April's Rotterdam Marathon.

But what was most remarkable about Mtolo's race is that he won it with such maturity. He was one of the elite runners entangled in a premature surge at the start. "Willie was off to the side, going toward the start when people started running," de Vries said. "I pushed him out there and said, 'Run your [butt] off.'" Mtolo said, "I didn't know what was happening."

Yet despite never having run in a major international race, and despite the prerace scratch by Mark Plaatjes, a former South African living in Colorado with whom Mtolo had hoped to run, Mtolo stayed cool. He sat back in the middle of a pack that tailed first-half rabbit Paul Pilkington (1:04:10). And

Mtolo (1) would break away just past 22 miles. *Photo by George Tiedemann/*Sports Illustrated *via Getty Images*

when Espinosa and 21-year-old Kenyan Lameck Aguta shot free past 17 miles on First Avenue, Mtolo waited.

He had seen the New York course before, when the New York Road Runners Club invited him to the race a year ago, as an ineligible spectator. "He was the saddest guy in the world," de Vries said. But he remembered. And when Espinosa and Aguta broke, he sat.

"I didn't follow those two guys," Mtolo said. "I remembered there were many hills later in the race." He waited while Espinosa, a 29-year-old who runs with a flat, even cadence and who finished second to Salvador Garcia in this race last year, opened a 50-yard lead on Fifth Avenue. But suddenly, past 22 miles, Mtolo rushed past a dead Aguta and Kim and up to Espinosa's heels. There he stayed for a quarter mile.

"He was tired," Mtolo said. "I could see he was tired." As the course turned sharply from Fifth Avenue up a sharp hill into Central Park at 102nd Street, Mtolo dropped to Espinosa's right and shot into the lead, abruptly opening a 15-yard lead that only grew larger as the race lengthened.

Espinosa said, "I tried to go with him. My legs were dead. I was too tired." Mtolo remained light until the last 800 meters, his thighs lifting like a track runner's, his head unmoving and

focused. Short of the finish, he waved wildly to the crowd and then raised two arms. He fell into de Vries's arms and the two embraced.

It has been an excellent adventure of sorts for Mtolo to get here, from last year's pained spectating to this year's victory. He brought his fiancée with him so she might cook phutu, a native corn meal dish, for him each night. Saturday night, they set off smoke alarms at the Hilton and scrambled to stash the hot plate beneath a bathroom vanity, lest they be expelled.

And past 22 miles yesterday, before he pounced on Espinosa, Mtolo dropped a small tablet into his mouth. Glucose replacement pills, de Vries called them, presumably something legal, like solid Gatorade. "Magic things," Mtolo said.

A man is set free to run and to win and to prosper. Surely, this is magic, indeed.

THE VISIONARY

BY GEORGE A. HIRSCH

Fred Lebow loved to give away T-shirts. Wherever he went, whether in London or Helsinki or Marrakech, Fred put smiles on people's faces with his cotton-and-polyester largesse. Of course, the shirts carried the logo of the New York City Marathon or other events he had created during his long tenure as the impresario of running.

Fred gave his T-shirts to more than just runners. Six weeks before his death last October 9, he walked through the chambers of the New York City Council distributing "In Training for the 1994 New York City Marathon" shirts to some of the city's most hardened pols. They grasped his hands and patted him on the back to thank him for creating New York's finest day.

Fred and I had a close friendship that dated back to our first running encounter in Central Park 25 years ago. It was a friendship that spanned successes, failures, breakups, countless trips to other cities and foreign lands, and thousands of T-shirts handed out to the famous and powerful, but mostly to rank-and-file runners.

I had a direct-dial button to Fred's office, and we talked virtually every day in person or on the phone. We talked about various things, but usually it was about running—the politics, the gossip, the athletes, the events and the business of our sport. Fred kept his finger on the pulse of running like no one else. He constantly cited the latest race-participation figures. And when the running boom began to level off, Fred, a true promoter and eternal optimist, always put the best spin on the numbers. "The real running boom hasn't even begun yet," he'd say. Or, "Last evening there were more runners in Central Park than back in the '70s, and most of them were women." In the accent of his native Romania, that last word came out as "vimmen."

Fred's story is intriguing and well known: he grew up in Arad, Romania, near the Hungarian border, in a large, orthodox Jewish family that fled the town after World War II. As a teenager, he lived by his wits, smuggling sugar and diamonds from the Continent to England and Ireland. After immigrating to the United States, he settled in Cleveland, where he ran an improv nightclub, The Left-Handed Compliment. Finally, he moved to New York City and made a good living in the garment center by manufacturing knockoffs.

Fred's life changed after his friend and tennis partner Brian Crawford challenged him to a race around the Central Park Reservoir. Despite an 11-minute pace over the 1.6-mile loop, Fred beat Crawford. Soon Fred was running everywhere and at every opportunity. Since he had kept his life stripped to a minimalist existence, with no hobbies, no serious romantic commitments and no interest in acquiring personal possessions, he was free to pursue his new obsession.

In the late 1960s, Fred joined the handful of runners in the New York Road Runners Club (NYRRC) and began entering club races, which were often held on the streets and sidewalks outside Yankee Stadium. Unlike the rest of us, Fred realized that running had the potential to play in the big leagues, and he set out to change things. In 1970 he organized the first NYC Marathon on a four-loop course around Central Park, digging into his own pockets to buy soft drinks for the finishers and cheap watches for the winners.

The race grew over the next few years, and in 1976 Fred made the

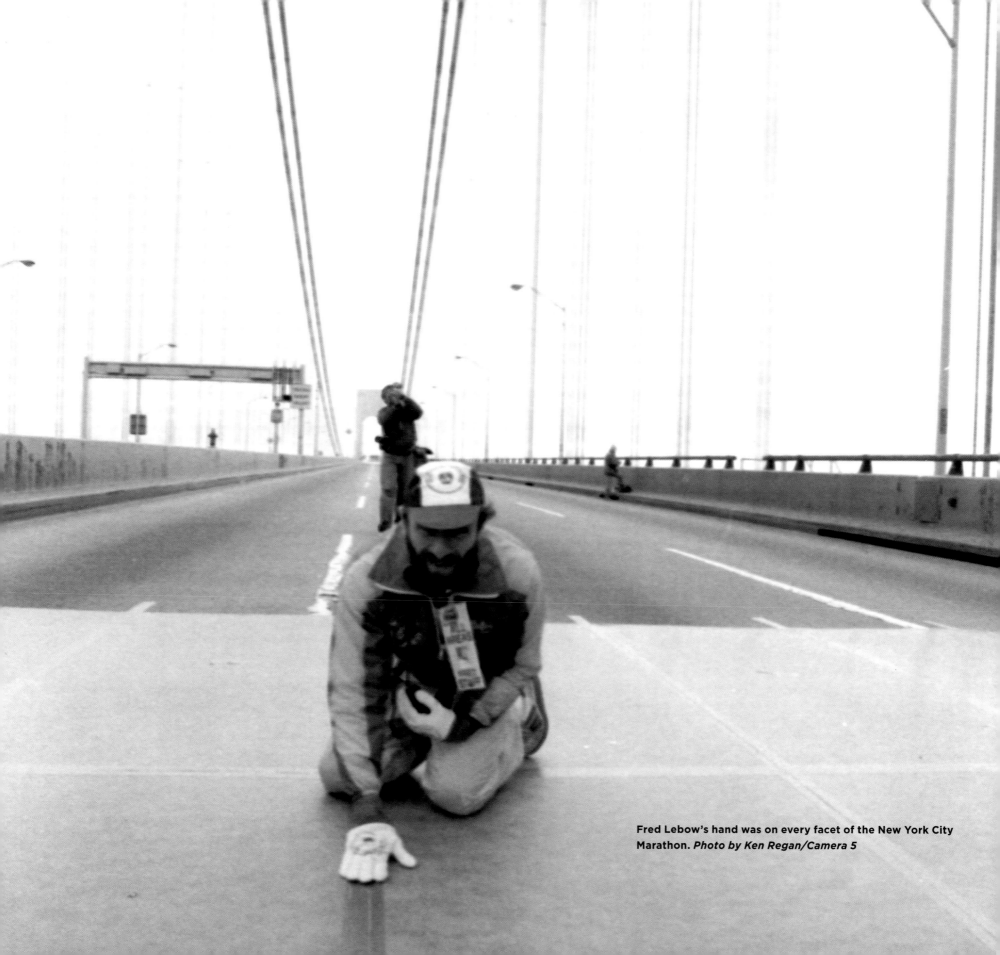

Fred Lebow's hand was on every facet of the New York City Marathon. *Photo by Ken Regan/Camera 5*

boldest move of his career: he took the race to the streets of the city's five boroughs. Now he needed to round up sponsors—a daunting task. Just three years earlier, General Motors had turned down his proposal to finish the Central Park marathon in front of GM's new headquarters on Fifth Avenue for a mere $2,000.

While the new challenge was far bigger than any he had yet faced, Fred tackled it with great enthusiasm, and I got a close-up look at his skill, guile and energy. He managed to secure Frank Shorter and Bill Rodgers, massaged city agencies, fought over myriad details, attended endless meetings and worked the press without letup. He succeeded in signing up several sponsors, including my own *New Times* magazine, which contributed $5,000. The race was a tremendous success, but Fred was not satisfied. He told us it could be much bigger and much better. From then on, Fred had found his life's work.

Fred was the perfect person to put running on the map, a blend of priest of our sport and P. T. Barnum—style promoter. One without the other would not have worked. As Fred began to push running forward, he sometimes faced resistance from old-timers who liked the low-key, amateurish ways of the past. But Fred stayed the course, paid little heed to the criticisms and kept on running. Wherever he went, to other races around the United States and the world, he looked for

new ideas he could bring back to his beloved marathon: street banners from Los Angeles, long-stemmed roses for the women finishers from Berlin and postrace party activities from everywhere.

Like any great promoter, Fred understood the importance of the media, which he constantly courted with a mix of finesse and gamesmanship. He knew the press needed real stories and good quotes, and he gave them what they wanted. He enjoyed the personal attention and his growing celebrity, and ignored those who said he was on an ego

trip. He knew full well that all the attention helped the marathon.

In 1983, Fred and I were invited to a small private audience with the Pope at the Vatican. The Pope greeted each person individually. When he heard that Fred directed the New York City Marathon, he commented that it was a marvelous event known throughout the world. Later that day, Fred and I were preparing to go out for a run when he mentioned that he had called in the story about meeting the Pope. "It should get good press tomorrow," Fred said with a twinkle in his eye.

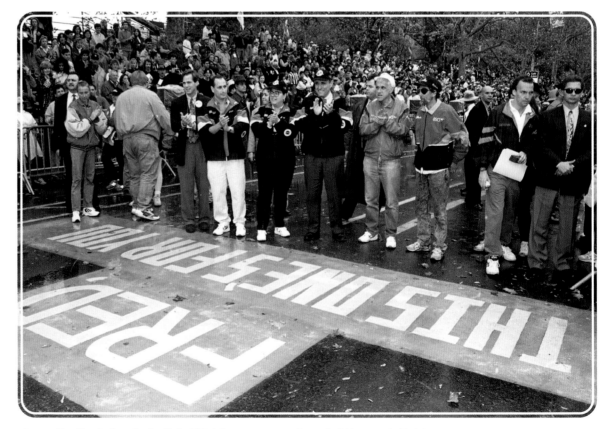

A month after Lebow's death in 1994, he was remembered at the race's finish.
Photo by NYC Parks Photo Archive

As the NYC Marathon gained popularity, an entry became a hot ticket, but Fred knew how to make it hotter. "Just today I had to turn down requests from Koch and Cuomo," he might say, sounding pained. He told of runners who offered bribes and women who offered themselves, allowing that from time to time a good story might require him to alter the facts.

When it came to his own running, however, Fred followed a strict honor code. Years ago he told a reporter, "I feel running is the oasis in life, the one area, unlike business or relationships with women friends, where one does not cheat or exaggerate. I will never write in my log that I ran a mile more than I really did. Running is my area of total honesty."

Fred has been called a visionary because he could imagine things that others couldn't. One time I thought he was dreaming too big. In 1980 he decided that the barely solvent NYRRC should buy a townhouse on New York's expensive Upper East Side to house its growing organization. The risk seemed too great. But, as it turned out, the move was one of Fred's masterworks. It allowed the club to expand its promotion of races like the women's Mini, the Trevira Twosome, the Chemical Bank Corporate Challenge, the Fifth Avenue Mile and the Midnight Run.

A visionary is never fully satisfied, and Fred suffered most in the days after each annual marathon, as he wondered how the event could keep getting bigger and better. His worst year was 1981, when Alberto Salazar and Allison Roe had both set world records. I remember his day-after-the-marathon voice, strained and raspy, as he asked, "How can we ever top this?"

His depression lasted weeks rather than days. Finally, Fred's typical upbeat mood kicked back in, and he began talking about a marathon in which a head-to-head duel to the finish was more important than new

Photo by Duomo/PCN Photography

"I FEEL RUNNING IS THE OASIS IN LIFE, THE ONE AREA, UNLIKE BUSINESS OR RELATIONSHIPS WITH WOMEN FRIENDS, WHERE ONE DOES NOT CHEAT OR EXAGGERATE. I WILL NEVER WRITE IN MY LOG THAT I RAN A MILE MORE THAN I REALLY DID. RUNNING IS MY AREA OF TOTAL HONESTY."

—FRED LEBOW

records. Sure enough, the next two years saw two of the greatest marathon finishes of all time, first Alberto Salazar battling Rodolfo Gomez and then Rod Dixon going against Geoff Smith.

Fred's work was not free of feuds and controversies. Some of them became public dialogues. Bill Rodgers lambasted him for not paying athletes enough, and Bob Bright of the Chicago Marathon tangled repeatedly with

Fred, as did the USATF (TAC at the time), the International Management Group and even his own board of directors. Sometimes things got pretty hostile, but Fred could never hold a grudge. Before long, he was having a friendly dinner with his adversary. Try as you might, it was impossible not to like the man.

Meetings in Fred's office often took on a zany Laurel-and-Hardy style. People were constantly walking in and out to say something, and Fred would start flipping through newspapers when he got bored. One time I brought Marc Cannon of Alamo Rent-a-Car to Fred's office to discuss a sponsorship idea. Among the numerous interruptions was a man on a ladder who fixed a ceiling light while talking with Fred. "It's like Grand Central Station in there," Marc said later. Still, he was charmed, and by the time

we left, the Alamo Alumni Runs had been created.

Very few entrepreneurs become successful managers after they have built an institution. Fred was an exception. A classic control freak in the early days, he alone talked with sponsors, the police department and city officials, not to mention personally picking up invited athletes at the airport. Over the years he came to realize that the NYRRC and its crown jewel, the marathon, had gotten too big for any one person. Against his instincts, he delegated more and more responsibilities to his technical director, Allan Steinfeld.

A few week's before Fred's death, Mayor Rudy Giuliani held a reception at Gracie Mansion to honor the marathon's 25th running. That evening the mayor announced that 89th Street between Fifth and Madison, the

block where the NYRRC is housed, would be named "Fred Lebow Place." Allan, who for years had worked behind the scenes and avoided the limelight, spoke with conviction and confidence. When I visited Fred the next night, I told him Allan had done extremely well. Fred pulled me close and whispered, "Truman," referring to Harry Truman's emergence from the long shadow of Franklin Delano Roosevelt.

When Fred learned of his brain cancer in 1990, I was deeply moved by his personal courage and fighting spirit. As soon as he could get out of bed, Fred asked for a cane and began walking the corridors of his hospital, which he calculated at 12 laps to the mile. It seemed he willed the cancer into remission. His tour de force 1992 marathon, with Grete Waitz at his side and throngs of adoring fans waiting hours to see him, easily ranks as the emotional highpoint of the NYC Marathon's 25-year history.

Early last year, the cancer returned, but Fred fought to maintain his work routine. When he could no longer run, he would walk two or three miles a day. During the final weeks, with the strength draining from his body, his spirit never diminished. I visited Fred each day during this period and marveled, as I had many times in the past, that he

Lebow wore his love for the Marathon on his sleeve—and on his sole. *Photo by* NY Daily News *via Getty Images*

had never learned to complain. When I asked him if there was anything I could do, he nodded his head, smiled and whispered, "Be nice." He enjoyed many visits from friends, some, such as Salazar, Waitz and Carl Lewis, coming from long distances for a final good-bye. His sister, Sarah Katz, was in constant attendance, making potato latkes and giving massages.

Salazar came from Portland, Oregon, on Friday, October 7, as Fred was slipping into a deep sleep. As if speaking for all runners, Alberto told him, "You've changed my life, Fred. You're a real inspiration. I love you."

On Saturday I went to visit Fred but wasn't sure that he could hear me. I told him that the 25th Anniversary Marathon was shaping up as the best ever. His blue eyes opened, and he put both thumbs up. The next morning, while the Marathon Tune-Up 30-K was being run in Central Park, Fred Lebow passed away.

Photo by Ken Regan/Camera 5

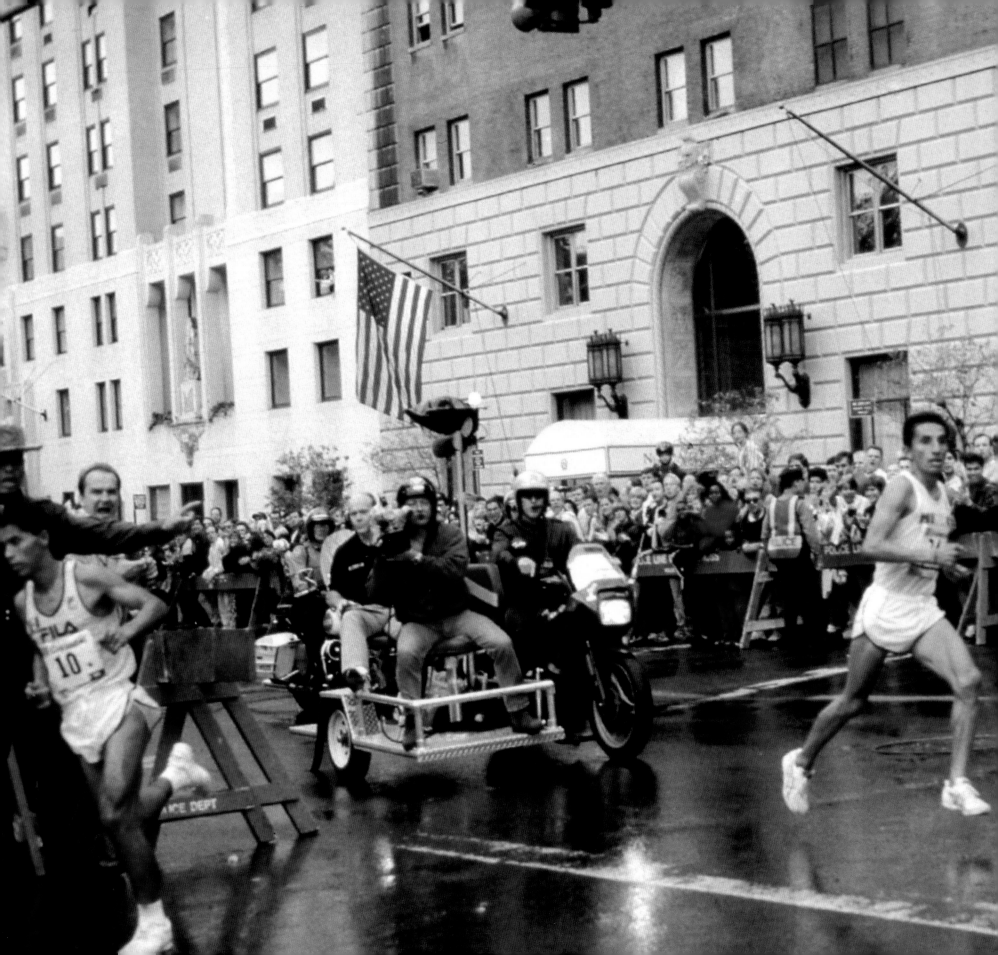

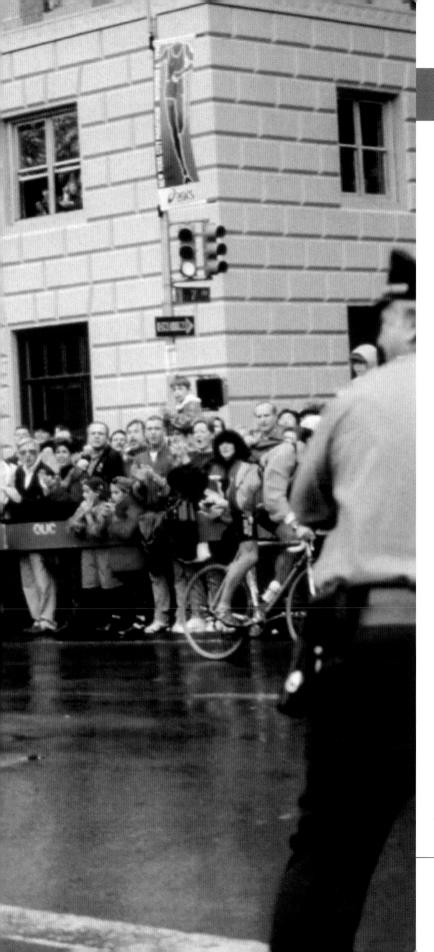

SILVA: DETOUR, STOP, REVERSE, VICTORY

BY JERE LONGMAN

The standard marathon distance is 26 miles 385 yards, unless you happen to be German Silva of Mexico, who took an alarming detour into Central Park yesterday only to slam on the brakes, retrace his steps and rescue a stirring victory from heartbreaking disaster in the strangest, closest finish ever run in the New York City Marathon.

From the 23-mile mark, Silva ran shoulder to shoulder with his countryman and training partner, Benjamin Paredes, dropping a pack of runners on a hot, humid day that claimed the life of a 27-year-old runner who went into cardiac arrest at the finish line. Another runner, an unidentified man said to be 45 years old, also died. These were the second and third deaths recorded in the 25 years of the New York City Marathon.

The women's race was marked not by a finishing drama but by a blistering surge in the final 13 miles by Tegla Loroupe, a 21-year-old from Kenya who became the first black African woman to win a major marathon. Her time of two hours 27 minutes 37 seconds was more than two minutes ahead of Madina Biktagirova (2:30:00) of Belarus and Anne Marie Letko (2:30:19) of Glen Gardner, N.J.

Loroupe missed the course record for a first-time marathoner by only five seconds. It was set in 1991 by Liz McColgan of Scotland.

Moment of oops! Less than a mile from the finish and dueling for the lead with compatriot Benjamin Paredes, German Silva of Mexico (10) made a wrong turn into Central Park.
Photo by Carol Zoccola/AP Photo

Silva, on the other hand, came perilously close to becoming the Wrong Way Riegels of distance running.

With Silva, 26, and his friend Paredes, 33, running alone for the final three miles, a Mexican runner was guaranteed to win New York for the third time in four years. Silva had superior finishing speed, and he appeared to be biding his time before passing Paredes, whose head had begun rolling slightly.

He eventually did pass him, winning with a time of 2:11:21, two seconds ahead of Paredes. But as the runners headed out of Central Park onto Central Park South and were crossing Seventh Avenue at the 25.5-mile mark—seven-tenths of a mile from the finish—the unimaginable happened.

With a police officer gesturing for him to continue west toward Columbus Circle, Silva veered instead into the park, apparently following vehicles carrying the race director, Allan Steinfeld, the official timer and photographers. A throbbing crowd had been cheering the racers on. Now Silva saw only a few incredulous, wrenched faces.

"I saw the faces and I knew I had made a mistake," Silva said. "I didn't have to ask anybody."

As a second police officer pointed back toward the course, Silva turned and saw that Paredes had continued along Central Park South. By now, Silva had taken 12 strides in the wrong direction. His first thought was panic.

"This is it," Silva told himself.

When Silva turned prematurely into the park, Paredes seemed confused for a moment and appeared to slow down, as if to follow his friend, but he stayed on course and stepped on the gas, gaining a lead of about 40 yards.

"When I saw I was in a good way, I decided to push it," Paredes said.

At the finish line, Steinfeld uttered an obscenity and began making contingency plans. This was the 25th running of the race, the first without its spiritual leader, Fred Lebow, and, in a second, all had become chaos. Steinfeld went through a mental Rolodex of possibilities. He could declare Silva the champion if the race was close or he could declare the Mexicans to be cowinners. Whatever he decided, Steinfeld knew that it might have to stand up in court.

"I'm just glad I didn't have to make the decision," he said later.

Silva regained his composure quickly. He had predicted victory several days earlier. He had trained earnestly for months, running at altitude in a forest outside of Mexico City. He had survived torturous training runs up the side of a volcano. He had stood toe to toe with Mexican track officials in a bitter dispute. And now he had run for two hours in 67-degree weather, with 78-degree humidity, ignoring a stitch in his stomach.

"I had done too much work," Silva said. "I was thinking, 'Even if I break myself, I will catch him.'"

He reversed his course, took a right at Central Park South and the chase began. Silva lost 12 or 13 seconds, by his own estimate, but easily slipped into another gear. Three months ago, he had finished second by one second at the world half-marathon championships in Oslo. An Olympian at the 1992 Summer Games in Barcelona, Spain, Silva had also run a 10,000-meter race in 27:46. He had a finishing kick that Paredes could not match.

Rapidly, Silva made up the gap as the runners continued along Central Park South for a final crosstown block before turning up into the park at Columbus Circle. Just before the 26-mile mark, where Rod Dixon of New Zealand passed Geoff Smith of Britain to win the 1983 race, Silva gained the lead. The time was 2:10:42, only 39 seconds from the finish. As his friend went by, Paredes extended his left hand and patted Silva on the back.

"When he caught me, I knew I was in trouble," a gracious Paredes said later. "I knew it would take a miracle to beat him. A Mexican won. I'm very happy for that."

Even with that unintended detour, Silva covered the last mile in 5:15 to win by two seconds, joining Salvador Garcia in 1991 and Andres Espinosa in 1993 as Mexican victors in New York and receiving $35,000 in prize and bonus money, as well as a Mercedes-Benz. The previous closest finish had been Alberto Salazar's four-second victory over Rodolfo Gomez of Mexico. The very same

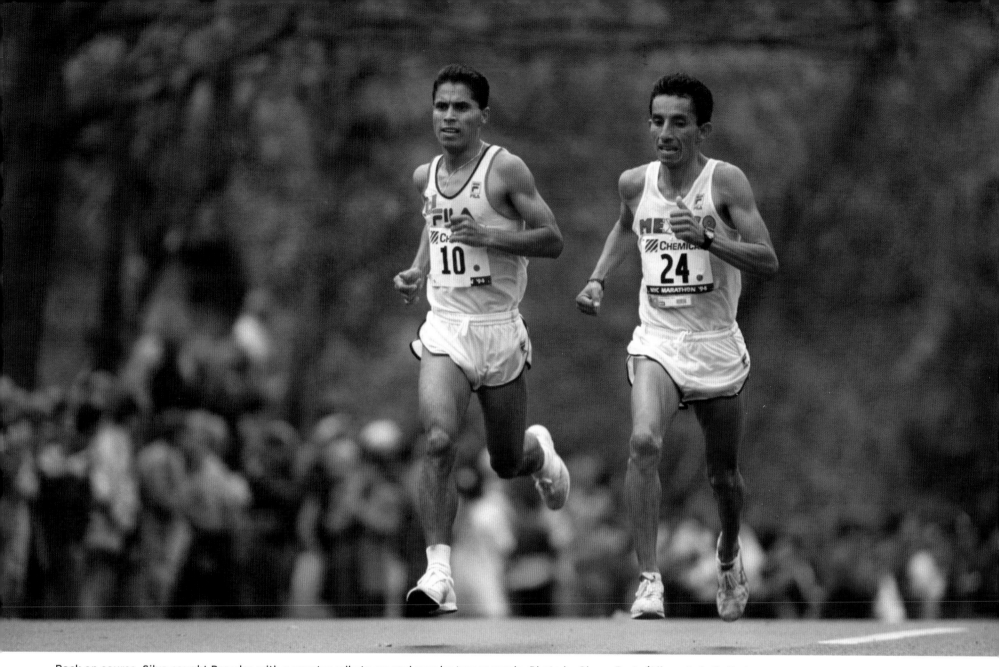

Back on course, Silva caught Paredes with a quarter mile to go and won by two seconds. *Photo by Simon Bruty/Allsport via Getty Images*

Gomez who now coaches both Silva and Paredes.

Both runners had spent most of the race in a large pack that numbered up to 20 runners and winnowed itself to five racers only at the 21-mile mark. Arturo Barrios, a native of Mexico City who became an American citizen in September, made a move at 22-plus miles, but Silva and Paredes remained in his slipstream. Eventually, Barrios faded to finish third in 2:11.43.

"I tried to push the pace. If someone was going to beat me, they were going to have to pay the price," said Barrios, 31, of Boulder, Colo. "That's what I did. When they came with me, I knew I was in trouble."

That Silva would even participate in yesterday's race, much less win, had been in doubt at one point. After the 1992 Summer Olympics, Silva was among a group of Mexican runners suspended for four years by the national track

and field federation. The federation had demanded all of the athletes' winnings from a relay race in Japan, and the athletes refused. Silva and his teammates contested the suspensions with a lawsuit, which was dropped in March, when the federation restored their eligibility.

One of nine boys and four girls, Silva grew up in the remote village of Tecomate in the state of Veracruz. He ran five miles round trip to school each day, but his father thought running was a foolish sport, wanting his son to work in the family orange grove. Today, on his 70th birthday, Agapito Silva has no running water or electricity, but he has a son who is the winner of the New York City Marathon.

"Now he's one of my biggest fans," German Silva said. Even if his son ran 25 or 30 yards out of the way.

"WHEN HE CAUGHT ME, I KNEW I WAS IN TROUBLE. I KNEW IT WOULD TAKE A MIRACLE TO BEAT HIM."
—BENJAMIN PAREDES

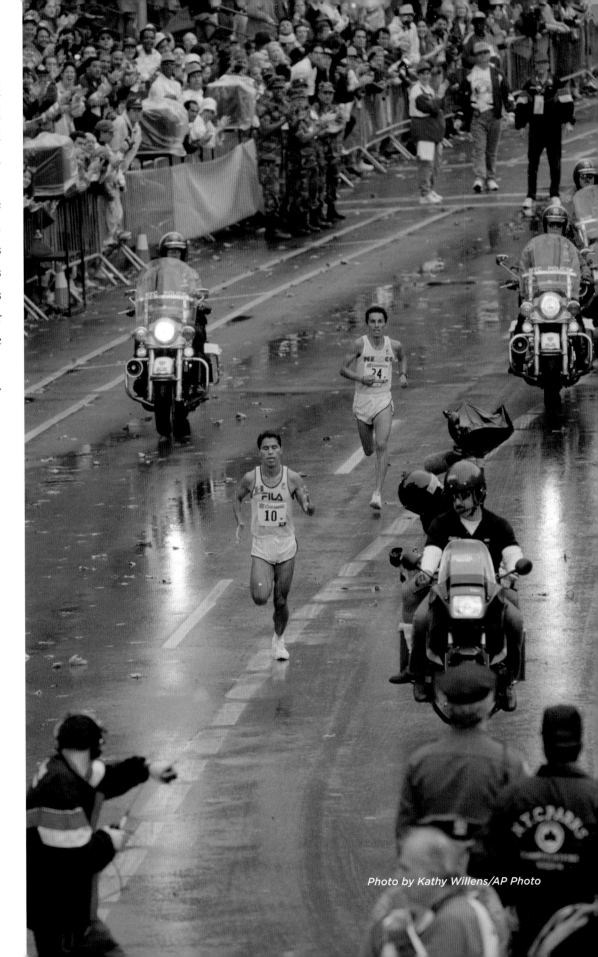

Photo by Kathy Willens/AP Photo

NEW YORK TIMES, OCT. 27, 1998

TEGLA LOROUPE'S RACE FOR RESPECT

BY JERE LONGMAN

When she arrived here seven years ago from Kenya, looking for a coach and a manager, searching for someone to take her seriously as a runner, Tegla Loroupe found that sexism traveled without a passport. The man who would become her coach joked to another runner, "Is this your girlfriend?" He had never trained men and women in the same group. Women can be difficult to manage, he told her. What if romance interfered with running?

"I am a Christian," Loroupe replied. "I will not play around. I want to show that I am able to run."

For two weeks, she cleaned house for other runners from Kenya and Tanzania, cooked for them and washed their clothes. She was 18 and did not want to make trouble. She trained on her own in the farm country of western Germany, looping through the hardwood forests and the fields of hay and corn and sugar beets. "I was fearing they might send me home," she said.

After two weeks, it became apparent to Loroupe that she was considered more of a maid than an athlete. When a runner demanded that she wash his clothes, she refused.

"You left your wife at home; there are no wives here," Loroupe said. "We are all athletes. Wash your own clothes."

It was the same refusal to capitulate that had carried her from the village of Kapsait in western Kenya, where, like the other women of the Pokot ethnic group, she was expected to live a life of domestic servitude. Her father wanted her to work in the house and in the fields of the family farm. She would marry early and have children. He objected to her becoming a runner and did not even want her to attend school.

But her mother had grown up as an orphan and taught Loroupe the value of independence. One of her aunts told her never to be caught crying in front of men. Her older sister, Albina, told her that if you don't own something of your own, like property, men will not respect you.

"I thought, one day I would have something unusual, something different from other women," Loroupe said.

And she would. Last April 19, in Rotterdam, the Netherlands, Loroupe set a women's world record in the marathon with a time of two hours 20 minutes 47 seconds. On Sunday, she will attempt to win her third New York City Marathon after taking back-to-back titles in 1994 and 1995. This year she could earn as much as $500,000, an extraordinary amount for a woman from a country where women are often treated like chattel. She has bought a farm in Kenya and several houses that she rents to others; she wants eventually to return home to start her own business.

Her sister's admonition lingers. If you own something, men will have to respect you.

Loroupe, 25, has joined the vanguard of African women who are dominating the sporting landscape now that they are being given chances similar to those given African men. Derartu Tulu of Ethiopia won the 10,000 meters at the 1992 Olympics in Barcelona, Spain. Fatuma Roba of Ethiopia won the 1996 Olympic marathon in Atlanta, while Chioma Ajunwa of Nigeria won the long jump. Two

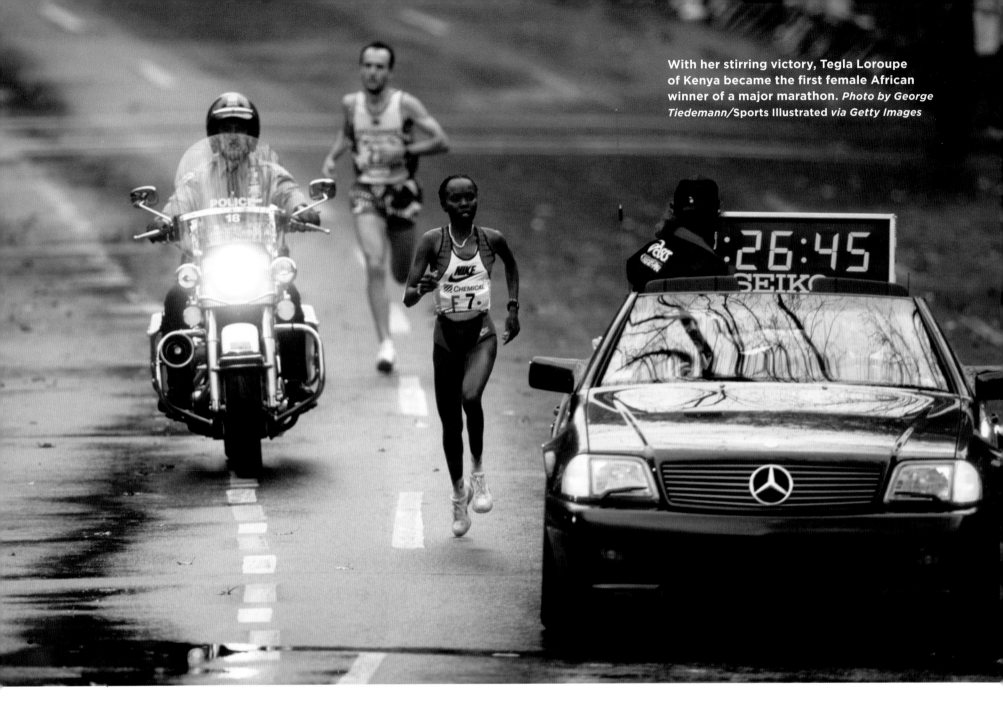

With her stirring victory, Tegla Loroupe of Kenya became the first female African winner of a major marathon. *Photo by George Tiedemann/*Sports Illustrated *via Getty Images*

weeks ago, Loroupe's roommate and training partner, Joyce Chepchumba of Kenya, made up a 19-second gap in one late mile to win the Chicago Marathon.

"No one was expecting women from Africa to be the best in the world at some-thing," Loroupe said. "This gives women encouragement."

At five feet, and a listed weight of 88 pounds that seems extravagant, Loroupe appears almost frail and birdlike. A year ago, her career seemed threatened by a serious back injury after a seventh-place finish in New York. And her world record has caused controversy because she was paced by two men. Still, she has succeeded by the sheer force of her will, by running through cultural stop signs, by ignoring what had been prohibited and scorned.

"I look at her, and she's this tiny, tiny thing," said Anne Roberts, who coordinates the elite runners at the New York City Marathon and who has become a second mother to Loroupe. "But on the inside, she's Muhammad Ali in terms of strength and guts and purpose."

Loroupe lives the ascetic life of a runner in a rural village on the outskirts of Detmold. Four Kenyan women share a modest house; Loroupe shares a bedroom with Chepchumba and has decorated her corner with stuffed animals and photographs. The living room is a sort of trainer's room, with an exercise bike and a massage table. There is time for shopping, visiting and even helping the neighbors bring in the hay crop, but mostly it is an austere life of eating, sleeping and training.

For about two months a year, Loroupe returns to Kenya. After New York, she said, she will meet with President Daniel arap Moi to receive an award for breaking the world record. But Kenya for her is not a place for running. She could not find a reliable coach there, she said. She feuded with the Kenyan track and field federation over its treatment of her and other women, and she overexerted herself at home, training three times a day with men.

"It was too much for me," she said. "I got exhausted before competitions."

Another problem is her popularity. There is little time for training when she is home—too many people to see, places to visit, business matters to attend to. She is also concerned about contracting parasites from the food or water, and about rising crime, fearing that because people know she has money, they might try to take it away. Twice she has been attacked while on long runs, she said, once by a man carrying a knife.

So she remains in Germany, coached and managed by Volker Wagner, 48, a pleasantly rumpled high school mathematics teacher who lives with his parents. He has long coached runners from Africa, and Loroupe said that, despite that first crude joke, she was drawn to him by the professional way that he treated his athletes.

Unlike many Kenyan athletes who have been exploited by managers, Loroupe said she has set her relationship with Wagner on an equal footing. "The manager works for you; you don't work for the manager," she said.

Recently, Wagner said, Loroupe lent him money to buy a house where other Kenyan runners are staying.

"There is something inside that drives her," he said of her running. "It's like she is on a mission."

It is a career built on a foundation of resistance. Her father, Loroupe Losiwa, wanted his daughter to live a traditional life in a patriarchal society. From the beginning, Tegla said, she defied this subjugation. "I did not want to get married," she said.

She sneaked off to school before breakfast,

"I LOOK AT HER, AND SHE'S THIS TINY, TINY THING. BUT ON THE INSIDE, SHE'S MUHAMMAD ALI IN TERMS OF STRENGTH AND GUTS AND PURPOSE."

—ANNE ROBERTS

so that no one could question where she was going. To her father, she said: "I have two arms and legs and I came out of the same stomach as my brothers. Why can't we do the same things?"

At the age of 12 she was sent to boarding school in the nearest town, Kapenguria. There was one caveat. She could not be a runner. She was a promising mathematics student, and her father wanted her to concentrate on her studies. For six months, she stopped running. But school officials insisted that sports were important. She faced a punishment of having to run around the school track on her knees, or even expulsion, she said. So she relented.

As she became a national high school champion at middle distances and cross-country, her father began to see the value of running, she said.

"He said it was better that I was very hardheaded," Loroupe said. "He could have spoiled my talent. Now he's glad I didn't listen to him."

After high school, Loroupe took college accounting classes and became an auditor for

the Kenyan postal service. In December 1991, the postal service gave her permission to travel to Germany to train. Even now, seven years later, she still nominally represents the postal service and receives her auditor's salary.

By 1994 she was ready to run her first marathon, in New York. Taking Roberts's advice not to start too quickly, Loroupe won. She won again in 1995. Running 26.2 miles did not seem so difficult, considering she had spent much of her childhood hauling loads of firewood and corn and younger siblings on her back for hours at a time.

"African women know how to live with pain," Loroupe said. "When it comes time to struggle, they don't quit. They keep going."

A marathon is no certain thing, however, and her career grew erratic. Her sister Albina, a guiding force in her life, died before the 1995 New York City Marathon. Then Loroupe suffered anemia and faded to seventh in New York in 1996. A year ago, she finished seventh again, bothered this time by menstrual cramps and back problems. Wagner began to hear criticism from other coaches and managers that Loroupe was wearing her body down by running too many races.

Several days after the 1997 race, she was treated by Dr. Lewis Maharam, a sports medicine expert in Manhattan, and was found to have two serious stress fractures on her spine. She was advised not to run for four months and not to attempt a marathon for eight months. If she continued to

For all her international success, Loroupe has remained steadfastly committed to her home country.
Photo bySusan Meiselas/Magnum Photos

run without treatment, Maharam said at the time, Loroupe risked paralysis.

She was fitted with a back brace that was to be worn 23 hours a day. Because it was difficult to tell whether the stress fractures were new or were healing, Maharam requested that Loroupe return to New York in four weeks for further tests.

Three weeks later, however, German doctors cleared Loroupe to begin training again. They found no stress fractures, Wagner said. Saying that the back brace impinged on a

nerve and sent pain down her leg, Loroupe quit using it. She ran another marathon last January, finishing seventh in Osaka, Japan. By April, though, she had rehabilitated her back to the point that she set the world record in Rotterdam.

Maharam said in an interview and in a February letter to one of Loroupe's German doctors that, upon further examination of Loroupe, he believed she had suffered a chronic back problem from childhood that was aggravated by a fall during the 1996

Boston Marathon. The injury was nearly healed by the time of the 1997 New York City Marathon, he wrote, adding, "She is quite lucky no serious harm came to her while running on this serious lesion."

"She's come so far because she's worked hard," Maharam said in an interview. "If someone was not as focused on rehab as she was, they might not have come back this quickly."

Loroupe's world record was front-page news in *The Nation*, Kenya's largest newspaper. "She has inspired lots of other women, given them the feeling that, 'If this sister can do it, I can do it,'" said Joseph Olweny, an assistant sports editor of *The Nation*.

Judith Masai, a Kenyan woman who now lives in the Netherlands, said: "She gives us a different story. Instead of just getting married, you can develop."

Not everyone was so jubilant about the record, though. Some runners thought it unfair that Loroupe was paced the entire way by two Kenyan men. (Ingrid Kristiansen of Norway, whose 1985 record Loroupe broke by 19 seconds, was paced to the halfway point of her run.) Loroupe's defense was, men are paced, so why not women? The pacers were needed almost like bodyguards, she said, because male runners gather around the leading female runner during a marathon, hoping to get on television, and they tend to jostle her.

"I still had to run the race," she said. "If you don't have your own energy, you won't make it."

Loroupe's speed has had a slightly unnerving effect on Kenyan men, who risk losing to her if they are not in top form. Several years ago, in a half marathon, she defeated Richard Chelimo, who finished second in the 1992 Olympic 10,000-meter race.

The night before the Rotterdam Marathon, a group of Kenyan men pleaded with Loroupe, half-jokingly, "Don't do to us like you did to Chelimo." The next day she nearly caught Sammy Lelei, who, at the time, owned the second-fastest marathon in history. "I came close to being beaten by a woman," Lelei said to Loroupe after the race.

"Next time, wait," she replied.

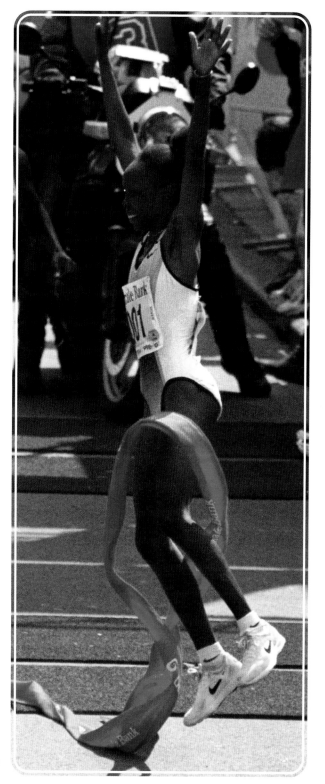

Photo by Jerry Lampen/Reuters

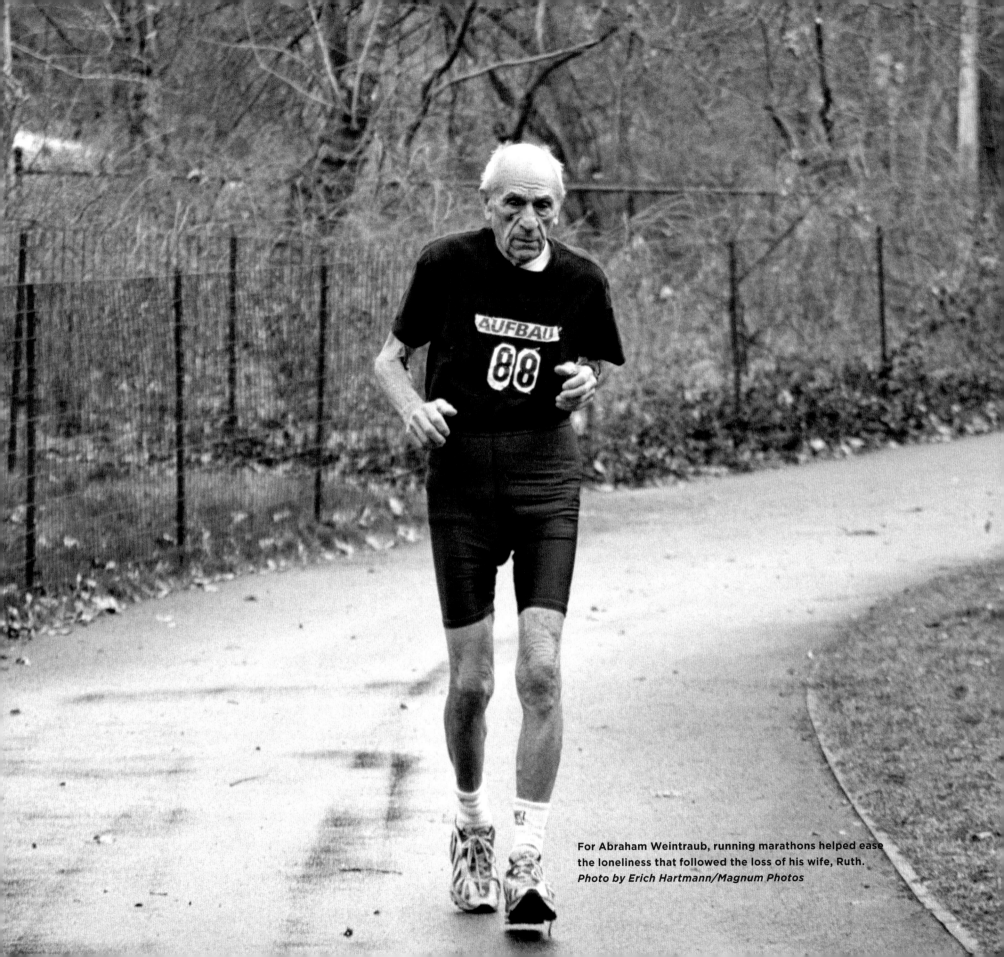

For Abraham Weintraub, running marathons helped ease the loneliness that followed the loss of his wife, Ruth.
Photo by Erich Hartmann/Magnum Photos

A LIFE, MUCH LIKE A RACE, MAY BE LONG

BY JAMES BARRON

The first time Abraham Weintraub tried to enter the New York City Marathon, he was not thinking about how fast he could cover the 26 miles and 385 yards. All he wanted to do was push his wife, Ruth, in her wheelchair.

She had Alzheimer's disease, but that did not stop them from doing things together. He wheeled her through their neighborhood stores in Bay Ridge, Brooklyn. He wheeled her through tourist attractions in Ireland and Israel when they went on vacation. But when he applied for the marathon, officials told him, "You can't push a wheelchair in the New York Marathon," their son Joel recalled.

Mr. Weintraub began training anyway. He went ahead and ran, by himself, in the marathon in 1992. He had never been much for sports, but after his wife died the next year, he kept on running, as an antidote to loneliness and loss. "My father just wanted to keep busy all the time, to forget," Joel Weintraub said.

Now 87, Mr. Weintraub will run in his fifth New York City Marathon tomorrow, with number X6150 pinned to his shirt.

After watching him trot along his favorite course in Bay Ridge, one can safely say that Mr. Weintraub will cover the five-borough circuit at a pace that will not take him to the Olympics, but that is definitely faster than walking. Last year, his time was a respectable 6:18:34. He was the 27,346th runner to cross the finish line and came in ahead of 836 mostly younger entrants. The New York Road Runners Club says that about a dozen other runners who are over 80 enter the race every year, including Sam Gadless of Boca Raton, Fla., who is 90 now and has been slowing down a bit. In 1993, he finished in 6:04:47. Last year his time was 7:24:59.

Mr. Weintraub, though, has been getting faster. Last year, he dropped almost six minutes off his 1995 time, which was three minutes faster than 1994, which was more than 90 minutes faster than his time of 7:59:29 in 1992. In 1995 he even earned a place in New York City Marathon history: he became the fastest 85-year-old ever to complete the race. (Mr. Gadless set a record that year as the fastest 88-year-old, in 7:12:18. He also holds the record as the fastest 86-year-old in 1993 and the fastest 87-year-old in 1994.)

"Every year, I shave off a few minutes," Mr. Weintraub said before a practice run this week. "I'm steady. When I run three, four miles, I get my wind. That's when I start passing people."

Yes, passing people. In the London Marathon on April 13, where he was the oldest entrant, Mr. Weintraub finished ahead of more than 2,000 and first among the 20 older than 80. He was also something of a star on the BBC. (He brought home the videotape.)

"He has passed quite a number of athletes in the last hour or so," the deep-voiced announcer declares as the tape shows a reporter with a microphone in her hand catching up to Mr. Weintraub.

The tape shows him pausing to chat with the reporter. Then, a surprise end to the interview: he kisses her before he jogs off toward London Bridge.

"I asked permission," he whispers in his apartment in Bay Ridge, watching the tape for perhaps the hundredth time.

The tape shows him finishing just ahead of No. 47202, who Mr. Weintraub said was 65. "He could have beaten me," Mr. Weintraub said. "I'm faster than he is, but my feet were full of lead by then."

But the BBC experience was puzzling. "I don't understand," he said, watching yet another replay of the kiss. "This was five miles before the end. How'd they know I'd finish?"

Finishing is his motto. "Every race I run, I'm scared, scared I won't finish," said Mr. Weintraub, a retired postal worker who competes in about 30 races a year of various distances. "Sometimes people are trying to keep up with me. I tell them the important thing is not to quit. Finish. It's not a question of the order, just finish."

Having started marathon running late in life, Mr. Weintraub does not talk much about runner's highs or the differences between Nike and Adidas. "He claims the reason he could run when he was 80 was he wasn't all that athletic before," his son said, "that people wear out their joints if they're athletic."

Mr. Weintraub developed a regimen: an early-morning run, a game of tennis and a subway ride to Manhattan, where he cruised the fancy food stores. "You know Fairway? You know Zabar's? Citarella?" he asked with the authority of one who has lugged home fully loaded shopping bags from each. "Balducci's, the strip steak is $19 a pound. It's this thick. I go by taste."

Lately, he has dropped the tennis, but not the running. And so, after a cup of extra-strong coffee, he walked two blocks to the long stretch

> ## "SOMETIMES PEOPLE ARE TRYING TO KEEP UP WITH ME. I TELL THEM THE IMPORTANT THING IS NOT TO QUIT. FINISH. IT'S NOT A QUESTION OF THE ORDER, JUST FINISH."
> ## —ABRAHAM WEINTRAUB

of pavement on the Brooklyn waterfront where he has put in so many miles that he knows every stride-throwing hummock and dip.

He had to pull up his white socks, which had slipped to somewhere just north of his ankles. Then he decided to peel off his dark blue sweatshirt, even though it was one of those mornings when the temperature was struggling to make it out of the 40s.

Mr. Weintraub has the course figured out. He plans to jog to the Williamsburg Savings Bank in Brooklyn, about eight miles from the starting line. "If my pace is slowing up, I'll walk after that," he said. "I'm a fast walker." But when he hits Greenpoint Avenue, he intends to start jogging again, right straight into Long Island City. He may do some more walking on the way to Manhattan, but by the time he is closing in on Central Park, he will be going full speed.

"You're born with your speed—nothing you can do about it," he said. "Speed doesn't mean a thing when you run 26 miles. The good

runners, the fellows who teach me, they start off very fast. But it's not how you do the first five miles. It's not a question of the order, just finish."

The medical director for the marathon, Dr. Andres Rodriguez, said much the same thing.

"Older people know not to push themselves to go too fast or too far, so they finish and finish fine," he said. "It's the younger people who think, 'I can do it in five hours.'" Asked about Mr. Weintraub, he said, "If he feels comfortable running this distance, fine. Physiologically, he sounds like he's 50 or 60."

Mr. Weintraub's memories are those of a much older man, though. In his apartment, he is looking at the photographs of himself and his wife on their wedding day in 1936. He is talking rapidly now, remembering his courtship and one unexpected moment. "She gave me the ring back," he says. "I thought she'd picked somebody else."

It turned out that she had not. They were married for 57 years. But questions about their life can still be troubling. How long has it been since she died?

"I can't remember," he says, and there is a catch in his voice. "I always think of her smile, her beautiful smile, and she took that with her."

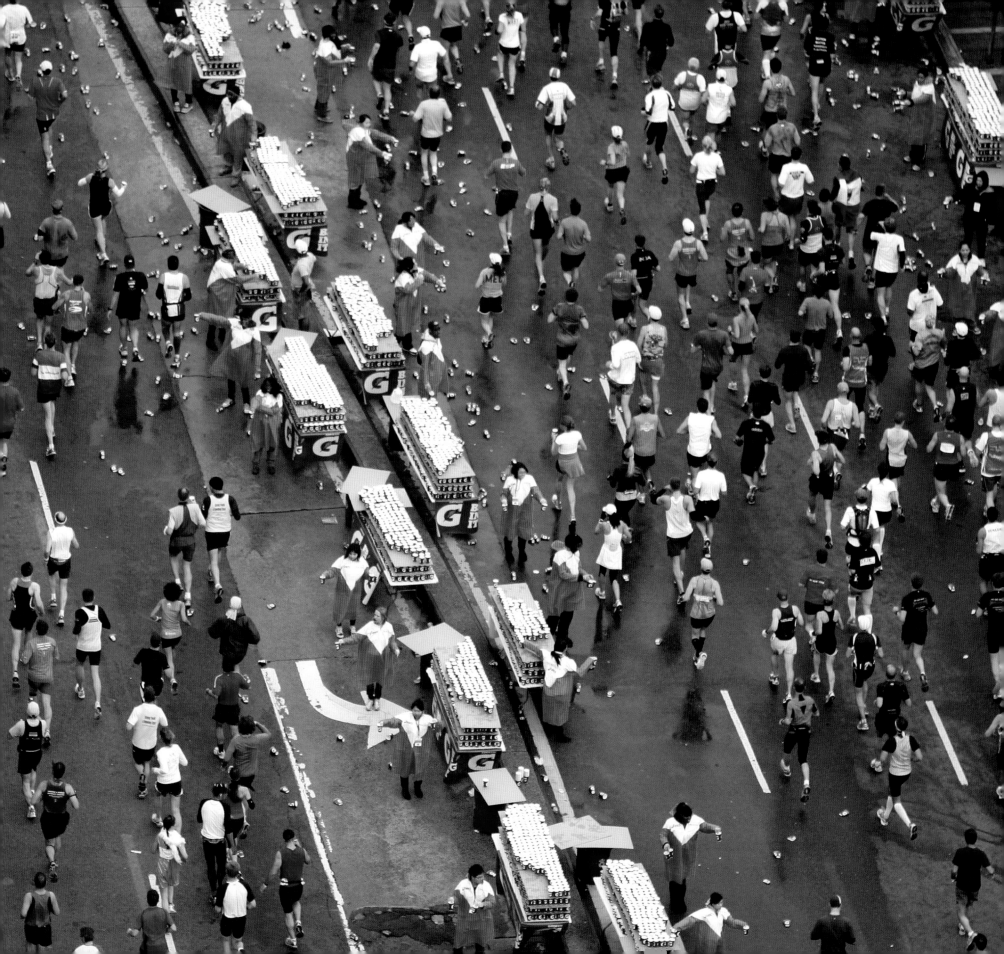

THROUGH THE YEARS:
SPONSORS

The budget for the inaugural New York City Marathon, in 1970, was just $1,000. Fifty years later, the cost of putting on what has grown into the world's largest marathon has increased just a bit. But thanks to help from sponsors, broadcasters, city agencies, and other key partners—both on and off the course—New York Road Runners makes sure that the runners have all they need to make it to the finish.

Since 2014, Tata Consultancy Services (TCS) has been the title sponsor of the Marathon, as well as a year-round premier partner of New York Road Runners. It has been a fortuitous match. Under the leadership of Chief Executive Natarajan Chandrasekaran (known as Chandra and a marathoner himself) and his successor, Rajesh Gopinathan, as well as Surya Kant, president of TCS North America, TCS has helped to make New York City the most technologically advanced marathon in the world, while also supporting its many community initiatives.

Foundation partners for the marathon are Mastercard, New Balance, United Airlines, and the Rudin Family, longtime giant in New York real estate and philanthropy. The Rudin connection is at the very heart of the Marathon. In 1976, Lewis and Jack Rudin honored their late father, Samuel Rudin—an avid long distance runner—by becoming a sponsor of the New York City Marathon. For more than 40 years, the Rudin Family has presented the race's champions with the Samuel Rudin Trophy. As then-NYRR President and CEO Mary Wittenberg said when presenting the Rudin family with the 2013 Abebe Bikila Award, "Their steadfast, decades-long support of NYRR and our marquee event have helped advance the race as one of NYC's most treasured traditions."

Photo by Da Ping Luo/NYRR

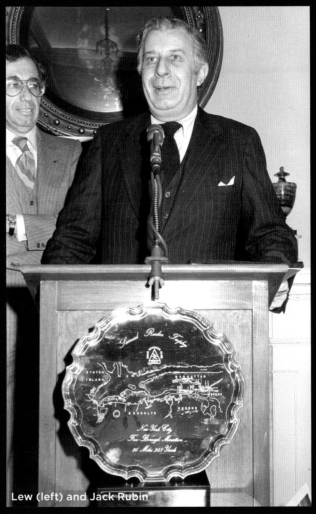

Lew (left) and Jack Rubin

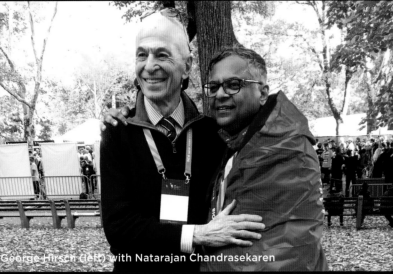

George Hirsch (left) with Natarajan Chandrasekaren

THROUGH THE YEARS:
PARTNER AGENCIES

Frank Shorter famously said, when he agreed to run the first five-borough marathon in 1976, that he was coming because he wanted "to see if the police could close down New York City's streets for a footrace." New York's Finest pulled off the trick that year and have been doing so ever since, even as the race and the crowds have grown far beyond Shorter's—or anyone else's—imagination.

And, of course, the NYPD does much more than simply close down the streets. The several thousand police officers on duty for the marathon control traffic and provide security for the tens of thousands of runners and more than 1 million spectators who make up one of the world's biggest and most logistically challenging public events.

The NYPD, though, is only perhaps the most visible of the nearly 20 city agencies that partner with New York Road Runners to help stage the marathon each year. In addition to security, countless details and tasks must be seen to, from preparing 26 miles of pavement for 100,000 passing feet to moving runners once they're done moving themselves, to cleaning up after the party. The Fire Department, the Sanitation Department, Transportation, Parks and Recreation, Environmental Protection, the MTA, and the Port Authority, among others, all play a role. As, through the years, have the city's leaders, eager to share in the visibility and goodwill created by an event that showcases the best of their city.

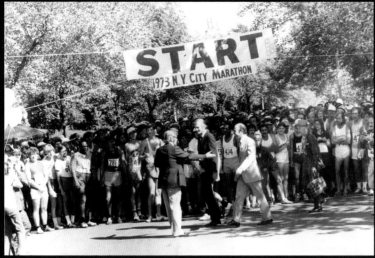

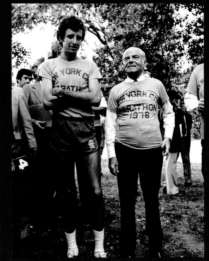

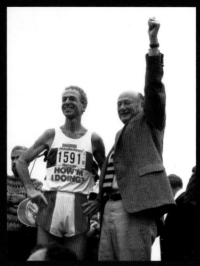

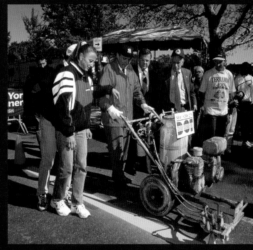

Running for mayor? How about mayors for running? Since its inception, the Marathon has received high-profile support from New York's mayors, including (left to right, top to bottom) John V. Lindsay (in dark suit), Abe Beame (with Frank Shorter), Ed Koch (who was doin' great with George Hirsch), David Dinkins, Rudolph Giuliani (in red), Michael Bloomberg (with Mary Wittenberg and Shalane Flanagan), and Bill de Blasio (with Peter Ciaccia, left, and Bill Rudin).

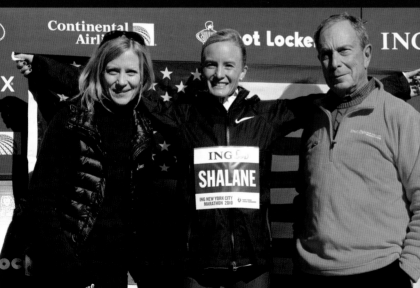

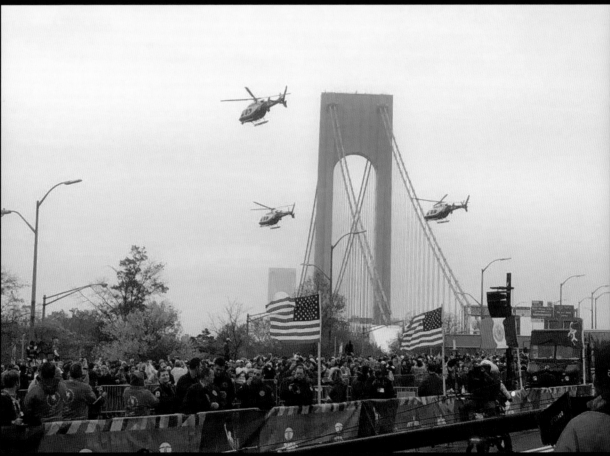

New York City Parks Commissioner Mitchell Silver

2000s

Any marathon, at its heart, is the ultimate personal, *individual* experience. In the course of those 26.2 miles, a runner will get to know herself on the deepest level; he will test his very limits before finally crossing that finish line and realizing, perhaps in amazement: I did it. *I* did it.

But stand on the curb for even a minute, as the New York City Marathon flows past, and you'll know that the race—the moment, the day—is also the ultimate *community* experience. Every *I* running by is also part of an extraordinary *we*. The personal accomplishment is driven, and carried, by the collective passion and energy. That was true from the start in New York, readily and ruddily apparent among the 127 intrepid souls circling Central Park in 1970. But it was made profoundly and inspiringly clear in the first decade of the new millennium.

The 2001 race, of course, took place just 54 days after the terrorist attacks of 9/11 had shaken the city, and indeed the world, to the core. Amid mourning and ongoing apprehension, but buoyed by a determined sense of togetherness, 24,000 runners and two million spectators took to the streets—*their* streets—in a united act of faith and renewal. Running, after all, is about moving forward.

That sense of progress was borne out throughout the decade. The 2000 race included the first official wheelchair division, the hard-earned addition of what would be a compelling part of every race to follow. Driven by New York Road Runners' energy and innovation, overall participation continued to climb, as the race repeatedly set records for the most finishers. At the front of the field, the competition was deeper than ever with such notable moments as the closest finish in the race's history, the brilliance of three-time champion Paula Radcliffe, and, in the decade's final race, the first victory by a U.S. man since 1982. That that champion was 30-year-old immigrant Meb Keflezighi, who left his home in war-torn Eritrea at age 12 to find a haven—and a sport—in America underscores once again what a community this marathon really is.

Above and beyond: From the Verrazzano,
all of New York lies ahead.
Photo by Photo Run/NYRR

119

NEW YORK TIMES, NOV. 2, 2001

MARATHON: SEEKING LONG-DISTANCE SOLACE

BY MARC BLOOM

For a week after Sept. 11, Chris Bilsky was too distraught to train. "Running seemed trivial," said Bilsky, 38, of Manhattan, who lost several friends in the attack on the World Trade Center. "I felt that in honor of the people who died, I shouldn't run."

Then, like many marathoners preparing for the New York City Marathon on Sunday, for whom running has been the centerpiece

Photo by Photo Run/NYRR

of their lives, Bilsky resumed training with renewed strength. "I felt a sense of responsibility to run as an act of defiance against terrorism," she said. "Many times, I couldn't stop crying when I ran, but I feel a duty to stand with 30,000 runners and be united."

"United We Run" is the theme for the 32nd annual marathon, an event that began in 1970 with a field of 127 confined to Central Park and became a five-borough race 25 years ago. The chance to conquer the 26-mile 385-yard run has always offered salvation to those struggling with personal issues. But this year, the event, with 30,000 participants, offers collective healing for the runners, as well as for a city and a region confronting the lingering horror of terrorism.

Bilsky, a nurse who works with patients at Memorial Sloan Kettering Cancer Center, joined in training with a friend, Kathleen Coughlin, whose brother-in-law Tim died in the attack. Coughlin, 34, of Manhattan, is running her eighth New York marathon. "Running together has been a big comfort to both of us," Bilsky said.

Runners gain empowerment by going long distances. "Being physically active helps people cope with trauma," said Douglass Roy Reitter, a therapist who is counseling people who witnessed the World Trade Center attacks from nearby buildings. "Running, especially in a group, reduces feelings of vulnerability and helplessness," said Reitter, who formerly served on the New York City Marathon psyching team, which counsels participants at the start and the finish.

Bilsky and Coughlin are members of the Moving Comfort women's team. Ten of the club's 30 members are entered in the New York marathon, including the coach, Gordon Bakoulis, a former world-class competitor and a contender in the 40-and-over masters division. Bakoulis, who trains 75 to 80 miles a week and hopes to better two hours 40 minutes, said running has been an outlet for her emotions.

Bakoulis expects the marathoners' emotions to be tested at the start of the race on the Verrazano-Narrows Bridge. "With a view of Lower Manhattan, a lot of people will be seeing the devastation for the first time," she said. "I'm trying to prepare myself for that emotionally."

More than 700 people who were injured in the terrorist attacks were brought to St. Vincent's Hospital in Greenwich Village, where the chief surgeon, Marc Wallack, 55, a marathon entrant, put in a week of 15-hour days. "My running saved me," Wallack said. "It's real therapy."

Wallack, a five-hour marathoner, trained mostly late at night on his home treadmill. But after one long weekend run in Central Park, Wallack felt at least briefly that he had regained his runner's idealism. "It was almost as if the tragedy had never happened," he said, "until the run was over."

Wallack is running on Sunday in part for St. Vincent's, which he said lost $6 million to $8 million in the month after the attack, because of a reduction in hospital visits. "We were on the front lines," he said. "We hope people will remember us."

Jamie Wetzl, a 33-year-old Washington lawyer who formerly served on the staff of the National Security Council, was, like Bilsky, too despairing to run after the attacks. But a desire to make "a statement to the world" boosted his energy.

Wetzl, a veteran of 12 marathons, has a best time of 2:56. He recalled his first marathon, in Bangkok in 1993, when he was working with a United Nations peace mission in Cambodia. "The Cambodians had lived through a decade of war and ran in Bangkok to show their enduring spirit," Wetzl said. "At the time, I never thought I would be in a similar position, to use the marathon as a statement of humanity."

Americans who are running abroad have expressed similar feelings. Sabrina Brianca Oei, a 26-year-old teacher in Basel, Switzerland, ran the Berlin Marathon on Sept. 30 with the name of her tennis teammate at Williams College, Lindsay Morehouse, on her racing jersey. Morehouse, who graduated from Williams in 1999, died in the terrorist attacks.

Oei, the first American woman to finish at Berlin, ran 3:16:23. "Lindsay was my fighting

spirit during the marathon," she said. "When the running got tough, I drew upon the energy she'd shown on the tennis court."

Bilsky, whose best marathon is 3:10:30, has run 16 marathons in seven years. On Sunday, she will run in memory of three people lost on Sept. 11: Dick Morgan, Liam Colhoun and Tim Coughlin. Their names will be written on her arms.

Morgan, 70, a retired Con Ed worker from Glen Rock, N.J., and a friend of Bilsky's, was called in to help with gas lines after the first tower at the trade center was hit. Morgan had helped Bilsky, who has a nine-year-old daughter, get through a divorce in 1996. "He was one of the most caring people I knew," she said.

Liam Colhoun, 35, was the son of a friend, Joe Colhoun. Liam worked for Bank of America on the 86th floor of the north tower and was last seen trying to help someone out of the building. Joe Colhoun lives in Brooklyn and holds up a sign with Bilsky's name every year when she runs up Fourth Avenue in the marathon.

Bilsky's patients also look out for her during the marathon. "Some are out on the course, others watching on TV from their hospital beds," she said.

Bilsky, too, recognizes them. "Every year," she said, "I concentrate on one patient who has suffered a great deal and dedicate the marathon to him or her in a prayerful way."

The mix of joy and sorrow that will mark this year's marathon is recalled in the memory of Tim Coughlin, Kathleen Coughlin's brother-in-law, who was a managing director at Cantor Fitzgerald, which lost more than 650 employees on Sept. 11. Tim was 42, the father of three children and a runner who led many family members into the Montauk Triathlon each year on Long Island.

Kathleen Coughlin, 34, has five-year-old triplets with her husband, Rob, who worked in the World Financial Center. Kathleen said Rob and his brother Tim were best friends.

"MY RUNNING SAVED ME. IT'S REAL THERAPY." —MARC WALLACK

Kathleen grew up with eight brothers in Rockaway Beach, Queens. One brother escaped from the World Trade Center and four others—three police officers and one firefighter—helped with rescue efforts. In the aftermath, Kathleen felt guilty running until Bilsky summoned her to train, saying, "We're going to get through this."

Inspired by Coughlin's strength, Bilsky increased her training to a high of 80 miles a week. But her 20-mile runs with her husband, Mark Bilsky, a neurosurgeon and a marathoner, which would take them past the World Trade Center, were no longer as carefree as they used to be. "It seems like a tiny piece of me is gone," Bilsky said.

On Sunday, she hopes to get it back.

CELEBRATING CONTINUITY, MOURNING THE ABSENT

BY JERE LONGMAN

As police officers and firefighters linked arms to lead the field of 30,000 onto the Verrazano-Narrows Bridge yesterday, they wore race bibs, but they also wore photographs of their fallen colleagues and relatives. They wore the names of the dead on their arms and they scribbled badge numbers on their headbands.

Then the New York City Marathon began, and as the runners began to climb the bridge, many looked to their left to see the brutal altering of the Manhattan skyline, a construction crane visible where the twin towers of the World Trade Center once stood.

"It's empty, like something important is missing," said Patrick Chambon of Bordeaux, France, who was running this race for the fifth time.

"Like someone moved a mountain range," said Greg Sichenzia, a volunteer working his 15th New York City Marathon.

In the wake of Sept. 11, the mood at the start was subdued. In many ways, it was a race of the absent—5,000 lives, the World Trade Center, the usual thick crowds and festive celebration all along the 26.2-mile route.

Yet the mood lightened and built as the race went on. No incidents of terrorism were reported. The crowds bulged along First Avenue and in Central Park. The cheering grew louder, and a spirit of resilience, defiance and diversity finally prevailed, as evidenced by the patriotic fervor of the runners and spectators and the course records set by the men's and women's winners, Tesfaye Jifar

Photo by E.H. Wallop/NYRR

of Ethiopia (two hours, seven minutes, 43 seconds) and Margaret Okayo of Kenya (2:24:21).

"The mood was so positive; people were so proud to be out there," said Carrie Quill, 22, of Boston, who finished 125th in the women's race in 3:13:08. "To see the firemen and policemen out there cheering for us for something that seems so inconsequential, it was just beautiful."

At 3:07:46, Tim McCauley of Ladder Company 78 on Staten Island became the first New York City firefighter to cross the finish line. He lost a close friend in the insurance business in the trade center disaster, along with two colleagues from his former ladder company. After Sept. 11, McCauley trained for the race after working long shifts at ground zero, coming home early in the morning, forcing himself to go out and run instead of lying on the couch. Other firefighters and police officers said they had trained at the oddest of hours: 10 at night, three in the morning.

"It was heartbreaking not to see those towers," McCauley said. "But I feel proud for all of New York's Bravest. Sept. 11 kept coming in and out of my head. Any time I started feeling pain, I started thinking of my friends, what they went through, and I think it pulled me through."

As the runners gathered for the start at Fort Wadsworth on Staten Island, a number of them mentioned that the tone of the race seemed more emotional, somber, restrained than usual. Some admitted that they were concerned about the vulnerability of tens of thousands of people beginning a race on the

Photo by Photo Run/NYRR

Verrazano-Narrows Bridge. "You can sense the sadness," said Maritza Vega of Brooklyn, who was running the marathon for the 10th time. "You see a lot of quiet, straight faces."

Yet Vega and the vast majority of runners had certainly started training well before Sept. 11 and had put in hundreds of miles on lonely preparatory runs. Many said they would not allow terrorists a psychological victory by dropping out.

"You have to continue to live your life," said Cucho Gómez-Barrios, a former naval officer from Lima, Peru, who said he had experienced the attacks of the Shining Path guerrillas in his own country. "If you don't, the terrorists have achieved their objective."

Competitors wore "United We Run" ribbons. Some carried American flags or wore flag tattoos, socks, headbands or running shorts. Three red-white-and-blue balloon arches swayed over the starting line, and the line marking the course was painted red, white and blue for the final miles in Central Park.

"I'm hurt; the only reason I'm running here is because of what happened on Sept. 11," Cheryl Yohai of Huntington, N.Y., said. "My friends and family told me not to come. Everybody thinks they're going to blow up the bridge while we're on it. But I want to show that New Yorkers survive."

Security was tight but not overbearing. The five bridges along the way were devoid of automobile traffic for the first time, the race director, Allan Steinfeld, said. Runners

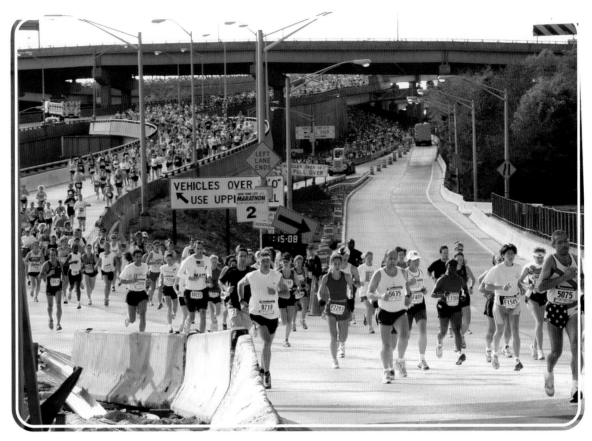

Photo by William Lopez/AP Photo

were allowed to store their gear only in clear plastic bags. A cordon of buses sealed off the tollbooth entrance to the Verrazano-Narrows Bridge. A fire boat sprayed plumes colored red, white and blue, but Coast Guard boats kept all other traffic away.

Some runners said they wanted to show the resolve of the living; others said they wanted to honor the dead. All had personal goals, of course. It is well-nigh impossible to train for a grueling race like this without doing it for oneself. Yet there seemed to be a larger

purpose evident in both the running and the cheering.

Firefighters positioned their ladder trucks at intersections and decorated them with banners to honor colleagues who had died on Sept. 11. Fans held up signs for individual runners named Ray and Bry and Augie, but they cheered, too, for the New York Fire Department and the New York Police Department. "Come on, America," read a sign held by a little girl on Fourth Avenue in Brooklyn.

"Bomb Iraq," another sign hanging on the route read.

Mayor Rudolph W. Giuliani gave a prerace speech at Fort Wadsworth that some runners said they found stirring to the point of tears. "We are stronger than they are," the mayor said of the terrorists. "Our ideas are ideas of free people. Their ideas are ideas of oppressed people. We are right, they are wrong." As the runners gathered on the bridge, he said, "Thirty thousand people are showing they're not afraid."

Joan Benoit Samuelson, the 1984 Olympic marathon champion, ran this year. "I was a little nervous to get on that bridge, a little preoccupied," she said. "But I thought everything was upbeat. It came alive. The people came out and cheered, and not just for the Americans, but for the Kenyans and Chileans and Mexicans. Every time I saw firefighters and police, I felt like tipping my hat."

Ali Kahya, a musician from Queens, ran with a T-shirt bearing the name of Jack Fanning, a fire battalion chief who was killed on Sept. 11. Kahya did not know the firefighter, but his sister did. "I talked to his wife, and I wanted to run in his honor," Kahya said.

Denise Atwood of Brooklyn, a junior high school teacher, ran with a red-white-and-blue ribbon in her hair. Her students feared for her safety, she said, but she decided to run anyway.

"I said, 'Don't worry, I'll be back Monday with plenty of homework,'" she said. "I'm going to give them my finishing time and make them figure out my minutes per mile."

"IT WAS HEARTBREAKING NOT TO SEE THOSE TOWERS, BUT I FEEL PROUD FOR ALL OF NEW YORK'S BRAVEST. SEPT. 11 KEPT COMING IN AND OUT OF MY HEAD. ANY TIME I STARTED FEELING PAIN, I STARTED THINKING OF MY FRIENDS, WHAT THEY WENT THROUGH, AND I THINK IT PULLED ME THROUGH."
—TIM MCCAULEY OF LADDER COMPANY 78

Photo by Photo Run/NYRR

REFLECTIONS ON A DAY OF TRIUMPH

BY DEENA DROSSIN

It is now three weeks after the New York City Marathon. Enough time has passed to distance myself from the "hurt" and really capture all that was wonderful about that weekend. The side stitch I had at the starting line seems less of an obstacle. The fluids I was throwing up at 22 miles seem less repulsive. The fatigue in my legs at the 24-mile mark seems less intense. During it all, I was having the time of my life! The burdens I felt along the way have diminished and I am left with the elation of having been part of the 2001 New York City Marathon.

The world was watching on September 11 when New York was attacked. Resilient. Strong. Enduring. New York is all of these. So are the 24,000 runners who lined up on November 4. People of different races, religions, and fitness levels came to the New York City Marathon with the enthusiasm that successfully launched the city back to its buzzing pace.

Doves of peace flew high over the Verrazano-Narrows Bridge. A banner reading *United We Run* stretched across the starting line. During the national anthem and "God Bless America," Kenyans Susan Chepkemei and Joyce Chepchumba sang along with the Americans. The cannon fired and we were all released for the 26.2-mile challenge ahead of us.

As we crossed the bridge, there was a great gap in the distant skyline where the Twin Towers once stood. The gap was filled with the

Deena Drossin with NYRR President, CEO, and race director, Allan Steinfeld. *Photo by Photo Run/NYRR*

pride of running for a much deeper cause. We were showing the entire world that our spirit could not be shattered. It seemed that more than half a million spectators waved American flags, while the remainder held handmade banners reading *Go USA* or *United We Run*.

When you prepare well for a goal, you go to the line with confidence. Luck seemed to be challenging me the morning of the race. But, when you feel you are running "united" with 24,000 other people for a good cause, that is when great things are accomplished.

Opposite: 2001 New York Marathon, In Memory, FDNY.
Photo by Scott McDermott/NYRR

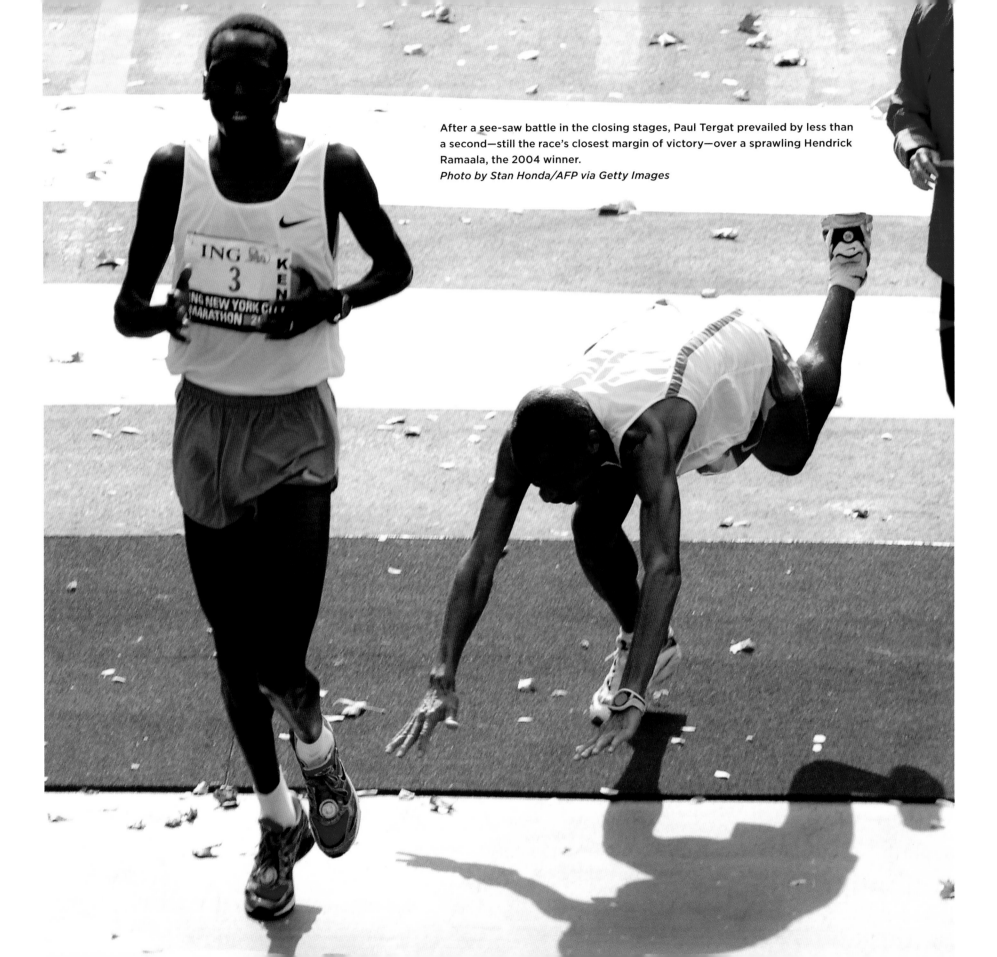

After a see-saw battle in the closing stages, Paul Tergat prevailed by less than a second—still the race's closest margin of victory—over a sprawling Hendrick Ramaala, the 2004 winner.
Photo by Stan Honda/AFP via Getty Images

DOUBLE BREASTED

BY BRIAN CAZENEUVE

In the three months leading up to the New York Marathon, Kenya's Paul Tergat often sprinted through the hills of N'gong, near the capital, Nairobi, with the final leg of the course, a hilly portion of Central Park, in his mind. "I thought the race could be won in the last kilometers in the park," he said. "Every hill I ran in training, I ran [to gain] an extra step in the park." On Sunday afternoon Tergat's hunch proved right. He and defending champion Hendrick Ramaala ran shoulder to shoulder through the park, and Tergat outsprinted the South African to the finish by less than a second—the closest margin in the race's history—in 2:09:30. Meb Keflezighi, the Eritrean-born American, ran with the leaders until the final mile but faded to third in 2:09:56. (No U.S. runner has won the race since Alberto Salazar in 1982.)

Tergat's victory added to a career littered with stellar performances and near misses. He has won the World Cross-Country Championships five times, and two years ago he won the Berlin Marathon in 2:04:55, lowering the world record by a staggering 42 seconds. Yet he has settled for four Olympic or world championship silver medals at 10,000 meters—most notably at the 2000 Sydney Games, when Ethiopia's Haile Gebrselassie barely outsprinted him to the line. "As Hendrick and I began to sprint," said Tergat of Sunday's race, "I thought about Sydney and said, 'Not second again. Two hours is too long to be second.'"

In New York the lead changed hands four times in the final .2-of-a-mile section of the park. With a few feet to go, Tergat pulled ahead and held on even as Ramaala flung himself across the tape and fell to the ground. (The women's champ had an easier time. Jelena Prokopcuka of Latvia won by 14 seconds over Susan Chepkemei of Kenya.)

In a postrace interview Tergat—whose wife, Monica, met him at the finish line—expressed fascination with American TV, particularly the reality show *The Biggest Loser*, which rewards contestants for losing weight. The champ is an ambassador for the UN's World Food Program, which used to feed him lunch at school. Those meals, he said, supplemented the daily porridge bowl his mother could afford to give him and two of the 17 siblings from a polygamous family who lived with him in a mud hut. "I arrived here prepared for anything," he said. "Not for the lifestyle, but certainly for the race."

"I THOUGHT ABOUT SYDNEY AND SAID, 'NOT SECOND AGAIN. TWO HOURS IS TOO LONG TO BE SECOND.'"

NEW YORK TIMES, NOV. 7, 2005

AFTER A BUMPY CHALLENGE, A ROAD RECORD AND SORE ARMS

BY FRANK LITSKY

Ernst Van Dyk was born with congenital birth defects or, as he put it, "basically without legs from the knees down."

At 22, Edith Hunkeler was in an auto accident that left her legs paralyzed.

Both took up sports and enjoyed quick success. Yesterday they reached high points in the New York City Marathon.

Van Dyk, a 32-year-old South African, won the men's wheelchair race in one hour 31 minutes, 11 seconds, a course record. He set the world record of 1:18:27 last year over the Boston Marathon's largely downhill course. He has won in Boston the last five years; this year he raced in five marathons and won them all.

This was his second marathon victory in eight days. Last Sunday he won in a field of 300 in Oita, Japan, then flew to South Africa to pick up his wife, then flew here Wednesday.

Hunkeler, a 33-year-old Swiss, won the women's race in 1:54:52. Last year she set the course record of 1:53:27.

Each winner collected first-place money of $3,500, and Van Dyk earned an additional $1,500 for breaking the course record. Although they are elite professionals and race full-time for a living, they received no appearance money.

Van Dyk and Hunkeler are sponsored by Invacare, which makes medical equipment and wheelchairs. Every year, the company gives each of them a made-to-order racing wheelchair, a sleek 17-pound machine that is worth $5,000 to $7,000.

"They last," Van Dyk said. "I'm going to use this one next year, too."

Unless he and the chair have a bad crash.

"Like runners, we have to struggle with injuries," he said in a postrace interview. "Ours are just different. We get shoulder, neck, upper- and lower-back problems because of the impact of our hands coming down on the wheels. I'm going to be hurting after this one."

Earlier, in a news conference, Van Dyk said that New York City was physically and mentally the toughest marathon in the world.

"It's a very, very challenging course," he said. "All those bridges, hills, lots of turns. The roads are real bumpy. There are a lot of holes in the roads, and you have to be very alert. Boston is just a straight shot with one sharp turn. Here, there is a lot of turning, a lot of climbing, a lot of descending. And sometimes we reach 40 miles an hour."

When the winners were asked if the physical demands were as great for them as for the runners, they said they had no basis for comparison.

Ernst Van Dyk celebrated his course-record victory.
Photo by Gregory Bull/AP Photo

1:31:02

"That's a really tough question because I've never run a marathon," Van Dyk said. "I think there are different challenges. If you're climbing up a hill and stop, you could go backward. If you're a runner standing still, you'll stay where you are. So we have to overcome that. But we have the advantage in the downhills of resting a bit and recovering, so I think it's pretty much even."

Hunkeler said: "I've never run a marathon, either, but I know it's hard. I train very hard like a runner. The distance is the same, and I think that's the most important thing."

Two years after Hunkeler's auto accident, she started racing in a wheelchair. It wasn't easy.

"You realize you're never going to walk again," she said. "You struggle with yourself a lot, but I had good opportunities in sports and I took them."

Van Dyk said his parents encouraged him to take up sports.

"In school," he said, "I did wheelchair basketball, track and field, table tennis and swimming. I went to the 1992 Paralympics in Barcelona, where they let spectators in free, and there were 80,000 people screaming every day. To compete in front of crowds like that sold me."

What if Van Dyk and Hunkeler could have become marathon runners rather than wheelchair racers?

"If I wasn't disabled," Van Dyk said, "I would never have achieved what I have in life. If I was able, I probably would never have achieved this."

Hunkeler listened and nodded.

"I don't think much about that," she said. "I have a good life now. I can do everything I want except walk."

"IF I WASN'T DISABLED, I WOULD NEVER HAVE ACHIEVED WHAT I HAVE IN LIFE. IF I WAS ABLE, I PROBABLY WOULD NEVER HAVE ACHIEVED THIS."
—ERNST VAN DYK

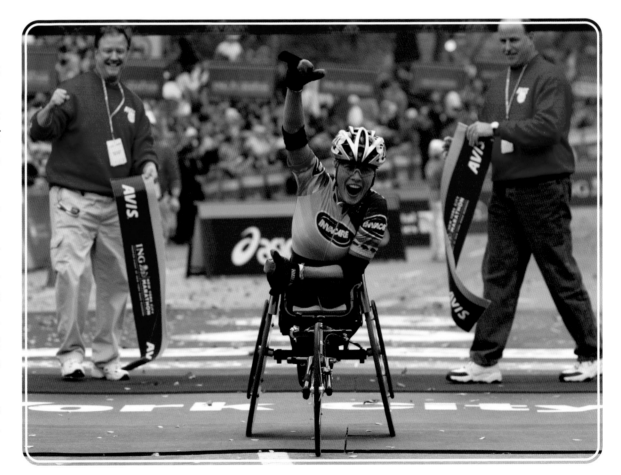

For Edith Hunkeler, it was win No. 2. She would add three more in her career. *Photo by Photo Run/NYRR*

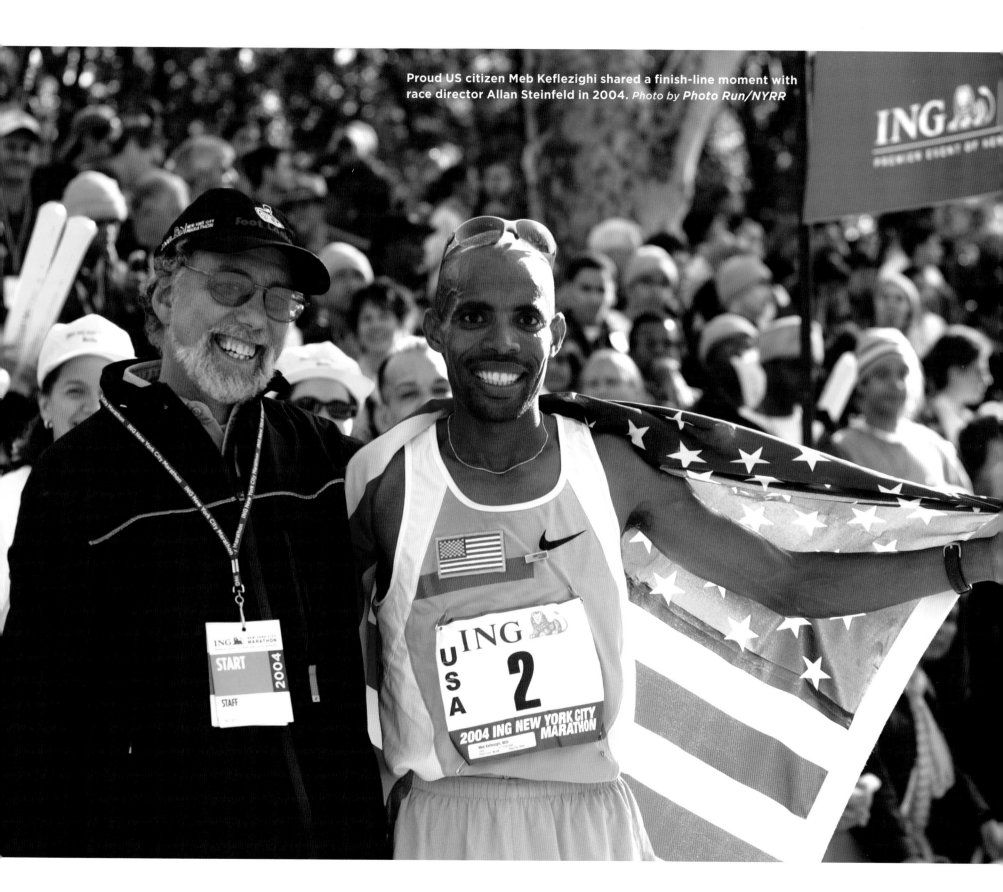

Proud US citizen Meb Keflezighi shared a finish-line moment with race director Allan Steinfeld in 2004. *Photo by Photo Run/NYRR*

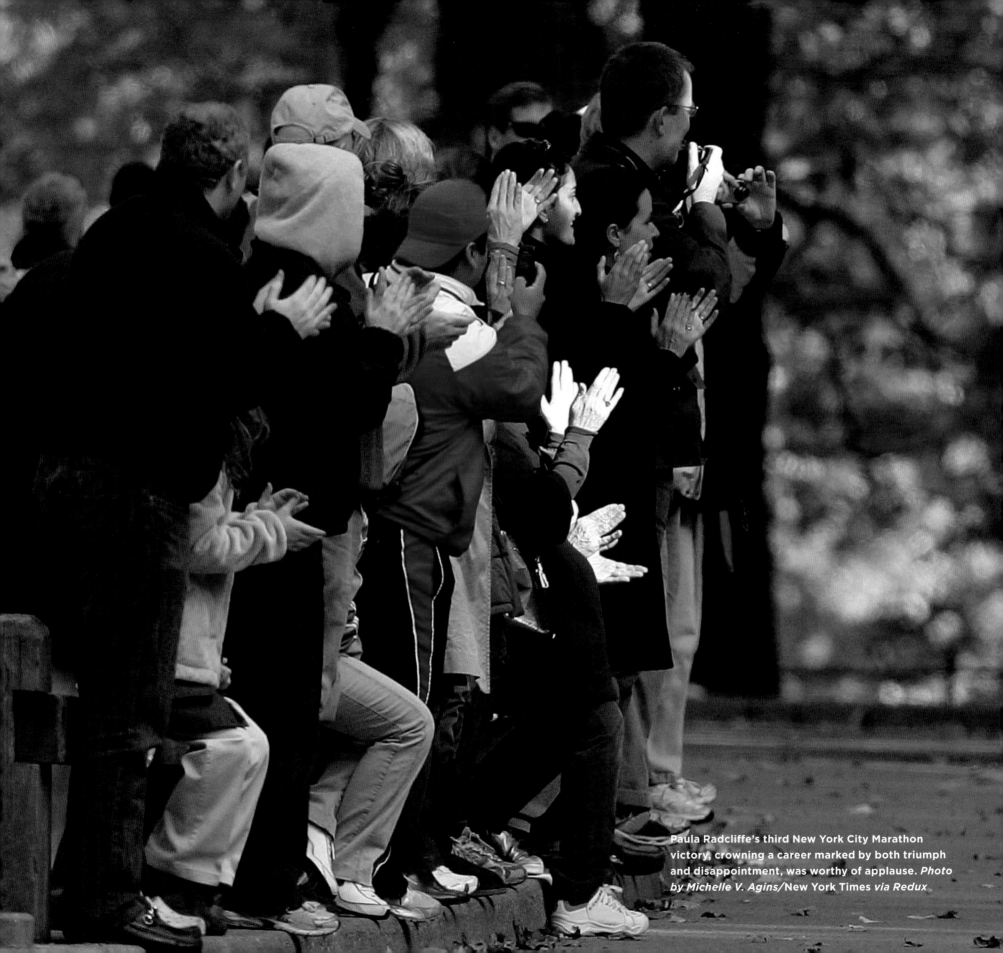

Paula Radcliffe's third New York City Marathon victory, crowning a career marked by both triumph and disappointment, was worthy of applause. *Photo by Michelle V. Agins/New York Times via Redux*

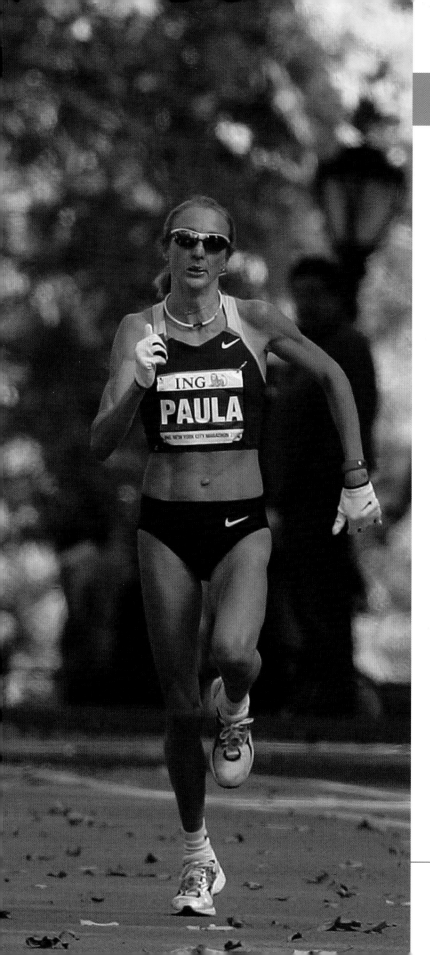

RADCLIFFE REASSERTS HER SUPREMACY

BY JERE LONGMAN

For elite runners, marathons are not unlike bank accounts. Only so many withdrawals can be made before the body exceeds the available balance of miles, and speed and stamina.

At 34, battling recent stress fractures and two Olympic disappointments, Paula Redcliffe of Britain had come to a moment of accounting on Sunday—a victory at the New York City Marathon would signal that her career remained encouragingly solvent at the top international level, while defeat might indicate that her legs had reached the overdraft of inevitable decline.

On a windy, cold morning, Radcliffe ran a pitiless race, leading from beginning to end over 26.2 miles, hammering the pace, shedding the rest of the field with four miles remaining and winning in New York for the third time, in two hours 23 minutes 56 seconds.

Radcliffe won so thoroughly that she finished almost two minutes ahead of the next runner and completed the second half of the race nearly three minutes faster than the first half. She did not approach her world record of 2:15:25, but that was not the point while running into the hills and into a headwind. Victory in New York is always more important than time.

The win will give Radcliffe leverage when her Nike contract comes up for renewal in January and will let the rest of the world's top marathoners know that she is serious in her ambition of challenging for a gold medal at the 2012 London Olympics. By then she will be 38, the same age as the 2008 Olympic champion, Constantina Tomescu-Dita of Romania.

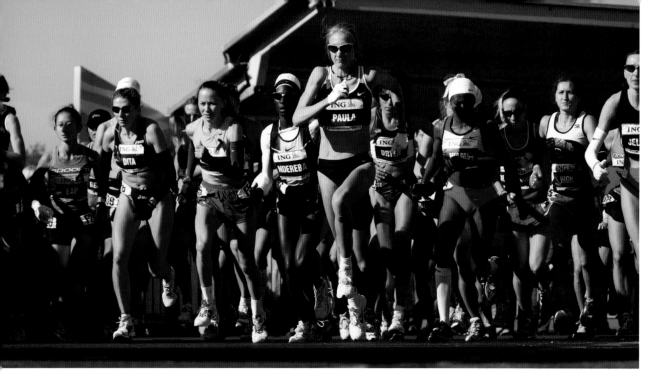

Radcliffe charged to the lead from the start.
Photo by Suzy Allman

"I'm sure she can do it," Tomescu-Dita, a spectator on Sunday, said. "She was so strong today from beginning to end."

Lyudmila Petrova of Russia, the 2000 New York champion, took second at age 40 in 2:25:43 and set a world record for a masters age-group runner.

Kara Goucher of the United States, competing in her first marathon, fought off stomach cramps and took third in 2:25:53, a debut record for an American woman. Deena Kastor held the previous debut mark of 2:26:58, set in 2001. Goucher's finish was the best by an American woman in New York since Anne Marie Letko took third in 1994.

Beyond Sunday's start, Radcliffe knifed into the lead on the humpbacked first mile along the Verrazano-Narrows Bridge, with the temperature at 41 degrees and a northeast wind blowing at 15 miles an hour. That is her style, assertive, unwavering, no patience for letting others set the pace.

Dressed in a purple singlet with only a pair of white gloves to protect against the chilly headwind, Radcliffe ran with her familiar nodding style. She served as a windbreak for the lead pack. Petrova, Goucher and the other challengers tucked in behind.

"It was tough out there because of the wind," Radcliffe said. "Everyone seemed to want to run behind me."

Less than three months ago, at the Beijing Olympics, Radcliffe stopped during the race to stretch her aching, cramping legs and

finished a distressed 23rd. She had been unable to train sufficiently after a stress fracture in her left femur in May. This had come after the huge disappointment at the 2004 Athens Games, where Radcliffe did not finish in the oppressive heat and humidity.

She had no such vulnerability on Sunday. After reaching the halfway point in 1:13:23 in a pack of five runners, Radcliffe began to escalate the pace. Wearing black sleeves to warm her arms, Goucher, 30, seemed comfortable running in Radcliffe's slipstream. At least for a time. Her return home for her marathon debut bore a sense of the bittersweet. Goucher is a native of Queens, but she moved to the Midwest at age four after her father was killed by a drunken driver on the Harlem River Drive.

She won a bronze medal in the 10,000 at the 2007 world track and field championships and competed in the 5,000 and the 10,000 at the Beijing Games, which left Goucher entering Sunday's marathon with ebullient hopes. But hope is not the same as experience.

On First Avenue, Radcliffe covered Mile 17 in 5:16. One moment, Goucher appeared relaxed, the next she was in trouble. Then she fell away, as others had before her, including Catherine Ndereba, the 2008 Olympic silver medalist, and Gete Wami, the 2007 New York runner-up, who lost a chance to win a $500,000 bonus as part of the World Marathon Majors competition.

A year ago, Radcliffe did not subdue Wami until the final mile. The suspense ended much earlier Sunday.

Radcliffe began to bob her head more noticeably, as she always does, a tic that seems to signify her exertion and determination. By Mile 20, only Petrova was left to challenge her. Radcliffe did not look back, fearful of stepping in a pothole and of violating her father's assertion that peering at other runners "is a sign of weakness."

Mercilessly, Radcliffe put her foot heavily on the accelerator. She ran Mile 21 in 5:18 and Mile 22 in 5:12, striding easily and boldly, while Petrova shuffled desperately behind, fading, trying to hold off a renewed Goucher for second place. First place had been long decided, though victory in New York only highlighted Radcliffe's failures at the Athens and Beijing Olympics.

"It does make it frustrating," she said. "You think, 'Why can I get it right in New York and I can't get it right there?' "

Others have begun to suggest to Radcliffe that she reduce her training or her racing in an effort to preserve whatever greatness remains in her legs. So far, she has resisted the advice. Sunday demonstrated why.

"There is a finite number of good marathons in anyone," Radcliffe said. "But I do believe that number varies from person to person. You never know until you are kind of on the downside that you are. So I'm grateful for each one and hope it's going to hold."

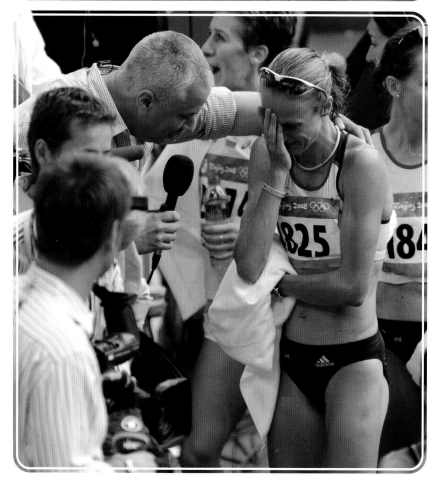

Though favored at both Athens (top) and Beijing, Radcliffe would see her Olympic marathon hopes twice dashed. *Top photo by Nick Laham/Getty Images*; *bottom photo by Bob Thomas Sports Photography via Getty Images*

"I AM AN AMERICAN"

BY TIM LAYDEN

He watches calmly as his defining moment is replayed. Mebrahtom Keflezighi leans forward on a soft couch in the living room of his home in Mammoth Lakes, Calif., a high-altitude training paradise amid glacial lakes and craggy gray peaks. On the television screen he is at the 2004 Olympics winning a silver medal, the first U.S. men's medal in the marathon since Frank Shorter's silver in 1976. On the couch Keflezighi is autopsying his performance—and, more painfully, its aftermath.

There were slightly more than two miles to run in Athens when Stefano Baldini of Italy boldly dropped the hammer on Keflezighi, pulling away in the gathering darkness and dense humidity. Keflezighi, who had trained and raced brilliantly, chose to protect a silver medal finish rather than risk a collapse by racing for the gold. "If I had it to do again," he says, "I would go with him."

Baldini cramped at the end, while circling the track in ancient Panathinaiko Stadium, and Keflezighi felt strong and light. But it was too late; Baldini's lead was too large. Still, the silver was sweet. Then came the postgame.

Before Keflezighi (pronounced ka-FLEZ-ghee) could wrap himself in the U.S. flag and fully celebrate his—and his adopted country's—medal, he was whisked away for drug testing. The medal was hung from his neck that night just before the closing ceremonies (the marathon was the final event), and a few hours later the Games were over. The world moved on. For Keflezighi there were no morning talk-show appearances, no lingering star-spangled glory. "Bad things for me," he says. "I would have carried the flag; I would have gone on television."

On Sunday, Nov. 6, Keflezighi will run in the New York City Marathon, trying to become the first American to win the five-borough race since Alberto Salazar did so in 1982. His Olympic silver 14 months ago, and his runner-up finish in New York 70 days later, have made him rich (he commands six-figure fees for top marathons) and given him a small degree of celebrity. "People shake my hand in airports," he says. Yet he still straddles two cultures.

Keflezghi, who was born in Ethiopia 30 years ago, has led a revival of U.S. elite-level distance running since graduating from UCLA in 1998. He has won two national championships in cross-country, three at 10,000 meters and two at 15,000 meters; broken a 15-year-old U.S. record in the 10,000 (by running 27:13.98, in 2001); and won that Olympic medal. "He's not just a leader," says U.S. marathoner Alan Culpepper. "He's been a pioneer."

Young runners idolize Keflezighi. In the summer of 2004 members of a high school cross-country team from Southern California were in Mammoth Lakes for a training camp and found Keflezighi's house. He was not home, but they left a message with one of his friends: Tell Meb he's our hero. "I've told him, 'Meb, you have no idea how many people you're inspiring,'" says Salazar.

But he confuses people too. Keflezighi immigrated to the U.S. from war-torn Eritrea at age 12 and took his first serious steps as a runner when he ran a 5:20 mile as a seventh-grader. Still, some Americans won't credit a domestic distance-running rebirth to a man born in Africa. They whisper and blog. "Meb has my respect as a great runner, a great person and a great American," says U.S. runner Dathan Ritzenhein, 23. "But I'm sure it's hard for some people to differentiate between Meb and the East African runners who seem to dominate the sport."

Says Keflezighi, "All because my name is difficult to pronounce."

After winning Olympic silver, Keflezighi awaited a congratulatory call from Shorter, the 1972 gold medalist in the marathon. He is still waiting. "Meb's performances speak for themselves," Shorter told SI. As for his reasons for not calling, he said, "I'm not going to talk about it."

Meb's story begins in Eritrea a quarter century ago. Russom Keflezighi was the father of five young children (Meb was number 4), husband to a pregnant wife, Awetash, and a hunted member of the Eritrean Liberation Front, a civilian organization seeking independence for Eritrea from Ethiopia. "By 1981 the enemy was very close," he says. He would often sleep in the woods outside his village to avoid detection.

His wife urged him to leave the country rather than be jailed or killed. In July 1981 Russom walked out of his village in tears and headed for the border with Sudan, nearly 100 miles and seven days away. Two years later he moved to Milan, Italy, with the aid of an Eritrean woman who had borne him a daughter, Ruth, before he married Awetash.

Russom worked as many as four jobs at once and sent money back to Eritrea. At home the Keflezighi boys dodged violence every day. "We saw body parts on the highway," says Meb. "But it was the only life we knew." In 1986 Russom brought his family to Milan and then—14 months later, sponsored by Ruth, who was 19 years old and living in the U.S.—to San Diego.

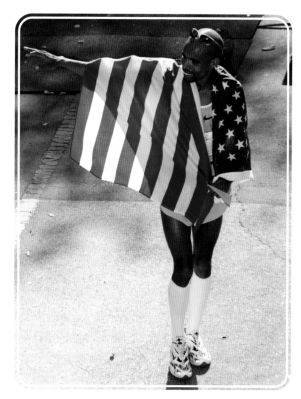

Born in Eritrea, Meb Keflezighi became a US citizen in 1998. *Photo by Kathy Willens/AP Photo*

In California, Russom worked tirelessly. He did not let his children take jobs. "I told them, 'You will have a better life if you study,'" he says. The family grew to 11 kids. Today the six oldest have college degrees, and the seventh is a freshman at Stanford.

Meb, preternaturally quiet (even now), found expression in running. When he joined his brothers on the San Diego High cross-country and track teams, his passion and discipline set him apart. By his senior year he was state champion in the 1,600 and 3,200 meters. UCLA track and cross-country coach Bob Larsen offered him a scholarship. "I liked the way he moved," says Larsen, who still coaches Keflezighi, "and look at his family. These are tough people."

A U.S. citizen since 1998, Keflezighi runs with a lapel pin on his singlet, an American flag next to an Eritrean flag. The suggestion that his East African genes are the key to his success brings a high-pitched laugh from him. If so, he asks, "why did I lose to so many Americans in high school and college?"

In fact Keflezighi has benefited as much from doggedness as from pure talent. "A phenomenal runner, but with great drive," says Deena Kastor, who won bronze in the women's Olympic marathon in 2004. Meb plotted his course for Athens long in advance and, as he told Culpepper, believed he could win a medal.

Looking toward New York City this year, Keflezighi rushed to get fit after recovering from a right thigh-muscle injury he sustained in August. But he reaches racing shape quickly, and earlier this month he ripped off six one-mile repeats in times ranging from 4:50 on the first to 4:27 on the last, with just three minutes' rest, comparable to his best interval-training sessions.

In New York City he will face defending champion Hendrick Ramaala of South Africa, world marathon record holder Paul Tergat of Kenya and 14 other runners with personal bests faster than Keflezighi's 2:09:53. "I should be able to run much faster," Meb says, unintimidated. "Right now, everything is good. Everything is right."

And there is, of course, no place quite like New York to win a race, to wave a flag and to cast aside stubborn labels.

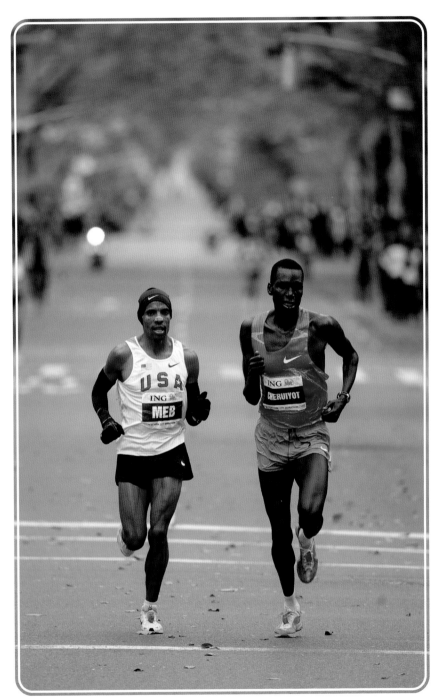

Running in his fifth New York City Marathon, Meb Keflezighi outdueled Robert Cheruiyot to become the first US champ in 27 years. *Photo by Emmanuel Dunand/ AFP via Getty Images*

AMERICAN FLYER

BY TIM LAYDEN

Just beyond the finish line of last Sunday's ING New York City Marathon, fourth-place finisher Ryan Hall of the U.S. embraced the winner, fellow countryman Meb Keflezighi, and said, "You deserved this." It was true. He really did.

New York had carved a small hole in Keflezighi's life. Four times—2002, '04, '05 and '06—he had run its marathon, and four times he had fallen short. In 2007 he ran the Olympic trials marathon, held almost entirely within Central Park, and lost his close friend Ryan Shay, who collapsed and died of heart failure five miles into the race. Meb, as he is known to all in the running world, finished eighth in that race, hobbled by a stress fracture of his right hip that left him unable to walk. In the days after the competition he had to crawl on all fours just to get to the bathroom.

On Sunday, Keflezighi, 34, ran a personal best of 2:09:15 to win the 40th New York Marathon, becoming the first U.S. runner to take the five-borough race since Alberto Salazar in 1982. (Keflezighi emigrated from Eritrea at age 12 and became a U.S. citizen in 1998.) "It doesn't get any better," he said after the race, considering his "whole thing with New York."

His performance continued the steady rise of U.S. distance running, which, appropriately, began when Keflezighi and Deena Kastor won silver and bronze marathon medals, respectively, at

the 2004 Olympics in Athens. Since then two other U.S. runners have won championship medals—Kara Goucher, bronze in the 10,000 at the 2007 Worlds, and Shalane Flanagan, bronze in the 10,000 at the 2008 Olympics—and this past summer in Zurich, Dathan Ritzenhein ran the 5,000 meters in 12:56.27 to break Bob Kennedy's 13-year-old U.S. record.

Hall, who ran 2:06:17 at London in 2008, had been expected to be the next American to win a big-time marathon. But Keflezighi had quietly recovered from his injury at an age when others might have been finished. ("It took me a full year," he says.) He took control of Sunday's race just before the 24-mile mark, surging away from Kenya's Robert Cheruiyot, a four-time Boston winner, as the course turned into Central Park.

At the bottom of a long hill, Keflezighi passed the spot where Shay had died. The two friends had trained together; Keflezighi had admired Shay's relentless work ethic, and Shay had passionately defended Keflezighi on message boards that questioned whether Meb was truly an American runner. Now, in full flight, Keflezighi made the sign of the cross with his right hand, at once honoring the past and pointing to the future.

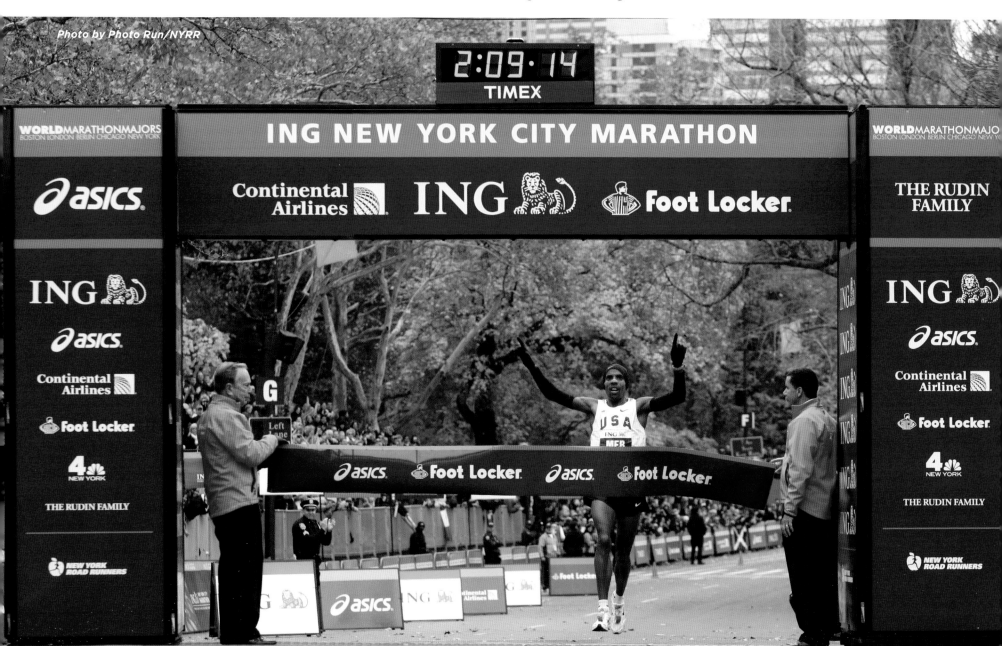

Photo by Photo Run/NYRR

THE STUBBORNNESS OF THE MARATHONER

BY CHARLES WILSON

Old habits die hard.

George Hirsch is 75. He is the founding publisher of *New York* magazine, he ran for Congress in 1986, and he has a personal-best marathon time of two hours 38 minutes (Boston, 1979). A founder and publisher of running magazines, Hirsch helped Fred Lebow plan the first five-borough New York City Marathon, in 1976, and is now chairman of the New York Road Runners, the race's organizer. He has run more than 30 marathons over four decades.

On Nov. 1, Hirsch plans to be at the starting line of the New York City Marathon on the Verrazano-Narrows Bridge. His friends are hoping for the best. Some of them also worry.

"The last few times George has raced marathons, he literally came out looking like a welterweight boxer who had been TKO'd in the eighth round," said Amby Burfoot, a longtime editor at *Runner's World*.

At the Chicago Marathon in 2003, Hirsch, then 69, collapsed 50 yards from the finish and fell on his face. He lost part of two front teeth. At the Mesa Falls Marathon in Idaho in 2007, Hirsch, then 73, fell on his face again. His sunglasses smashed and he was left with a black eye.

Two months later, Hirsch was on pace to run a 3:27 marathon in Albany when he lost his balance running downhill after the 20th mile. He was bleeding, but he picked himself up and took off again.

His back soon seized up. Two police officers on bicycles escorted him the rest of the way. He refused their requests to go to a hospital.

Bart Yasso, who has run more than 1,000 races, described Hirsch as the "most mentally tough runner I have ever met." But in Albany, Hirsch's wife, Shay, watched her bloodied husband shuffle into the finishers' gate and decided they should talk.

"I said, 'This has got to be it, George,'" she said. "'You've run your marathons. You've put it out there and you know what you can do, but this is not good.'"

Hirsch is not the only septuagenarian who has found it difficult to give up marathoning. Ed Whitlock, a Canadian athlete, was 73 when he ran a 2:54 marathon; this month, at 78, he ran a 1:37 half marathon. Last year, 174 finishers of the New York City Marathon were 70 or older, and 15 were in their 80s.

Hirsch, razor thin with a warm smile, had always longed to be good at some athletic endeavor. "I had no natural gifts," he said.

Growing up in New Rochelle, N.Y., he set up a high-jump pit in his parents' backyard and spent hours trying to clear the bar, even though "there isn't a single high-jump gene in there," Shay Hirsch said. In his 30s, he took up distance running—a sport in which "you can improve a lot just on persistence," Hirsch said.

His grit served him as well in life as in running. Hirsch built *The Runner* and *Runner's World* into popular magazines that conveyed his enthusiasm and broadened the sport's appeal. Then, in 1988, Hirsch was working at an exposition for the New Jersey Waterfront Marathon when he met Shay Scrivner, then 40, a brunette with kind eyes.

Hirsch asked her to dinner that night, but she refused. He was so taken with her, however, that he showed up at the starting line the next day—for a race that he never intended to run. He surveyed the

George Hirsch, 2009. *Photo by Todd Heisler/*New York Times *via Redux*

crowd but still had not found her when the gun went off.

"I waited for every person to cross the starting line," Hirsch said. "And then I started to jog. I kept looking left and right, and looking and running and jogging and looking, and at five miles, there she was up ahead of me. I came up next to her and said, 'Hi, how are you?' She said, 'What are you doing here?' And I said, 'Looking for you.'"

They ran the remaining 21 miles together and shared their life stories, including their failed first marriages, and wed the next year.

Hirsch loves his wife more than running, so when she suggested after the Albany race that it was time to stop doing marathons, he agreed. He even seemed relieved. He e-mailed his close friends, including the four-time Boston and New York City winner Bill Rodgers and the Olympic champions Frank Shorter and Joan Benoit Samuelson.

"I'm retiring from marathoning," he wrote. "Yes, this time for good. I really do mean it."

Mary Wittenberg, the president and chief executive of New York Road Runners, remembered receiving that message. "I never accepted or believed that resignation," she said.

In early August, Hirsch went for a long run and made it 17 miles. He began to see some significance in numbers. It was the year of his 20th wedding anniversary and the 40th running of the New York City Marathon, which he last ran in 1994. As he took longer runs, Shay asked, "Are you training for anything in particular?" He kept saying no.

In September, though, Hirsch told her that he wanted to run one last marathon in New York. She agreed.

Hirsch intended to run only part of the Chicago Marathon this month as his final long training run. He told friends he would go no farther than 20 miles. At Mile 20, he felt good and decided to jog in the last six miles. He finished in 3:58 without injury.

Hirsch's friends have mobilized to help him through the finish line in New York. Germán Silva, the 1994 and '95 winner, will run the early miles with Hirsch. Rodgers, who is fighting plantar fasciitis, will run the last few miles with him.

Shorter, the 1972 Olympic champion, said he received a cortisone shot in his damaged left hip so he could join Hirsch and Rodgers. But he realized last week that he would not be healthy enough.

"George is whipping Frank and me," said Rodgers, who has been friends with Hirsch since 1976. "We're 15 years younger than him. We're struggling a little."

Shay Hirsch will be waiting at the finish. Her husband is running for a charity that benefits research into multiple myeloma, an incurable blood cancer that she is battling. When she was recovering from a stem-cell transplant three years ago, he rarely left her bedside for months.

"He is very tenacious," she said. "He doesn't give up on people, either."

THEY RAN THE REMAINING 21 MILES TOGETHER AND SHARED THEIR LIFE STORIES, INCLUDING THEIR FAILED FIRST MARRIAGES, AND WED THE NEXT YEAR.

THROUGH THE YEARS:
WHEELCHAIR RACE

A huge part of the New York City Marathon's magic has been its ability to turn the unheard-of, or even the seemingly impossible, into the new—and inspiring—normal. A handful of oddball guys running 26 miles? How about 50,000-plus men *and women*? A one-off race through all five boroughs? How about an annual city-wide block party copied in capitals around the world?

Nowhere has this transformation, this blossoming, been more dramatic or meaningful than in the race's wheelchair division. Following a long legal struggle, a separate division for wheelchair athletes was established in 2000. A year later, under the division's first race director, Robert L. Laufer, prize money was added. Today, the wheelchair race is one of the most exciting and compelling features of Marathon Day. With their own separate start ahead of the other divisions, the elite wheelchair competitors—a field of 40–50 professional athletes from around the world—pilot their specially designed chairs over New York's bridges and hills (with hay bales placed at the tightest corners),

their wheel-to-wheel duels cheered on by the million-plus spectators and covered mile-by-mile on TV.

Over the years the division has seen some of the Marathon's most exciting finishes and crowned champions whose names resonate alongside those of Rodgers and Waitz, Keitany and Kamworor. Five-time winners Kurt Fearnley of Australia, Edith Hunkeler of Switzerland, and American Tatyana McFadden—along with young US sensation Daniel Romanchuk, who edged Marcel Hug of Switzerland, himself a three-time champ, to win in 2019—have helped to change the perception of wheelchair racing around the world.

In the words of Dorian Kail, New York Road Runners' Manager, Professional Athletes and Program Design, "These men and women don't want to be seen as 'inspiring.' They want to be seen as 'athletes.'"

Their performances on the New York stage over the past 20 years have seen that wish fulfilled.

Daniel Romanchuk

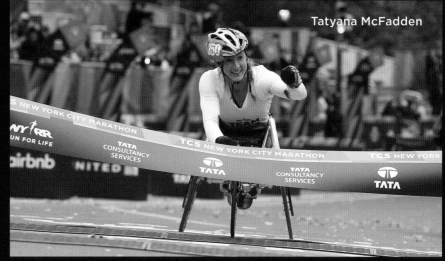

Tatyana McFadden

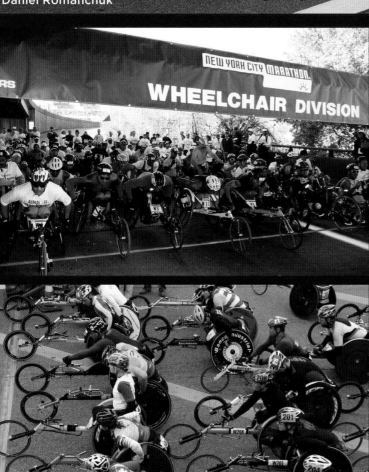

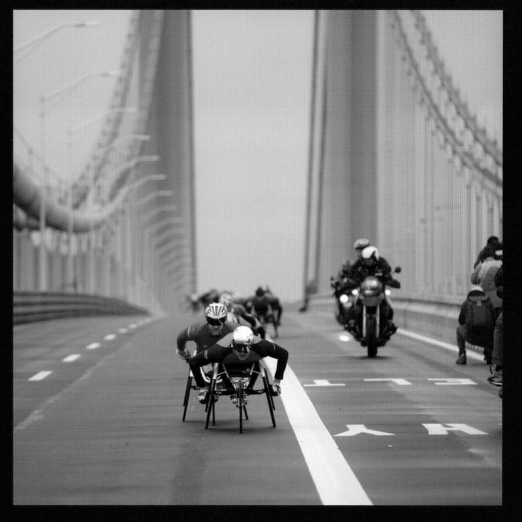

Photo credits, clockwise from top left: Scott McDermott/NYRR; Photo Run/NYRR; Scott McDermott/NYRR; Jillian Babcock/NYRR; Photo Run/NYRR

THROUGH THE YEARS:
CHARITIES

Completing a marathon is, unquestionably, a significant individual achievement. But every year in the TCS New York City Marathon, thousands of the men and women driving themselves toward the finish line are running for something beyond themselves. Inaugurated in 2006, the race's Official Charity Partner Program has given runners a chance to dedicate their efforts to raising money for causes they care deeply about—more than $350 million through 2019. That year, the race field included charity runners representing 421 Official Charity Partners, and raising more than $40 million.

The list of charities represented takes up six pages in the Marathon's media guide, from Achilles International to ZERO, a nonprofit battling prostate cancer. At the top are New York Road Runners Gold-Level Charities:

Team for Kids Founded in 2002, Team for Kids is an international group of adult runners who raise funds for NYRR's youth and community programs while competing in 15 different races. Together they have raised more than $82 million over 18 years.

Fred's Team Created in 1995 to honor the life and legacy of Fred Lebow, Fred's Team is the running program of Memorial Sloan Kettering Cancer Center. Dedicated to funding critical cancer research, runners for Fred's Team have raised more than $85 million.

NYRR Community Champions These runners make a one-time, tax-deductible donation of $2,620 to support NYRR's youth and community programs. In return, they receive four finish line grandstand tickets for the Marathon, VIP bus transportation, and access to a members-only tent at the start of the race—as well as the satisfaction of giving something back with each stride.

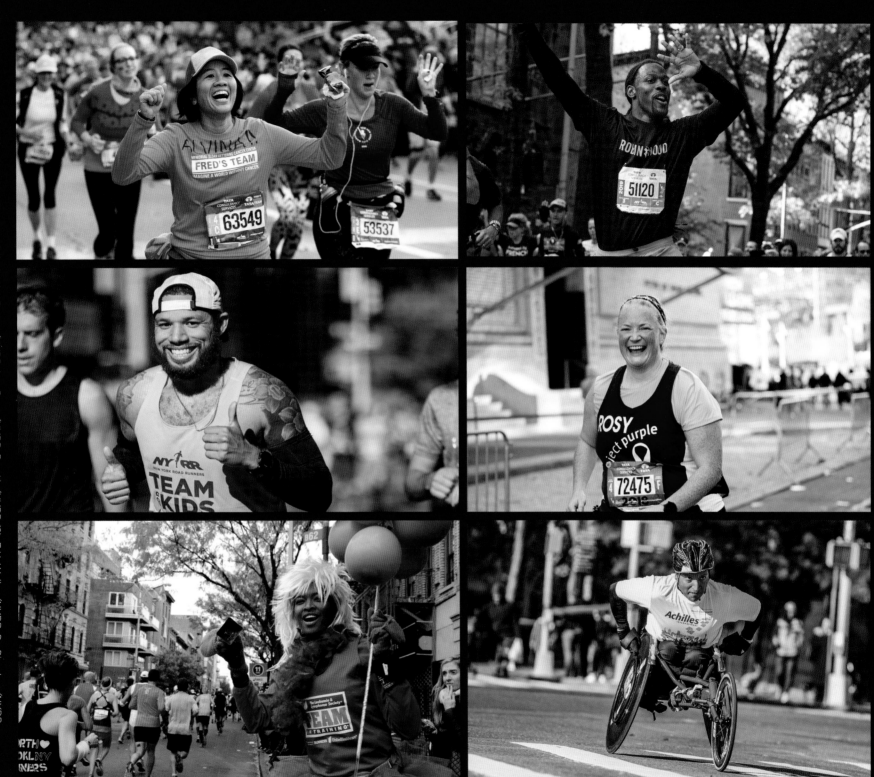

Photo credits, clockwise from top left: Paul J. Sutton/NYRR; Lou Bopp/NYRR; Ben Ko/NYRR (2); E.H. Wallop/NYRR; Da Ping Luo/NYRR

THROUGH THE YEARS:
CELEBRITIES

New York doesn't buy stars," Fred Lebow famously said of his race's longtime refusal to pay appearance fees to top runners. "New York creates them."

New York also attracts them. Since the cannon boomed on the first five-borough marathon, a dazzling roster of men and women more used to performing in front of thousands have shown themselves eager simply to be among the tens of thousands of runners making the 26.2-mile run through the streets of New York.

In 2017, comedian Kevin Hart took time out of a peripatetic schedule that saw him appearing in seemingly every movie released that year to train for and run New York, his first marathon. Said Hart, with unaccustomed seriousness, after his 4:05:06 finish. "It's an amazing feeling," adding, "I can check this goal off my list."

And he's not the only one. To borrow from a popular magazine's familiar headline, Celebrities—when it comes to running—They're Just Like Us! Which means they want to run New York.

The New York Road Runners' list of luminaries from all walks (runs?) of life who, like Hart, have put aside the comforts of their celebrity long enough to make it to that finish line in Central Park—most of them running for charity—is dazzling. Yet, from Sean "Diddy" Combs ("It was a life-changing experience") to Christy Turlington ("So much love in every borough!") to Alicia Keys (postrace tweet: "The LOVE that was out in NYC TODAY was OUTRAGEOUS!!!!!!!"), it's clear the biggest star remains the race itself.

Photo credits, clockwise, from top left: Courtesy of George A. Hirsch; Errol Anderson/NYRR; ZUMA Press, Inc. via Alamy Stock Photo; Mark Mainz/Getty Images; Matt Marquez/NYRR; Photo Run/NYRR; Errol Anderson/NYRR; Steven Ryan/NYRR

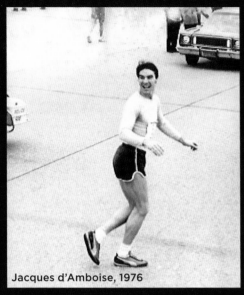

Jacques d'Amboise, 1976

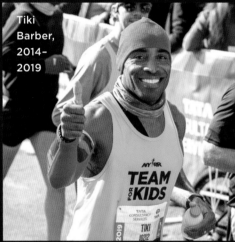

Tiki Barber, 2014–2019

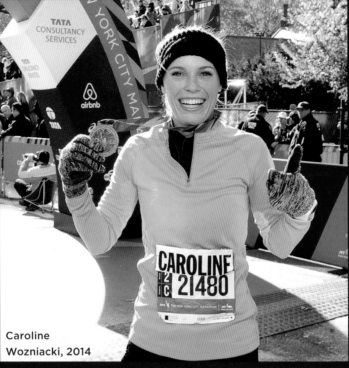

Caroline Wozniacki, 2014

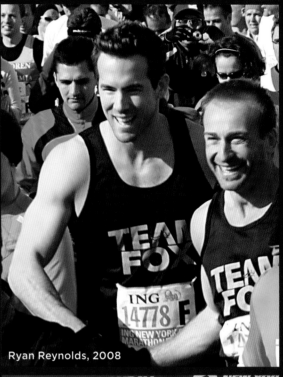

Ryan Reynolds, 2008

Katie Holmes, 2007

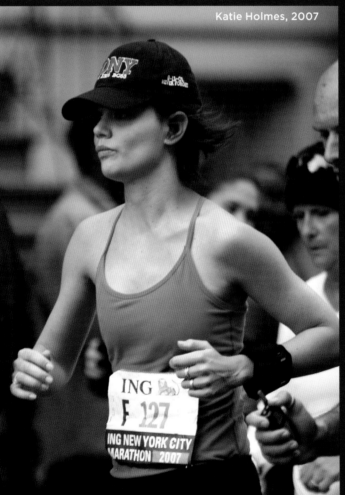

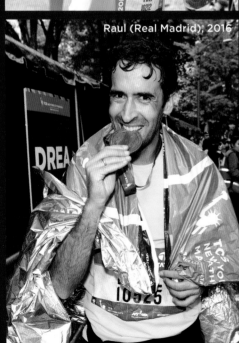

Raul (Real Madrid), 2016

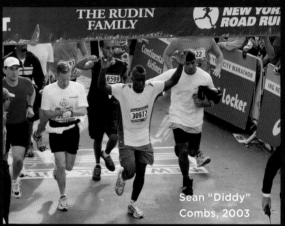

THE RUDIN FAMILY

Sean "Diddy" Combs, 2003

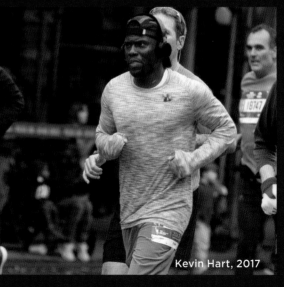

Kevin Hart, 2017

Brian d'Arcy James, 2018

Hugh Jackman, 2014

Ed Norton, Alanis Morissette, 2009

Apolo Ohno, 2011

Karlie Kloss, 2017

James Blake, 2015

Photo credits, clockwise from top left: David Gardiner Garcia/NYRR; Errol Anderson/NYRR; Splashnews.com; David Gardiner Garcia/NYRR; Da Ping Luo/NYRR; David Berkwitz/NYRR

Nev Schulman, 2015

Prince Royce, 2017

Christy Turlington, 2013

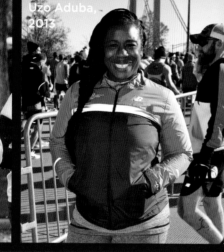

Uzo Aduba, 2013

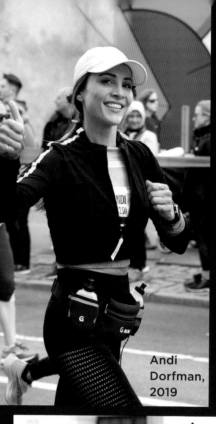

Andi Dorfman, 2019

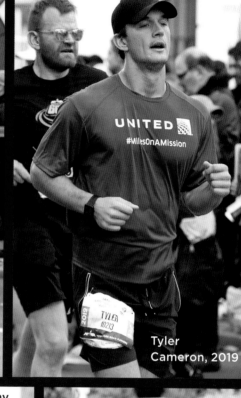

Tyler Cameron, 2019

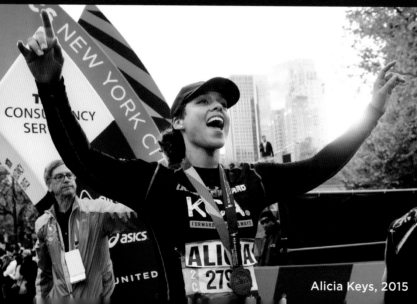

Alicia Keys, 2015

Amy Robach, 2019

Ethan Hawke, 2015

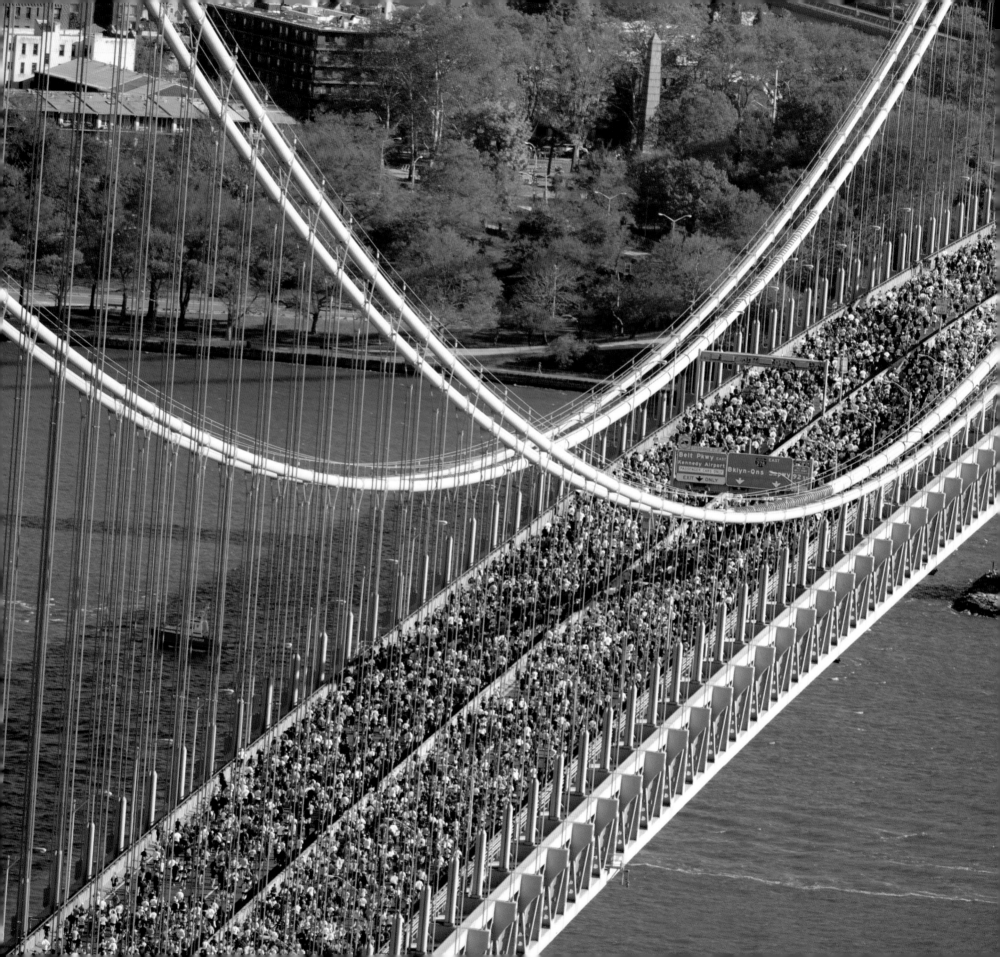

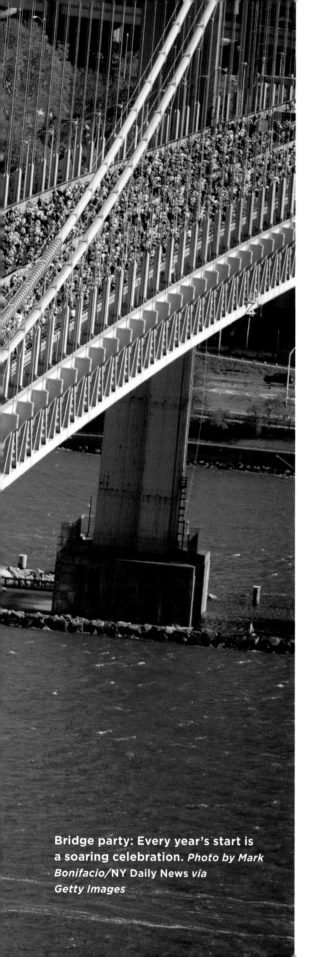

2010s

According to legend, the 6th-century Greek wrestler Milos of Croton could carry a bull on his shoulders—a feat he trained for by hoisting a newborn calf and then repeating the exercise every day until the bull was fully grown. Witnessing the New York City Marathon in recent years should bring the Milos method to mind. Had someone suggested, back in 1970, that 50,000 or more men and women, from more than 150 countries, could set off on a Sunday morning in November and run *26.2 miles* around the five boroughs of New York City—not only without causing chaos but actually bringing joy and vast benefits to the city—such a thought would have been deemed, well, pure bull.

But here we are. From those baby steps in Central Park a half century ago the race has grown year by year—and the city has embraced that growth, stride for stride. And beyond even the five boroughs, the New York Marathon has transformed the sport itself, spawning big-city marathons around the world and opening up the very notion of who runs marathons and why.

The most recent decade continued the trend, with ever-expanding fields and stirring competition. Even cancellation of the race in 2012 in the aftermath of Superstorm Sandy—a painful and difficult decision—underscored how much more than *just a race* the New York City Marathon had become.

How unimaginable this year's race would likely seem to those few dozen inaugural marathoners of 1970. Not just the sheer number of winners and the big bucks showered upon them (We were running for a watch!), not just the spectacular we're-taking-over-this-town course and the million

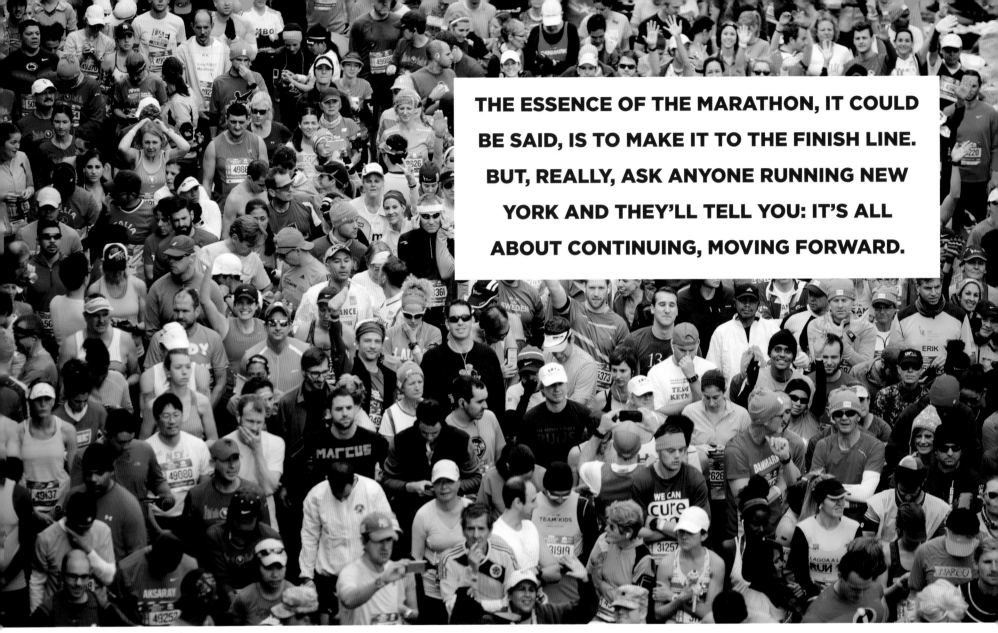

THE ESSENCE OF THE MARATHON, IT COULD BE SAID, IS TO MAKE IT TO THE FINISH LINE. BUT, REALLY, ASK ANYONE RUNNING NEW YORK AND THEY'LL TELL YOU: IT'S ALL ABOUT CONTINUING, MOVING FORWARD.

Photo by Drew Levin/NYRR

cheering, partying spectators lining the way, but so many other elements as well that have become essential parts of the experience: the wheelchairs racing out ahead, the celebrities chugging along in the pack, the vast media spotlight shining down on the runners and the supportive, inspiring social media linking them with one another, and finally the charitable commitments driving so many of the runners who know that no one truly runs alone.

The essence of the marathon, it could be said, is to make it to the finish line. But, really, ask anyone running New York and they'll tell you: It's all about continuing, moving forward. Let's see what the next 50 years bring.

NEW YORK TIMES, NOV. 7, 2010

INTO THE SUNLIGHT AND ONTO THE STREETS OF NEW YORK, THE MINER PERSEVERES

BY THOMAS KAPLAN

Edison Peña could be forgiven for having to slow to a walk at times during the New York City Marathon on Sunday. His training, after all, came via subterranean loops of only a few miles at a time, with the tunnels of a collapsed gold and copper mine for a course and sawed-off work boots for footwear.

But after fighting through knee pain to jog across the finish line in under six hours, Peña wanted to clear something up.

"First of all, I want to say that I would have run faster," he said. "And I did run faster in the mine."

Peña hardly needed to apologize. Three and a half weeks after being freed from the mine in Chile where he was trapped for 69 days, and with no significant distance-running experience, Peña captivated spectators at the marathon in a way few have in the 41 years the race has been run.

He jogged triumphantly across the finish line in Central Park in five hours, 40 minutes 51 seconds, topping his own six-hour goal and stealing the show from the professionals. The race director, Mary Wittenberg, choked back tears when introducing Peña to reporters after the race.

"I think we've just seen the best story in running I think I've ever seen," she said.

It is a story that has already become the stuff of marathon legend—and that was before Peña even laced up his sneakers.

During his confinement in the mine alongside 32 other miners, Peña took to jogging in its tunnels—looping three to six miles per day more than 2,000 feet underground. After he was rescued last month, marathon officials immediately invited him to attend the race as a guest.

Wittenberg said she expected Peña to sit in a warm tent and soak in his newfound celebrity. Peña had other plans: He wanted to run.

When he arrived at Kennedy Airport on Thursday, Peña was greeted by some of the legends of the sport and then proceeded to charm the news media at a surreal press conference where, among other things, he crooned an Elvis tune to demonstrate his affection for the musical artist. Then he was ushered on a whirlwind tour of the city, visiting the Empire State Building, making an appearance on *The Late Show with David Letterman*.

By Sunday morning, his celebrity almost seemed to have eclipsed the race itself, earning him a special introduction from Wittenberg before the race. The New York Road Runners set him up with two escorts: Juan Jesus Lopez, 34, of the Bronx, and Rene Cuahuizo, 27, of Elmhurst, who were charged with making sure other participants—seeking a brush with celebrity, or at least the chance to be captured on television with one—did not crowd him too much.

Crowd him they did. Many runners went so far as to whip out cameras midrace and snap

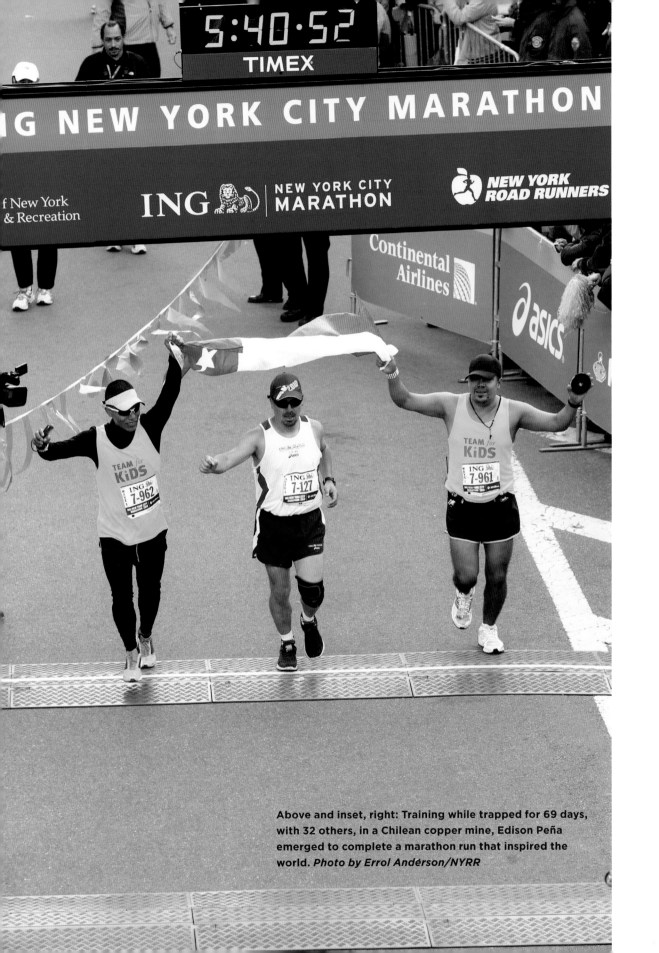

Above and inset, right: Training while trapped for 69 days, with 32 others, in a Chilean copper mine, Edison Peña emerged to complete a marathon run that inspired the world. *Photo by Errol Anderson/NYRR*

pictures of Peña as he jogged along. Meanwhile, for many spectators along the course, Peña was the No. 1 subject of conversation.

For Chileans in attendance, it might as well have been a national holiday.

One of them, Claudia Lillo, traveled hours from Dutchess County with her mother, sister and niece merely in the hope of catching a glimpse of Peña. They camped out on the northeast corner of Central Park with a Chilean flag and a sign that read, "Run, Edison, Run."

"Not only is he from Chile, but he's an inspiration for everyone here," Lillo said.

Peña jogged by a few minutes later—despite never having run anything approaching a marathon before. He told reporters on Thursday that he hoped to finish the marathon in six hours.

Photo by Edison Pena/Adam Patterson/ Panos Pictures via Redux

See and be seen: Peña's New York adventure included a stop at the top of the Empire State Building (left) and a visit with David Letterman.
Left photo by Bebeto Matthews/AP Photo; right photo by Jeffrey R. Staab/CBS via Getty Images

Marathon officials said they were encouraging a "walking and running approach," as Wittenberg put it.

Peña chose to take a running approach.

Wearing sunglasses, a navy blue cap and a brace on his left knee, Peña made it across the half-marathon mark in 2:07:34, well ahead of the goal he set for himself.

But while running up First Avenue in Manhattan, he began to favor his left knee.

> **"I THINK WE'VE JUST SEEN THE BEST STORY IN RUNNING I THINK I'VE EVER SEEN."**
> **—MARY WITTENBERG**

Peña eventually slowed to a walk and ducked into a medical tent between Miles 19 and 20 to get ice packs for his knees.

He said later that the knee pain, which he said he has long battled, almost made him withdraw from the race. "But I said to myself, I didn't come this far, I didn't travel so many thousands of kilometers, to drop out," Peña said. "So I kept going."

Peña started to jog again after passing through Columbus Circle and heading toward the finish line in Central Park, clutching a Chilean flag as fans roared. Photographers swarmed him as he crossed the finish line; Peña immediately clutched his knees, the crowd cheering wildly and Wittenberg ready with a medal.

He immediately said that he would have

been able to finish the race faster if not for his bothersome knees, a point he reiterated when speaking to reporters later. Through an interpreter, Peña said he was taken aback by all the signs and cheers he received along the course, saying all the support helped him get past his knee pain.

"I could have just been a special guest, but I wanted to take up the challenge of running, and perhaps that was a mistake," Peña said. "But I wanted to show that I could do it."

Asked by a reporter to sing another Elvis tune, Peña dutifully complied, offering a few lines of "Don't Be Cruel." And in perhaps the best news of all for those whom he delighted so much on Sunday, Peña said this would not be his last marathon.

"I know I can improve my time," he said.

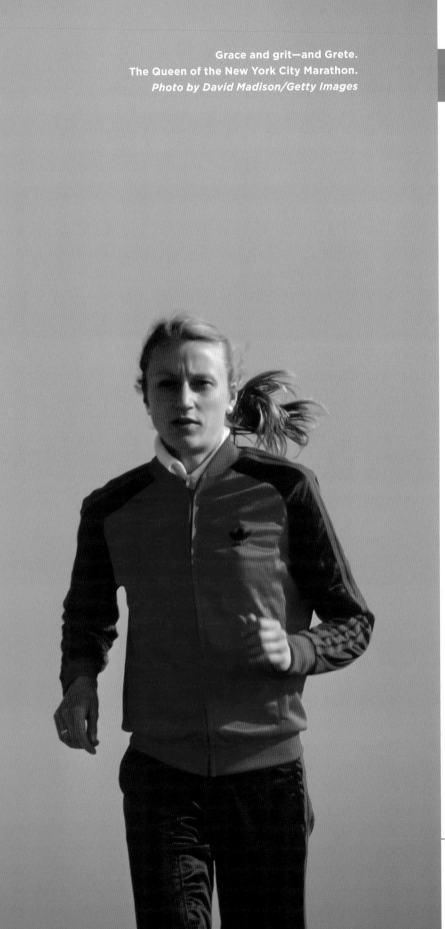

NEW YORK TIMES, APRIL 23, 2011

THE HUMANITY OF THE LONG-DISTANCE RUNNER

BY GEORGE A. HIRSCH

Grete Waitz, the most private of individuals, ended up excelling in the most public of sports, marathon racing. She ran past millions of cheering, hand-extending New Yorkers on the way to breaking the finish-line tape in Central Park nine times. Moments later, she faced the swarming news media.

She was approachable, easygoing and even funny in interviews. New Yorkers grew to love Grete, a down-to-earth, humble Norwegian, and reporters actually looked forward to their annual marathon date with her.

Cancer was a different deal. She drew a firm line in 2005 when she learned she had the disease. She gave no details, not even identifying the type of cancer she had.

"I look at this as something that concerns me and my family and no one else," she said. "You know the day that I beat it, then I will talk about it."

Sadly, that day never came. Grete died at 57 last Tuesday in Oslo.

In 1978, on her first visit to New York, the 25-year-old Grete had slipped into town quietly. No fanfare, no flashbulbs, no limo. And little idea where she was, or what she was supposed to do. In a Felliniesque scene at the start on the Verrazano-Narrows Bridge, she sought the race director, Fred Lebow, tugged on his pants and said, "Mr. Lebow, where do I stand?"

Through his megaphone, Fred shouted, "Women and first-timers to the left!" Then he changed his mind, "No, to the right!"

Grete must have felt almost panicky among the 8,937 runners. She had never run a race longer than about 12.5 miles, never mind 26.2 miles. Yet a little more than two hours, 32 minutes later, she had set the women's marathon world record.

I finished several minutes later and was introduced to Grete. Before I could congratulate her on the record, she asked about my race. When I told her I had run a personal best, she seemed as happy for me as she did for herself. I remember thinking how incredibly cool and composed she was in the midst of all the hoopla.

A year later she returned to New York as the favorite, and set another world record, 2:27:33. The ensuing years brought more records, championship trophies and increasing fame.

Her victories carried ever-higher expectations, especially for the first women's Olympic marathon at the 1984 Los Angeles Games. Waitz was the favorite, but a day before the race the American Joan Benoit overheard her talking with her physiotherapist.

"You know how Grete was always on guard, playing her cards close to her chest?" Joan told me last week. "Well, she mentioned back spasms, and I sensed a vulnerability."

So Joan pushed hard from the start, opened a big lead on a hot day and never relinquished

it. Grete finished second but set the gold standard for grace and sportsmanship. The next day the two rivals, now friends for life, sat together in the Olympic stadium.

In 1992, Grete ran her last New York City Marathon to help Fred, whose brain cancer was in remission, realize his dream to run and finish his own marathon. Although running at a painfully slow pace, she covered every inch of the course with

SHE HAD NEVER RUN A RACE LONGER THAN ABOUT 12.5 MILES, NEVER MIND 26.2 MILES. YET A LITTLE MORE THAN TWO HOURS, 32 MINUTES LATER, SHE HAD SET THE WOMEN'S MARATHON WORLD RECORD.

him, coaching, encouraging and crying at the end. Their five-and-a-half-hour run through the city remains the emotional high point in the marathon's history.

Even in retirement, Waitz stayed close to the race. *Photo by Getty Images*

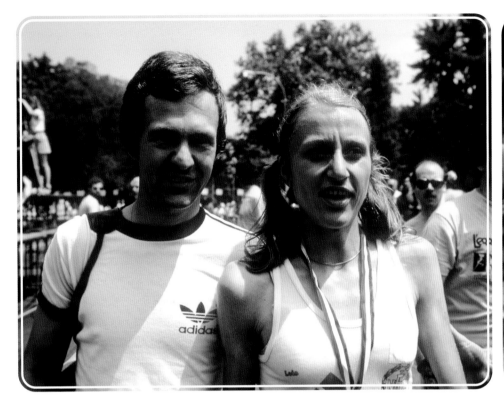
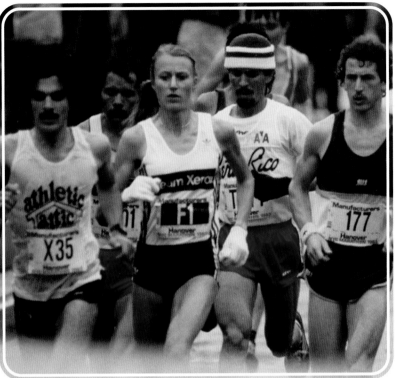

Waitz (left, with husband, Jack, in 1978) arrived in New York as an unknown. She would be front and center every year after that.
Left photo by Duomo/PCN Photography; right photo by David Getlen

Two years after receiving her cancer diagnosis, Grete helped start Aktiv Mot Kreft, or Active Against Cancer, the Livestrong of Norway. When she died, the organization's manager, Helle Aanesen, said, "She wanted the least possible attention to her own illness, but worked tirelessly to the very end to help others."

One of those was my wife, Shay, who also has cancer. Our long friendship with Grete only deepened in the last five years.

We followed her treatments and daily regimen, which often included one-hour treadmill workouts. Shay and Grete would see each other several times a year, and quickly fall into conversation about chemotherapy and radiation, the power of positive expectations and wigs. Always wigs.

"Cancer was the bridge that allowed Grete to let me cross over and get closer to her," Shay said. "When we met and hugged, it was a real embrace that said so much."

Last Monday, Joan ran the Boston Marathon in 2:51, amazing for a 53-year-old. She did not know that Grete was dying. But when I talked to her several days later, Samuelson recalled a gust of wind that assisted her late in the race.

"It gave me a big push when I most needed it," she said. "Looking back on it now, I think it must have been Grete saying, 'Keep it going, Joanie, not just today but for life itself.'"

Hours later, Grete died in Oslo, with her beloved husband, Jack, by her side, as always. I spoke with him the next day.

"She was Grete to the end, still more concerned about me than about herself," he noted with a slight chuckle. "On Friday night after I left the hospital, she called me at home to make sure I had enough milk."

He pledged to run the New York City Marathon this November.

"I will run in honor of Grete," he said.

So will many others.

FIRST STEPS MATTER

BY KENNY MOORE

For the New York City Marathon, it was a matter of not knowing how bad it was until it was too late. I had been invited by the New York Road Runners to a race-week reception to accept an award for my writing about running. But from the distance of my home in Eugene, Ore., it seemed inconceivable that a 26-mile race could be run through the city just six days after the storm, with fires having leveled blocks in Queens, with neighborhoods in Brooklyn under eight feet of water, with the subways and the airports flooded and 40,000 left homeless. It seemed best to stay home, give to the Red Cross, light candles for the dead and not be a bother to people in genuine need.

But then Mayor Bloomberg pushed for the race to go on. Marathon director and NYRR president and CEO Mary Wittenberg's teams scouted the course and failed to discover anyone in need near the start in Staten Island. The NYRR announced the event would take place as scheduled on Sunday. I saw in that decision an act of pure marathoning nature, our keeping on, going step by step, mile by mile. I saw our defining tenacity, and how we become stronger through enduring.

I had to show solidarity. I caught one of the first flights into Newark last Thursday. From the air, I was struck by how the trees in Manhattan's Riverside Park were undamaged but gas lines in New Jersey went for miles. "Either power or gas," lamented my cab driver. "But not both."

That night the news showed a woman from Staten Island crying out with justifiable anger that her family, her neighborhood had been abandoned. All were in mortal need. I couldn't get her voice out of my head.

I should have known right then that if the marathon couldn't do anything to shelter and feed those people, it shouldn't be held. But that didn't fully register. I had been a marathoner in the 1972 Olympics, and in my remarks at the reception the next morning I invoked how we athletes had grieved after terrorists murdered our Israeli fellow Olympians. I said we had channeled our sorrow into performance. Frank Shorter had done it so well that he won. I urged all 47,000 runners to channel their grief and be stronger for it.

But this was a rotten parallel. In Munich we'd had some time to grieve. The killing was over. In New York it was as if the firefight were still raging, people still bleeding and screaming.

And New York rose up to declare that. Pressure on the race came from everywhere. Runners were blasted for simply running. Julie Culley, an Olympic 5,000-meter runner, had been preparing for her first marathon. "People have been tearing me apart on Twitter," she said. "Cursing at me. This [hostility] just doesn't happen in our sport. I think the marathon is turning into the scapegoat for the city."

The mood quickly turned vicious. There was grumbling that the city's resources should be reserved for relief efforts and even talk of not being able to guarantee runners' safety on the course.

At last, on Friday, the organizers, after frantically considering alternatives, did the right thing and called it off. NYRR board chairman George Hirsch then recalled the event's ironic history. "The race was conceived in crisis," he said. "In 1976 the idea of a citywide marathon was unheard-of. It was the Bicentennial, and the city was

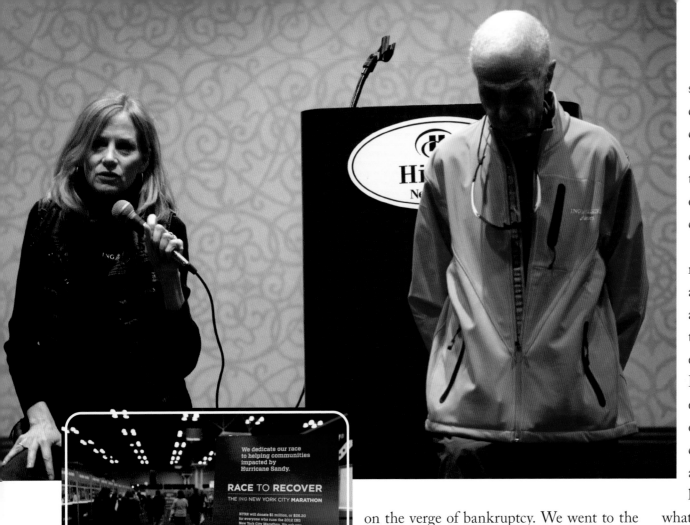

sports. The problem is negotiating the disconnect between what can seem our callous, even selfish, urge for familiar distractions and others' rightly embittered rage. We seem to have to measure our ease against others' pain before we can be of service.

Marathoners quickly found ways to redirect their energies. Jordan Metzl, a sports surgeon and marathoner, created a Facebook page urging runners to head to Staten Island with donated material. Marathoners Jaclynn Larington and Sarah Hartmann started NYCMore2012.org, to connect and organize volunteers in the worst-hit communities. "The response has been amazing," said Larington. "I think a lot of good will come out of this." (On what would have been race day an estimated 10,000 runners would put their energies into relief work.)

But Culley's suspicion that the marathon was being unduly scapegoated had some merit. At the Giants-Steelers game on Sunday in East Rutherford, N.J., few thought it was too early to return to sports. Prevailing opinion was that the game was serving the same reunification duty that had been the inspiration for that first five-borough race.

"Having sports events is great," said Pete Moog, a retired NYPD detective who put in 23 years on the force. He's from Tottenville,

Top: On November 3, 2012, the day before what would have been the 43rd running of the Marathon, NYRR President and CEO Mary Wittenberg (top, with NYRR chairman George Hirsch) spoke to runners about the wrenching decision to call off the race in the wake of Superstorm Sandy, which had devastated the New York City area just five days before. After an initial announcement that the Marathon would go on, and would help to raise money for relief efforts (inset), the call was made to cancel, allowing runners, volunteers, and spectators to devote all efforts to recovery.
Photos by Allison Joyce/Getty Images

on the verge of bankruptcy. We went to the mayor, Abe Beame. We said the marathon could be unifying, really tying together the boroughs. The mayor agreed, and it became the most unifying day of the year. So as the desperation of the people became clear—the 40-block gas lines, the devastation on Staten Island, the anger building—we would have sacrificed the founding idea of unity if we had run it."

Whether it was after 9/11, or the murders in Munich, the question is always when is it moral to return to normal? And nothing else underlines that quandary more vividly than

on devastated Staten Island. For three days last week he took his tailgating grill and a school bus painted Giants blue and fed the hungry in his hometown.

"After 9/11 going back to sports was to show the terrorists that we weren't going to cave to anything," he said. "This shows how resilient we are as Americans."

The New York City Marathon and its tens of thousands of runners are counting on that. "Next year," says Wittenberg. "Next year it will be the greatest ever."

"AS THE DESPERATION OF THE PEOPLE BECAME CLEAR, WE WOULD HAVE SACRIFICED THE FOUNDING IDEA OF UNITY IF WE HAD RUN [THE RACE]."
—GEORGE HIRSCH, CHAIRMAN, NYRR

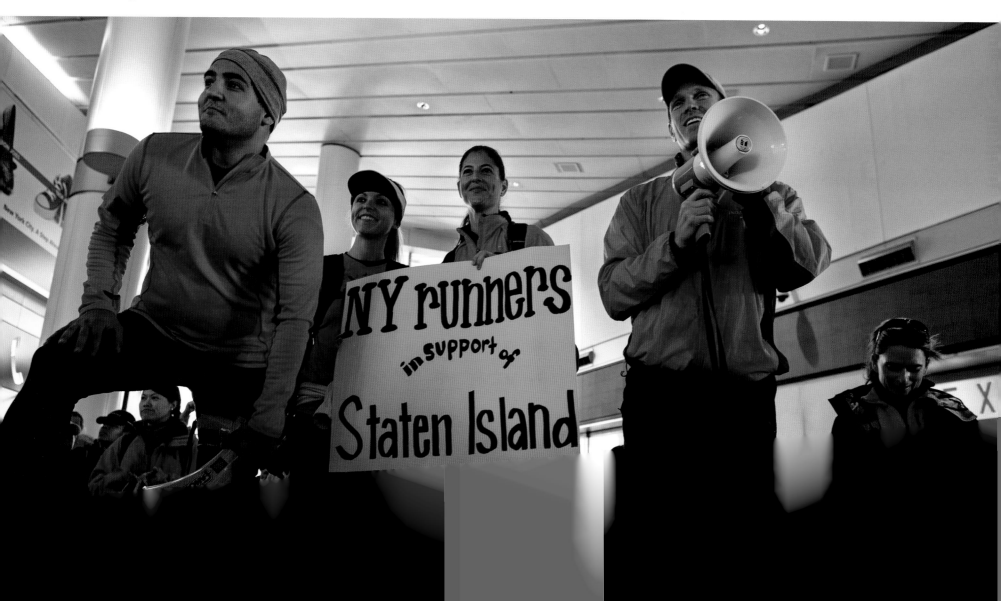

BEYOND COMPETITION, RUNNING FOR A GREATER CAUSE

BY JOHN HANC

They missed the exhilaration of the start on the Verrazano-Narrows Bridge. The sidewalks along First Avenue, where they are usually welcomed like heroes, were empty. No one got a finisher's medal.

Yet, on what was referred to jokingly by some as "Non-Marathon Sunday," many runners who had been expecting to participate in the 2012 New York City Marathon, canceled because of Hurricane Sandy, managed to honor their commitment—to charity.

At 9:15 a.m., 28 runners wearing white T-shirts with colorful logos set out in a group from the front of the Metropolitan Museum of Art on Fifth Avenue and ran into Central Park.

They were among 52 marathoners who had raised an average of $3,000 each for Shoe4Africa, an organization that began in 1995 as an informal effort to send running shoes to Kenyan athletes who couldn't afford proper footwear. In the years since, it has grown into a charity now raising money to build a public children's hospital in the city of Eldoret, Kenya.

"People involved in running are giving people, helping people," said the organization's founder, Toby Tanser of Manhattan, who led the group Sunday. "I wanted to base my charity around those people."

At about the same time, on the opposite side of the park, Rebecca Hanson and a group of her friends started on a run from Columbus Circle. Four days earlier, she and a friend, Mwangi Gitahi, both of whom live in Manhattan, formed a Facebook group to raise money for hurricane relief.

On Sunday, Hanson, who had been registered for the official marathon, ran her own 26.2-mile race in the park for her charity. Thanks to contributions from 65 donors, she and Gitahi ended up surpassing their goal of $2,620.

On hurricane-ravaged Long Island, John Feyrer pinned his official New York City Marathon race number on his shirt, posed for a

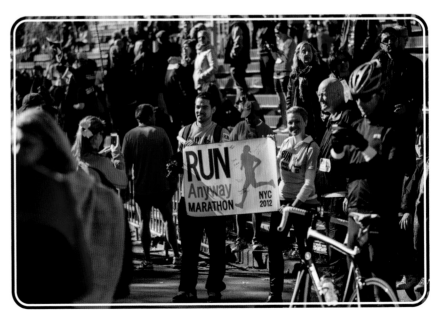

Photo by Piotr Redlinski/New York Times via Redux

photo with his family and took off on his own marathon: 26.2 miles through the streets and neighborhoods of Garden City.

The goals of these runners involved money as much as mileage. They were not alone. According to Running USA, an organization based in Santa Barbara, Calif., that tracks running trends, about 20 percent of the participants in most large marathons are running to raise money for some charitable organization. The beneficiaries include large national nonprofits, local animal shelters and nature preserves.

Last year, according to the New York Road Runners, organizers of the New York City Marathon, more than $34 million was raised for charity. Moreover, fund-raising experts expect that the vast majority of runners in this year's race will still honor their commitments.

"I'm sure they're disappointed, and there might be some who are annoyed," said Michael Nilsen, spokesman for the Association of Fundraising Professionals in Arlington, Va. "But based on what we've seen in other situations where a charity event has been canceled because of weather or some other once-in-a-lifetime type circumstance, people generally don't take it out on the charity." . . .

Clearly, an idea that was novel two decades ago, that distance runners might want to use their highly individualistic sport to help others, "has worked beyond anyone's imagination," said Running USA's spokesman, Ryan

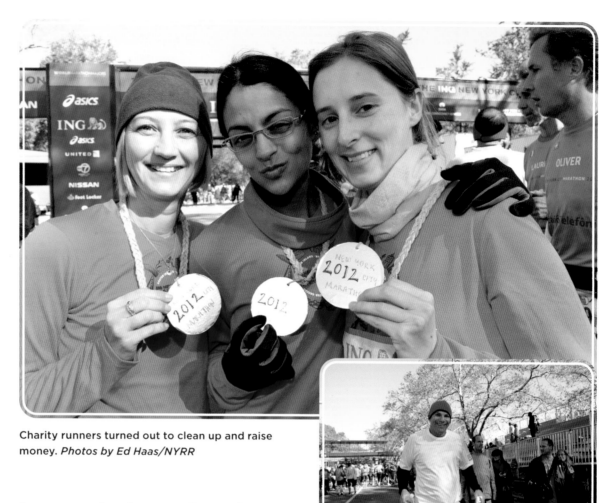

Charity runners turned out to clean up and raise money. *Photos by Ed Haas/NYRR*

Lamppa, noting that according to data compiled by both his organization and USA Track & Field, the total estimated amount raised in American road races in the last decade has more than doubled, from $520 million in 2002 to more than $1.2 billion in 2011.

While that is a significant figure, "the real impact is raising awareness and building community," said Andrew Watt, president of the fund-raising professionals association. "There is an extraordinary sense of coming together for the common good in these events, and that is quite unique."

Whether it is through large national programs like the Leukemia and Lymphoma Society's Team in Training—largely credited as a pioneer in this area—or smaller groups like Shoe4Africa, organizations that use marathons (or the popular 13.1-mile half marathons) as a fund-raising platform have succeeded in other ways too. "They've gotten a lot of people to do something they would not have thought they could do," Lamppa said. . . .

Social media has been a major tool for spreading the word, raising the funds and getting people across the finish line. "When you say to everyone on Facebook or Twitter, 'I'm doing this for charity,' there's some stickiness there," said David Hessekiel, president of the Cause Marketing Forum. "If you tell everyone you're going to do it, you better do it."

Hurricane or no hurricane.

"I felt like I had told people I was going to run a marathon, so I'm going to run a marathon," said Feyrer, who had raised $3,700, mostly in donations from friends and family, for Fred's Team, the charity associated with Memorial Sloan Kettering Cancer Center and named in honor of Fred Lebow, founder of the New York City Marathon, who died of brain cancer in 1994.

Feyrer runs to raise money for a cancer hospital in part because of a brother-in-law who has melanoma. This was his second marathon for Fred's Team, but the first in which people sitting on gas lines and in bagel shops came out to applaud him.

"It was cool," said Feyrer, who was accompanied at various points during his personal fund-raising marathon by his wife, Diane, several running buddies and a group from the Garden City High School cross-country team that included his 16-year-old son, Timothy.

There were other benefits to running solo in the suburbs, as opposed to being part of a pack of 47,000 in the streets of the city. "I actually got down on the grass and did some stretches a few times," Feyrer said after completing his GPS-measured course in about four hours, 13 minutes. "Because I did that, I feel a lot better now than I did after last year's marathon."

For Hanson, Sunday was her first venture into the world of charity running. "I have tons of running friends who have done fund-raisers," said Hanson, 32, who lives in Manhattan. "I know this makes me sound like a bad person, but I just never felt passionate enough about a cause to want to raise money. But this was really important to me."

While running four grueling loops of hilly Central Park on Sunday, she said, she thought of all the friends who had responded with money in such a short time. "I felt very touched by the support," she said. "I most definitely wanted to do it for them." . . .

RUNNER'S WORLD, MAY 13, 2015

AT NYRR, WOMEN AND PROS FOUND AN ADVOCATE IN MARY WITTENBERG

BY ERIN STROUT

Mary Wittenberg's favorite place during the past 17 years has been the finish line of the New York City Marathon on the first Sunday of November. As the race director, it was where she greeted the triumphant, the disappointed, the injured, the elated, the fast, and the slow. But all of them finishers of the largest marathon in the world.

So that line on the west side of Central Park is naturally the site of one of Wittenberg's favorite memories of her time leading New York Road Runners as president and CEO, which she departs next week to join a new venture at Virgin Sport.

It was 2007 and Paula Radcliffe had just won the race. The champion celebrated holding her daughter, Isla, then 10 months old, on her hip. At the time, it wasn't often that a professional female athlete would return to training and competition so soon after giving birth, especially in distance running.

"It was a moment that transcended sport,"

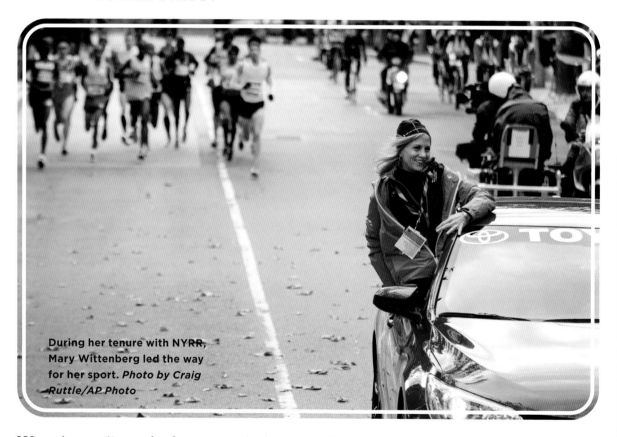

During her tenure with NYRR, Mary Wittenberg led the way for her sport. *Photo by Craig Ruttle/AP Photo*

Wittenberg, 52, said, during a telephone interview on Tuesday. "All these moms who were watching were like, 'Wow. Okay. We can do that.'"

Radcliffe, the world record holder in the marathon who retired from competition last month, recalled in an email on Wednesday that Wittenberg was the first person outside

With Paula (and Isla), 2007. *Photo by Photo Run/NYRR*

CREATING BUZZ AND CHAMPIONS

It was never so apparent to Wittenberg that U.S. elite distance running was in need of resuscitation than in 1998—the first time she went to the starting line of the marathon. She stood next to her predecessor, Allan Steinfeld, and said, "Boy, there's no buzz. Where are the Americans?"

U.S. runners didn't have the talent to compete on the high-level, global stage.

"That became a big need and opportunity in our early years. I became very passionate about helping get it started," she said. "Now there's a lot of support around professional athletes. We always need more, but the connections are strong—you can take Meb [Keflezighi] anywhere and people are motivated."

NYRR began awarding grant funding to Olympic-development training groups across the country and also started recruiting promising emerging Americans to debut at the marathon distance in New York. The course is challenging and doesn't offer a chance for fast times, but Wittenberg and her team were able to convince many to take a shot. It's a testament to their persuasive powers, said

of the family to know that she was expecting her first child—a big secret to share in a profession that is not always supportive of athletes who take time off to have babies.

"As I ran together with her in Central Park, I just couldn't keep the secret from her," Radcliffe wrote. "She was so happy for us and full of welcomed parenting advice. That's why it was special to share the finish-line moment with Mary 17 months later."

Wittenberg joined NYRR in 1998 and became chief operating officer in 2000. In 2005, she became the first woman to lead the organization as president, CEO and director of the New York City Marathon. She

also juggled work and home, giving birth to two sons, Alex (now 13) and Cary (age 12), during her tenure.

Along the way, she recognized the lack of support for professional American distance running, as well as the need for more opportunities for youth in the sport. As a result, NYRR grew beyond a local club. In many ways it began setting the national agenda for running at all levels, and it changed its mission to reflect a broader goal: to become "a leader in the worldwide running movement, helping people of all ages and abilities discover the power of running to improve their health, fitness, and overall well-being."

"IT WAS A MOMENT THAT TRANSCENDED SPORT."
—MARY WITTENBERG

Kara Goucher, who ran her first marathon there in 2008, finishing third in 2:25:53 and becoming the first U.S. woman on the podium since 1994.

"She's done a terrific job of highlighting Americans when they come to the race—they're treated just as well as the world record holders there, although she'd never water down the field for you," Goucher said. "It became a desired race to run. As soon as I ran my first half marathon, five weeks later I was on the press truck in New York being sold on running it the next year—and I committed basically that same day."

Some of Keflezighi's career highlights are in no small part due to Wittenberg's support and encouragement. His debut at 26.2 miles was also in New York in 2002—he placed ninth that year and followed it up with an Olympic silver medal at the distance at the Athens Games in 2004. In 2009 he became the first American to win New York in 27 years.

"She started at New York Road Runners the same year I became a professional and it's been a long journey," Keflezighi said. "I talked to her yesterday and she said, 'You know I'm not going to be at the finish line to see you anymore.' It's always been great to have her there whether it was when I won in 2009 or like even in 2013 when I finished [in 23rd place]."

Keflezighi remembered when Wittenberg called him to let him know that they had

decided to award the women more prize money than the men at the 2006 race—the first woman would get $130,000 compared to the $100,000 given to the men's champion, in an effort to highlight the female side of the sport. It followed a tradition launched in 2002, when New York began an early start of the women's elite race to allow for more airtime and exposure for female contenders.

"Mary has always been forward-thinking," Keflezighi said. "To me her actions spoke louder than just saying what she thought about an issue."

In 2007, Wittenberg and other NYRR executives saw an opportunity to start drawing more attention to the Olympic pursuits of the country's top runners. They put a bid in to host the Olympic Marathon Trials on the same weekend as the marathon. NYRR hosted the men's race in the fall the day before the New York City Marathon. Boston hosted the women's Trials in the spring the day before the Boston Marathon.

"The Olympic Trials will be a highlight forever—it was incredible," Wittenberg said. "If somebody else is filling a need, we don't need to fill it, but back then the Trials weren't a big deal beyond the athletes who made the team.

With Shalane, 2010. *Photo by Paul J. Sutton/NYRR*

It was groundbreaking when we and Boston put the Trials in the middle of big city races."

That event also presented one of the biggest challenges of her career, when Ryan Shay, a top candidate for the U.S. team, died on the course.

"Any time we had a significant medical issue or death, that was just the worst. They all

stand out. But when Ryan passed away, that was really trying," she said. "We were emotional and we had to go on with the marathon the next day. That was a really tough moment."

NEXT STEPS

Wittenberg's bold decisions over the years weren't free of criticism, of course. Many local runners have voiced concern that the grassroots culture of a local running club has been lost and the cost of participation has risen as the leadership's focus trended toward grand initiatives.

But it's local weekend races and events—more than 50 per year, mostly sold out—that stand out in Wittenberg's mind as some of her more outstanding moments at the helm.

"Most rewarding was on the weekends, the number of people who would say, 'Thank you, NYRR. You got me running through a difficult time; you helped me lose 100 pounds; you helped my mom believe in herself,'" she said. "Most incredible was introducing people who didn't have running in their lives to it and supporting them so they became regulars."

Another challenging moment came in 2012, when the marathon was canceled about 36 hours before the start, due to the devastation caused in the area by Hurricane Sandy. It was a situation that, in hindsight, Wittenberg would have handled differently.

"That was tough because we're always about our community first and I wish I had known that it wasn't the time, that we weren't in a position yet to help uplift the city," Wittenberg said. "It would have been much better if we had all gotten [to that decision] faster. I learned a lot through that."

Tracey Russell, CEO of the L.A. Marathon, said watching Wittenberg rebound from missteps has allowed her to become a trusted ally to other leaders within the sport. When L.A. faced a hot race day forecast this year, Russell called her friend, who has also been a career mentor, in New York for advice. And as L.A. prepares to host the next Olympic Marathon Trials, Wittenberg has fielded many more questions.

"She answers calls, texts, emails, regardless of the time of day or night," Russell said. "She is always trying to help anyone in the sport, because we all do better when our events go off very successfully—she recognizes that, whether she's providing best practices or lessons learned over the years."

In Wittenberg's next act, as global CEO of Virgin Sport, she'll be building a division of Richard Branson's Virgin Group from scratch.

She'll lead a worldwide initiative to launch, as well as acquire, running and cycling events geared toward recreational athletes.

Back at NYRR, Michael Capiraso, currently chief operating officer, will become president and CEO. Peter Ciaccia, chief production officer, will be president of events, including director of the New York City Marathon.

It's not lost on many women in running, perhaps in good-natured jest, that it will take two men to fill Wittenberg's shoes. The news of her departure has left some athletes with mixed emotions.

Molly Huddle, who this year became the first American to win the NYC Half, a 13.1-mile race created under Wittenberg's leadership, said she's sad to see her go, but is also curious whether Wittenberg may arrive at that fabled Central Park finish line a different way now.

"She recently told me that she has never actually been able to race the NYC Marathon herself," Huddle said. "I wonder if now she will have the chance to enjoy the event as a participant and see how special she has helped make it?"

THE NEW YORKER, OCTOBER 30, 2015

SPIKE LEE'S MARATHON PREP

BY MARY PILON

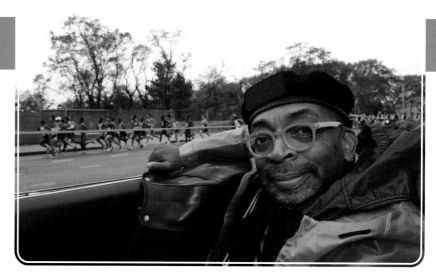

Photo by Alice Proujansky/NYRR

On Thursday morning, the filmmaker, Brooklyn native, and grand marshal of the New York City Marathon Spike Lee was comfortably perched in Central Park offering a limited screening of what he announced was his latest "short, short joint."

"It's a love letter to the greatest city on this planet," Lee, clad in a blue camouflage tracksuit and bright-orange glasses, said. Running under three minutes (a short preview can be found online under the title Da New York Joint) and set against a sweeping jazz score, the film will air before the broadcast of the race, on Sunday morning. With Lee's signature staccato rhythm, the film briskly cuts through images that Lee said represented "the people the food the diversity the culture, architecture, all the stuff that makes it New York."

Alongside many shots of New York City's culinary delicacies, Lee's short film highlights Do the Right Thing Way (the intersection that pays tribute to Lee's 1989 classic), plus Times Square, Chinatown, the Brooklyn Bridge, Chris Rock, a park-goer with a bird on her shoulder, firemen, brownstones in "the Republic of Brooklyn," Cumberland Hospital (the birthplace of Mike Tyson and Michael Jordan), Coney Island, the 9/11 Memorial, the Apollo Theatre, and so on.

"Boston is not even in the running," Lee said.

Lee is the first New Yorker to serve as grand marshal of the New York City Marathon in the forty-five-year history of the race. The marathon has only had two other grand marshals in its history (the Czech runner Emil Zátopek, in 1979, and Norway's Grete Waitz, in 2003); organizers said that they wanted to bring on a quintessential New Yorker this time. Lee, who also teaches film at New York University and will soon receive an honorary Oscar, fit the bill.

Lee's short played on a screen in a pop-up media tent near the marathon's finish line, to a varied crowd: in addition to the phalanx of elite runners, including the Paralympic wheelchair champion Tatyana McFadden and the returning New York City champions Mary Keitany and Wilson Kipsang, was a stable of security guards muttering into earpieces and the New York City police commissioner, William Bratton. The mood was light, despite this dash of officialdom, an atmosphere Lee seemed determined to sustain as he presides over what is sometimes touted as New York City's "largest block party."

When he was first approached by New York Road Runners executives about the opportunity, Lee said he was eager to play a part, having watched the race many times from the corner of Lafayette Avenue and South Elliott Place, in Fort Greene, Brooklyn, as a youngster.

He's Gotta Lead It. *Photo by Ed Haas/NYRR*

"I was elated," he said. "Next thing, I was honored. The third thing was, 'What do I gotta do?'"

A fair amount, it turns out. Earlier this week, Lee travelled to Bristol, Connecticut, to confer with ESPN, a broadcast partner of the marathon. On Thursday, after debuting his film, under perfect running skies, Lee and other officials engaged in the ceremonial painting of the blue line that marks the path of the 26.2-mile course through the city. "All five boroughs," Lee said. "Even Staten Island!"

On Friday evening, Lee was scheduled to make an appearance at the marathon's opening ceremony alongside the Hall of Fame inductee Paula Radcliffe, a three-time champion of the race. Sunday morning would be a long affair, as Lee would lead the race seated in the back of a convertible with his wife, Tonya Lewis Lee. The wheelchair athletes are the first at the official start, at 8:30 a.m., followed by the professional women, at nine-twenty, and then the professional men, along with the first wave of amateurs, at nine-fifty. Three more waves will bring the total to more than fifty thousand runners, from all fifty states and more than a hundred and twenty-five countries, the last of them setting off at eleven. Lee said he didn't plan to leave his vehicle and that he and his wife planned to "take lots of pictures" along the way.

This will be his first time seeing the marathon from the finish line, he said. And, in spite of the pomp inherent in leading the sweaty parade, he was wary of taking too much of the spotlight.

"Look, it's not about me," he told a gaggle of reporters Thursday morning. "People train long and hard for this race. They were self-motivated. If they weren't self-motivated, they wouldn't be here."

Lee took the opportunity to proclaim his support for the New York Mets in the World Series, even though he's a Yankees fan. ("But if they don't win Friday night, it's ovah. O-V-A-H," he said.) He also expressed his support for Hillary Clinton in the Presidential race. ("I think that she is the best person now to continue what Obama has done the last eight years.") And he challenged an Italian reporter who implied that the pizza in her country bested the pies of New York. ("Grimaldi's!")

In addition to Lee in the convertible, several other celebrities will be at this year's marathon, running: the retired professional tennis player James Blake, Katrina Bowden (formerly Cerie on *30 Rock*), Ethan Hawke, the soprano Susanna Phillips (who will be singing the national anthem before running the course), and Alicia Keys.

As a child, Lee said, he loved playing sports, especially basketball. Would he be among the high-profile marathoners in next year's race?

He was quick to answer.

"No!"

"IT'S A LOVE LETTER TO THE GREATEST CITY ON THIS PLANET."

—SPIKE LEE

THESE COMPETITORS MEASURE THEIR TIMES IN YEARS

BY JULIET MACUR

The trash talking began days before Sunday's New York City Marathon. Not among the elite runners, though, at least for this story.

Among runners in their 60s.

David Laurance, a 63-year-old podiatrist from Manhattan, had heard last week from a fellow marathoner that another runner thought Laurance had not run fast enough in recent New York marathons. Basically called him a wimp.

"I was told that this one particular person thought I was babying myself too much and that I needed to go harder," said Laurance, who said he didn't know the smack talker's name but had a feeling it was someone in his age group. "That particular person said I wasn't pushing like I used to, and that didn't make him happy, because to him it wasn't fair."

Why unfair? Because both men have run more than 30 consecutive New York City Marathons—and both were near the top of the list of runners who had extended streaks.

According to unofficial statistics kept by New York Road Runners, which organizes the race, Laurance was tied for second on the list of most consecutive New York City Marathons. Going into Sunday, he had run 37 straight.

Road Runners calls those who have completed at least 15 consecutive New York marathons streakers. All run clothed.

"Some people are extremely covetous of their streaks and are jealous of me; I know it," Laurance said. "But for the most part, the streakers are a pretty friendly group. When we get together every year, it's like a group of Marines seeing each other after a long time."

But there's a reason Marines are Marines. And it's not because they like being defeated. They pride themselves on accomplishing goals with drive and intensity.

There are about 1,000 people who have run the New York City Marathon again and again and again. And among the roughly 50,000 who crossed the finish line on Sunday, these streakers take marathons to another level.

Because they just can't stop running the New York City Marathon.

In the late 1990s, Connie Lyke Brown fell near Mile 2 of the 26.2-mile race, smacking the pavement after doing what she called "a Pete Rose dive" and bloodying her knees and hands. Brown, who will turn 72 this week and is the top female streaker, with 37 in a row, wanted to stop running but simply couldn't.

"I've done so many now, I just can't quit," she said.

Twenty-one and far from done: For streakers, every race finished is just another step along the road.
Photo by Drew Levin/NYRR

Richard Shaver, who is tied for second on the men's list, with 38 straight finishes after Sunday's, had had knee surgery since last year's marathon but didn't consider skipping this one, even though he hadn't trained as much as he had planned. He is achingly close to the top of the streakers' leaderboard, you know.

"Am I the one with the longest streak?" Shaver, 63, said. "Frankly I don't know. But I'm going to be the last one standing."

He then took a shot at a 72-year-old runner named Dave Obelkevich, the current No. 1 streaker, who finished his 39th straight New York City Marathon on Sunday. "I'm sorry; he's a retired music teacher, a grandfather," Shaver said. "I'm working every day, and I fit my running in."

Shaver, a lighting specialist, laughed as he spoke because Obelkevich seems invincible, having finished 104 marathons and 185 ultramarathons. But I got the feeling Shaver wasn't kidding. This is a tough guy we're talking about, one who passed out from heat exhaustion a half-mile from the finish in 1979 and then said to medical workers, "Give me back my shoes!" so he could finish.

(For the record, Shaver finished Sunday's race in 4 hours 56 minutes 35 seconds. Obelkevich finished in 4:57:01.)

A streaker is now even running the Road Runners organization.

Michael Capiraso became the president and chief executive of Road Runners in the spring and even then didn't pull his entry in Sunday's marathon, which was to be his 24th in a row.

After all, there was a guy named Mark Myers who lived two buildings away from him and who started running the race in 1991, just as Capiraso did. Each year, the two of them competed to see which one ran faster.

"Let's just call it a friendly competition," Capiraso said.

So even though Capiraso is one of the people in charge of the whole marathon, he still ran on Sunday. Afterward, he told me it was worth the trouble of squeezing the epic run into a more-than-full workday.

On the Queensboro Bridge, about 15 miles in, he saw Myers in the distance and caught up with him. They ran side by side for the next four or five miles, joking, "You can go first; I don't want to hold you back." Then, "No, you go first."

Capiraso eventually pulled ahead, to finish in 3:54:05, nine minutes faster than Myers.

The Queensboro Bridge, however, only brings up painful memories for Laurance.

"These days, when I'm running on that bridge, I have to strike it from my mind that I used to be finished by now," he told me on the eve of Sunday's race.

He tries to put things in perspective. He is still healthy. Still has his streak going. All of that, even though he finished in the dark, in 6:45:06.

For him, what counted most was that he just kept going.

"My father used to tell me about my eating habits, 'Even a machine stops sometimes, David,'" he said. "But I always proved him wrong."

ROAD RUNNERS CALLS THOSE WHO HAVE COMPLETED AT LEAST 15 CONSECUTIVE NEW YORK MARATHONS STREAKERS. ALL RUN CLOTHED.

ODE TO JOY

BY MATT FUTTERMAN

The one woman I have thought about leaving my wife for was an 81-year-old former Minnesota farm girl named Joy Johnson.

Joy, the most aptly named person I have ever met, had sturdy, pointed shoulders, smooth, tan skin that resembled soft leather, and a leggy, slim-waisted figure women 50 years her junior would kill for. She rose with a burst in the darkness of 4 a.m. at her 1950s, four-bedroom ranch house on a quiet street in south San Jose. She read her Bible for an hour, then set out into the eucalyptus- and citrus-tree-scented air on her predawn run, her running mantra from the Book of Isaiah buzzing through her head. "But they who wait for the Lord shall renew their strength. They shall mount up with wings like eagles. They shall run and not be weary, they shall walk and not faint."

How Joy loved to run. And how she loved to race. Never mind that she didn't start to run until she was 55, and didn't run her first marathon until she was 61.

In 2007 she won the 80–84 age group at the New York City Marathon, but she finished in seven hours and 15 minutes. That was far too slow, she decided. So she cranked up her training. She ran 50 to 55 miles each week instead of 30 to 35. She ran hills and bleachers at the local high school football field, and she worked to build up her core strength at a running camp in Minnesota.

The following October she ran the Twin Cities Marathon in six hours, six minutes and 48 seconds, more than an hour faster than her time in New York the previous year.

Like any aging runner, Johnson faced enormous obstacles. Aging affects every system the body uses in long-distance running. An elderly heart doesn't pump as fast or as hard, so oxygen—the body's gasoline—doesn't circulate as efficiently. And average 60-year-old pumps 20 percent less oxygenated blood than a 20-year-old. Like all human tissue, the lungs become stiffer and less expansive. Muscles atrophy at an increasing rate and ligaments and tendons grow brittle, making injuries far more likely. Muscle strength generally peaks at 30. After 70, it declines 30 percent per decade. Knowing that, Joy never skimped on the strength training at the running camp Dick Beardsley put on in Minnesota. He pushed her through a series of stomach crunches, push-ups and hovers (holding the body in a push-up position) that helped her avoid becoming hunched as her body

Joy Johnson began running at age fifty-five.
Photo by Jonathan Sprague/Redux

"SHE LIVED FOR 86 YEARS, COMPLETED A MARATHON, AND WENT TO SLEEP. THAT'S ABOUT AS GOOD A DEATH AS ANYONE COULD EVER GET."

tired. Into her mid-80s she ran 11 races each year, including three marathons, the 12-kilometer Bay to Breakers race through San Francisco, and the 13.1-mile Securian Frozen Half Marathon in St. Paul each January. "Cold as the dickens, but it's so much fun," she told me one morning when we ran together. "I want to die running," she said.

On November 4, 2013, my girl completed the New York Marathon for the 25th time, even though she tripped at Mile 16 and suffered cuts to her face. She was still bleeding when she crossed the finish line in the dark nearly eight hours after she started. She got bandaged up in the medical tent but didn't bother going to a hospital for further examination. She woke the next morning and followed the ritual that had become a part of her New York Marathon routine—she went to stand outside the *Today* show studios with her medal to say hello to Al Roker. As usual, Roker found her and shared a few words. She felt tired after that venture and went back to her hotel room to lie down. She fell asleep and never woke up. She was 86 years old.

I cried in the middle of the *Wall Street Journal* newsroom when I learned of her death. Then I sat down at my computer and wrote her obituary while wiping tears off my face.

A friend and fellow runner wandered over to console me as I typed. "She lived for 86 years, completed a marathon, and went to sleep," he said. "That's about as good a death as anyone could ever get."

Maybe he was right.

Johnson completed her 25th and final New York City Marathon in 2013.
Photo by MarathonFoto

MARY KEITANY AND THE POWER OF NOT KNOWING

BY NICK PACHELLI

Mary Keitany jogged across the Reservoir Bridge in Central Park early Thursday morning, three days before the New York City Marathon. A petite woman, she wore a black warm-up suit, bright purple shoes, and a black beanie pulled low to her eyebrows. "Good luck, Mary!" a passerby shouted.

I was jogging alongside her—until she dropped me as we passed Sheep Meadow. She was running a seven-minute-mile "shakeout" pace, a relaxed warm-up to loosen any tight muscles. While I waited for her to loop back around, I thought about my email exchange with her coach, Gabriele Nicola, a week before. "The long hills in the Bronx down to Central Park, as runners start to be tired, provide opportunities for the kill," he said.

Keitany will run for her third consecutive victory in the New York City Marathon on Sunday, with 80-year-olds, quadruplets, and roughly 50,000 other runners behind her. If she wins, she'll become just the second woman to secure a three-peat in the marathon's 46-year history, after Norway's Grete Waitz, who managed the feat in the late 1970s and early '80s.

Keitany doesn't come across as someone who would go for the kill: the shy, genial 34-year-old has a gentle demeanor to go with her five-feet-two, 88-pound frame. And yet her dangerous finishing power is among the best in the modern era of distance running. Keitany won last year's New York City Marathon by more than a minute, with her fastest split—an unofficial five minutes, 13 seconds—coming in the 22nd and 26th miles.

At the end of her third lap around the Central Park trails, Keitany paused. She chatted easily, with a wispy lilt, about her past few weeks at home, in Iten, Kenya. "I think I ran about 150 kilometres"—approximately 90 miles—"each week, and making time for the children," she said. Keitany has two kids: Jared, who is nine, and Samantha, three. This year, they've come to New York for the first time. As for whether they'll watch their mother cross the finish line, Keitany and her husband, Charles Koech, hadn't decided yet. "I guess it depends on how the weather is," she said.

Keitany is best known as the second-fastest women's marathoner ever: she finished the 2012 Virgin London Marathon in two hours, 18 minutes, and 37 seconds—three minutes slower than the world record, set by Paula Radcliffe in 2003. She also won the Virgin London Marathon in 2011 and set a world record, since surpassed, in the Ras Al-Khaimah half marathon—all things she accomplished between the births of her two children.

"She is sort of the Kenyan Ingrid Kristiansen," Michael Joyner, a Mayo Clinic physician whose research has focused on distance runners, told me. "Kristiansen used to go out, have children, and come back and run fast. And there's a theory that, when people are pregnant, they get a big expansion in their blood volume . . . which could translate to improved endurance performance over time."

But what's the secret to her finishing power? And how has she lost only four races, at any distance, since 2011? One answer, most obviously, lives back in Iten, where female runners train in relative isolation among high-altitude hills and a bevy of elite male runners with faster personal bests than their own. "You have to watch your teammates," Keitany told me. "See if you are comfortable with pace,

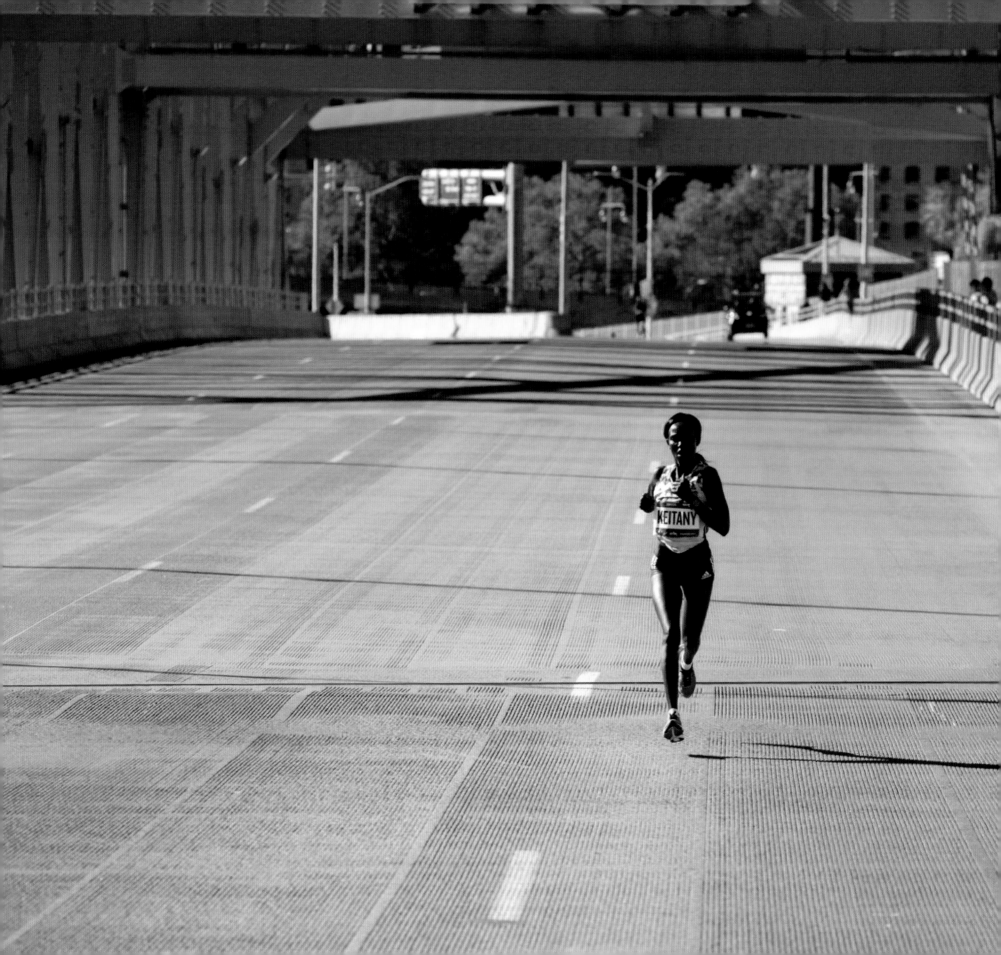

and if you feel like moving." Coach Nicola puts her through long sessions with two-to-four-mile intervals alternating at elevated and relaxed paces, to make speed increases at pivotal spots second nature.

But there's something subtler going on as well. I asked Keitany about her final split from last year's race—how she ran her fastest time in her last mile. She responded, "No! Really? Wow." She thought about it. "Well, maybe. I'm not remembering how I did."

This is how Keitany works: through a method of unknowing.

After running with a collective of Iten athletes including Keitany, in 2011, the journalist Adharanand Finn wrote a book called *Running with the Kenyans*. "Nobody keeps a training log or adds up their weekly mileage," Finn writes. "Each session is forgotten as soon as it is done." Keitany is no exception. As Finn explained to me over email, "Often after a race you will hear a Kenyan runner say something like, 'I felt good so I decided to push.' Rarely will they say, 'I was running 4:50-mile pace, so I knew I had to pick it up.'" And while some in the Kenyan contingent do track their splits and pace, Keitany does not.

By choosing not to dwell on the ubiquitous numbers and data points of the sport, Keitany intentionally supplants analysis and overthinking with instinct. "I just follow my fatigue," she told me. "With this, I can push my pace or go a bit easier or go and make a move." She says she lets Nicola monitor the details of her training and performance numbers, and rarely, if ever, questions the rationale.

"It's nothing new," Joyner told me. "Ron Clarke and Herb Elliott trained by feel in the late '50s and '60s and did just fine." Clarke set 19 world records. Elliott, a middle-distance runner, won an Olympic gold medal.

In an age of fitness and performance technology and expert analysis, Keitany's approach gives weight to simplicity and clarity of mind. And she wins. Course familiarity helps: of all the courses she has run in a decade of competition—Berlin, London, New York, Ras Al-Khaimah—she was emphatic about the one she knows best. "New York. It's New York. I love the commentator noise in Central Park, the long trail up First Avenue and then down Fifth Avenue; you can see to the distance or someone behind you. And the corners in the Bronx."

Those corners are where Keitany's lethal engine will kick in for her bid for three, on Sunday. And for the first time, weather permitting, her "major motivating factor," her kids, will be waiting for her at the finish.

No one even close: Mary Keitany would claim her fourth New York City Marathon title in 2018, winning by more than three minutes. *Photo by Lou Bopp/NYRR*

Before Keitany left the morning shakeout to go to a press conference, I asked if she would be devastated by a loss. She shrugged; she hadn't considered it. But, either way, in keeping with tradition, she said she would return to Central Park the day following the race for a few last, "slower" laps. Then I asked when her final race might be—how long can she keep going?

She was quick to answer. "I don't have any idea," she said. "I will just run."

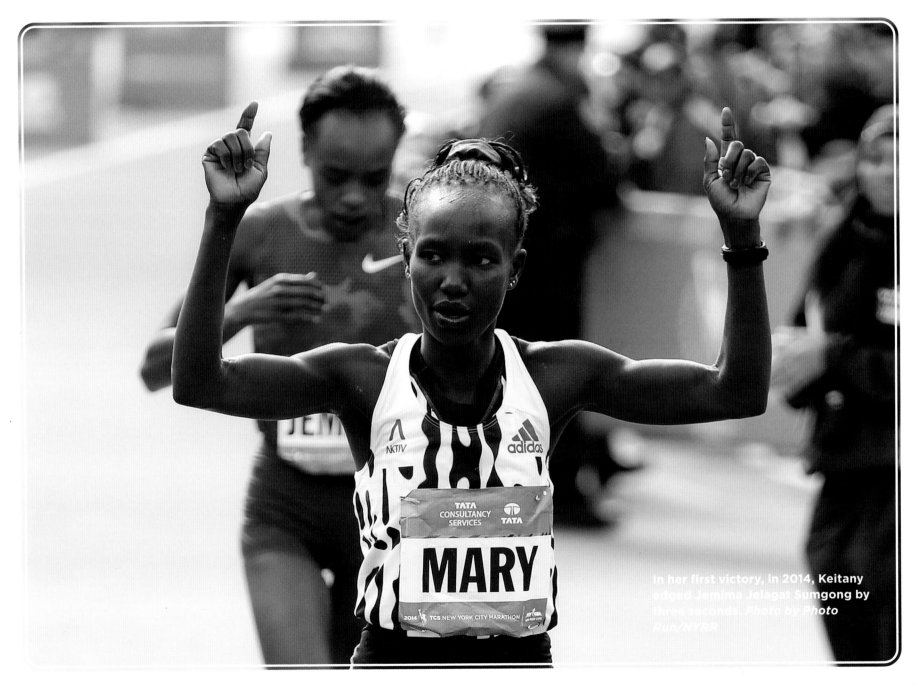

In her first victory, in 2014, Keitany edged Jemima Jelagat Sumgong by three seconds. *Photo by Photo Run/NYRR*

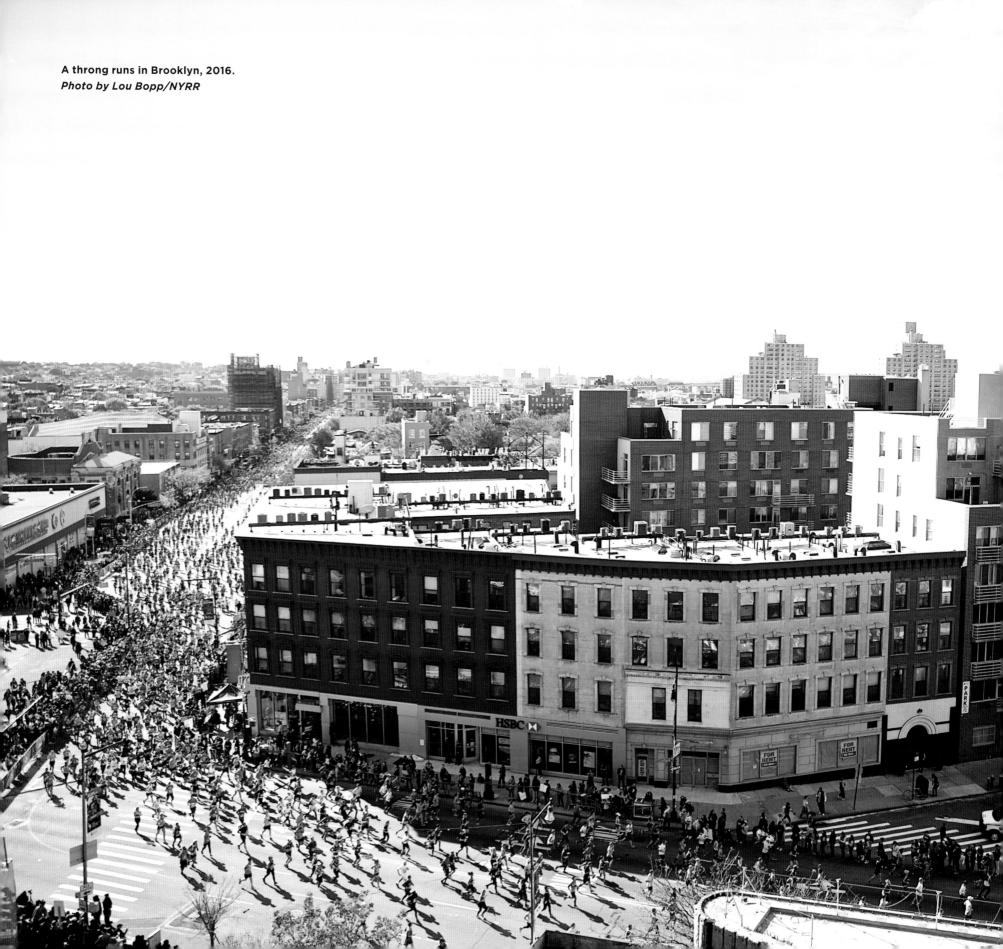

A throng runs in Brooklyn, 2016.
Photo by Lou Bopp/NYRR

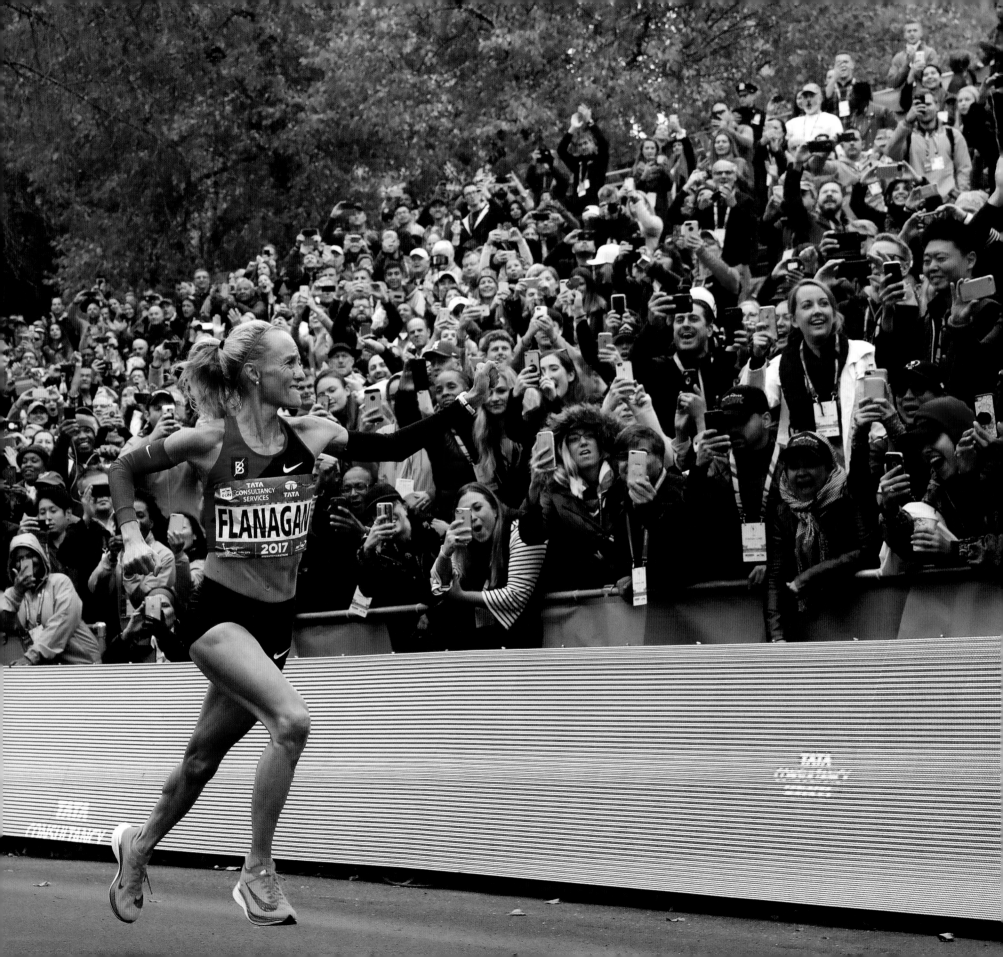

SHALANE FLANAGAN SOLVES N.Y.C. MARATHON FOR AMERICAN WOMEN

BY ZACH SCHONBRUN

The simple thought crossed Shalane Flanagan's mind as she raced alone through Central Park: *Just keep it together, keep it together.*

She would not dare look over her shoulder. Her gaze remained ahead, on the prize that had eluded an American female marathon runner like herself since 1977.

Flanagan, 36, had a vague sense of the history. She felt a more personal stake in this New York City Marathon taking place just days after a terror attack in Lower Manhattan. It reminded her of the inspiring performance by her friend Meb Keflezighi, the American male winner of the first Boston Marathon after the bombing in 2013 (he was in this race, too, in what he said would be his last marathon).

That is partly why, as the finish line neared, Flanagan, with tears in her eyes, began pointing and shouting (with maybe a few colorful words thrown in).

"That's for Meb," she said, after crossing, in first place, 40 years after the last American won the women's field.

Flanagan, a Massachusetts native, won with a time of two hours, 26 minutes, 53 seconds. She finished a full minute ahead of the champion for the last three years, Mary Keitany of Kenya, whose time was 2:27:54. Mamitu Daska, of Ethiopia, competing in the New York City Marathon for the first time, finished third with a time of 2:28:08.

Another American, Allie Kieffer, finished fifth in 2:29:39.

Keitany, 35, was seeking to cap a banner year, in which she won the London Marathon with a blistering time of 2:17:01, a record for women running without male pacesetters on the course. She had blown away the field in New York a year ago, winning by a margin (three minutes, 34 seconds) not seen in the women's race since 1980.

It was clear almost from the start, though, that Sunday's race was not going to follow the same trajectory. Keitany, who last year burst out in front around Mile 10 and never looked back, appeared more tentative and conservative with her approach this time.

After the race, the soft-spoken Keitany said an unspecified personal incident on Saturday afternoon had kept her from feeling her best. She said only that it was not an injury.

"That's part of life," Keitany said. "I was not able today to do what I wanted. That's why I did the way I did today."

Still, she managed to stay in the front of the pack and at times appeared to threaten to pull away. A large group of nine competitors consistently jockeyed for the lead, without much separation between them, until there were only a few miles left in the race.

As the runners made their way down Fifth Avenue, the pack of nine had been whittled to three: Keitany, Daska and Flanagan, looking calm and collected. Their paces picked up. They stayed within an arm's reach of one another.

But it was Flanagan who would enter the Engineers' Gate into

Shalane Flanagan's crowd-pleasing victory made her the first U.S. women's champion since 1977. *Photo by Photo Run/NYRR*

Central Park with a wide berth. In a bizarre decision, Keitany began to drift toward the east side of Fifth Avenue, away from Flanagan and Daska, before zigzagging back to the customary route. At that point, though, it was too late to catch up.

Flanagan had been preparing as if this were her final race, which she had hinted about.

"We'll have some decisions to make," she said Sunday.

She had suffered a stress fracture in her back in the winter that forced her out of the Boston Marathon and kept her away from running for 10 weeks. In the interim, she took a vacation. She focused on her foster children. She brainstormed ideas for a second cookbook, following the success of her first, a bestseller.

The daughter of Cheryl Bridges, who once held the world record in the marathon, Flanagan had been an insatiable runner, splitting her time between world marathon majors and track events. But gearing up for New York, she had not run a marathon for more than a year. She altered her training regimen, opting for a shorter buildup, fewer workouts in between lengthy runs.

She also had a strategy: Stay patient. Keitany might zoom out ahead, in which case, good luck. But when she didn't, Flanagan could sense an opportunity.

"My coaches told me that it was possible—the training I put in was the best I've ever put in," Flanagan said. "These are the moments we dream of as athletes. This is going to feel good for a really long time."

Keflezighi, who finished 11th in the men's race, said he had been texting and emailing Flanagan words of encouragement throughout the spring and summer.

"I just couldn't be happier for her," he said. "She deserves one of those, whether it's here or Boston, and I'm so delighted for her."

Afterward, overcome at several points by tears and emotion, Flanagan said 40 years was too long, "way too long."

She added: "I've been dreaming of a moment like this since I was a little girl. It means a lot to me, to my family. Hopefully it inspires the next generation of women to just be patient. It took me seven years to do this. A lot of work went into this one moment."

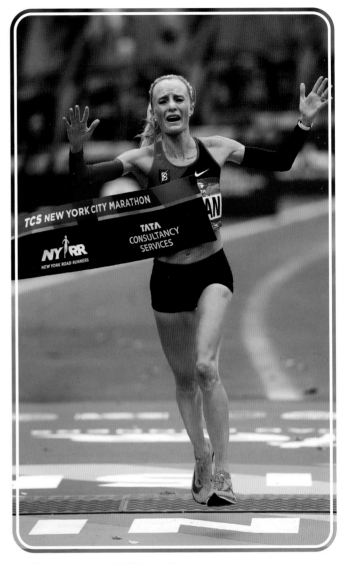

Flanagan's win fulfilled a lifelong dream.
Photo by Photo Run/NYRR

"THIS IS GOING TO FEEL GOOD FOR A REALLY LONG TIME."

—SHALANE FLANAGAN

I'M A PLUS-SIZE RUNNER AND I GOT HECKLED AT THE NYC MARATHON

BY L. SHAUNTAY SNELL

Photo by W. Eric Snell, Sr./E. Snell Design

THIS YEAR, I RAN MY seventh and eighth marathons within four years of running—all as a plus-size woman. I ran the Chicago Marathon on Oct. 8 and the New York City Marathon on Nov. 5—followed by the New York Road Runners 60-K ultramarathon less than two weeks later. The year 2017 was my most ambitious marathon season to date.

Despite months of emotional and physical hurdles, I invested endless hours on the pavement in training. I committed to waking up at ungodly hours each morning, programming my body to an insane routine of regularity, learning what foods worked well with each distance, and mastering leaving my brownstone at dawn without waking my husband and son.

Naturally, when you sign up for any endurance event, you prepare your body and mind for harsh conditions. Unfortunately, I never considered the need to prepare myself for harassment on the course—especially not in a place I call home.

As a seasoned and proud back-of-the-pack runner, I'm accustomed to starting much later than the elites. I know the miles are set, the challenges will be there and the

fatigue will set in eventually. I am a runner who feeds on the adrenaline of the day, the roars of the crowd and following through on our respective goals.

But between the 22nd and 23rd miles of the New York City Marathon, my home-stretch high was disrupted by a tall, balding white man who felt it appropriate to shout, "It's gonna take your fat ass forever, huh?"

Shocked and angry, I stopped and retorted expletives and insults, then posted my frustra-tions to my Facebook page. Two other female runners witnessed our confrontation and told me he wasn't worth it. They were right, of course, but the damage was already done. By that point, I'd lost minutes and much-needed energy to a man who took pride in poking fun at my size.

On marathon day, you focus on your breath-ing and your stride. Each step matters, and as the time passes, your thoughts can dictate your movements. By mile 23, my mind was in a boxing ring, enraged by the man who tried to rope-a-dope my headspace.

He didn't know what I'd sacrificed to be there; how I'd contemplated abandoning a sport I often refer to as "oxygen" because I was still grieving the miscarriage of my twins in August. He didn't know I'd had emergen-cy surgery for endometriosis, or the 142 times over the course of a year that I'd been called everything from "fat bitch" to the n-word online, simply for being a black, plus-size food-and-fitness blogger.

And he didn't care. As a mere spectator, he saw my five-foot-three-inch, 218-pound body as a joke. And I—an exhausted runner who was so close but still so far from the finish line—fell for the bait, as he lured me with insults.

That man didn't know that prior to 2013, I'd stopped weighing myself when my scale tipped 265 pounds. How, by that point, I was criticized about my weight any time the opportunity presented itself. Even if I was eating a half sandwich and small soup, I'd receive unprovoked, backhanded com-pliments about my healthier eating habits; imagine daring to indulge in a candy bar in public!

When I was finally ready to change my life-style, I fell in love with fitness—and, even-tually, running. Running helped me shed significant pounds, but that didn't translate to happiness with my transformed body. My new sport helped me find freedom and strength through the pavement, but it also taught me that the number on the scale didn't dictate or govern my happiness.

So I tweaked my goals a bit, and found that when I gained some of the weight back, my mind was stronger. In the years since, my con-fidence has become as strong as my endurance. But despite my generally positive outlook on life, I'm still human. And on any particular day—like marathon day—words have a way of empowering or crippling a person.

But after seeing several friends on the side-lines who'd waited hours for me to pass, I

couldn't remain bitter any longer. Because I didn't sign up for the New York City Marathon to prove anything to anyone but myself. Every marathoner has her or his own reasons for being out there, but after four years of running, it's hard to picture *not* run-ning. I embrace the challenges and fears of not making it, the glory in earning a medal I can't earn anywhere else, and even the crip-pling, unofficial 27th mile each marathon finisher makes to exit the park.

And as I finished the New York City Marathon—a few minutes over the sev-en-hour mark—I felt content. I didn't need to harbor anger or aggression; that man wasn't the first, and likely won't be the last, to toss off a callous comment about my weight. I'm aware of what I look like and the stereo-types that accompany my size, and anyone who thinks I need to be educated about the laundry list of obesity risks needn't bother. He didn't say anything about which I'm not already aware.

I'm fat. Full-figured. Thick. Plus-size. Powerful. Capable. Empowering. Phenomenal. And in the end, my real clapback that day came from the power of my thick legs shuffling me from New York's Staten Island, across five boroughs and ending in the drizzling rain in Manhattan. I am powerful because I believe that I am. And I owe nobody an explanation for what moves me.

NEW YORK TIMES, NOV. 3, 2018

LAST TIME AROUND: NEW YORK CITY MARATHON CHIEF TAKES MEASURE OF A LONG JOURNEY

BY KEVIN ARMSTRONG

From his perch, riding through Brooklyn on a black bicycle, Peter Ciaccia noticed things that only someone with his experience and, more to the point, his responsibilities would notice.

A dumpster needed to be moved from 94th Street in Bay Ridge. Dedicated "no parking" signs were not up yet, and he wondered when they would be.

It was two weeks before Sunday's New York City Marathon, and Mr. Ciaccia's last as the race director. It was time for the annual spot check of the 26.2-mile course.

Dressed in layered clothing to combat high winds and temperatures in the low 40s, he advanced in a 10-person peloton composed of New York Road Runners staff members to inspect the route for any potential problems that would need to be addressed before more than 50,000 runners take the stage. . . .

For Mr. Ciaccia (pronounced CHA-cha), it was his last dance with the details. After 18 years with New York Road Runners, the last four as the marathon's race director, Mr. Ciaccia, 65, reflected on his tenure by eyeing milestones and revisiting old haunts along the path.

It was his 10th annual inspection outing that also served as a reminiscence ride, with no one clocking his time. By day's end, he estimated that there would be 12 stops at his favorite coffee shops.

But even with fortification from numerous breakfasts along the way, and a bicycle to navigate the course, getting there was no easy task.

Just a mile in, he braced for a bridge that led into the marathon's maw. "I think the wind is going to be in our face as we are going over the Queensboro Bridge, which is the worst climb in the world,"

Peter Ciaccia (third from left) checks out his course. *Photo by Kevin Hagen/*New York Times *via Redux*

Smiles for the miles: Ciaccia (sixth from left) and his cycle mates pause to pose during their final pre-race ride over the course. *Photo by Kevin Hagen*/The New York Times *via Redux*

he said. "The course is undulating. There is always something going on with this bike ride."

8 A.M. IRISH HAVEN, SUNSET PARK

Mike Collins, a retired city police officer, held an Irish flag in his right hand as he called out to the group. He motioned toward a choke point caused by ongoing construction for subway tunnel rehabilitation on the N and R lines. It stretched from 52nd Street to 58th Street, across from the Irish Haven, a pub at the corner of Fourth Avenue.

"I don't know what you're going to do out there," Mr. Collins said, "but normally that is never like this. Never."

An orange sign emblazoned "SLOW" was affixed to a chain-link fence.

"We're working with D.O.T. on it," Mr. Ciaccia said. "It'll be here, but we'll get

through it. It'll slow people down and they'll come into your place."

"Numerous people use the bathroom, have a quick shot of, um, Guinness basically," Mr. Collins said. "Maureen will be cooking soda bread, too."

"What time do you open up?" Mr. Ciaccia said.

"We're open before we should be open," Mr. Collins replied.

"Technically, 8 a.m.," Mr. Collins's wife, Maureen, said.

"On my way down, chuck me a piece of that soda bread," Mr. Ciaccia said. "You know, I might jump in here for a Guinness on my way down the course. Not today! I'd be swerving."

9:15 A.M. NEW YORK MUFFINS, WILLIAMSBURG

There was plenty to elude: Obstacles that no elite marathoner ever encounters dotted the streets. There were double-parked trucks and car doors swung open. City buses idled eight deep by Fourth Avenue and Flatbush Avenue because the Q train was down for repairs. Mr. Ciaccia looked at the clock atop the Williamsburgh Savings Bank Tower. He used it to orient himself.

"That points the way to heaven," he said. "So much has changed over here."

Constants remained, too. It has always been a critical space as runners lean left along Flatbush before turning right onto Lafayette Avenue, where trees shade the asphalt and

brownstones line both sides. Denizens perform "The Electric Slide"; Bishop Loughlin High's band plays "Gonna Fly Now," the theme song from *Rocky*.

Mr. Ciaccia called it his favorite part of the course as he admired the russet colors of Autumn, and the Halloween decorations on display. He has photos of fans hanging out windows to cheer runners.

"Kind of like the Kentucky Derby," Mr. Ciaccia said. "It gets intense down here."

He learned early that not every neighborhood wants noise. In Williamsburg's Hasidic community, the Road Runners purposely do not put any music or bands.

"It's not their thing," he said. "We're very respectful."

He can be nostalgic, too. Farther down Bedford Avenue, he noticed a closure.

"I can't believe they closed New York Muffins," he said. "That was a go-to."

11:30 A.M. SWEET LEAF, LONG ISLAND CITY

Bells at St. Anthony–St. Alphonsus Church rang out above Manhattan Avenue as the troupe made a right onto Greenpoint Avenue's downhill toward McGuinness Boulevard. It is known as a treacherous stretch for wheelchair racers, who have crashed while trying to negotiate a sharp turn.

Ted Metellus, a director for event development in his first year with the Road Runners, was out in front and went straight at a traffic

light where a left should have been made. On race day, hay bales are positioned to protect wayward racers. None were set up today, though.

"You're in the hay bales!" Mr. Ciaccia shouted, shaking his head. "Rookie mistake."

They continued up the Pulaski Bridge. He stopped to pose, like a model in a plank position, atop a cement barrier at the 13.1-mile marker that is spray painted in orange on a wall year round.

"Graffiti art has really come a long way," Mr. Ciaccia said. "In my youth, the height of graffiti, it wasn't considered art back then. The vandals!"

Vintage has always been en vogue for Mr. Ciaccia. The next stop was Sweet Leaf, which he called a "punk rock café," in Long Island City. Customers thumbed through the collection of vinyl albums in the record room. It brought him back to his music industry days when he held executive positions for CBS Records and Sony Music Entertainment. One patron wound up in the middle of the riders' order.

"Put him on our tab," Mr. Ciaccia said. "You're with the bike gang now."

1:05 P.M. MITCHEL HOUSES, BRONX

Mr. Ciaccia, the son of southern Italians, grew up by West 233rd Street and Broadway in the Bronx. He went to Lehman College, refers to Van Cortlandt Park as "Vanny" and

trots out D.J. Kool Herc to perform on stage for some events. He does what he can for his home borough, but also knows there is only about a mile of the course in the Bronx.

Each year, Rubén Díaz Jr., the borough president, asks Mr. Ciaccia to give the Bronx a greater share of the route. Mr. Ciaccia insists he is limited by the race's footprint, but when the city built a sidewalk at Mile 8 in Brooklyn, Mr. Ciaccia repurposed the altered mileage in the Bronx, giving the borough "a little more distance."

"I said, 'The only way we can do this is if I finish it in Yankee Stadium. You got to let me finish in Yankee Stadium,'" Mr. Ciaccia said. "Maybe one year they will do that. Not in my tenure."

Over the Willis Avenue Bridge they went, crossing the Harlem River into the Bronx. They pedaled past broken glass in the middle of Rider Avenue. When Mr. Ciaccia and Jim Heim, the technical director who will inherit Ciaccia's job, came across an orange construction cone turned upside down, they stopped and lifted it up. They saw it was being used as a plug for an opening in the pavement.

"Looks like the start of a sink hole," Mr. Heim said.

Mr. Ciaccia nodded.

"This will all get cleaned up," Mr. Ciaccia said.

2:15 P.M. CENTRAL PARK, UPPER EAST SIDE

Up a hill and into a headwind, Mr. Ciaccia trailed his staff along Fifth Avenue. Skateboarders circled him as he talked about the finish line.

"There's a whole world of senior discounts to explore," he said, looking ahead to his retirement. "I can go to the movies three times a day for five bucks."

He mapped out a few of his next steps. Soon after completing his marathon responsibilities, he will board a plane to vacation in New Zealand and Australia. Until then, he remained on the clock. When he applied his brakes for the last time, he was at Engineers' Gate, where marathoners enter the park.

"It's going to be bittersweet. Actually, a little surreal," he said. "Now it's like, 'Oh my God, it's around the corner.'"

It had been more than seven hours on course. Mr. Ciaccia picked up his prize—not a marathon medal, but a street-vendor pretzel—and ambled over to the statue of Fred Lebow, the marathon's founder. Lebow, his eyes trained on his wristwatch, stood sentinel. Mr. Ciaccia noticed that a few leaves covered his predecessor's face. He added one more chore to his to-do list.

"We really need to trim that tree," he said.

"THAT POINTS THE WAY TO HEAVEN. SO MUCH HAS CHANGED OVER HERE."
—PETER CIACCIA

Everybody line up! Time for a quick photo before the start in 2017.
Photo by Drew Levin/NYRR

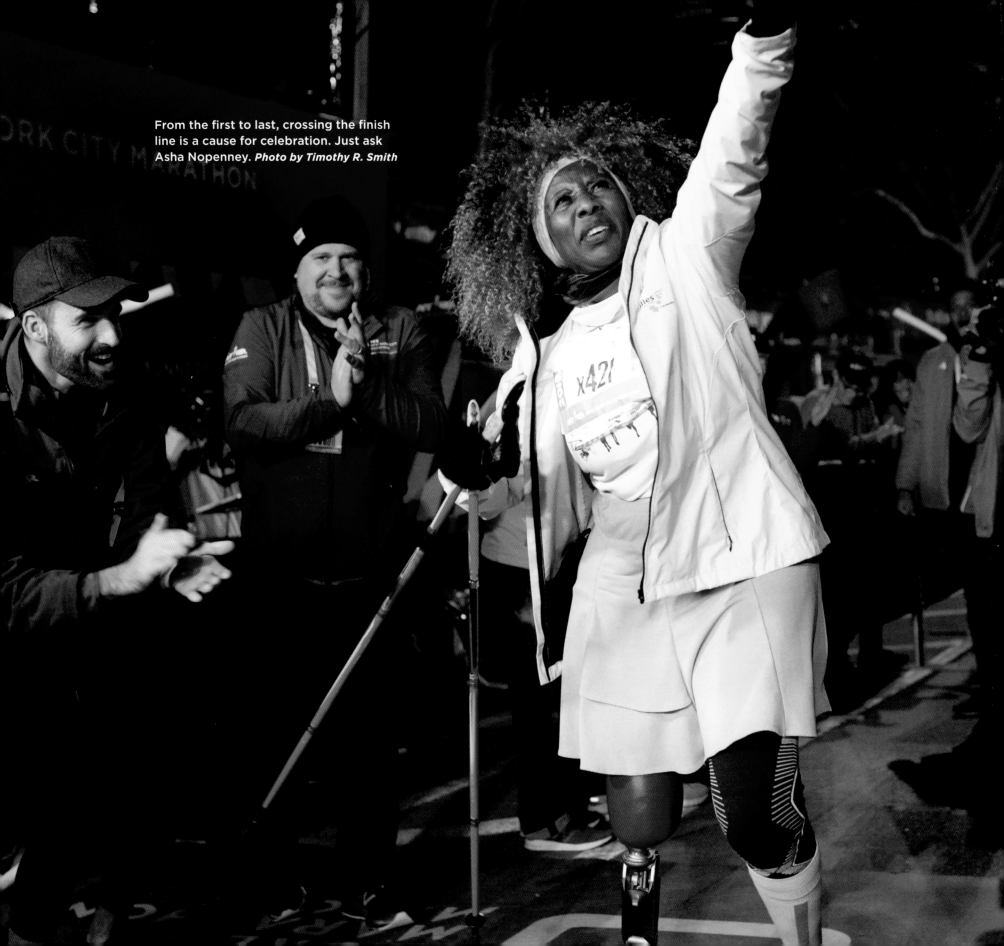

From the first to last, crossing the finish line is a cause for celebration. Just ask Asha Nopenney. *Photo by Timothy R. Smith*

ESPN, NOVEMBER 5, 2019

THE ASTONISHING STORIES BEHIND NEW YORK CITY MARATHON'S FINAL FINISHERS

BY CHARLOTTE GIBSON

A final finisher, Asha Noppeney of Germany danced her way across the finish line of the 2019 New York City Marathon after 13 hours on the course.

On the first Sunday in November, as the sun begins to set and the temperature drops to the mid-40s, the TCS New York City Marathon starts to become a thing of the past. The marathon staff and volunteers break down barricades along the race course. The police escort, along with the medical vehicles and the shuttles, slowly drive up First Avenue in Manhattan announcing to the small number of racers crossing Mile 16 that the streets will open back up to the public soon. It's only 4 p.m., and these runners still have more than 10 miles—and at minimum four hours—to go before they cross the finish line.

More than 50,000 runners crossed that finish line while the sun was still shining and thousands of spectators were still packed like sardines at the grandstands. Not for these 100 or so racers. It will be dark, lonely and cold when they enter Central Park for the last mile. About 150 spectators will be gathered around the last few yards of the finish line, cheering but sounding faint in comparison to the cacophony just a few hours earlier. As the time inches toward the 7:25 p.m. race cutoff, these racers will technically finish but won't be listed as official

finishers. Many will take nearly 12 hours to get through 26.2 miles. But they aren't running for the accolades or the bragging rights. They are here for much more personal reasons. Here are their stories.

KATHERINE RASHDAN
FINISH TIME: 8:52:33 AT 7:58 P.M.

"Annabella ... Annabella ... Annabella ..." That's the name Katherine Rashdan, 36, repeated for 26.2 miles. When Katherine's legs started to give at Mile 12, she didn't think she was going to finish. But then

Katherine Rashdan. *Photo by MarathonFoto*

she remembered her 7-year-old daughter, Annabella. "I wanted to show her that you can do anything you put your mind to," Rashdan said while wiping away tears.

Just three months ago, Rashdan began training for the marathon after winning an online contest for a late entry into the race. It had been 19 months since she had given birth to her second child, and she knew she lacked the training but she didn't want that to deter her from trying. "I can't even believe that I did it," said Rashdan, of Long Island. "When I go home, I'm going to give this medal to Annabella. And when my son is old enough, I'm going to tell him all about how his mom completed a marathon."

DENISE HIDALGO & ROCHELLE ROSA
FINISH TIMES: 9:13:29 AND 9:13:27, RESPECTIVELY, AT 8:21 P.M.

For Rochelle Rosa, 68, it has seemed like every year for the last decade she's faced a medical crisis. Eight years ago, after getting hit by a car while crossing the street, Rosa could barely walk. Her left knee was completely destroyed, and her dreams of ever competing in a marathon started to dissipate. Then, after suffering an aneurysm in her stomach three years ago and being temporarily paralyzed for six months, her marathon fate seemed sealed. But, one morning, Rosa woke up and said, "I'm going to run." Fighting her way back

Denise Hidalgo (left) and Rochelle Rosa.
Photo by MarathonFoto

from a wheelchair to a walker to a cane to no assistance at all, Rosa began running in her late 60s. "I'm not a quitter," said the New Yorker. "This is everything to me."

When the time came to sign up for the 2019 New York City Marathon, Rosa's good friend and running partner, Denise Hidalgo, 60, knew she would be running alongside Rosa. Said Hidalgo, who has completed eight marathons, four in New York City: "I was actually hoping I could keep up with her. She drove me. On the bridges, her pace was astonishing."

HANNAH GAVIOS
FINISH TIME: 11:02:35 AT 8:45 P.M.

Running has always been a huge part of Hannah Gavios's life. But in 2016, she injured her spinal cord after falling 150 feet from a cliff as she tried to escape an assault from a man in Thailand. Gavios was paralyzed and told she may never walk again. She didn't let that stop her.

Last year, Gavios completed her first NYC Marathon with the support of Team Reeve, a part of the late Christopher Reeve's foundation. She raced the entire course on crutches. This year, Gavios did it again. "After my injury, I told myself that no matter what the circumstances are, I'm a runner no matter what," said Gavios, who lives in Astoria, New York.

Still the 26-year-old is not done and has aspirations beyond another marathon:

She's eyeing Africa's highest mountain. "My dream," Gavios said, "is to do Mt. Kilimanjaro."

DAVE FRASER
FINISH TIME: 12:29:46 AT 9:21 P.M.

Dave Fraser and "final finisher" have become synonymous over the years at the New York City Marathon. Over the course of 26.2 miles, Fraser can be seen throughout the five boroughs pushing himself backward in his wheelchair for 90% of the race, only facing

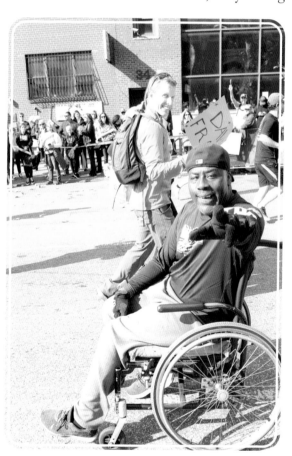

forward on the downhill portions. "This is how I get around every day," said Fraser, who lives in Brooklyn. "This is just my life. I've always done it like this. I don't know any other way."

Born with cerebral palsy, Fraser entered his first NYC Marathon in 2007, in search of a new challenge. It wasn't until the next year when his wife, Nora, got stomach cancer that he decided he'd race—and finish—every year for her. Sunday's race was his 12th consecutive, and Nora has been in remission since 2008. "The only way I'm not competing is if I have an IV in my arm," the 52-year-old jokingly said.

Now, 11 years later, Nora and their three sons meet Fraser and his guides for the final mile of the race. "When I see her face, I know that I'm close," Fraser said.

ASHA NOPPENEY
FINISH TIME: 13:13:41 AT 10:05 P.M.

At the age of 7, Asha Noppeney underwent amputation surgery on her right leg after a bicycling accident in her birth country of Uganda. She had to learn to walk and run on a prosthesis. Throughout her childhood and most of adulthood, Noppeney never imagined she could complete a marathon. "I never, never thought I could run marathons," Noppeney, 65, said after she did a dance across the finish line. "I started at 40 years old—and now look at me! Never, never lose hope. Never give up."

Hannah Gavios. *Photo by Timothy R. Smith*

Dave Fraser. *Photo by Steven Ryan/NYRR*

For the last decade, Noppeney, who now lives in Bayreuth, Germany, has competed in nine marathons around the world—usually finishing in less than nine hours. But here in New York, she struggled over the last six miles, due to pain caused by her prosthetic leg. "I told myself to keep pushing. Don't feel the pain and just do it. And I did it," Noppeney said, as she raised her hands toward the sky.

PAPA OTENE
FINISH TIME: 11:45:44 AT 10:26 P.M.

When Papa Otene crossed the finish line at the New York City Marathon, all he thought about was the beauty. This year, the 72-year-old completed the marathon with his wife and his granddaughter, and ran in memory of friends and family who have passed. Just a week before the marathon, Otene's mother-in-law died, and he knew his family would feel her beauty when they finished the race. "There was nothing like running in the honor of those who we have lost," Otene said.

Otene traveled more than 21 hours from New Zealand with 150 members of Influence Crew, a group dedicated to healthy lifestyles, to compete in his third NYC Marathon. Most of them stayed together the entire race. Near the end, a member from the group fell and Otene stayed behind to help them finish. "I would always do that to be with my community," he said.

Papa Otene was greeted with a kiss at the finish. *Photo by Timothy R. Smith*

SHELLIE WARREN
FINISH TIME: 12:06:03 AT 11:14 P.M.

Five years ago, Shellie Warren's son, Brett Warren, died by suicide after jumping off a bridge above the Hudson River in New York. Just months later, news came that the former Navy machinist mate was selected to run the 2014 New York City Marathon. Warren decided then what she had to do: She would run the marathon this year in his honor. Not being a runner, she knew the race would be physically and emotionally challenging. But no matter what, she would finish for Brett. "It was never an option not to finish," said Warren, 59. "I felt him every step of the way. He was with me."

At the starting line, Warren stood on the Verrazzano Bridge and took a moment. She knew she would have to cross a few bridges over the course and see more rivers—and she associated trauma with both. So, in this moment, she stopped and had a talk with her son. "I told him I was sorry that he was in so much pain, and that I always loved rivers and I always loved bridges and I wanted to love those things again. I told him I was going to have to stop hating rivers and bridges," Warren said.

Warren crossed the finish line after 11 p.m. as the official final finisher—long after organizers called the race and started sending people home, including the ESPN photographer and reporter. "I feel like I said goodbye to that trauma," she said. "I needed to say goodbye to that deepest part of grieving and realize that there's so much good that I can still do."

7802

New York City Subway

Training for the Marathon: Some runners took the subway to the start in 2018.
Photo by Ben Ko/NYRR

2

THROUGH THE YEARS:
YOUTH RUNNING

The rules state that you must be 18 years old to run in the New York City Marathon. But you can lace on a pair of running shoes and take to the roads at any age, and that fact is the inspiration behind New York Road Runners' commitment to youth running. What began in 1999 with a 20-student after-school group in Red Hook, Brooklyn, has blossomed into a range of programs, events, and resources serving nearly 250,000 students across the country.

At the forefront is Rising New York Road Runners, which, with support from sponsors TCS, New Balance, and the New Balance Foundation, provides free youth fitness programs for students from prekindergarten through grade 12. Implemented through schools, after-school programs, and community centers, Rising New York Road Runners incorporates the latest athletic-development research to build fitness skills, self-assurance, and healthy attitudes that will carry over into adulthood. Rising New York Road Runners Wheelchair Training Program is a free, year-round program for youth with physical disabilities ages six to 21. The program offers weekly training sessions, in-school resources, and competitive events on the road and track.

NYRR Run for the Future is a free seven-week program for young women entering their senior year of high school who have had little or no athletic experience. Over the course of the program participants learn about such things as running technique and nutrition, as well as goal setting and time management, and cap it all off with their first 5K race. Those who fulfill all the requirements receive a $2,000 college scholarship.

Said one participant, Aminata, of her goals for the program: "I wanted to be a stronger, healthier, better me."

Spoken like a future marathoner.

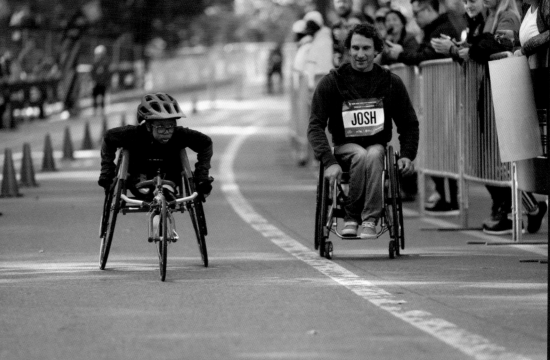

THROUGH THE YEARS:

TECHNOLOGY

Recall the first New York City Marathon: runners looping Central Park, not quite certain of the distance, their mile times perhaps shouted out to them by someone holding a stopwatch; their supporters (if any) waiting, unsure where their heroes were on the course or if they were even still in the race. How dazzled would those runners and spectators be were they miraculously transported into the hypertech world of today's race?

Over the ensuing five decades, New York Road Runners introduced innovations such as on-course digital clocks, electronic chip timing, large-screen video monitors, searchable online results, live-streaming and runner tracking that have fundamentally altered the experience of what is, after all, the simplest of sports. And the technological advances just keep coming.

Eager to track your favorite runner? The TCS New York City Marathon App Powered by Tata Consultancy Services (the race's title sponsor and technology partner since 2014), with more than half a million downloads in 2019, provides mile-by-mile splits for every competitor on the course, as well as pro runner bios, spectator guides, and interactive course maps. The app's Share Tracking button on the Runner Details page allows users to share links that automatically download the app and track a specific runner's progress.

Finally, remember how outlandish the notion of a five-borough New York City Marathon seemed back in 1976? Try a *seven-continent* one. The NYRR Virtual Racing Powered by Strava platform gives runners around the world the chance to run the race at their convenience and location of choice, logging their miles on Strava.

This isn't your grandfather's marathon anymore.

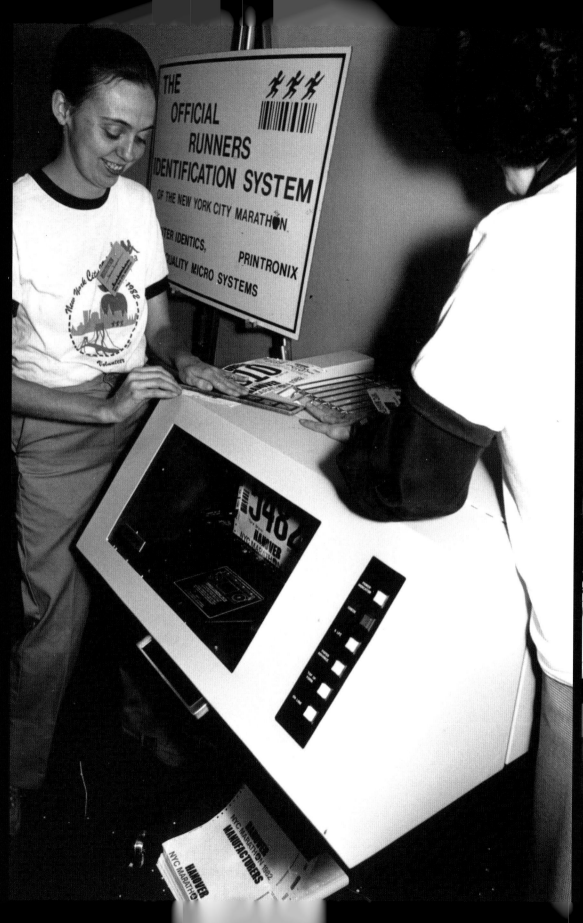

Photo credits, clockwise from left: Ken Levinson; David Madison/Getty Images; Ed Haas/NYRR; Da Ping Luo/NYRR; Jon Simon/NYRR

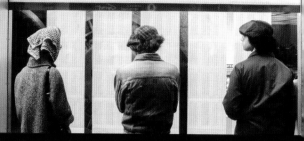

RESULTS
of the
NEW YORK CITY MARATHON

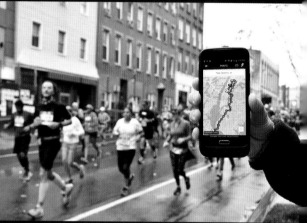

TATA
CONSULTANCY
SERVICES

PERFORMANCE METRICS
POWERED BY **TATA** CONSULTANCY SERVICES

During the long and challenging months of the pandemic, the city shut down and races were canceled, but runners everywhere—including (top, left) one springtime strider in Brooklyn's Sunset Park—carried on. Among them was the Marathon's first champion. On September 13, 50 years to the day after the inaugural race, Gary Muhrcke (top, right, with grandson Colin Kern) marked the anniversary of his historic victory with a lap of Central Park. That same month (bottom, left and right), NYRR's Return to Racing series launched, giving runners a chance to come together again (while socially distanced) and compete safely. *Photos by (clockwise from upper left): Da Ping Luo/NYRR; NYRR; Carla G. Torres/NYRR (2)*

EPILOGUE

Every marathoner will tell you that even in the best races there will come a bad patch—a mile, maybe, that is particularly challenging, a mile that can seem to last forever. But getting through that hard stretch, regrouping to *keep going*, is what makes the athlete. In the long run of the New York City Marathon, the year 2020 was the toughest of miles.

It was to have been a year of celebration, the golden anniversary of this singular and beloved race—*50 Years Running*. But then the global pandemic upended plans around the world. In June, after weighing all options, organizers made the painful but necessary decision to call off the 2020 marathon, only the second cancelation in the race's history. Sporting events, concerts, all gatherings large and small everywhere, were suspended as, well, everything shut down.

But running itself remained, a life-saving and life-affirming constant. There may not have been any races, but each day runners took to the streets and parks—and even backyards and balconies—of New York and of cities and towns around the globe, putting in their miles as a way to preserve their health and fitness, both physical and mental. And each footstep spoke to the promise of better days ahead, declaring that we would get through this.

Reflecting that spirit of optimism and determination, New York Road Runners responded with the same innovative energy that had given birth to the marathon a half century before. A slate of virtual races throughout the year provided runners with both a competitive outlet and, even more important, the sense of connection and community that is at the heart of our sport. Foremost among those events was the third edition of the Virtual TCS New York City Marathon, which opened on October 17 and concluded on November 1, the original date of the 2020 marathon. Over those 16 days, 16,370 athletes from 107 countries and all 50 states completed a run of 26.2 miles on a course of their own, cheered on if not by millions of New Yorkers, then certainly by their families and friends. The field included runners who

had served on the frontlines battling the pandemic and others who had themselves overcome COVID-19. As always in the NYC Marathon—in-person or virtual—many ran to raise money for charity or for a cause close to their heart. Participants uploaded their times to Strava and many also shared their stories and photos online. Fastest among the men was Kevin Quinn, from Carshalton, England, who finished his personal course in 2:23:48. Stephanie Bruce of Flagstaff, Arizona, was the quickest woman, and 10th-fastest overall, in 2:35:28. Among the wheelchair participants, 2018 NYC champion Daniel Romanchuk of Mount Airy, Maryland (1:14:09), and Susannah Scaroni, of Champaign, Illinois (1:47:30), led the way.

It was, in the end, a moving and fitting celebration of New York's 50th—as was one runner's somewhat shorter outing a month before. On September 13, the actual 50th anniversary of the first race, then held entirely in Central Park, Gary Muhrcke, the marathon's inaugural champion, returned to the scene of his victory and—at age 80—churned out a commemorative six-mile loop. Marathoners keep going.

As will the TCS New York City Marathon. On May 17, 2021, it was announced that the race would be held on November 7, with a field of 33,000 runners. Said race director Ted Metellus, "This will be an unprecedented and historic year for the TCS New York City Marathon. As we stage a safe and memorable race for the 50th running, this year's marathon will showcase our great city's strength, inspiration, and determination."

And, as always, it will showcase the spirit of the remarkable athletes of all ages and abilities who come to test themselves on the streets of New York, supported as they have been for half a century by the race's committed partners and indispensable City Agencies, enthusiastic volunteers, and inspirational spectators. As the first 50 years have taught us, no one runs alone.

CHAMPIONS: OPEN DIVISION

	MEN		WOMEN	
1970	Gary Muhrcke, USA	2:31:38	No female finisher	
1971	Norman Higgins, USA	2:22:54	Beth Bonner, USA	2:55:22
1972	Sheldon Karlin, USA	2:27:52	Nina Kuscsik, USA	3:08:41
1973	Tom Fleming, USA	2:21:54	Nina Kuscsik, USA	2:57:07
1974	Norbert Sander, USA	2:26:30	Kathrine Switzer, USA	3:07:29
1975	Tom Fleming, USA	2:19:27	Kim Merritt, USA	2:46:14
1976	Bill Rodgers, USA	2:10:10	Miki Gorman, USA	2:39:11
1977	Bill Rodgers, USA	2:11:28	Miki Gorman, USA	2:43:10
1978	Bill Rodgers, USA	2:12:12	Grete Waitz, Norway	2:32:30
1979	Bill Rodgers, USA	2:11:42	Grete Waitz, Norway	2:27:33
1980	Alberto Salazar, USA	2:09:41	Grete Waitz, Norway	2:25:41
1981	Alberto Salazar, USA	2:08:13	Allison Roe, New Zealand	2:25:29
1982	Alberto Salazar, USA	2:09:29	Grete Waitz, Norway	2:27:14
1983	Rod Dixon, New Zealand	2:08:59	Grete Waitz, Norway	2:27:00
1984	Orlando Pizzolato, Italy	2:14:53	Grete Waitz, Norway	2:29:30
1985	Orlando Pizzolato, Italy	2:11:34	Grete Waitz, Norway	2:28:34
1986	Gianni Poli, Italy	2:11:06	Grete Waitz, Norway	2:28:06
1987	Ibrahim Hussein, Kenya	2:11:01	Priscilla Welch, G.B.	2:30:17

Year	Men's Winner	Time	Women's Winner	Time
1988	Steve Jones, G.B.	2:08:20	Grete Waitz, Norway	2:28:07
1989	Juma Ikangaa, Tanzania	2:08:01	Ingrid Kristiansen, Norway	2:25:30
1990	Douglas Wakiihuri, Kenya	2:12:39	Wanda Panfil, Poland	2:30:45
1991	Salvador Garcia, Mexico	2:09:28	Liz McColgan, G.B.	2:27:32
1992	Willie Mtolo, South Africa	2:09:29	Lisa Ondieki, Australia	2:24:40
1993	Andrés Espinosa, Mexico	2:10:04	Uta Pippig, Germany	2:26:24
1994	Germán Silva, Mexico	2:11:21	Tegla Loroupe, Kenya	2:27:37
1995	Germán Silva, Mexico	2:11:00	Tegla Loroupe, Kenya	2:28:06
1996	Giacomo Leone, Italy	2:09:54	Anuta Catuna, Romania	2:28:18
1997	John Kagwe, Kenya	2:08:12.	Franziska Rochat-Moser, Switzerland	2:28:43
1998	John Kagwe, Kenya	2:08:45	Franca Fioconni, Italy	2:25:17
1999	Joseph Chebet, Kenya	2:09:14	Adriana Fernàndez, Mexico	2:25:06
2000	Abdelkader El Mouaziz, Morocco	2:10:09	Lyudmila Petrova, Russia	2:25:45
2001	Tasfaye Jifar, Ethiopia	2:07:43	Margaret Okayo, Kenya	2:24:21
2002	Rodgers Rop, Kenya	2:08:07	Joyce Chepchumba, Kenya	2:25:56
2003	Mertin Lel, Kenya	2:10:30	Margaret Okayo, Kenya	2:22:31
2004	Hendrick Ramaala, South Africa	2:09:28	Paula Radcliffe, G.B.	2:23:10
2005	Paul Tergat, Kenya	2:09:30	Jelena Prokopcuka, Latvia	2:24:41
2006	Marilson Gomes dos Santos, Brazil	2:09:58	Jelena Prokopcuka, Latvia	2:25:05
2007	Martin Lel, Kenya	2:09:04	Paula Radcliffe, G.B.	2:23:09
2008	Marilson Gomes dos Santos, Brazil	2:08:43	Paula Radcliffe, G.B.	2:23:56
2009	Meb Keflezighi, USA	2:09:15	Deratu Tulu, Kenya	2:28:52
2010	Gebre Gebremariam, Ethiopia	2:08:14	Edna Kiplgat, Kenya	2:28:20
2011	Geoffrey Mutai, Kenya	2:05:06	Firehiwot Dado, Ethiopia	2:23:15
2012	NO RACE			
2013	Geoffrey Mutai, Kenya	2:08:24	Priscah Jeptoo, Kenya	2:25:07
2014	Wilson Kipsang, Kenya	2:10:59	Mary Keitany, Kenya	2:25:07
2015	Stanley Biwott, Kenya	2:10:34	Mary Keitany, Kenya	2:24:25
2016	Ghirmay Ghebreslassie, Ethiopia	2:07:51	Mary Keitany, Kenya	2:24:26
2017	Geoffrey Kamworor, Kenya	2:10:53	Shalane Flanagan, USA	2:26:53
2018	Lelisa Desisa, Ethiopia	2:05:59	Mary Keitany, Kenya	2:22:48
2019	Geoffrey Kamworor, Kenya	2:08:13	Joyciline Jepkosgei, Kenya	2:22:38

CHAMPIONS:
WHEELCHAIR DIVISION

	MEN		WOMEN	
2000	Kamel Ayari, Tunisia	1:53:50	Thi Nguyen, Vietnam	2:46:47
2001	Saúl Mendoza, Mexico	1:39:25	Francesca Porcellato, Italy	2:11:57
2002	Krige Schabort, South Africa	1:38:27	Cheri Blauwet, USA	2:14:39
2003	Krige Schabort, South Africa	1:32:19	Cheri Blauwet, USA	1:59:30
2004	Saúl Mendoza, Mexico	1:33:16	Edith [Wolf] Hunkeler, Switzerland	1:53:27
2005	Ernst van Dyk, South Africa	1:31:11	Edith [Wolf] Hunkeler, Switzerland	1:54:52
2006	Kurt Fearnley, Australia	1:29:22	Amanda McGrory, USA	1:54:17
2007	Kurt Fearnley, Australia	1:33:58	Edith [Wolf] Hunkeler, Switzerland	1:52:38
2008	Kurt Fearnley, Australia	1:44:51	Edith [Wolf] Hunkeler, Switzerland	2:06:42
2009	Kurt Fearnley, Australia	1:35:58	Edith [Wolf] Hunkeler, Switzerland	1:58:15
2010	David Weir, G.B.	1:37:29	Tatyana McFadden, USA	2:02:22
2011	Masazumi Soejima, Japan	1:37:29	Amanda McGrory, USA	1:50:24
2012	NO RACE			
2013	Marcel Hug, Switzerland	1:40:14	Tatyana McFadden, USA	1:59:13
2014*	Kurt Fearnley, Australia	1:30:55	Tatyana McFadden, USA	1:42:16
2015	Ernst van Dyk, South Africa	1:30:54	Tatyana McFadden, USA	1:43:04
2016	Marcel Hug, Switzerland	1:35:49	Tatyana McFadden, USA	1:47:43
2017	Marcel Hug, Switzerland	1:37:21	Manuela Schär, Switzerland	1:48:09
2018	Daniel Romanchuk, USA	1:36:21	Manuela Schär, Switzerland	1:50:27
2019	Daniel Romanchuk, USA	1:37:24	Manuela Schär, Switzerland	1:44:20

*** Shortened course**

PARTICIPANTS

MY, HOW WE'VE GROWN!

FROM 55 FINISHERS TO 53,640: THE GROWTH OF THE WORLD'S BIGGEST MARATHON

NYRR NEW YORK ROAD RUNNERS

YEAR	TOTAL FINSHERS	MALE	FEMALE
1970	55	55	0
1971	164	161	3
1972	187	185	2
1973	282	277	5
1974	259	250	9
1975	339	303	36
1976	1,549	1,486	63
1977	3,701	3,522	179
1978	8,588	7,819	769
1979	10,477	9,274	1,203
1980	12,512	10,890	1,622
1981	13,223	11,466	1,757
1982	13,599	11,700	1,899
1983	14,546	12,341	2,205
1984	14,590	12,195	2,395
1985	15,881	13,403	2,478

YEAR	TOTAL FINSHERS	MALE	FEMALE
1986	19,689	16,366	3,323
1987	21,244	17,555	3,689
1988	22,405	18,431	3,974
1989	24,659	19,971	4,688
1990	23,774	19,274	4,500
1991	25,797	20,593	5,204
1992	27,797	22,356	5,441
1993	26,597	20,781	5,816
1994	29,735	22,758	6,977
1995	26,754	20,284	6,470
1996	28,182	20,749	7,433
1997	30,427	22,014	8,413
1998	31,539	22,587	8,952
1999	31,786	22,626	9,160
2000	29,336	21,005	8,331
2001	23,664	16,811	6,853
2002	31,834	21,625	10,209
2003	34,729	23,014	11,715
2004	36,562	24,574	11,988
2005	36,857	24,795	12,062
2006	37,866	25,546	12,320
2007	38,607	26,072	12,535
2008	38,096	25,216	12,880
2009	43,660	28,485	15,175
2010	45,103	28,948	16,155
2011	47,340	30,068	17,272
2013	50,266	30,699	19,567
2014	50,530	30,108	20,422
2015	49,595	28,899	20,696
2016	51,394	29,930	21,464
2017	50,773	29,682	21,091
2018	52,704	30,592	22,112
2019	53,640	30,894	22,746
TOTAL	1,283,002	888,702	394,300

ABEBE BIKILA AWARD

Established in 1978, and named for the great Ethiopian marathoner, the Abebe Bikila Award is presented annually to individuals who have made significant contributions to the sport of long-distance running. Fittingly, the first recipient was Ted Corbitt, founder of both New York Road Runners and the Road Runners Club of America, and, just as fittingly, the honorees since have included men and women from around the world, all of whom have helped to elevate the marathon.

YEAR	RECIPIENT	YEAR	RECIPIENT
1978	Ted Corbitt, USA	1991	Alain Mimoun, France
1979	Emil Zatopek, Czech Republic	1992	Ingrid Kristiansen, Norway
1980	Lasse Viren, Finland	1993	Rod Dixon, New Zealand
1981	Frank Shorter, USA	1994	Juma Ikangaa, Tanzania
1982	Mamo Wolde, Ethiopia	1995	Fred Lebow, USA
1983	Grete Waitz, Norway	1996	Orlando Pizzolato, Italy
1984	Derek Clayton, Australia	1997	Lisa Ondieki, Australia
1985	John A. Kelley, USA	1998	Rosa Mota, Portugal
1986	Joan Benoit Samuelson, USA	1999	Tegla Loroupe, Kenya
1987	Kee Chung Sohn, Korea	2000	Khalid Khannouchi, USA
1988	Alberto Salazar, USA	2001	Mayor Rudolph Giuliani, USA
1989	Bill Rodgers, USA	2002	Allison Roe, New Zealand
1990	Waldemar Cierpinski, East Germany	2003	Katherine Switzer, USA

YEAR	RECIPIENT
2004	Stefano Baldini, Italy
2005	Mizuki Noguchi, Japan
2006	Paula Radcliffe, Great Britain
2007	Not Awarded
2008	Lornah Kiplagat, Kenya
2009	Allan Steinfeld, USA
2010	Paul Tergat, Kenya
2011	German Silva, Mexico
2012	Postponed
2013	The Rudin Family, USA
2014	Dr. Norbert Sander, USA
2015	Haile Gebrselassie, Ethiopia
2016	Mary Wittenberg, USA
2017	Meb Keflezighi, USA
2018	Deena Kastor, USA
2019	Jenny Simpson, USA ∇

Photo by Jon Simon/NYRR

BY THE NUMBERS

25	Combined men's and women's running victories for Kenya, most for any country
22	Combined men's and women's running victories for the USA, second most
9	Combined men's and women's running victories for Norway, third most (all by Grete Waitz)
$100,000	Prize money awarded to the male and female open division winners in 2019
$25,000	Prize money awarded to the male and female wheelchair division winners
1,319,514	Total starters, through 2019
1,283,002	Total finishers, through 2019
129	Countries represented among finishers, 2019
4:26:55	Average finishing time for all male runners, 2018
4:53:49	Average finishing time for all female runners, 2018
4:40:22	Average finishing time overall, 2018
8	Age of youngest-ever finisher, Wesley Paul, 1977
93	Age of oldest-ever finisher, Josef Galia, 1989
80°	Hottest race day temperature (Fahrenheit; 27° Celsius), 1979
41°	Coldest race day temperature (Fahrenheit; 5° Celsius), 1995

$1	Entry fee for the first New York City Marathon, 1970
$255	Entry fee for 2019
4	Width in inches of blue line marking the running route
65	Gallons of paint used for blue line
850	Buses used to transport runners to the start on Staten Island
64,890	Gallons of water available on course
32,040	Gallons of sports drink available
2.3 million	Paper cups set out along route
14,000	Bananas available between Mile 20 and Mile 23
396	Portable toilets on the course
29	Locations with wheelchair accessible ADA toilets
57	Dedicated ambulances stationed along course on race day
5	Average number of live bands playing along the marathon course
10	Hours of continuous live music provided
444,180	Pounds of material that was recycled at the 2018 TCS New York City Marathon
20,671	Pounds of unused food that was donated to local food banks
91,000	Pounds of clothing discarded by runners that was collected and donated
6	UPS trucks used to transport runners' donated clothing from the Verrazzano-Narrows Bridge
1	Kings of the Netherlands who have run the marathon, Willem-Alexander, in 1992

RECORDS

Course Record

Men	2:05:06	Geoffrey Mutai, Kenya	2011
Women	2:22:31	Margaret Okayo, Kenya	2003
Wheelchair Men	1:29:22	Kurt Fearnley, Australia	2006
Wheelchair Women	1:43:04	Tatyana McFadden, USA	2015

Closest Finish

Men	0:01	Paul Tergat, Kenya, over Hendrick Ramaala, South Africa	2005
Women	0:03	Paula Radcliffe, GB, over Susan Chepkemei, Kenya	2004
Wheelchair Men	0:00.06	Marcel Hug, Switzerland, over Kurt Fearnley, Australia	2016
Wheelchair Women	0:02	Amanda McGrory, USA, over Shelly Woods, GB	2006

Fastest Debut

Men	2:05:06	Geoffrey Mutai, Kenya	2011
Women	2:23: 10	Paula Radcliffe, GB	2004

Most Victories

Men	Bill Rodgers, USA	4
Women	Grete Waitz, Norway	9
Wheelchair Men	Kurt Fearnley, Australia	5
Wheelchair Women	Edith Wolf Hunkeler, Switzerland, and Tatyana McFadden, USA	5

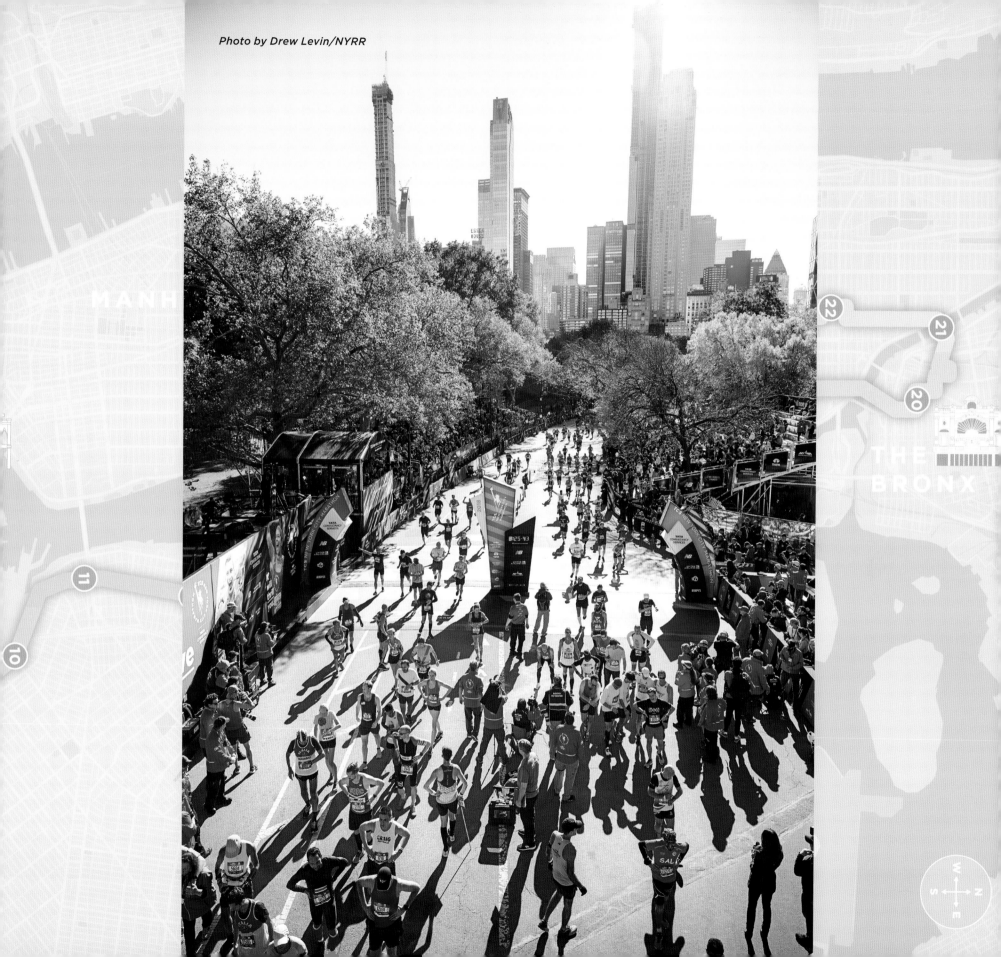

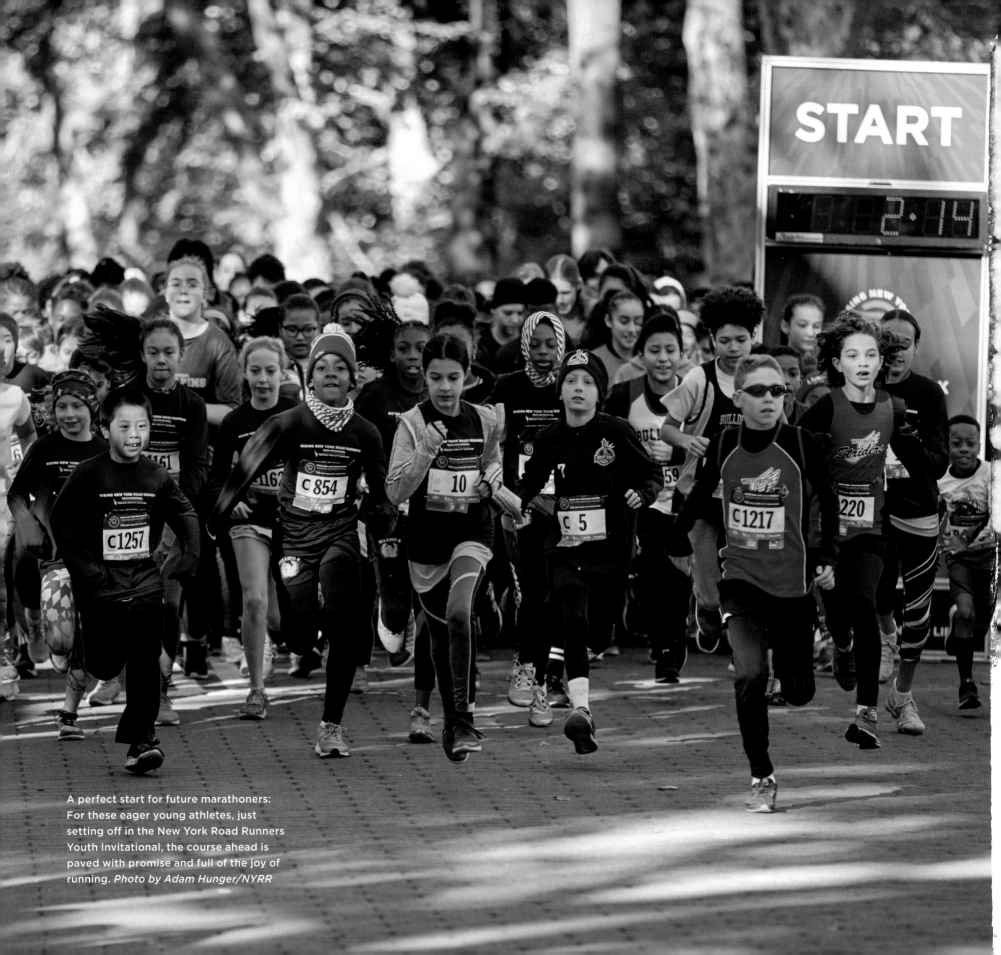

START

2:14

A perfect start for future marathoners: For these eager young athletes, just setting off in the New York Road Runners Youth Invitational, the course ahead is paved with promise and full of the joy of running. *Photo by Adam Hunger/NYRR*